W9-CND-683

"This adroitly crafted biography of Rubens brings to life an artist so busy wheeling and dealing with the crowned heads of Europe that it's amazing he found the time to put brush to canvas. Lamster's account engages the student of history as much as it opens the eyes of those who love Rubens's art."

—Timothy Brook, author of *Vermeer's Hat:*
The Seventeenth Century and the Dawn of the Global World

"Rubens's story surprises and dazzles." —*Kirkus Reviews*

"*Master of Shadows* is a fascinating account, as lively as it is informed. This utterly intriguing narrative has the knowledge and verve that infuse Rubens's brushstrokes."

—Nicholas Fox Weber, author of *Le Corbusier: A Life*

"Art, war, diplomatic intrigue, secret spy missions—all rendered with the erudition of a scholar and the deft touch of a gifted writer. This is exactly what popular history should be. I was utterly transfixed by this book."

—Jonathan Mahler, author of *The Challenge:*
Hamdan v. Rumsfeld and the Fight over Presidential Power

"Piercing the darkened, secret world of agents, operatives, and diplomats is a difficult task at the best of times—and in Rubens's case, one thought impossible—but Mark Lamster brilliantly succeeds at shedding light on this most enigmatic, and aptly dubbed, Master of Shadows."

—Alexander Rose, author of *Washington's Spies:*
The Story of America's First Spy Ring

MARK LAMSTER

MASTER OF SHADOWS

Mark Lamster writes on the arts and culture for many publications, including *The New York Times*, the *Los Angeles Times*, and the *Wall Street Journal*. His first book, *Spalding's World Tour*, was an Editor's Choice selection of *The New York Times Book Review*. He lives in New York City.

www.marklamster.com

ALSO BY MARK LAMSTER

❧

*Spalding's World Tour: The Epic Adventure That Took Baseball
Around the Globe—and Made It America's Game*

MASTER OF SHADOWS

❧

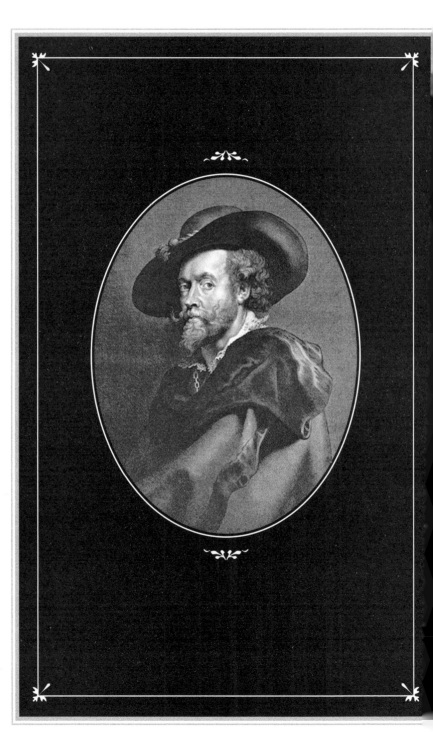

MASTER *of* SHADOWS

THE SECRET DIPLOMATIC CAREER OF

THE PAINTER PETER PAUL RUBENS

MARK LAMSTER

Anchor Books
A Division of Random House, Inc.
New York

FIRST ANCHOR BOOKS EDITION, OCTOBER 2010

The Library of Congress has cataloged the Nan A. Talese/Doubleday
edition as follows:
Lamster, Mark, 1969–
Master of shadows : the secret diplomatic career of the painter
Peter Paul Rubens / Mark Lamster.—1st ed.
p. cm.
Includes bibliographical references and index.
1. Rubens, Peter Paul, Sir, 1577–1640. 2. Painters—Belgium—Biography.
3. Diplomats—Belgium—Biography. I. Rubens, Peter Paul, Sir, 1577–1640.
II. Title. III. Title: Secret diplomatic career of the painter Peter Paul Rubens.
ND673.R9L25 2009
759.9493—dc22 [B] 2009009750

Anchor ISBN: 978-0-307-38735-6

Author photograph © Blip Studio
Maps by Jeffrey L. Ward

www.anchorbooks.com

Printed in the United States of America
10 9 8 7 6 5 4 3 2 1

For Anna & Eliza and Hal & Jane

I could provide a historian with much material, and the pure truth of the case, very different from that which is generally believed.

—PETER PAUL RUBENS

CONTENTS

❧

THE
LOW COUNTRIES
at the time of the
TWELVE YEARS' TRUCE
1609-1621

North Sea

Amsterdam

UNITED PROVINCES
(HOLLAND)

The Hague • Utrecht •

• Delft

s'Hertogenbosch

Rhine R.

ZEELAND

Breda

Fossa Mariana
(1624–1629)

Rheinberg

Truce Line - - - •

• Roosendaal

Bergen op Zoom

Venlo

Ostend

Kieldrecht

Kallo

Maas R.

Dunkirk

Bruges Ghent

• Antwerp

to Cologne →

• Calais

Lys R. *Scheldt R.*

Brussels •

SPANISH

• Maastricht

Mons
•

NETHERLANDS
(FLANDERS)

Atlantic Ocean

to Paris
↓

Avesnes •

Vallad

FRANCE

Madrid

SPAI

Cadiz •

Jeffrey L. Ward

North Sea

DENMARK

JUTLAND

Baltic Sea

UNITED
PROVINCES
(HOLLAND)

ENGLAND

Amsterdam

London

The Hague

GERMANY

Calais

Antwerp

Cologne

English Channel

Brussels

Siegen

SPANISH
NETHERLANDS
(FLANDERS)

Dillenburg

Paris

PALATINATE

FRANCE

0 Miles 100 200 300

0 Kilometers 300

SPANISH ROAD

Alps

La Rochelle

SAVOY

MANTUA

Milan

Venice

Mantua

Bordeaux

Genoa

Pisa

Florence

Pyrenees

ITALY

Rome

EUROPE

IN THE TIME OF

RUBENS

Alicante

Mediterranean Sea

ᴄ◦ᴛ◦ᴗ

The primary action of this book concerns the status of the Low Countries—today, Belgium and the Netherlands—during the late sixteenth and early seventeenth centuries. As Europe emerged from its feudal past, this territory came under the sovereignty of Habsburg Spain, which had extensive holdings across the Continent. Spanish rule in the Low Countries was so divisive as to instigate a prolonged war of rebellion—the Eighty Years' War—within the seventeen provinces of the greater Netherlands. The ten southern provinces (modern Belgium) remained loyal to Spain, and came to be known as the Spanish Netherlands, or Flanders. The seven northern provinces fought for their independence, and became the Dutch nation, commonly known as Holland. This conflict ensnared all the great powers of western Europe, who were perpetually jockeying among themselves in disputes of political ambition, commerce, religion, and territory.

For the sake of clarity, I generally use the designation "Flanders" to refer to the southern, loyalist region that is properly known

as the Spanish Netherlands. In fact, Flanders was just one of several provinces that constituted the Spanish Netherlands. Similarly, I use the designation "Holland" to refer to the rebellious Dutch provinces to the north, though it was just one of several provinces in the coalition that became the modern Netherlands. It was standard practice to refer to "Flanders" and "Holland" (and "Fleming" and "Hollander") at the time the book is set, so it is reasonable to turn to them again here. The Latin term *Belgica*, also familiar during that period, referred to the Low Countries in their entirety.

For convenience, dates are regularized to the Continental standard calendar. England, at the time, operated on a calendar ten days behind the rest of Europe, with the New Year begun on the twenty-fifth of March. There was also no standard currency used across Europe during this period. For reference, one Flemish guilder or florin was roughly equivalent to one-tenth of an English pound and a twelfth of a Continental crown. An average annual salary for an unskilled tradesman in Flanders was roughly 300 guilders.

MASTER OF SHADOWS

PROLOGUE

ᡄᡄᢟᢇᢆᢙ

Few artists have left so deep an imprint on their times as Peter Paul Rubens, the painter whose sense of grandiosity and drama gave visual definition to Baroque power. Fusing the lessons of the Italian Renaissance and the artistic traditions of his native Flanders, Rubens created a style that was entirely original and universally appealing, an international language that bespoke authority and cultivation. It was a heroic vision, one that allowed him to picture the most powerful men and women of his day, and the institutions they controlled, not necessarily as they were, but as they wished to be seen. His unique ability and keen sense of entrepreneurship brought him a seemingly endless stream of royal clients, but he was adored by the general public as well, especially for the moving evocations of devotion he created for their places of worship. No artist better managed the delicate task of translating the ethereal passion and splendor of religious faith onto canvas. The reverence shown him by other artists was almost fanatic. A young Rembrandt, like many painters who followed in his wake, modeled himself on

Rubens—he even dressed in imitation of the great master from Antwerp.

The nearly universal esteem in which Rubens was held, combined with his access to the highest reaches of international power, provided the foundation for his conscription into diplomatic service. Painting gave Rubens the perfect cover for clandestine work; he could appear at any foreign court and always use his art to allay suspicion of ulterior motives. It's hard to imagine this happening in our own time; we don't expect artists to be spies or diplomats. Political figures dabbling in art is one thing—Churchill and Eisenhower were amateur painters, and Hitler a failed professional—but not the reverse. From the Romantic era, we have inherited a vision of the painter as an emotionally volatile, impecunious radical: a critic or enemy of the state, and not someone to be entrusted with its most delicate and urgent business.

Rubens does not fit into that archetype. He was born in 1577 and came of age at a time when painting was still a respected guild profession. Those who met him almost invariably remarked on his affable nature and winning personality. He was tall and physically attractive, with a disarming, scholarly mien. His innate charisma was only augmented by his preternatural artistic ability and his encyclopedic knowledge of subjects ranging from architecture to political theory to zoology. The images for which he is now most famous—swooning women, their flesh alive in puckered ecstasy— suggest a man of unchecked libertinism. In fact, he was a devoted husband and generally moderate in his personal appetites, the chief exception being his zeal for work. A life so disciplined and successful might well have transformed him into an insufferable pedant, but instead he wore his authority lightly, and that only magnified it. He had few vices besides the occasional flash of pride.

What prompted Rubens's engagement in politics was the con-

dition of his native Flanders, a land beset by sectarian violence and occupied by a negligent foreign empire, Spain, to which he owed allegiance. His beloved but decimated Antwerp, once a haven of international trade and culture, sat on the front lines of a war of independence waged against that Spanish empire by the nascent Dutch republic to the north. Rubens made it his personal mission to resolve that seemingly intractable conflict, known to history as the Eighty Years' War. It was a goal he pursued with the same energy that he brought to his art, and one for which he risked all that he had acquired—his career, his reputation, his life.

This project, more ambitious than any painting, consumed him for over a decade, during which time he traveled from capital to capital, often under false pretenses, to negotiate with statesmen and monarchs who were also clients. Sequestered in their luxurious palaces, isolated from their subjects and the world beyond by meticulously orchestrated systems of protocol and social stratification, these rulers could be oblivious to and sometimes contemptuous of political realities. Decisions of enormous consequence were often made on ideological grounds, for the sake of national or personal pride, or merely on whim. Rubens, in contrast, was a consistent voice of moderation, a pragmatist or *politique*, in the parlance of the day.

Sectarian conflict and political dogmatism still plague the community of nations, a reality that gives particular resonance to the story of a moderate and pragmatic man who spent so much of his life fighting entrenched forces in the halls of international power. For all its relevance, however, Rubens's diplomatic work and philosophy are for the most part unknown but to scholars, an unfortunate, though not surprising, circumstance. Contemporary audiences can hardly be expected to recall his political career when even his accomplishments as a painter remain largely unfamiliar. Among the great mas-

ters of art history, Rubens is something of a forgotten man, respected but misunderstood, hidden in plain sight. The reasons are many. There is no single painting that defines his career, no image so iconic as the *Mona Lisa* or the *Demoiselles d'Avignon*. He does not conform to our favored image of the artist as a tortured soul. The allegorical, mythological, and biblical figures that populate his canvases are alien to modern viewers, and those canvases can be so large and so complicated as to defy ready explanation. He has been tarred by the undistinguished politics of his clients. To many, he is simply the man who painted lascivious pictures of fat, naked women.

Our inability to fully grasp Rubens's achievement is at least in part a failure of narrative. His story and his paintings have been robbed of their urgency over the centuries following his death. What passed for common knowledge and experience in the seventeenth century can seem altogether foreign to a modern audience. It is the historian's challenge to bridge this divide, and the rewards are well worth the effort. Rubens was possessed of an alchemical gift, an ability to bring colorful, breathtaking life to inanimate matter, and he is responsible for some of our most arrestingly beautiful and emotionally stirring investigations of the human condition. The essential lessons of these works are as fresh now as they were four hundred years ago, and we can recapture them in all their complex grandeur if we give the Rubens story the careful and sustained attention it so richly deserves.

A NOVICE WITHOUT
EXPERIENCE

❧

> You are going as official representative into Spain, a
> country different in her ways and customs from Italy and
> unknown to you. Furthermore, it is your first commission.
> Hence if you make a good showing in this office, as
> everybody hopes and believes, you will gain high honor;
> and so much higher, the greater the difficulties.
>
> —NICCOLÒ MACHIAVELLI

Sometime in the late spring of 1602—there is no record of exactly
when—Vincenzo Gonzaga, the Duke of Mantua, decided it would
be a good idea to send an extremely large gift to Philip III, the king
of Spain. This was to be an act of considerable generosity, but not
one motivated by pure altruism. To be a minor European monarch
in the seventeenth century was to live in fear of Spain's pitiless and
well-disciplined *tercios*. Those professional armies, bristling with
artillery, pikes, and Toledo steel, and drilled in formations that
seemed well-nigh invincible, made Spain the most potent military
force on the Continent. Spain's possessions encompassed much
of Italy, including Lombardy, Mantua's neighbor to the west.

Vincenzo, no fool, eyed Spanish power with a healthy wariness. Like Philip, he was of Habsburg blood, but attachment to Europe's foremost dynasty did not guarantee the autonomy of his duchy. It was therefore only prudent that Vincenzo place himself squarely within Philip's good graces, as the young king was new to his throne.

Philip had a reputation as something of a sportsman, so Vincenzo tailored his offering accordingly. The centerpiece of the gift was to be a plush riding carriage driven by six of the finest horses from the duke's stable, revered across Europe for its thoroughbreds. That was a good start, and Vincenzo added to it with eleven harquebus guns decorated with whalebone and silver filigree, a rock crystal vase filled with perfume, and—somewhat immodestly—portraits of himself and his wife for the king's cabinet. These items were for Philip alone, but the duke did not stop there, for he knew that the king, in his hedonistic youth, had voluntarily surrendered much of his authority to his rapacious political Svengali, Francisco Gómez de Sandoval y Rojas, the Duke of Lerma. He, too, would be on the receiving end of Vincenzo's generosity.

Whereas Philip was a Habsburg scion, Lerma was born to minor nobility, and only created a duke by an act of his patron, the king. As with so many of history's arrivistes, Lerma understood the practice of collecting art, traditionally a pastime of royalty, to be a path to improved social respectability. Vincenzo's gift to him, then, was shrewdly designed to appeal to a man who would be a great connoisseur from a man who could already claim that distinction: some twenty old-master paintings, most of them actually copies of works by Raphael, several of which belonged to Vincenzo himself. (In an era before the easy mechanical reproduction of color images, there was little stigma attached to well-executed copies, even if originals were preferred and more valuable.) Lerma's own favorite minister, or *valido*, the ruthless Don Rodrigo Calderón, would also

receive works copied from the Mantuan collection, along with damask and cloth of gold. Lerma's religious sister would have a crystal crucifix and a pair of candelabra. A cash gift would be provided to the director of music at the royal chapel—Vincenzo was a patron of that art as well.

That Vincenzo might deliver these gifts himself was out of the question; that would have been too great an act of fealty for someone of his stature. The duke was a prideful man—in his own youth he had even killed a man over a minor indiscretion—and considerably older than Philip, who was still in his early twenties. Vincenzo thus preferred to cast himself as a benevolent elder statesman, an avuncular figure to be respected as a fellow Habsburg sovereign. He had even taken to the battlefield on behalf of the Habsburg cause, participating in a series of campaigns against the Ottomans, usually to his discredit. (He was an early—and failed—experimenter with poison gas; inept soldiering was something of a Gonzaga family tradition.) With this in mind, Vincenzo decided that an emissary would chaperone the gift. Any number of courtiers might have qualified for this job. The duke, like so many royals, surrounded himself with a cadre of ambitious grandees who would have thrilled at the prospect of a trip to the great Spanish court, not to mention a personal audience with Philip, the highest of royal highnesses. Vincenzo, however, did not choose any of these men. Instead, the duke summoned into his chamber a young Flemish painter with neither noble blood nor diplomatic pedigree. Vincenzo required someone reliable, preferably a painter who could handle any minor restoration work necessary after the long trip across the Mediterranean. But this agent also had to be someone with a bit of panache: someone who could handle the inevitable obstacles of a long journey while keeping its purpose quiet, for the duke most assuredly did not want every royal on the Italian boot to know of his private business groveling before

the Spanish throne. More important, however, Vincenzo required someone who could represent him with appropriate dignity before his Habsburg relation in Madrid.

PETER PAUL RUBENS, age twenty-five, had been on the duke's pay-roll for only two years when he was selected for this mission. In that time, he had worked without ceremony on tasks of no great import: the minor portraits and copy work that were the routine business of a court studio. There was something about Rubens, though, that made him stand out from the several other painters employed by Vincenzo. People were naturally drawn to him, and the duke in particular. Vincenzo may even have noticed a slight resemblance between himself and the artist fifteen years his junior, even if the younger man, to be frank, had a good deal more hair and a good deal less paunch around the middle. Rubens was unquestionably handsome: tall for the age, with gently receding brown hair, neatly trimmed whiskers, and a piercing gaze. Those who knew him found him to be confident but not cocky, with an innate charisma that attracted both sexes. He possessed that ineffable quality Italians called *sprezzatura*—a kind of easy, knowing charm. In the brief time they spent together, Rubens managed to impress Vincenzo as a quick-witted, refined, and highly intelligent individual of no small ambition. He was comfortable in the society of court, obsequious when circumstances demanded, and possessed of a diplomat's natural ability to appear both deferential and sincere even when conveying unpleasant information or shaving the rough edges of truth. That he was gifted with languages was especially useful; already he was fluent in Dutch, French, German, Italian, Latin, and Spanish.

Despite these qualities, Rubens was an unorthodox candidate for an important embassy. Diplomatic work was typically reserved

for members of the aristocracy, men with political experience and the means to fund the considerable expenses of a life at court. Only those of high breeding, it was thought, could be expected to have the social dexterity and intellectual aptitude necessary to represent a sovereign prince in a foreign land. There were, however, exceptions to this rule. In one of the earliest primers on ambassadorial conduct, the Dutch-born diplomat Abraham de Wicquefort wrote that "it be not absolutely necessary, that the Embassador should be a Man of Birth, yet at the same time there must be nothing sordid nor mean in him."

As members of the court, painters were granted a standing above that of other tradesmen, and could be counted on to possess a worldliness typically restricted to those of hereditary advantage. Indeed, the profession required mastery of a broad range of fields, from chemistry (required to mix pigments), geometry (for perspective), and anatomy (for the drawing of the figure) to the classical and biblical history that served as the subject matter of so much painting. The most celebrated artists, prized for their seemingly magical image-making prowess, on occasion became trusted princely advisers. Leonardo da Vinci was a counselor to several princes (often on matters of defense and engineering) and in his later years an intimate of the French king François I. Jan van Eyck, until Rubens the most famous of Flemish painters, represented the duke of Burgundy on several diplomatic missions. Gentile Bellini, in 1457, was dispatched by the Venetian senate as a goodwill emissary to the Ottoman sultan Mehmet II at Constantinople. At the time of his trip, Rubens had yet to achieve the artistic reputation of Bellini, but his presence would similarly confer a bit of the Gonzaga family's considerable cultural authority on the Spanish court. That the paintings sent with him were largely copies of works from the Mantuan collection, rather than originals, only reinforced the

sense of paternalism that Vincenzo hoped to convey. Every time the king and the duke glanced at these works, they would be reminded of both the magnificence and the munificence of their esteemed Mantuan ally.

The choice of an artist, then, was not unprecedented, but the choice of this artist, Rubens, occasioned a good deal of chatter among Vincenzo's notoriously chippy courtiers. He had good manners, yes, but he was not of aristocratic blood, and he was not a member of Vincenzo's inner circle—for that matter, *he wasn't even Italian.* His relevant experience was, indeed, practically nonexistent, though he had been prepared, at least in his early years, for a life in court service. As a child, he had been enrolled, along with his older brother Philip, in Rombout Verdonck's school for boys, the academy of choice for Antwerp's burgher elite. There, the Rubens brothers were drilled in the classics: Virgil, Horace, Pliny, and especially Seneca, whose stoicism was considered a philosophical model for contemporary behavior. Art was not on the program. Jan Rubens, the boys' late father, had been a lawyer and an alderman, and it seemed the young Peter Paul was headed down a similar path. He had always been an eager student, and a gifted one. The painter's nephew would later write that "he learned with such facility that he easily outstripped his classmates." Economic circumstances, however, put an end to Rubens's formal schooling at the age of thirteen. In 1590, the family education fund was diverted to provide a dowry for an older sister, Blandina. Rubens's evident intelligence and charm, even then, made him a prime candidate for a career as a court functionary, and his devoted mother, Maria, arranged through family connections to have him set up as a page in the residence of the Countess Marguerite de Ligne-Arenberg, whose father-in-law had been a governor-general of the Netherlands during the reign of Philip II.

It was a good appointment, but Rubens was unhappy. "There always glimmered inside him a desire for the noble art of painting," wrote Joachim von Sandrart, a German painter who traveled with Rubens in his later years. As a child, he had spent hour after hour poring over the woodblock prints of the artists Hans Holbein and Tobias Stimmer, which were popular among middle-class families like the Rubenses. Young Peter Paul was a natural with a pen, and found himself especially drawn to the robust figures in Stimmer's book of illustrated stories from the Bible, which had a physical presence so strong—like the imposing statues of cathedral facades—that it seemed they might just stomp off the page. From even those early drawings it was plainly evident that Rubens had artistic talent, and now he wanted to make a career of it. This was not an unprecedented decision for a Rubens; an older brother, Jan Baptist, had left the family many years earlier to pursue a career in the arts, and was thought to be in France. Rubens was not prepared to forsake his kin as his sibling had, but life as a functionary was not going to satisfy him either.

Whether or not she approved, Maria understood that once her headstrong young son had fixated on some goal, refusing him would be pointless. Again using family connections, he was apprenticed to Tobias Verhaecht, an Antwerp landscape painter of minor reputation who was a distant relative by marriage. Roughly a year later he moved on to the atelier of Adam van Noort, a respected member of the painters' guild, and some two years after that to the studio of Otto van Veen, who figured among Antwerp's artistic elite. He learned the basics of his craft in these apprenticeships: how to make pigments and prime a canvas, the techniques required of different mediums, how to layer colors, how to model a figure, how to compose the elements of an image. Soon enough he was working on canvases that would be finished by his masters. His education was

more than just practical. Van Veen especially encouraged Rubens's academic interests. Before establishing his studio, Van Veen had traveled through Italy, where he absorbed the ideals of the Renaissance and the classical tradition. This was not uncommon at the time. Among the informal circle of like-minded humanists who dominated Antwerp culture, an extended tour of Italy was practically de rigueur. Even Jan Rubens, the painter's father, had made such a trip, earning his law degree in Rome after seven years of study abroad. Van Veen was more of a proselytizer than most. Upon his return he went so far as to assume a Romanized name: Octavius Vaenius.

By 1598, Rubens had completed his training and become a member in good standing of the Guild of Saint Luke, the painters' guild. He was a master, but he knew that he did not have all of the education he required, and he could see this deficiency quite plainly in his first commissions. A large panel painting of Adam and Eve showed his promise, but there was an undeniable stiffness to the picture, a frozen quality, that he intuitively understood as a weakness. Italy beckoned.

Rubens's quest to travel abroad for personal and professional enrichment was contingent upon his receipt of documents from the Antwerp town hall. These letters were required of all travelers, and verified that their bearers had good standing in the community and clean health—"no plague or contagious disease." Rubens received his papers on May 8, 1600. The next day he was off, accompanied by his first pupil, Deodate del Monte, who was similarly certified and would serve as a faithful assistant for many years to come. They traveled by horse, and though there is no precise record of their path, in all likelihood they traveled south and west, crossing through Alpine passes into northern Italy. Their first destination was Venice, a city that had supplanted Rome as an artistic capital for a brief moment in the previous century. If Venice had lost that momen-

tum, it could nevertheless boast a modern school of painting that was like nothing Rubens had seen in Antwerp. In place of the studied classicism of Van Veen, the works of Bassano, Veronese, Tintoretto, and above all Titian, with their explosive colors, dynamic compositions, and expressive brushwork, suggested new directions for the young painter.

Rubens made it to Venice in time for the city's June carnival, a raucous annual event of masquerades, feasts, exhibitions, and performances with a history dating back to the thirteenth century. Vincenzo was also in town for the festivities, as an honored guest. The duke was a man of considerable appetites and liked to be on hand when there was a good debauch to be had—he was notoriously ill-tempered when not sated. To prevent this eventuality, the duke traveled with a sizable entourage, a group that included his secretary and chief political officer, Annibale Chieppio, a chubby-cheeked Milanese with a punctilious nature. In addition to his diplomatic duties, Chieppio kept an eye peeled for fresh artistic talent for the duke's Mantuan studio. At some point during the carnival, he met the enterprising young master from Antwerp. A review of the work Rubens had brought with him over the Alps was apparently enough to convince Chieppio to add him to the Mantuan payroll. Vincenzo already had one Flemish painter on staff, the portraitist Frans Pourbus, and that had worked out well. If nothing else, Rubens would prove useful in filling out Vincenzo's nascent "Gallery of Beauties." The duke enjoyed the prestige of his art collection, but he was frankly more interested in the lascivious pleasures it might provide him, and kept his court studio busy knocking out portraits of Europe's most attractive ladies. Rubens would soon find that work beneath his dignity, but for the moment he was happy for the appointment, which came with a respectable salary and accommodations in the royal compound. That same October, when Vincenzo

left Mantua for Florence to attend the proxy marriage of Marie de' Medici to King Henry IV of France, Rubens was brought along as part of the duke's retinue.

That wedding, which united the Medici and Capetian dynasties, gave Rubens a taste of royal splendor that made a lasting impression. The ceremony took place at the Basilica di Santa Maria del Fiore, under the soaring vault of Brunelleschi's great dome. At the sumptuous banquet that followed, figures dressed as Roman gods serenaded dignitaries assembled from across Europe. (Henry, however, awaited his bride back in France, not wanting to expose himself to the predations of his prospective relatives.) In the future, Marie would become one of Rubens's most important patrons and political allies, but at her nuptial event he was relegated to the periphery. It served, however, as a useful lesson in the formalities and grand scale of Baroque political theater.

Rubens completed his first formal diplomatic "mission" for Vincenzo in the following year, 1601, when he delivered a letter from the duke to Alessandro Cardinal Montalto, nephew and adviser to Pope Sixtus V. The job, not a particularly difficult one, required the navigation of the halls of Roman power, but served primarily as an excuse to send Rubens to Rome, where he stayed for eight months making copies of old-master works for the duke. He also took on private commissions during his residency in the Eternal City, in the process substantially elevating his reputation as an artist.

That budding notoriety may well have been a factor when Vincenzo made the decision to send Rubens abroad in 1602. Word that Rubens was a bright new talent was already beginning to filter through Europe's capitals, and the fact that Vincenzo could claim him as a member of his artistic stable would be seen as yet another feather in the duke's cap. As an added bonus, Rubens could paint

all the most attractive women in Madrid for Vincenzo's cabinet. Indeed, the painter would be instructed to return from Madrid by way of Paris for no other reason than to bring images of the fairest figures in that city back for the duke's museum of high-end soft-core pornography.

Vincenzo, then, knew just what he was doing when he had Rubens summoned to his private apartments at the Castello di San Giorgio. The artist walked briskly, as was his wont, through the halls of the palace and was ushered into the duke's presence by an elaborately uniformed chamberlain. Chieppio was there to provide him with his instructions, or at least the basics; there'd be plenty of time to go over logistics before his departure.

It was a plum assignment, and Rubens knew it. His whole Italian experience had thus far eclipsed all of his aspirations. He had departed Antwerp in an effort to enrich himself intellectually, and almost at once he had found himself attached to one of the most distinguished courts south of the Alps. The tasks of the Mantuan studio had proven to be no great challenge for him, and he had virtually unlimited access to the duke's collection of old masters, which he could study at his leisure. He had already traveled to Florence and to Rome on the duke's payroll, and now he was being offered the opportunity to ingratiate himself with the new Spanish king and his many acolytes, all potential clients. The logistical and diplomatic demands of the trip would be a chore and a distraction from Rubens's primary passion—his art—but the benefits were so great as to outweigh any thought of refusal. At the very least, he would have access to the famed royal collections in Madrid and at the Escorial, the art-filled monastery and palace complex in the nearby Guadarrama hills. And so when the delicate final moments of his meeting with Vincenzo and Chieppio arrived, Rubens was effusive. Yes, he was very pleased to be charged with this mission,

and he would do all in his power to represent the duke with appropriate dignity.

<center>⚘</center>

IT WAS NEARLY a year before Rubens actually left Mantua with Vincenzo's gifts for the Spanish king and his courtiers. That long delay, the product of some bureaucratic snafu, augured poorly for the journey. At least it should have given the palace stewards time enough to map out an easy route to Spain for the painter, one that would have avoided mountain passes, unfriendly tax collectors, and the prying eyes of the duke's rivals. Unfortunately, careful attention was not devoted to the logistics of the journey, and Rubens did not have the experience to see just what trouble lay in store for him.

All this was beginning to dawn on him, however, when he found himself standing uncomfortably in an opulent Pisan receiving room before Vincenzo's uncle Ferdinand I de' Medici, the Grand Duke of Tuscany. This was in late March 1603, when he was already three weeks into his long-delayed journey. Rubens recognized Ferdinand's shrewd countenance; he had seen him in person a few years earlier, at the proxy wedding of Henry IV and Marie de' Medici in Florence. But that viewing was from a distance only. This audience was something altogether more intimate, and Rubens was grateful that Ferdinand opened it with a disarmingly friendly introduction. The grand duke politely inquired as to the painter's background and his purpose in Pisa, a long distance and a difficult mountain passage from his patron's Mantuan palace. Rubens offered the truth, though he went light on the details of his mission; he was in no position to discuss Vincenzo's affairs with another prince, no matter their relation. The grand duke nodded. In fact, the question was a con. He knew precisely who Rubens was, where he was going, why he was going there, and what he was carrying along

<center>· 16 ·</center>

with him. To demonstrate this knowledge, he cut Rubens off in midstream and proceeded, in rather bemused fashion, to rattle off the entire extravagant catalog headed for Philip III—every last item, down to the final whalebone harquebus. It was an impressive performance, and it concluded with the grand duke "asking" that Rubens add two more articles to the manifest: a horse and a marble table to be deposited with one of the grand duke's own allies at Alicante, on the Iberian coast. What could Rubens do but say yes?

Back at his room in the aftermath, Rubens sent off a dispatch to Chieppio in which he described the meeting in some detail. "I stood there like a dunce, suspecting some informer, or in truth the excellent system of reporters (not to say spies) in the very palace of our prince," he wrote. "It could not be otherwise, for I have not specified my baggage, either at the customs or elsewhere. Perhaps it is my simplicity which causes me astonishment at things that are ordinary at court. Pardon me, and read, as a pastime, the report of a novice without experience, considering only his good intention to serve his patrons, and particularly yourself." If things had not gone according to plan, at least he might try to ingratiate himself with his superiors.

Rubens's plea of naive innocence was disingenuous, for at the very least he should have anticipated what was to transpire at that meeting. He had, in fact, already agreed to take on the grand duke's horse two days earlier, when he was approached by a fellow Antwerp native in Ferdinand's employ. Had he let slip with one too many details during their conversation? Probably not, but the assertion in his letter to Chieppio that he had not "specified" his baggage was patently false. If Rubens was surprised at all, it might have been that the grand duke was willing to trust him with his horse in the first place, given that his journey from Mantua to Pisa had been something of a fiasco from its very outset, and its tortured progress

no great secret in the halls of Tuscan power. This was probably on Ferdinand's mind as well, but the audience with Rubens had been called less as a test of the painter's competence than as a message to his Mantuan nephew, Vincenzo. Ferdinand was not prepared to simply cede his role as Italian arbiter of cultural authority to the Spanish crown. Just two years earlier, Ferdinand had sent his own immense gift to Lerma: a marble fountain capped by a statue of Samson slaying a Philistine. This masterpiece was the work of the sculptor Giambologna, himself a Flemish transplant to Italy. Now Vincenzo's gift would pass, but not without Ferdinand's tacit approval.

Rubens's journey from Mantua to Pisa had in fact been such an amateurish farce that any number of sources could have provided Ferdinand with information on its bungled early stages. At Ferrara, the convoy's first stop, customs officials had insisted upon opening for inspection each of the seven trunks in the shipment, not counting the plainly visible horses and carriage. (Rubens, who could be obsessive about his reputation, conveniently neglected to mention this when he had asserted that his luggage had not been inspected.) The Ferrarese presented Rubens with a duty so large that it exceeded the entire projected cost of the trip to Spain. Vincenzo might have sent along a formal request that the cargo be exempted from such levies, but he considered it beneath his dignity to do so; that would have looked cheap. Instead, Rubens was provided with a packet of letters of introduction, and forced to scurry about begging the intercession of local figures of influence with ties to the duke. Acting nimbly, he managed to free the cargo, but the scene was rehearsed again at Bologna, the next stop, where authorities were satisfied by what was generously described as a "tip," and once again in Florence, after an arduous trek over the Apennines.

The drive over the mountains was particularly expensive and

time-consuming. Rubens was forced to commission oxen to pull the luggage through the muddy Apennine passes, with their narrow switchbacks and steep inclines. The Tuscan vistas were spectacular—when they were visible through the rain and fog—but the cost for hauling the carriage alone was enormous, and that was without the protective cart built to carry it, which had to be left behind. Upon arrival at Florence, things didn't much improve. When Rubens presented his credentials, he was met by looks of bewilderment. What was he doing in Florence? Why hadn't he taken the direct route from Mantua to the port of Genoa? "They almost crossed themselves in their astonishment at such a mistake," Rubens observed. Instead, incompetent Mantuan court functionaries, perhaps jealous of his mission, had sent him on a circuitous fool's errand southeast through Tuscany, forcing a needlessly difficult mountain crossing. Worse still, he might sit idle and bleeding funds for three or four months waiting for a ship to Spain at Pisa, whereas service out of Genoa was far more dependable.

The delay with the carriage and spring flooding along the route to the coast kept Rubens in Florence for ten days. When he did reach Pisa, at least there was good news: a fleet of ships from Hamburg happened to be in port and en route to Alicante. He booked passage, but now there was an additional problem. It was Rubens's understanding that once he arrived in Spain, the ride to Madrid would take roughly three days. Once again, even a brief glance at a map would have shown quite clearly that on this he had been badly sold by his handlers in Mantua. (No small irony, given that the astronomer and cartographer Giovanni Antonio Magini was a Mantuan court resident and had been working on an atlas of greater Italy for ten years.) The journey was actually some 280 miles—a good two weeks in travel time—and the funds with which he had been provided would not suffice. Vincenzo's precious

horses, bathed regularly in wine to maintain their lustrous coats, could not be pressed, lest they appear worn out at their presentation to the king. Frustrated, Rubens wrote to Chieppio asking for additional funds, while promising to spend his own salary until he could be reimbursed. "No one can accuse me of negligence or extravagance; my clearly balanced accounts will prove the contrary," he wrote. "I beg you to favor me by informing His Highness freely of everything, or by having him read this letter." A few moments later he thought better of this presumptuous request and tacked on a postscript: "It would be better for me if you were to make a verbal report; the letter in certain places may exceed the limits of modesty and reverence for His Highness."

The journey across the Mediterranean was slow but uneventful, and for a while it seemed that luck had turned in favor of the young painter. At Alicante, he consigned the horse and table of the grand duke without difficulty. But he also learned that the overland trip across Spain, which was already going to be weeks longer than expected, was to be longer even still. The Spanish court was not in Madrid; since 1601, it had been removed to Valladolid, several days to the northwest over difficult terrain. That shift, which lasted five years, had come at the bidding of Lerma, whose intention was to isolate Philip III from the chattering political busybodies of Madrid, and thereby enhance his own influence.

The trek from Alicante to Valladolid was a twenty-day slog through wind and rain that matched all the difficulty of the crossing of the Italian boot. And when Rubens finally did arrive at the residence of Annibale Iberti, Vincenzo's Spanish ambassador, he was greeted by another surprise. Philip wasn't in town. Earlier on the same day, the king had departed on a rabbit-hunting expedition into the nearby hills. At least he'd be back soon. Satisfied with himself, Rubens composed a missive to Vincenzo. "I hope that for

this first mission which Your Serene Highness has condescended to entrust me, a kind fate will grant me your satisfaction, if not complete, at least in part," he wrote. "And if some action of mine should displease you, whether excessive expenditure or anything else, I beseech and implore you to postpone reproach until the time and place when I may be permitted to explain its unavoidable necessity."

Alas, the note was written with something less than absolute candor. Ambassador Iberti, it seems, had not been expecting Rubens and his gift horses, and he was not pleased at their arrival—and in a bedraggled state at that. One of the grooms charged with administering the equine wine baths was nearly dead with a fever contracted on the journey, and would only last out the week. Iberti could not have been happy to welcome that contagion into his house, and was perhaps even less pleased to learn about the rather large debt Rubens had accrued along the way, for which he would now be responsible. The costs of the journey had grown to 500 ducats, 200 of which Rubens had fronted out of his own salary (in the neighborhood of 300 ducats per year), with another 300 borrowed from a merchant banker in Valladolid. "I regret that I am poor and have not the resources to correspond to my good will," he wrote to Chieppio. "If this repayment of my loan is made promptly, I shall be grateful; I do not ask it as a gift or reward, as others may pretend I do." Presumably, he meant Iberti. Rubens, a craftsman from a burgher family in Antwerp, could hardly be expected to finance his own mission.

Debt was the least of his problems. A week after Rubens's own damp arrival in Valladolid, the shipment carrying the paintings and vases, delayed by the inclement weather, finally made it to Iberti's door. Rubens opened the cases for inspection, only to be sickened by what he found: "Malicious fate is jealous of my too great satis-

faction." He had hand packed the paintings himself back in Mantua, lovingly wrapping them in oilskin before placing them in tin casings and airtight wooden chests. At Alicante, he had checked the contents to make sure everything had survived the sea journey, and found all to his satisfaction. But now the paintings were practically ruined beyond repair, "so damaged and spoiled that I almost despair of being able to restore them," he wrote, adding, "I am in no way exaggerating." It had been the rain, the three steady weeks of it. Dampness seeped through all of his careful packing, and the result was a mess of rotted canvas, faded color, and flaking paint.

As a remedy, Iberti pressed Rubens to do what repainting he could with the assistance of a team of Spanish artists, and to then slap together a half-dozen woodland scenes as replacements, ideas Rubens greeted with little enthusiasm. Rubens was not particularly impressed with the local Spanish talent, a fact he made clear in no uncertain terms in a letter to Chieppio. "God keep me from resembling them in any way!" A hasty job wasn't going to fool anyone, especially a well-known connoisseur like Lerma. "I am convinced that, by its freshness alone, the work must necessarily be discovered as done here," he wrote, "whether by the hands of such men, or by mine, or by a mixture of theirs and mine (which I will never tolerate, for I have always guarded against being confused with anyone, however great a man). And I shall be disgraced unduly by an inferior production unworthy of my reputation."

If Rubens's reaction to Iberti's meddling was particularly sharp, it was because he found the ambassador's attitude in regard to his Flemish artistic pedigree offensive. Iberti's suggestion that Rubens toss off a few genre scenes for Lerma stank of the longstanding Italian prejudice that Flemish painters were capable only of cloying devotional pictures, fussy portraits, and the occasional landscape, but nothing more ambitious. Michelangelo summed

up this general perception in a rambling disquisition published in 1548:

> Flemish painting . . . will appeal to women, especially to the very old and the very young, and also to monks and nuns and to certain noblemen who have no sense of true harmony. They paint stuffs and masonry. The green grass of the fields, the shadow of the trees, and rivers and bridges, which they call landscapes, with many figures on this side and many figures on that. And all this, though it pleases some persons, is done without reason or art, without symmetry or proportion, without skilful choice of boldness and, finally, without substance or vigor. Nevertheless there are countries where they paint worse than in Flanders. And I do not speak ill of Flemish painting because it is all bad but because it attempts to do so many things (each one of which would suffice for greatness) that it does none well.

When it came to the backhanded compliment, Michelangelo was no less skilled than he was with a block of granite. Rubens, of course, did not share the Renaissance master's opinion. If he had any one great aspiration for his artistic career, it was to forever obliterate such preconceived notions, and he would do so, in part, by synthesizing the strengths of the Italian tradition—its muscularity in composition and figure, its boldness in color and execution—with the meticulous pictorial description so characteristic of art from the Netherlands.

The good news was that the situation wasn't quite so dire as Rubens and Iberti initially feared. Though Rubens claimed no exaggeration in his description of the damage done to the paintings, and may have been forthright in that immediate assessment, after

MASTER OF SHADOWS

giving them some time to dry out in the sun, and after a gentle cleaning and retouching, he was able to resurrect all but two of the works. These he replaced with one of his own compositions, making no secret of his authorship. This was a double portrait of the Greek philosophers Democritus and Heraclitus standing over a globe, a conventional pairing that typically contrasted the joyful Democritus, amused by the folly of man, with a more compassionate and teary-eyed Heraclitus. But Rubens's bearded Democritus seemed somewhat more pensive than joyful, and his wizened Heraclitus more circumspect than weepy. Grand in theme, it was a clear rebuke to Iberti and an overt demonstration of Rubens's capabilities as both a painter and a man of learning. It was also a perfect selection for a cagey statesman like Lerma, and perhaps also an allusion to the bond between Mantua and Spain (represented by the two philosophers with the world between them) that Vincenzo's whole gift-giving enterprise was intended to reinforce in the first place.

Iberti got a measure of retribution on the upstart painter. When Philip returned from the woods, the ambassador made it a point to shunt Rubens off to the sidelines at the formal presentation of the carriage and horses, even though the duke had left explicit instructions that he be given a prominent position during these proceedings. "He could still have reserved the entire management for himself, and yet have given me a place near His Majesty, to make him a mute reverence," Rubens carped. "I say this not to complain, like a petty person, ambitious for a little flattery, nor am I vexed at being deprived of this favor . . . He gave me no reason or excuse for the alteration of the order which, half an hour before, had been settled between us." In Iberti's defense, it was the ambassador's traditional role to make such presentations, and he can hardly be faulted for a certain degree of skepticism as to the abilities of the

· 24 ·

star-crossed political neophyte, operating above his social station, who had arrived at his door unannounced, in debt, carting a fatally ill groom, and with the spoiled fruits of his journey rotting in the leaky crates of his own devising.

Rubens was removed from the central action at the ceremony with Philip, but when it was time to make the presentation to Lerma, Iberti made sure he was front and center. If the duke was less than pleased with the touched-up reproductions, Rubens would be there to take the blame. But Lerma wasn't upset at all; he was thrilled. Cloaked in a luxurious crimson robe, for a full hour he carefully inspected each of the pictures, commenting on their refinement throughout. In an exultant letter addressed directly to Vincenzo, Rubens reported Lerma's "great satisfaction" with both the quantity and the quality of the paintings. "If the donor's reward is the approval of his gifts, Your Most Serene Highness will have achieved his purpose." The water damage had actually been a blessing, for it gave his fresh copies a patina of age, and with that "a certain authority and appearance of antiquity." Indeed, Lerma thought all but two were originals, and neither Rubens nor Iberti was foolish enough to dissuade him of his mistaken impression.

Back in Mantua, Vincenzo could be pleased that he remained in good stead with the Spanish court. For Rubens and Lerma, however, the trip marked the beginning of a long and productive relationship. Rubens, politically astute, had chosen his ally wisely. In later years, he would often muse about the duke's power over Philip III, and tell an anecdote about an Italian businessman granted an audience with the king. When Philip questioned why the Italian had not first taken his business to Lerma, the man responded, "But if I should have been able to have an audience with the duke, I should not have come to your majesty." Rubens admired the duke's influence, and Lerma was correspondingly

impressed by the young painter—so much so that he commissioned from him a life-sized equestrian portrait and then lodged him at his country house at Ventosilla so he might complete it. The result, lost and later found in the Lerma family collection at the turn of the twentieth century, is a masterpiece, one of the painter's first: the duke, clad in black armor and clutching a baton of command, sits formidably atop a white steed striding forward as if to march straight out of the picture frame. The obvious precedent was Titian's 1548 mounted portrait of the Holy Roman Emperor Charles V at his victory over Protestant forces at Mühlberg, a painting in the Spanish royal collection and so immediately familiar to Lerma. (Rubens sketched a partial copy during a visit to Madrid at some point during his stay.) It was also a rather overt allusion to Tintoretto's 1579–80 equestrian portrait of the present king's father, Philip II, riding into Mantua, and so a reminder of the political alignment that prompted the gift. This allusion was reinforced by a subtle visual reference within the picture: Rubens cribbed the foreshortened steed on which Lerma sat from Andrea Mantegna's celebrated Camera Picta frescoes at the Castello di San Giorgio, back in Mantua. Perhaps it was a reference only the artist would appreciate. But what no one could fail to see was the boldness of his composition. His face-on view of Lerma was both more dramatic and technically more difficult than the profile arrangements of Titian and Tintoretto, making it at once a repudiation of the prejudice against Flemish painters and a forthright demonstration of his own ambition.

The emphatically martial nature of Lerma's portrait was actually somewhat ironic, for the duke spent much of the two decades after its completion working to forge peace in Rubens's embattled homeland. The ugly situation in the Low Countries was surely a topic for discussion between Lerma and Rubens during the

painter's residence at Ventosilla. From the middle of the sixteenth century, the seventeen provinces of the Netherlands had been engaged in an on-again, off-again civil war, with the separatist and largely Protestant northern provinces seeking independence from Spain, and the predominantly Catholic southern provinces remaining, for the most part, loyal to Madrid. Rubens's native Antwerp, a divided city, was caught in the middle.

In the future, both Lerma and Rubens would spend enormous time and energy in their efforts to bring resolution to the conflict in the Low Countries; for Rubens, the quest for that peace would become a defining grail he would chase for much of his professional life. For the moment, however, his thoughts were focused on his painting, and he wanted nothing more than to return to Rome, where he could continue his professional development. He even refused an offer to join Lerma's court. It was nice to be wanted by so important a client, but as far as Rubens was concerned, Spain was an artistic wilderness. Italy remained the cultural heart of Europe; it was the wellspring of the Renaissance and the center of classical learning. Fueled by the great patronage engines of a resurgent Church and an urbane nobility, it was the best place for an ambitious young painter to confront the past and establish a reputation for the future. In Vincenzo, he had a patron who allowed him considerable, though not complete, autonomy.

There was also a matter of filial piety. Rubens's elder brother Philip was living in Rome, where he was the librarian of Cardinal Ascanio Colonna. Despite the three-year gap in their ages, the brothers had always been close, and now both of their careers were ascendant. Before moving to Rome, Philip had established himself as the protégé of Justus Lipsius, perhaps the most influential scholar in Europe, who considered him almost a son. He had also served as personal secretary to Jean Richardot, president of the

Flemish Council of State, a connection that must have been of great interest to Lerma.

As it was, Rubens would return to Italy as a more mature and able diplomat, and he would do so on his own terms. The travails of his embassy and the machinations of Iberti had hardened him, and his budding relationship with Lerma had boosted his already considerable confidence. His correspondence, passive and insecure during the ill-fated opening stages of his mission, became progressively more assured as he came into his own as a diplomat. The suggestion that he had been profligate or even dishonest in his accounts, presumably made by Iberti, was now met with an unequivocal defense from the painter. "I do not fear the slightest suspicion of carelessness or fraud," he wrote. In fact, Iberti had been fairly complimentary in his reports back to Mantua about Rubens, though he planned to check his books.

Rubens was not concerned with accusations about his conduct, nor was he interested in a Parisian side trip intended solely to gratify Vincenzo's prurient desire for painted French beauties. "I should not have to waste more time, travel, expenses, salaries (even the munificence of His Highness will not repay all this) upon works not worthy of me, and which anyone can do to the duke's taste," he wrote to Chieppio from Spain. The demand was bold, but Rubens was never one to beat around the bush. "*Qui timide rogat, docet negare*," he was fond of saying, a maxim attributed to Seneca. "Who asks timidly, courts denial." Rubens got his way.

Bypassing Paris and its women, Rubens returned by sea to Genoa, an elegant merchant city of churches and palazzi that enchanted him from the moment of his arrival. Rubens spent days on end dutifully recording its architectural wonders in his sketchbooks. His brother Philip was especially pleased to hear of his safe arrival on the Ligurian coast. Fearing the dangerous winter waters

of the Mediterranean, he had composed a Latin prose poem dedicated to the artist, then in transit. Like his brother's paintings, the composition evinced a fascination with classical history and a rather dramatic artistic disposition:

> Aegeus was less anxious than I am now, about the fate of his dear brother Theseus, when on his native shore he sacrificed himself to the spirits of Androgenes; for my heart is torn apart by anxiety for you my brother, who is more worthy of love than daylight itself; for you, whom a small ship now bears away across the Tuscan sea, and for you, who must—alas!—put your trust in the inconstant sea; now that the terrible power of the winds is unleashed and the waves churn under the influence of malevolent stars. Ah! May the first man who built a ship and dared set sail on the immense ocean eternally bewail his deed. . . . When will I be able to run to my brother, and our hands lock in a sweet embrace? It is then that the wild waves of Tages will come under my roof, and I shall welcome the opulent gifts of the oriental sea.

MANTUA MUST HAVE seemed a vision when Rubens saw it floating in a shroud of haze across the umbilical Ponte di San Giorgio. After a long and successful journey, it was a pleasure to return home, especially to so lovely a city. The birthplace of Virgil was a jumble of palaces and gardens enveloped by lakes that cast it in a fine mist. There was no questioning its beauty. Thomas Coryat, an English traveler in the early seventeenth century, declared it "the citie which of all other places in the world I would wish to make my habitation." It hadn't always been so. After a visit in 1459, Pope Pius II

complained that the place was "marshy and unhealthy," not to mention unpleasantly hot and overrun by frogs. Vincenzo's Gonzaga forebears took action. The architect Leon Battista Alberti was commissioned to improve standards of construction, architecture, and urban design. In the following century, Giulio Romano, the prized student of Raphael, filled the role of court architect—one of his official titles was "superior of the streets"—and set about a monumental project of building and beautification. Romano's work at Mantua included the Palazzo Te, a masterpiece of Mannerist style, and a lordly residence for himself, which Rubens would cast as a model for his own house in Antwerp, years later. The home of Andrea Mantegna, built during his tenure as court painter in the fifteenth century, would also serve as a model for Rubens, as would the astonishingly beautiful frescoes Mantegna created for the ducal palace.

Rubens was fortunate to have found his way into Vincenzo's illustrious stable of cultural luminaries. The Gonzagas had a long and distinguished history as patrons of the arts, a practice they had found to be both politically expedient and personally satisfying. The equation was simple: art begat prestige. Isabella d'Este, who sat for both Leonardo da Vinci and Titian, and her son Federico II—Vincenzo's grandfather—were only the most ambitious in a long line of collectors who used the family cultural program to promote what was, effectively, a provincial outpost with limited military capacity to a place of prominence on the international political stage. Only the Vatican could claim a superior collection of old-master works. In fact, the visual arts were but one component of the Gonzagas' patronage. The poet Torquato Tasso was a favorite of Vincenzo's. Literature, music, theater, and other humanistic studies were equally celebrated. Rubens's tenure at the Gonzaga court

coincided with that of the composer Claudio Monteverdi, who premiered his opera *L'Orfeo* for the duke in 1607. The astronomer Galileo Galilei was also a visitor to the Mantuan court during Rubens's stay, and there is reasonable (though not conclusive) evidence that he is the mysterious unidentified figure in a multiperson portrait, *The Mantuan Circle of Friends*, Rubens painted in 1601.

Despite Mantua's physical charm and the great minds that surrounded him, Rubens was naturally restive. In the year he spent in that city after his return from Spain, he completed just one major project for the duke: an altar for the city's new Jesuit church, with portraits of the duke (a ringer for the painter) and his wife at the base of the central panel. In truth, Rubens had never been happy as a courtier, dating back to his aborted appointment as a page to the Countess of Ligne-Arenberg, during his adolescence. The formality was stultifying, and the obligations drained his time and energy from the work he not only enjoyed but also considered his true calling. Mantua was, in the end, a provincial city, and he was anxious to reunite with his brother in more cosmopolitan Rome, international center of artistic patronage.

Rubens's personal romance with Rome had begun during his eight-month residency in the city in 1601. At that time, he had engrossed himself in Rome's unrivaled cultural patrimony, visiting both its ancient wonders and its more recent works, Michelangelo's Sistine ceiling and Raphael's Vatican frescoes being the most prominent among them. The recently uncovered *Aldobrandini Marriage*, a fresco dating to the first century A.D., struck him so powerfully that he could recall its composition in exacting detail nearly two decades later. He documented all that he saw, and his ideas on whatever subjects interested him, in a notebook he carried

with him on his forays around the city. Nothing escaped his attention. In that leather-bound book were architectural drawings; notes on anatomy, optics, proportion, and symmetry; classical quotations; poetry; and copied details from paintings of diverse genres and periods. Those sketches would serve as inspiration and source material for his practice in the years to come, and he supplemented them with original old-master drawings he purchased and occasionally tweaked to meet his own tastes and standards. Even at such a relatively young age, his confidence in his own vision was extraordinary, almost excessive.

Rubens was a busy student during those eight months, but his primary energies were given over to a prize commission landed in large thanks to his brother. The archduke Albert, sovereign of the Spanish Netherlands, was in the market for an altarpiece to be gifted to the Roman Church of Santa Croce in Gerusalemme. Albert had been a cardinal prior to assuming power in the Low Countries, and was a patron of Santa Croce, where he received his orders. Though he was a devout man, Vatican hard-liners found him disconcertingly moderate, especially in regard to the Protestant revolt within his dominion. An extravagant expression of devotion would therefore serve as a prudent political gesture. Conveniently, Albert's representative at Rome was the son of Jean Richardot, president of the Flemish Council of State, for whom Rubens's brother Philip had served as a personal secretary. Rubens was in the right place at the right time; that he was Flemish only made the gift, from the archduke to the people of Rome, more fitting. The three-panel altar, with *Saint Helena with the True Cross* as its centerpiece, was not a masterpiece—Rubens had not yet shed the stiffness of the Antwerp tradition in which he had trained—but the commission was prominent enough to place him in the minds of Rome's connoisseurs.

In 1605, with the successful embassy to Spain now under his belt, and having duly paid his respects to Vincenzo in Mantua, Rubens petitioned the duke for the right to relocate to Rome, where the continued upward trajectory of his career would only redound to the glory of his patron. Rubens got his release, but soon after being granted his furlough, he was unceremoniously recalled to Mantua. In the short time he had spent in Rome, however, he had managed to win for himself another prize commission: an altarpiece for the Chiesa Nuova, the magnificent new church built by the Oratorian movement. It was an extraordinary opportunity. That Rubens had won the job was a small miracle in its own right, even if the competition was thinned a bit by the fact that the presumptive favorite, Michelangelo Merisi da Caravaggio, was at present on the lam. (The irredeemable painter had murdered a local gangster in a fit of jealous rage.) There were other candidates, all Italians, but Rubens, growing in political savvy, had recruited several heavy-weights to support his bid, among them the cardinals Scipione Borghese (nephew of Pope Paul V) and Jacobo Serra (treasurer of the Vatican states).

With that job on his plate, and with his salary in constant arrears, Rubens was not anxious to return to Mantua. While dodging requests that he come back, he peppered Chieppio with letters dunning the duke for payment of his overdue salary. Rubens only accepted the Chiesa Nuova commission, he wrote, "out of pure necessity" to keep up his own expenses. This was something less than the whole truth, but it left Rubens emboldened enough to beg that his recall be conditional on the duke giving "his princely word" that he be allowed to return to Rome. Rubens larded up this impudent missive with sufficient obeisances to avoid a charge of ingratitude, or even outright insubordination, but the shift in the tenor of his relationship with Vincenzo was plainly evident.

Beyond his elevated stature, the time spent in Rome was a plea-
sure for Rubens, one of the most fruitful and enjoyable periods of
his life. He shared a comfortable house with his brother and two
servants on the Strada della Croce, not far from the Piazza di
Spagna. Though his stay hadn't begun well—he was diagnosed
with pleurisy, a painful inflammation of the chest that restricts
breathing—he recovered quickly, and the two brothers became fix-
tures among a circle of expatriate scholars, artists, and other men of
prominence. Rubens himself cut a handsome figure about town.
Women couldn't help but point out the handsome man known as Il
Fiammingo (the Fleming) who dressed like a gentleman, rode a
horse with natural grace, and audaciously wore the golden chain of
an aristocrat even though he held no title. Word had spread about
the portraits he had made on a side trip to the court of Genoa. With
a few strokes of his brush, it was said, he could transform even the
most ordinary matron into a Venus. They knew what he had done
for the marchesa Spinola Doria; she was attractive, but no goddess.
This was treatment they could most certainly not expect from
Caravaggio, the most famous and notorious of Roman painters;
he'd sooner transform the most beautiful woman—*even the Virgin
herself*—into a common streetwalker. This, in fact, was precisely
what Caravaggio had done in his altarpiece for the Church of Santa
Maria della Scala, a work so offensive to that church's Carmelite
fathers that they refused to accept it. Rubens, however, knew a
good thing when he saw it, and arranged for Vincenzo to pick it up
for the Mantuan state collection at a cut rate of 350 crowns.

Rubens admired Caravaggio, or at least the emotional force of
his characters and the sureness of his manipulation of paint on can-
vas. Temperamentally, the two artists could not have been more dif-
ferent. Caravaggio was a man of the street, a habitué of prostitutes,
and, as his present circumstance illustrated, tragically quick to vio-

lence. Rubens was never one for that type of behavior. He gravitated instead toward his brother Philip's intellectual circles; at heart he was a gentleman scholar, more interested in a colloquy on the significance of an antique coin than in a night of carousing among the demimonde at the ball courts along the Via di Pallacorda—Caravaggio's running ground. Indeed, Rubens often seemed as if he would have been happier in another era altogether: he set aside time every day for the study of classical history and literature, and with his brother collaborated on the production of *Electorum*, a philological study of ancient Rome, with Philip as the principal author and Peter Paul his consultant and illustrator. (The handsome volume was published in Antwerp by Jan Moretus, proprietor of the distinguished Plantin Press.) It was during this time that Gaspar Scioppius, one of the foremost Catholic theologians of the period, wrote of Rubens, "I know not which to praise most, his ability in painting, in which he attains the most exalted rank attained by any man of this century, or his knowledge of literature, his enlightened taste, and the all too rare agreement between his words and his deeds."

For all its joys, Rubens's time in Rome was not without challenges. By late 1607, his prize commission for the altar of the Chiesa Nuova had somehow transformed from personal triumph into an embarrassing professional fiasco. His first attempt at the job, a resplendently enrobed Saint Gregory standing beneath a portrait of the Virgin cradling an infant Jesus, was rejected after installation, though the painter deemed it "by far the best and most successful work I have ever done." The excuse was that it was too hard to see from the pews, though in truth it might have been just a bit too resplendent for the comfort of his ascetic Oratorian clients. Rubens hammered out a replacement, and on slate to cut glare, but receiving payment for it proved almost impossible. (He would not

be compensated until 1612.) He was also stuck with the original, which he was forced to try pawning off on Vincenzo, a humiliating development. The piece had been commissioned at a rather steep 800 crowns, but he told Chieppio that the duke could pay what he wished and on the terms of his choosing—"except for one or two hundred crowns, which I shall need now." This he followed with a pitch that now seems more suitable to a carpet dealer: "I will tell you that the composition is very beautiful because of the number, size, and variety of figures of old men, young men, and ladies richly dressed. And although these figures are saints, they have no special attributes or insignia which could not be applied to any other saints of similar rank. And finally, the size of the picture is not so excessive that it would require much space; it is narrow and tall. All in all, I am certain that Their Highnesses, when they see it, will be completely satisfied." It was a hard sell, and an indication that, for all of its exalted ability to confer prestige, painting remained a craftwork sold by the yard. The Gonzagas, in any case, weren't buying.

Rubens had other problems. Back in Antwerp, the brothers had lost their older sister Blandina to plague, and now their mother, Maria, was ailing with lung disease. Philip returned to her side. Peter Paul, after eight years abroad, wanted to join him, but his obligations to the duke prevented his departure. Vincenzo was generous enough to allow his prized painter to station himself in Rome, but not quite ready to let him quit Italy for his Antwerp home, from whence he might not return. Repeated efforts to procure a furlough came to nothing. Back in Flanders, Philip appealed directly to his brother's former client, the archduke Albert, who was happy to assist. "As he is my vassal, I have the desire to give him satisfaction," Albert wrote to Vincenzo, in the late summer of 1607. The duke might have suspected Albert's real desire was to add Rubens

to his own company of image makers, and so the request was politely refused, with Vincenzo coyly suggesting that Rubens preferred to stay in Rome, and far be it from him to interfere in the matter.

By October 1608 the deterioration of Maria Rubens was accelerating at a rate that made Peter Paul's continued presence in Rome impossible, regardless of the consequences. On the twenty-sixth of the month, a letter arrived from Philip with news that their mother was now coming to the end of her battle. With that, Rubens summoned his trusted pupil Deodate del Monte and began to put the house on the Strada della Croce in order. There were bills to settle, friends to bid farewell, possessions to pack against the hazards of a long journey over difficult terrain. (He had learned of these travails the hard way, and so was doubly careful in packing his own works.) When preparations were complete, the horses watered and saddled, there was one final matter to settle: a letter to Chieppio begging forgiveness in advance for his "impertinence" in leaving without authorization. He knew the duke himself was at present en route back from the Netherlands—a trip to a spa on which Rubens had not, to his frustration, been invited—and pledged he would try to meet up with him on the way, if only to beg the pardon of His Most Serene Highness in person. The letter, by turns fawning and passive-aggressive, was a small masterpiece of artful groveling, a form in which Rubens was by now expert. "It will be hard for me to go attend this scene," he wrote of his mother's bedside. "One can hope of no other outcome than the end common to all humanity." Even in a moment of personal distress, Rubens could summon a formidable capacity for eloquence. It was a trait he had fully developed in the duke's service, and it would serve him well throughout his career.

There was something else he would carry with him back to Antwerp, a change to his identity that marked his intellectual growth. Peter Paul Rubens would henceforth sign his name Pietro Pauolo Rubens. He may have been leaving Rome, but he was taking a bit of Italy along with him.

EVERY MAN FOR HIMSELF

❧

Who is of so hard and flinty a heart that he can anie longer
endure these evils? Wee are tossed, as you see, these manie
yeares, with the tempest of civill warres: and like Sea-faring men
are wee beaten with sundrie blastes of troubles and sedition.
If I love quietnesse and rest, the Trumpets and ratling of
armour interrupt mee. If I take solace in my countrie garden
and farmes, souldiers and murtherers force me into the
Towne. Therefore I am resolved, leaving this infortunate and
vnhappie Belgica (pardon mee my deere Countrie) to chaunge
Land for land, and to flie into some other part of the world.
—JUSTUS LIPSIUS

Rubens could be forgiven for thinking he had returned to a city of
ghosts. The journey back to Antwerp from Rome took him more
than a month, and when he finally arrived at the family residence
on Kloosterstraat, in the second week of December 1608, it was
already too late. Maria Rubens had passed away on October 19, a
week before Philip Rubens's final letter had even reached his
brother on the Strada della Croce. At least, in her will, Maria had
taken care to inventory the beautiful paintings her son had created,

with instructions that they be returned to him. That must have been a small consolation.

His mother was gone, and Antwerp was a haunted vision of its former self. The conflict between the Spanish and the rebellious Dutch had exacted a devastating toll on the city. The Scheldt, Antwerp's connection to the North Sea and its economic lifeline, was blockaded by the Dutch navy. The English diplomat Dudley Carleton, visiting just a few years later, lamented the sad state of a city he considered unmatched "for the bewtie and uniformitie of buildings, heith and largeness of streetes, and strength and faireness of the rampars." Those buildings and streets were lovely but barren, save for untended wild grasses sprouting up across the emptiness. "In ye whole time we spent there I could never sett my eyes in the whole length of streete upon 40 persons at once," he wrote. "I never mett coach nor saw man on horseback: none of owr companie (though both were workie days) saw one pennie worth of ware ether in shops or in streetes bought or solde. Two walking pedlers and one ballad-seller will carrie as much on theyr backs at once as was in that royall exchange."

For as long as Rubens had known it, from the very first time he passed through its gates in his eleventh year of boyhood, Antwerp had been in decline. The city was the Rubens family's ancestral home, and in the artist's maturity (and in posterity) he would be celebrated as its favorite son. But in truth he was not born there, or even in the Low Countries. This fact was occasionally omitted from the record by Flemish nationalists who wished to claim him entirely as their own, and by hagiographic biographers unwilling to let the embarrassing circumstances of his youth besmirch the image of a flawless genius. Rubens himself was understandably reluctant to address the subject of his family's sad story, a saga inextricably intertwined with the greater history of the Low Countries.

Rubens's predecessors, on both his maternal and his paternal sides, had made Antwerp their home for generations. His mother, Maria, née Pypelinckx, was born in Antwerp in 1538 to a respectable burgher family. At the age of twenty-three she married Jan Rubens, a natural charmer eight years her senior. He had just returned from seven years studying civic and canon law in Italy. It seemed a perfect match. Though his family was not quite as prosperous as hers (he came from a line of druggists), they were landowners, and he was considered a man of solid potential. Jan had lost his own father at a tender age, but his mother had remarried to a successful grocer named Jan de Lantmetere, the brother of an alderman.

The Antwerp that Jan and Maria Rubens knew in their youth was a thriving metropolis, an international center of commerce and culture. In 1561, the same year they celebrated their vows, the cornerstone was laid for an enormous new town hall on the Grote Markt, Antwerp's market square. With a wedding-cake central portico capped by a triumphal arch and a toy temple, the building was a six-story advertisement of civic pride. Cornelis Floris de Vriendt, a sculptor by trade, favored it with the most fashionable classical forms—a rusticated stone base, Ionic and Doric columns, obelisks for finials—but there was no restraining its quintessentially Flemish character. The sheer volume of decoration was telling. Antwerp was unafraid to put on airs—its citizens even called themselves *sinjoren*, or "sirs"—and de Vriendt's giant block conveyed the special combination of aspiration and joviality that defined the place.

All around the city there was construction, a building boom born from Antwerp's role as the leading port north of the Alps and the reigning financial capital in all of Europe, a position it had assumed just a few decades earlier. The city dates to Roman times, if not earlier, and reputedly took its name from the legend of a mythical giant who cut off the hands of those who refused to pay

him and then tossed them into the river. (*Hand werpen* means "hand tossing" in Dutch.) Its location was ideal for trade. Situated on a rise along the eastern bank of the Scheldt, Antwerp could be accessed by ship from the North Sea, but was also on the land routes from France to the south, Germany to the east, and the Dutch provinces to the north. Advanced systems of water management, a necessity in territory so often below sea level, transformed the region into the most fertile and productive in Europe, and bred in the populace a sense of political cooperation and interdependence. By the middle of the sixteenth century, cargo traffic through Antwerp had more than quadrupled that of London, and the population had soared past 100,000, a figure rivaled in Europe by only a handful of cities.

The Rubens and Pypelinckx families built their modest fortunes providing the staples of daily life—food, medicines, dry goods—to Antwerp's expanding middle class. Even greater sums were being made in Antwerp from a new kind of business, finance, that was conducted in a new kind of building: Unveiled in 1533 with a design by Dominicus de Waghemakere, the Nieuwe Beurs (New Exchange) was an arcaded three-story square with an open court—the trading floor—at its center. Ever after, stock exchanges the world over would follow its essential blueprint. They would also adopt the financial instruments Antwerp's merchants created on that floor, the forwards, futures, and options of the modern derivative market. Capital flowed readily, both for private enterprise and for public works. Europe's monarchs looked to Antwerp to finance their wars, their monuments, their extravagances. The city would eventually pay a steep price for its role as the world's banker, but when times were flush, there was no better place to become rich quickly, despite the occasional accusations of price-fixing and stock manipulation. The temper of the times was neatly

summed up by the maxim engraved on the correspondence of a prominent Antwerp businessman: "Every Man for Himself."

Antwerp's great wealth was a bounty for the large community of artists who made it their home; in 1560, the city roll boasted nearly twice as many painters as it did bakers. Carel van Mander, who in 1604 authored the first history of painting north of the Alps, *Het schilderboeck*, called the city "the mother of the arts," though he was not overly impressed by the "somewhat cold, fishy pallidness" that so often characterized the local color palette. The literary arts also flourished in Antwerp. In 1555, the French émigré Christophe Plantin founded the Golden Compass publishing house, or Plantin Press; in the years following, it produced an unrivaled catalog of exquisitely printed works on subjects ranging from philosophy to mathematics to religion, among them Abraham Ortelius's *Theatrum orbus terrarum*, the first modern world atlas, and the philological study the Rubens brothers collaborated on during their time in Rome. Plantin's grandson Balthasar Moretus, a friend of the Rubenses' from their days at the Verdonck school, built on the family tradition, publishing a wide range of humanist titles, many with elaborate title-page designs and illustrations by his childhood chum Peter Paul, who did them at cut rates in his spare time or in exchange for books.

Visitors to the city marveled at its energy. In 1549 a touring Spanish nobleman dubbed Antwerp "the metropolis of the world," and in 1567 the Italian merchant and writer Lodovico Guicciardini suggested it had transcended even that terrestrial praise. He called Antwerp the marketplace "of all the universe" and hailed its "beauty, grandeur, power, and magnificence." In those days, Antwerp's streets were so clogged with traffic during work hours that they were all but impassable. Even the paintings were crammed with activity and abundance. The Antwerp master Pieter Aertsen created a new genre that advertised the city's prosperity, a fusion of

the still life and the peasant scene in which market stalls overflowed with meat, fish, fruits, and flowers—the quotidian spoils of a booming consumer economy. Consumption, in fact, was something more than an art form. A typical *sinjoor* drank three pints of beer each day. Antwerp's feasts were legendary for their decadence, and nearly all of its citizens took part.

In such an atmosphere, the newlyweds Jan and Maria Rubens were naturally enthusiastic about their prospects. The Treaty of Cateau-Cambrésis, signed just two years earlier, had put a stop to the seemingly perpetual warring between Spain, France, and England, bringing considerable relief to Antwerp's bankers, who were pressed to fund Spanish military endeavors at enormous cost. Jan's career was ascendant. Barely five months after their marriage, Jan was elected an alderman. In short order, the Rubens family expanded with the additions of Jan Baptist (1562), Blandina (1564), Clara (1565), and Hendrik (1567).

The future appeared bright, but the Low Countries were notorious for rapidly shifting conditions, and there were dark clouds on the horizon. Trouble, inchoate for years, had become quite real in 1556 with the abdication of Charles V, the Holy Roman Emperor. Through a combination of force and diplomacy, Charles had united the territories of the Low Countries into a loose federation of seventeen provinces. But those provinces were naturally resistant to the centralized authority that would be the hallmark of the Baroque period. Their long history of collective cooperation, a practical necessity given the demands of the water table, had bred a sense of political self-reliance. As a price for peace, Charles had allowed the provinces considerable autonomy, formalizing their privileges in the Augsburg Transaction of 1548. But when he relinquished his crown to pursue a monastic life in the Catholic Church, the Habsburg Empire was cleaved in two, thereby sowing the seed of future dis-

content. Charles's younger brother, Ferdinand I, assumed sovereignty over the Austrian branch of the family dynasty, and with it the title Holy Roman Emperor. Charles's son, Philip II, took the Spanish crown, which also gave him dominion over the Low Countries.

Philip's relationship with his subjects in the Low Countries began on an auspicious note. In his tour of the region as crown prince and heir apparent, in 1549, he was received with considerable pomp. Antwerp alone spent a quarter of a million florins, an enormous sum, on the ceremonies attendant on his arrival. It was a gracious gesture, but it did nothing to remove the essential fact that Philip's command over the region would never be, to his immense frustration, complete. His vision of imperial power was a good deal less compromising than that of his father, and following Augsburg the unrestrained local population had become, to his mind, entirely and unacceptably too freethinking. Antwerp's bankers balked at the prospect of financing his wars with France, England, and the Ottoman Empire, and extracted massive interest payments in return for their support. The provinces demanded additional freedoms as compensation for their own acquiescence. His Catholic Majesty was especially displeased to find the ideas of the Reformation in full flower across the Low Countries; Protestantism, in its several denominations, had colonized much of the region, north and south. Its spread was as much a political repudiation as a religious one. The Catholic clergy had a well-earned reputation for corruption and decadence, traits that became especially offensive in lean years, when even the unrivaled agricultural machine of the Low Countries failed to meet the demands of a hungry and impoverished population.

The authority of the Church was perceived as but another infringement on local prerogatives, a feeling exacerbated when Philip insisted on bringing the full force of the Inquisition, with all

of its attendant cruelties, to the greater Netherlands. In this context, Protestantism took on the broad mantle of an independent-minded, moderating humanism, and was widely adopted by rich and poor, nobleman and commoner alike. Antwerp, by 1566, had a considerable Calvinist population; nearly thirty thousand *sinjoren* attended an outdoor service on a cool summer Sunday in that fateful year. Jan and Maria Rubens were almost certainly not in attendance at that event; it would have been improper for an alderman to be seen at an outlaw function. But like many among their social set, they had shifted their religious affiliation. In 1561, the Rubens family will was denuded of traditional Catholic language.

Jan and Maria were among Antwerp's burgher elite, an enterprising and urbane community alarmed by the reactionary winds blowing from Spain. But the new Spanish directives were even more of an affront to the historically independent Flemish nobility, especially those of Protestant faith. In 1566, three hundred of these emboldened aristocrats marched on the Brussels palace of Spain's regional governor, demanding a relaxation of the Inquisition and the open practice of religion. When they were disparaged as "beggars," they began dressing the part. The unlikely leader of this "Beggar" movement soon became William of Orange, a political moderate whose natural aversion to conflict had earned him the sobriquet William the Silent. William was born to a minor German count of Lutheran orientation, but through a quirk of dynastic succession, as an adolescent he unexpectedly inherited the title Prince of Orange, and with it much of Europe, including the region of southern France that gave name to his title. It also gave him most of the Low Countries. He was, however, obliged to forsake his father's religion in favor of Catholicism. This he did, but he retained an essential tolerance for Protestantism, a fact that placed him very much at odds with the Spanish king, Philip II, who was his sovereign. That tolerance was balanced by

a sense of propriety and steely resolve that Jan and Maria Rubens would come to know firsthand, and at great personal cost.

For the moment, however, William's association with the Beggars gave their cause an essential credibility, and presented a grave challenge to the Spanish governor of the Low Countries, Margaret of Parma. A temporary acquiescence to Beggar demands followed, but the overall conditions in the Netherlands suggested trouble was far from over. The economy had turned bleak; a bitter winter, a trade squabble with England, and an unrelated war in the Baltics left state coffers empty and kitchen cupboards bare. When even the black bread and salt soup that were the daily nourishment for the less privileged became scarce, they found their frustrations released by agitating Calvinist sermonizers who, in turn, directed their anger at the Catholic Church.

The righteous fulminations of those preachers bred an iconoclasm that swept across the Netherlands in the heated summer of 1566. On August 13, a monastery near the French border was raided by an angry mob. In the ensuing weeks, a core of henchmen sacked the churches and cathedrals of the Low Countries, destroying the graven images Calvin had derided as presumptuous blasphemies. In Antwerp, the *beeldenstorm* (image storm) came on the Sunday following Assumption, a festival day that predictably exacerbated religious tension. By tradition, it was the day of the Ommegang, in which religious icons were paraded through the city streets to the gates of the Onze Lieve Vrouwekathedraal, or Cathedral of Our Lady. The artist Albrecht Dürer, a witness to the procession in 1521, described the amazing splendor of the event in his travel diary. "Twenty persons bore the image of the Virgin Mary and the Lord Jesus, adorned in the richest manner, to the honor of the Lord God." All told, it made for a "delightful" spectacle, and one that was "very conductive to devotion."

Conductive to devotion. One could hardly imagine a vision more likely to incite the would-be iconoclast. Somehow, tempers were held in check for a day. But on the next an angry crowd gathered at the cathedral, and it became ever more rowdy the day after that. The Antwerp town council, on which Jan Rubens sat, sent out the civil guard in an effort to disperse the mob, but it was too late; the guard was forced to retreat to de Vriendt's town hall. Inside the church, Herman Moded, the most reactionary of Calvinist preachers, took the podium, and as he excoriated the paganism of Catholic idolatry, his makeshift flock attacked those idols with axes and sledgehammers and crowbars. Sculptures were yanked down from upper stories with ropes and pulleys. When they were done, the most extravagantly decorated cathedral in northern Europe was a standing ruin.

Back in Spain, Philip was appalled when he learned of these events, and especially displeased to find that William, in his capacity as margrave (hereditary lord) of Antwerp, had granted Protestants the right of free practice in that city. Philip was absolutely unwilling to brook the open worship of a religion he considered heretic within his kingdom, and he was assuredly not prepared to stand by as an emboldened opposition flouted his authority and spread insurrection across the Low Countries. The king took action. Goaded by his most bellicose advisers, Philip ordered that an army of nearly ten thousand men, an overwhelming force, be drawn from his dominions and assembled at Milan, in Spanish-controlled Lombardy. Military engineers were dispatched to ready a route through the Alps to the Low Countries that would circumvent hostile France. This was no simple task. Moving troops from Spanish territory to the Netherlands was so notoriously difficult that the phrase "send a soldier to Flanders" (*poner una pica en Flandes*) became a sardonic euphemism for asking the impossible. Some three hundred engineers were sent to expand

the military corridor known as the Spanish Road, and their preparations continued through the winter and into early spring. In June 1567, the army finally departed under the command of Philip's most militaristic counselor, Fernando Álvarez de Toledo, the Duke of Alva.

What followed was an object lesson in the dangers of an arrogant, insular, and incompetent occupation. The "Iron Duke" arrived with his troops in late August, and wasted no time in alienating the local population. His soldiers, hardened veterans in shiny battle gear, were a daunting vision as they marched in file through the Low Countries, trailing behind them an unruly horde of profiteers. Despite the objections of Margaret of Parma, the Spanish governor, the duke garrisoned his men in the loyal towns surrounding Brussels, where they were needed least and where their rough behavior was an affront that turned friends into foes. He then proceeded to decommission Margaret's army, a public rebuke that prompted her resignation and left him with responsibility for both military and administrative governance. Undeterred, he dismantled her entire bureaucracy. "Putting in new men one by one is like throwing a bottle of good wine into a vat of vinegar," he said. To see to his directives, he relied almost exclusively on his own staff of Italian and Spanish officers and functionaries. He even ordered that William's son, a university student in Louvain, be abducted and packed off to Spain. When the boy's professors complained about this outrage against their very conception of order and fairness, the duke's councillor replied, "We care nothing for your privileges."

In Antwerp, a hotbed of Calvinist insurgency, the duke saw to the design and construction of a fortified military compound. Just south of the city, and separated from it by a large open field that would leave would-be attackers fatally exposed, an enormous moated citadel—a "green zone" *avant la lettre*—was erected by the duke's Italian military architects, who then rerouted the city

ramparts to enclose it. Pentagonal in form, but with wedged bastions and ravelins projecting from its corners and flanks, the fortress offered a menacing profile to the city it was ostensibly intended to protect, an unholy inversion of the typical fort-defends-town program. Inside was a veritable city within a city: barracks, armory, stores, tavern, chapel, all the necessities a battalion might require to withstand a prolonged siege, including—presumably for inspiration—a bronze statue of the unrepentant duke himself. Its inscription was dedicated to the man "who extirpated sedition, reduced rebellion, restored religion, secured justice, and established peace."

With his army in place, the duke set about the subjugation of the local population, and did so using tactics honed during the Inquisition. "Everyone must be made in constant fear of the roof breaking over his head," the duke wrote in a letter back to Philip. He seemed entirely immune to the commonsensical idea that his harsh rule might come back to haunt him, though Machiavelli, in *The Prince*, had warned specifically of the danger of such measures. "He who becomes master of a city accustomed to freedom and does not destroy it, may expect to be destroyed by it," the Italian wrote in 1513, "for in rebellion it has always the watch-word of liberty and its ancient privileges as a rallying point, which neither time nor benefits will ever cause it to forget."

The primary instrument of Alva's terror was a secret court, the Council of Troubles. Flemings called it the Council of Blood. The tribunal prosecuted some twelve thousand citizens for heresy and treason, often on trumped-up charges and with evidence obtained via torture. Alva orchestrated mass arrests, midnight seizures, book burnings, a full catalog of horrors. More than one thousand were executed in gruesome public displays—live quarterings, burnings at the stake—designed to instill fear in the populace.

The duke's terror was directed at body, mind, and wallet. "A goodly sum must be squeezed out of private persons," he wrote. Maintenance of his new order, in particular his immense standing army, was an expensive proposition. Massive urban citadels didn't just pay for themselves, and Philip had more pressing needs at home. Funds would have to be raised from the native population, and that meant a series of new taxes on those least willing and able to bear them. Public disdain for the duke, under these harsh conditions, was enormous, as reflected by a contemporary parody of the Lord's Prayer:

> *Thou takest away daily our daily bread,*
> *While our lives and our children lie starving or dead.*
> *No man's trespasses thou forgivest;*
> *Revenge is the food on which thou livest.*
> *Thou leadest all men into temptation;*
> *Unto Evil hast thou delivered this nation.*
> *Our Father, in heaven which art,*
> *Grant that this Devil may soon depart;*
> *And with him his Council, false and bloody,*
> *Who make murder and plunder their daily study;*
> *And all his savage war-dogs of Spain,*
> *O, send them back to the Devil again.*

Even the Lord couldn't protect those caught reciting it.

⁂

JAN AND MARIA RUBENS escaped the worst of Alva's depredations, but just barely. Their days in Antwerp had been numbered from the moment the Calvinist preacher Herman Moded and his iconoclastic henchmen had forced their way into the Onze Lieve

Vrouwekathedraal, only to destroy it. In the wake of that catastrophe, but before Alva had taken control of the government, Margaret of Parma had ordered Antwerp's aldermen to explain how they had allowed the great cathedral to be defiled. This was an almost unconscionable act of buck-passing, given her own failure, as governor, to take precautions against the iconoclasts. The aldermen, in lawyerly fashion, responded with an exculpatory brief. That might have been good enough for Margaret, but it was squarely rejected by the newly arrived Iron Duke when he found it sitting on his desk. In December 1567, he demanded a more comprehensive explanation from the town fathers, Jan Rubens among them.

The prospects for those aldermen were grim; their presence on Alva's target list meant their very lives were in jeopardy. Antwerp's burgomeester (mayor) had been executed the previous September on a heresy charge, and Jan's name had already appeared on a manifest of suspected Calvinist converts. In January, he hired private counsel and submitted yet another pleading apologia for his conduct. (Yes, he had attended a Calvinist sermon or two, but he was curious and nothing more.) While his case plodded along toward an ugly conclusion, Jan Rubens packed up his family and sent them to a relation in Limburg. From there, Maria and the four children traveled to Cologne, safely beyond Alva's reach. A few months later, with his case still pending, Jan Rubens quietly slipped out of the city gates and took to the road for the German border.

The Rubenses were among those in the first wave of a great diaspora from the Spanish Netherlands, and from Antwerp in particular. Over the following decade, the city's population dropped from over 100,000 to fewer than half that number. Most of that migration would be to the north, to the seven provinces of the nascent Dutch republic, most prominently Holland, Utrecht, and Zeeland. That shift would eventually propel Amsterdam, the grow-

ing colossus of Holland, past Antwerp as the trade capital of north-
ern Europe. During the early exodus years, however, most refugees
of the duke's terror quit the Low Countries entirely. Cologne, rea-
sonably tolerant and tied to the Netherlands through trade, was a
convenient destination.

The distinguished leader of the fugitive horde was Silent
William himself. Anticipating trouble, he had departed the Nether-
lands before Alva arrived with his Spanish army. On the lam,
William established his base of operations at the gloomy Castle of
Dillenburg, seat of the Nassau family dynasty, some thirty miles to
the east of Cologne. He wasn't to be found there often, however;
most of his time was spent on the road, rallying opposition to Alva
and occasionally engaging the duke's troops in military action, to
unfortunate effect. Proceedings on the home front didn't fare much
better for William. Anna of Saxony, his free-spirited young wife, had
little patience for the family's dank castle, or indeed for William him-
self. When they had married, in 1561, William had been one of the
wealthiest men in Europe. Now he was an exile, and the good-time
girl was sequestered in the hinterlands, where there was little fun to
be had. While William was off on one of his expeditions, she ditched
Dillenburg for the more cosmopolitan pleasures of Cologne.

Distressed by her husband's penury, Anna engaged Jan Bets, a
prominent attorney, to reclaim personal assets seized from her by
the Spanish crown. (Philip had laid claim to all of William's prop-
erty, but she had possessions of her own that were, technically, sep-
arate.) This pursuit entailed a good deal of travel, so Bets required a
deputy to manage the proceedings at home, ideally someone with a
solid grounding in the property statutes of the Netherlands. He had
just such a person in mind: an old professional acquaintance and
former distinguished alderman of Antwerp who had recently
arrived in the city and was anxious for work.

Jan Rubens may have appeared an inspired choice, but the hiring proved a disaster for all parties. In their long, intimate hours spent working together on her case, Jan and Anna, two exiles with seven children between them, found their passions inflamed. This was not an unusual state for Anna. Her reputation for debauchery was already the subject of local gossip, and had prompted a series of letters from her traveling husband pleading that she reform her behavior. Instead, she moved to Siegen, a small hilltop town encircled by a defensive wall a day's ride east of Cologne. Perhaps the goal was to remove herself from the rumor mill. For that there was good reason: she was pregnant, and by the spring of 1571 she was beginning to show. William, long absent, was not a candidate for paternity.

The prospective father was Jan Rubens, and there was no covering up the fact. In early March, while he was traveling from his own family residence in Cologne to the hilltop aerie of his client and paramour, he was arrested and summarily tossed into the Dillenburg dungeon. The charge, levied under the authority of Johan of Nassau (William's brother), was adultery with Her Royal Highness, a capital offense.

Maria Rubens, devoted wife and mother of four, suffered the mysterious disappearance of her husband for three weeks. Finally, on March 28, news of his situation arrived, first in an official notice that revealed the nature of his crime, and shortly thereafter in a missive from the prisoner himself. Stuck in a damp cell and with his life in jeopardy, Jan Rubens was a contrite and fearful man. He begged his wife's forgiveness, and proposed she keep his embarrassing status quiet. She didn't have much choice. A stranger in a strange land, with a reputation to maintain, a family to support, and no great means available to her, Maria had little recourse but to accept his apology, regardless of its sincerity. But it did seem sincere, and Jan

Rubens, to his great good fortune, had married a woman of extraordinary forbearance. Maria immediately sent off a pardoning letter to her husband, and followed it with another offering "every satisfaction on the subject of the forgiveness you ask me for, which I grant you now once again, and will ever grant you when you ask it of me, but on one condition—that you will love me as you used to."

Jan Rubens had some difficulty coming to terms with his wife's unusually large generosity of spirit. His replies to her betray a justifiable sense of self-loathing and a sullen pessimism as to his future. Maria, now fully responsible for the household and her children, tried to rally the spirits of her self-described "unworthy husband" with a series of emotionally charged letters:

> *How could I have the heart to be angry with you in such peril,*
> *when I would give my life to save you if it were possible? And*
> *were it not so, how could so much hatred have succeeded so*
> *quickly to our long affection, as to make it impossible for me to*
> *pardon a slight trespass against myself, when I have to pray God*
> *forgive me the many grave trespasses I commit against him every*
> *day . . . I find nothing in your letter to console me, for it has*
> *broken my heart by showing me you have lost courage and speak*
> *as if you were on the point of death. I am so troubled that I know*
> *not what I am writing. One would think that I desired your*
> *death; since you ask me to accept it in expiation. Alas how you*
> *hurt me by saying that! In truth it passes my endurance . . .*
> *I hope still that the Lord will have pity upon me; if not they will*
> *surely kill me in putting you to death, for I shall die of grief, and*
> *my heart would cease to beat at the moment when I heard the*
> *fatal news . . . My God! I could not survive it! My soul is so*
> *bound up and made one with yours, that you cannot suffer but*
> *that I must suffer as well . . . Alas! It is not justice that we ask,*

it is pity, and if we can by no means obtain it, what shall we do!
O heavenly Father, father of mercy, deign to aid me! Thou
desirest not the death of a sinner, but rather that he should be
converted and live! Oh! Send forth thy mercy upon the soul of
these good lords whom we have so heavily offended that we may
soon be delivered from this great pain and sorrow. For thou seest
how long it has endured!

The heavily offended lords in question, namely William and his brother Johan, were not nearly so forgiving as Maria Rubens. In cuckolding the Prince of Orange, champion of the Dutch rebellion, Jan had committed an act of apocalyptic foolishness. But he did leave his wife with a political lever as she bargained for his life. The mysterious cause of Jan's arrest, though a subject of gossip as far away as Antwerp, remained a secret convenient to both the Rubenses and the Oranges. A trial and subsequent execution would have exposed the truth, and the last thing William needed was a public embarrassment just as he was building his reputation as a great man of action; far better to let the transgressor rot in a dank German cell, out of sight and out of mind. Anna was also removed from public visibility, to the town of Dietz, where she gave birth to a daughter, Christina "von Dietz," in August 1571. William refused to acknowledge her.

Maria, meanwhile, made a business of seeking clemency on behalf of her incarcerated husband. She moved the family to Siegen so that she might be closer to him, but was repeatedly turned away from the Dillenburg gates. Eventually, she was allowed to visit. In a series of pleading letters, and later in person, she begged Johan and William to restore her family, "for the sake of my poor children, who have seen not only the ruin of their father but their mother's distress of her senses." Eventually, they relented. On May 10, 1573,

EVERY MAN FOR HIMSELF

after more than two years behind bars, Jan was paroled, though he remained under house arrest. Johan credited Maria's heartfelt pleas for their reconsideration.

Circumstances for the Rubenses were difficult. Because of his arrest, Jan was unable to practice law. Compounding the family's already considerable problems, Jan then ran afoul of local authorities for violating the terms of his parole. He had been seen walking about the city and mingling with friends, among other precluded activities. Bereft of Jan's earning power, the family survived on its meager savings and on interest paid out of the large sum left as his bail. Matters improved after Anna's death, in 1577. Few mourned her loss, and with William now remarried, the entire sorry episode of her affair was swept under the rug. Rubens was allowed to return to his profession, though he was forever banished from William's territories in the Netherlands and similarly barred from coming within sight of the prince himself. Christina, referred to derisively as "the little girl," was raised by members of William's family at Dillenburg. With Jan working again, the legitimate Rubens family expanded. In 1574, Maria gave birth to a boy, Philip. Three years later, in 1577, with the family still residing in Siegen, she gave birth to another son. He arrived on June 28, the feast day of Saints Peter and Paul, and was named in their honor: Peter Paul Rubens.

The expanded Rubens brood eventually moved back to Cologne and began the slow process of resurrecting the family name. Changing circumstances in Antwerp allowed them to recover some of their property, even if a permanent return was impossible given Jan's banishment. Their misfortune was not yet over, however. The grim specter of disease, so little understood, haunted the family. In 1580, Jan and Maria's fifteen-year-old daughter, Clara, succumbed to some malady that could not be restrained. Three years later her brother Hendrik, aged sixteen, passed away. Between their deaths, Maria had

lost a third child, an infant named for Jan's father, Bartholomeus. The oldest of the Rubens siblings, Jan Baptist, no doubt embarrassed by his father's "situation," had long since left home to embark on a now entirely forgotten career as a painter. In 1587, the withered paterfamilias passed on himself. At fifty-six, Jan Rubens was not a young man by the standards of the day, and his time in the Dillenburg dungeon and the straitened circumstances that followed had taken their toll. But with his death, he had granted his family freedom. Maria and her three remaining children—Blandina and her precocious younger brothers, Philip and Peter Paul—were finally free to return to Antwerp, their ancestral home.

Back in the city she so missed, Maria Rubens set her family up in a house on the Meir, Antwerp's primary commercial boulevard. It was a good address, but then real estate was easy to come by at the time. Through its troubles, Antwerp had remained an open city populated by Catholics and Protestants in equal number. But a recent executive order had forced Protestants either to return to the Catholic faith or to liquidate their holdings and leave altogether. For Maria Rubens, this ultimatum posed no great moral challenge. The flirtations she and Jan had with Protestantism were, from the outset, more political than they were dogmatic. After so bitter an exile, the chance to remain at home surrounded by family and friends easily trumped whatever religious imperatives she might have felt. She was primarily interested in providing her two precocious sons education and opportunity. The Jesuit training of Rombout Verdonck's private academy would suit them well. The Rubenses, however, were an anomaly. The population drain spurred by that convert-or-leave directive cost Antwerp many of its leading citizens and correspondingly invigorated the intellectual and commercial life of the nascent Dutch republic to the north.

Indeed, the difficult years the Rubens family spent shuttling

back and forth from Cologne to Siegen had been especially hard on their Flemish homeland. Back in 1568, when Maria had rushed off with the family for the putative safety of Germany, Alva's terror was only just beginning. In 1572, France and England, frustrated by the Iron Duke's militancy, signed a truce of convenience and began plotting a joint invasion of Flanders with William the Silent as the standard-bearer. The attack began in April, and for a while it looked as if the Low Countries would fall. But Alva patiently massed his troops and then moved to regain his losses in a campaign of extraordinary vindictiveness. At Harlem, his soldiers massacred more than two thousand men, women, and children. Alva hoped to break the rebellion through fear, but his plan backfired. Knowing the atrocities in store, the residents of every city in his path stiffened in resistance.

In November 1573, the Iron Duke, out of funds, was unceremoniously relieved of his duties. Conditions, however, did not improve. Alva's unpaid Spanish troops held Antwerp hostage until they received 1 million florins in back pay. It was an ugly harbinger of trouble. Attempts to disband the mutinous soldiers failed. On the morning of November 4, 1576, an unpaid army descended from Alva's citadel and ransacked the city. More than eight thousand *sinjoren* were murdered during the "Spanish Fury," and over one thousand homes burned. Floris de Vriendt's magnificent town hall, barely a decade old, was torched.

The Spanish Fury's viciousness brought the entire population of the Low Countries together—albeit briefly. With the Pacification of Ghent, signed just four days after the Fury began, the provinces of the Catholic south and the Protestant north united in their demand that Philip remove his forces from the Low Countries in their entirety. The Spanish troops eventually departed, and Antwerp was soon under the control of its hereditary master,

William the Silent. But the harquebus marriage of north and south was headed for divorce. In January 1579, the increasingly militant northern provinces signed a mutual defense treaty, the Union of Utrecht, and later the Oath of Abjuration, by which they renounced the Spanish crown entirely. The southern provinces, led by a Catholic nobility still loyal to Spain, signed a pact of their own, the Treaty of Arras.

This crisis eventually precipitated decisive action in Madrid. Philip dispatched Alessandro Farnese, the Duke of Parma, to restore order and put an end to the Dutch rebellion. The duke proved a shrewd choice. Unlike his disgraced mother, Margaret of Parma, he never lacked for resolve, and his skill as a military tactician was rivaled only by his reputation for bravery, proven against the Ottoman Empire at the Battle of Lepanto, in 1571. Farnese began his campaign to retake the Low Countries for Spain in 1582, sweeping north and west from his base in the loyal southern provinces of Hainaut and Artois. His effectiveness as a commander was soon readily apparent. He kept his army well supplied, and pressed it forward with methodical efficiency. One by one, the cities of Flanders fell to his men. By the autumn of 1584, Antwerp was surrounded, and the Scheldt under blockade. The besieged *sinjoren*, loyal to William, held out heroically for months, but it was to be a losing effort. A last-ditch attempt to blast through Farnese's river cordon failed. By August 1585, Farnese had his prize, along with 1 million florins in cash to keep his troops from sacking what remained.

Farnese's success in securing Flanders had the unfortunate effect of drawing England into the conflict in the Low Countries. The English queen, Elizabeth I, had established Protestantism in England, and now feared that Spain might try to restore Catholic primacy within her very domain. Flanders, just across the Channel,

EVERY MAN FOR HIMSELF

would make for a convenient staging ground for an attack on the English homeland. Faced with that reality, Elizabeth signed the Treaty of Nonsuch, by which she agreed to provide both military and financial support to the Protestant Dutch rebels. Terms of that agreement also left England in control of several key defensive positions within the Dutch provinces.

Philip considered the English intrusion into this territory an act of war, and in response chose the drastic course of action Elizabeth most feared: an invasion of the British Isles with forces drawn from Flanders. Under his direction, Spain marshaled its resources for attack, and in May 1588 the great Spanish Armada set sail from Lisbon. The plan was for it to rendezvous with Farnese's expeditionary army of seventeen thousand men at Dunkirk. From there, the combined force would cross the Channel for the English coast and a march on London. Of course, it never came to that. As the armada plowed its way north from the Iberian Peninsula, it was dogged by the more nimble English navy. In August, it was finally broken at the Battle of Gravelines, off the Flemish coast.

The loss of the fleet was a devastating blow to Spain, and left matters in the Low Countries at an impasse. Farnese, in particular, well understood the plight of the long-suffering Flemish population, and had few illusions as to their prospects. "It is the saddest thing in the world to see what these people are suffering; this country is ravaged by the king's troops as well as by those of their enemies," he wrote. Sensing the moment for compromise, he dispatched a key adviser, Jean Richardot, to meet with Philip back in Madrid. His mission was to press the Spanish king to entertain a peace proposal with the Dutch, a proposal that would have given the Dutch the right to freely practice the Protestant faith in exchange for an end to their rebellion. Richardot would remain an influential figure within Flanders for years—and a patron of both

Rubens brothers—but in this task he was not successful. Philip was not prepared to negotiate with the Dutch. Time, he thought, was on his side. If the Dutch felt they could win a prolonged battle of attrition with the superior military and financial resources of Spain, surely they were fooling themselves.

~☙~

IN FACT, THE DUTCH were more than capable of holding off the forces of Spain. Two decades after the Spanish fleet had been routed in the icy waters off the Flemish coast, the situation in the Netherlands remained at a stalemate, even as the players in the drama had, for the most part, changed. In 1584, William of Orange was permanently silenced by an assassin's bullet while puttering down the stairs of his home in Delft. Maurice, his son with Anna of Saxony, Jan Rubens's old paramour, took control of Dutch forces. With frigid blue eyes and a strawberry shock of a beard, he was an intimidating figure, and quickly proved himself to be a far more able commander than his father.

Maurice did not have to contend with the equally formidable Farnese for very long. The Spanish commander died in 1592, leaving a power vacuum in Flanders that was not filled until the arrival, four years later, of Archduke Albert of Austria, Philip's nephew. Albert was soon joined, in both sovereignty and marriage, by Philip's daughter, the infanta Isabella Clara Eugenia. The Spanish king was pleased with the match. Albert had always been one of his favorites, and he doted on Isabella. Title to the Spanish Netherlands was his wedding gift to the couple, though he granted it to them with a key stipulation. If the newlyweds failed to produce an heir, title would revert to Spain.

In fact, Albert and Isabella were never fully autonomous as sovereigns. For all their independence, they remained vassals of the

Spanish king. Indeed, their policy making was overseen by a junta of Spanish councillors who answered directly to Philip II in Madrid. When he died, in 1598, the Spanish crown was assumed by Isabella's younger brother, Philip III. He was not especially interested in overseeing Spanish affairs in the Low Countries, but his *valido*, Francisco Gómez de Sandoval y Rojas, the all-powerful Duke of Lerma, was very much up to that task.

Rubens, of course, had become an intimate of Lerma's during his embassy to Spain on behalf of Vincenzo Gonzaga. At the duke's country retreat at Ventosilla, the two men had developed an easy rapport. If nothing else, they were united by their immense ambition. As Rubens was at work on his equestrian portrait of the duke, the two surely discussed the sad state of political affairs in the Low Countries. A natural entry into the subject would have come through their mutual respect for Jean Richardot, the old diplomatic hand and Rubens family friend. Lerma's grand strategy for the greater Netherlands, by that time, was already beginning to coalesce, and over the following years would provide him with new leverage at the bargaining table. Under his direction, Spain signed treaties with both France and England, at once relieving Madrid of its two most feared adversaries and undercutting relations between the upstart Dutch provinces and their natural allies. On the ground, Lerma could rely on a new and extremely able military commander, Ambrogio Spinola, a Genovese adventurer of immense independent wealth. Spinola, using troops subsidized by his own fortune, won a series of victories for Spain that recouped territory lost to the Dutch. The most important of these triumphs was the 1604 capture of Ostend, after a three-year siege, from forces under the command of Maurice, the Prince of Orange.

With all that, the Spanish treasury was depleted, and Lerma

was pressed to put a clamp on a regional conflict that had escalated into a global war. The growth of Dutch naval power, coupled with the formation of the East India Company and its nascent West India twin, represented an outright attack on Spain's colonial empire. The two joint-stock corporations had been established as trade monopolies with broad authority—including military and diplomatic powers—to develop Dutch colonies overseas. Spain, for its part, considered the extraction of wealth from the Indies and the Americas to be its exclusive purview. Indeed, the Spanish treasury was kept afloat by the infusion of capital from its colonies. Threats to that lifeline were untenable for Madrid. When Dutch forces swiped key ports in the Spice Islands (Indonesia) in 1605, Lerma responded by secretly dispatching first Spinola and then the archduke Albert to meet with Dutch representatives in The Hague. Their goal was to secure a peace in which Spain would recognize Dutch independence in exchange for a withdrawal of the Dutch from their colonial interests in Asia and the Americas. Those far-off colonies were now more important to Spain than its claims on the Low Countries, the prized economic engine of northern Europe.

Lerma's terms were met with hostility by militant factions in both Spain and the Netherlands. In Madrid, there was outrage at the very idea that Philip should abandon his sovereign territory at any price, and equal dismay that His Catholic Majesty might even consider the desertion of so many co-religionists still resident in Dutch territory. The outrage was only doubled when it was revealed that Albert had somehow put the Spanish offer of Dutch independence on the table without receiving the corresponding guarantee of a Dutch withdrawal from the Indies.

In the Dutch provinces, and especially Holland and Zeeland, where commercial interests were strongest, the prospect of relinquishing the enormous economic potential of the Indies trade was a

nonstarter. Serious talks did not resume until February 1608, with Spinola and Richardot as chief Spanish negotiators. Their adversary was Johan van Oldenbarnevelt, the advocate of Holland, political leader of the United Provinces. Again, the bargain was independence for withdrawal from the Indies, and again the result was deadlock. Oldenbarnevelt was in fact no less anxious for peace than Lerma, but like his Spanish counterpart he was constrained by the demands of a militant coalition that threatened his power. When the sides finally concluded the so-called Twelve Years' Truce, in 1609, the only concession the Spanish managed to secure was a temporary freeze on Dutch colonial expansion, and the terms were so vague as to be almost worthless. The Spanish negotiators could not even convince the Dutch to lift their naval blockade of the Scheldt River, which had restricted Antwerp's access to the North Sea at great cost to the city.

THE TWELVE YEARS' TRUCE may have been a bad deal for Spain, but in the Low Countries it was welcomed with considerable celebration. Peter Paul Rubens, just returned from Rome and still mourning his devoted mother, was especially optimistic. It did not take a great clairvoyant to see that even with the Scheldt closed, Antwerp would benefit from a cessation of hostilities. If the river would not be the floating Broadway it had been in the previous century, when Antwerp was at the height of its powers, at least the city could rely on the excellent canal and transportation network of the southern Netherlands, which gave it indirect access to the North Sea and opened it to the world's trade.

Rubens's brother Philip was certainly prospering in this hopeful environment. Upon his return from Italy, he had become one of the city's four councilmen, a post of considerable authority. He had

also, by 1609, fallen in love with one of Antwerp's fairest maidens, the beautiful Marie de Moy. Indeed, she was so attractive that Rubens quipped he might give up his own marital aspirations. "I will not dare to follow him, for he has made such a good choice that it seems inimitable. And I should not like to have my sweetheart called ugly if she were inferior to his." But even as Philip had been "favored by Venus, the Cupids, Juno, and all the gods," he seemed incapable of closing the deal without his younger brother's romantic direction. An artistic education was not, apparently, all that Il Fiammingo had picked up during his time in Italy. "I find by experience that such affairs [of the heart] should not be carried on coolly, but with great fervor," he wrote. "My brother has also proved this, for since my arrival he has changed his tactics, after pining for two years in vain."

The Rubens–de Moy wedding was a grand event in the old Antwerp style, and at some time during the festivities the best man, Peter Paul, was similarly struck by Cupid's arrow. His Venus was Isabella Brant, the eighteen-year-old niece of his brother's bride. Her father was Jan Brant, one of Philip's colleagues on the Antwerp secretariat. Isabella possessed all the qualities Peter Paul saw in her aunt, and the two were married on October 3, 1609, in a ceremony that rivaled his brother's. To commemorate the occasion, Rubens painted a disarmingly intimate double portrait of himself and his young bride, with the couple seated in complementary outfits beneath a bower of honeysuckle, which was traditionally associated with faithfulness and marital bliss. Isabella, in a burgundy skirt, looks out with a coy smile as her hand rests gently on his. The painter depicted himself sitting comfortably above her, his strong legs crossed casually in reddish stockings, with an aristocrat's sword dangling from his left hand—a gentleman, but also a family man.

As the picture suggested, they were a happy couple, and now

that Rubens was attached by what his brother called a "conjugal chain" to Antwerp, he chose to forsake Rome for good. The family expanded two years after the marriage, with the addition of a daughter, Clara Serena. Two boys followed: Albert in 1614 and Nicolas in 1618. In those blissful, bountiful years, Rubens proved his estimation of the entrepreneurial possibilities attendant upon the Twelve Years' Truce to be entirely accurate, and demonstrated a gift for business that practically equaled his talent with oils. He knew well that the archduke Albert coveted his services as a painter, and had ever since Rubens's days in Rome. Rubens's old patron Vincenzo Gonzaga had put a check on the archduke's attempts to lure the painter back to Flanders. But now the only obstacle Albert faced in adding Rubens to the roster of artists in his employ was Rubens himself. "I have little desire to become a courtier again," he wrote. Servitude cramped his freedom and chafed at his ego, and he had fought against it even as a boy, when he had pressed his mother for release from the stultifying employ of the Countess de Ligne-Arenberg.

The archdukes Albert and Isabella were more than happy to satisfy his demand for independence. Rubens's presence would not be required in Brussels, at least not daily. He could remain in Antwerp, with all the privileges of a court painter and an annual retainer of 500 florins, nearly double the income of a typical trades-man. To celebrate the appointment, he was given a gold chain valued at 300 florins. His title absolved him of taxes, and freed him from any obligation to the painters' guild of Saint Luke, which had its own restrictions and levies. In exchange for this considerable munificence, Rubens was required to produce nothing but a single portrait of each monarch. All other commissions from the crown— occasional state portraits and other public works—were to be paid for on top of his salary.

The portraits Rubens made for the archdukes, half-length images of considerable formality, were nothing like that image of comfortable ease the artist created for himself and his new wife on the occasion of their marriage. The sovereigns were shown wearing serious expressions and all their finery: broad ruff collars, silk brocades, jewels, the full trappings of Habsburg power and prestige. Conversation during the sittings for those portraits surely extended to subjects beyond art. Jean Richardot, one of the archdukes' closest political allies and a longtime friend of the Rubens family's, had no doubt encouraged the two sovereigns to take advantage of the painter's political acumen, and in particular his status as a favorite of the Duke of Lerma, the Spanish *valido* who exercised such enormous influence over their own affairs. The patent attaching Rubens to the service of the archdukes noted his qualifications in painting and, more cryptically, "several other arts."

In addition to the patronage of Albert and Isabella, Rubens could rely on his connections to Antwerp's political and merchant elite, the men and women who would rebuild the city's economy during the truce years. It was from this group, and not the archdukes, that he received his first major commission after his return from Rome, and one loaded with political meaning. The Twelve Years' Truce was to be formalized in an elaborate ceremony in Floris de Vriendt's restored town hall, and suitable decoration for the room in which the event was to take place, the State Chamber, was required. Rubens responded with his most ambitious work to date, an enormous and almost obscenely sumptuous *Adoration of the Magi*, a composition jam-packed with figures, animals, and riches depicted with a furious energy in a glowing, honeyed light. The treaty's signatories could not have escaped its thinly veiled symbolism: the Virgin (guardian of Antwerp) presents a baby Jesus (peace) to the three visiting kings (representatives of Spain, the

Dutch, and the archdukes), whose servants bear with them gifts (the profits of accord). When the truce was signed, on April 9, 1609, the painting was in place. Rubens would have to wait a year for his 1,800-florin fee, but when the city did pay, it included a twenty-eight-ounce silver chalice as a token of respect.

In the year after he completed that commemoration of peace, Rubens erected a more personal monument to a woman who had endured so much hardship during the long years of conflict: Maria Rubens. On October 11, 1610, standing with his wife and brother, Rubens unveiled a new altar dedicated to his mother at her tomb in the Abbey Church of St. Michael. At its apex he placed the rejected altarpiece he had made for the Chiesa Nuova, which he had carried back with him from Rome. He was proud of it, and despite what the Oratorian fathers thought, he knew she would have been, too.

CHAPTER III

THE PRINCE OF PAINTERS

ೊ಼ೞ

I cannot behold without ravishment the masterpieces in which
you vie with nature. Courage, Apelles of our age, may your
talents and your merit be recompensed by a new Alexander!
—DOMENICUS BAUDIUS

On one of Antwerp's typically pleasant summer afternoons, with a
cool breeze blowing in off the Scheldt and scudding clouds break-
ing across a crystalline sky, there was no more appealing place to
spend a few hours than the lush private garden tucked behind the
home of Peter Paul and Isabella Rubens. The painter designed it all,
house and garden, having been inspired by the elegant Mantuan
homes of the artists Andrea Mantegna and Giulio Romano. His
good friend Jan van den Wouvere wrote that he built it expressly to
astonish his many distinguished guests.

The property was located on the Wapper, a quiet canal street
just off the Meir, Antwerp's bustling commercial boulevard. Rubens
purchased it in 1610 from the Harquebusiers' Guild for 10,000
guilders, a princely sum. It was a great deal to pay, but the lot came
with a handsome house in the traditional Flemish style—three red-
brick stories with white stone trim and a steep roof punctured by



· 71 ·

stepped-gable windows—and an adjacent laundry house that, once demolished, would leave enough room for Rubens to build a new wing facing the street and, in addition, a pair of row houses to rent. In the back, there was space for a large formal garden.

It was a good five years before the Rubens family could actually move into their new home, and more than a decade before the artist was finally done tinkering and making alterations. The old Flemish house was gut renovated, and attached to it Rubens built a small Italianate palazzo to serve as his studio and workshop. The style of this building was something new to his neighbors, a precisely crafted jewel of classical design. The sketchbooks Rubens kept during his time in Italy attested to his careful attention to architectural detail. In 1621, he would even publish on this subject: a sumptuous two-volume monograph on the palaces of Genoa that so captivated him on his first visit to that city, years earlier. For the moment, however, Rubens did not build himself a Genovese-style villa. He considered those buildings, though attractive, "suited to housing families of simple gentlefolk." For his own home, he had something a bit more substantial in mind.

The contrast between Rubens's two buildings—the older Flemish house that came with the property and the new Italianate wing he designed himself—was stark, a visual statement of loyalties divided. Inside, however, Rubens characteristically found harmony in the marriage of disparate traditions. Visitors entered through a heavy wooden door in the Flemish side, and from there were led into a courtyard enclosed by a portico that physically and metaphorically united the two wings of the house. Visible beyond was the garden, an Edenic space with a pavilion, fountains, and exotic trees selected especially by the artist. The triple-arched portico, a mash of heavily articulated forms surmounted by statues of Hermes and Athena (gods associated with diplomacy and the arts), was something

entirely of Rubens's invention, a translation into stone of his artistic and personal philosophy. Its elements, architectural and literary, were drawn from the classical tradition, but applied with the same unique blend of exuberance and bravado Rubens brought to canvas. To that end, Satyrs held aloft tablets with inscriptions from Juvenal that warned of life's fragility and extolled the benefits of humility before the gods.

Rubens advocated humility as a general philosophy, but when it came to architecture, he made a distinction between houses that were solid blocks, like the Genovese buildings he recommended for "simple gentlefolk," and those with open courts at their hearts, like his own, which he considered appropriate for a sovereign prince. Rubens was similarly unafraid to suggest, with a wink and a nudge, a suitably elevated place for his talents in the canon of art history. Across the courtyard facade of the workshop, Rubens re-created in what appeared to be low sculptural relief the works of his esteemed forebears, the most famous painters of Greek history: Zeuxis, Timanthes, Protogenes, Apelles. Their works were known only from literary descriptions, and in his own writings Rubens himself suggested it was best they be kept "in imagination alone, like dreams." Attempts to reproduce them, he wrote, would result only in "something insipid or inconsistent with the grandeur of the ancients . . . and fail to do justice to those great spirits whom I honor with the profoundest reverence, preferring indeed to admire the traces they have left than to venture to proclaim myself capable of matching them, even in thought alone." Those words had an appealingly humble ring, but in practice he teasingly violated his own warning. The frieze running along the workshop facade was actually not a frieze but a trompe l'oeil depiction of a frieze painted in grisaille, a technique in which monochrome pigment can be used to mimic the effect of stone. This artifice was extended and expanded

on the garden facade of the workshop, where a three-dimensional loggia was faked onto what was in fact a blank wall. Above this scene, a painting by Rubens was stretched out to dry, apparently hanging over the "frieze." Only the drying canvas was not a real drying canvas but a painting of a drying canvas. The painter's more erudite friends (and especially the artists who visited) almost certainly appreciated this elaborate inside joke. The ancient painters Rubens most admired were famous for their ability to fool the eye. The masterpiece of Apelles, the greatest of those artists, was his *Calumny*, an allegorical rumination on the dangers of bearing false witness. On that front, Rubens had surely proven himself capable of matching his illustrious predecessor. Unfortunately, that subtext was lost on the royal eye of the Infanta Isabella, who supposedly asked that Rubens take the drying work down for inspection during one of her visits to the studio—an awkward moment, to be sure.

Inside, the house was furnished and fitted in the best taste, a necessity for entertaining distinguished guests. Royalty from across Europe came to the Rubens house to sit for the painter and to arrange for the purchase of works from his studio. A stop at the elegant home on the Wapper was all but obligatory for dignitaries visiting Antwerp, though travelers did not always arrive at its doors solely with art on their minds. The large formal garden in the back of the house was an excellent place for a private stroll, where delicate political affairs might be addressed away from prying eyes and ears. Moreover, Rubens himself was developing a reputation as a man of insight and discretion, and his proximity to the archdukes Albert and Isabella made him a useful conduit for those wishing to initiate back-channel negotiations with the sovereigns. The intimacy of his relationship with the archdukes during this time is plainly evident in a painting of a gathering at the Antwerp home of Cornelis van der Geest, one of the artist's friends. In this picture,

painted by Willem van Haecht in 1615, Albert and Isabella stand just below Rubens's recently completed *Battle of the Amazons*, which hangs on a back wall. In the foreground is the painter himself, lecturing the royal couple on the merits of a Quentin Metsys *Madonna and Child.*

Rubens kept a private office on the second floor of the workshop, and it was from there that he conducted most of his correspondence. Ever since his return from Rome, he had become an essential node in an informal network of like-minded thinkers—men such as Lipsius, Galileo, Isaac Casaubon, and Nicolas-Claude Fabri de Peiresc—who exchanged ideas on subjects ranging from ancient history to philosophy to the natural sciences. Political affairs figured prominently, especially for Rubens. A born scholar, he had supplemented his on-the-job political education with an academic investigation into the history, theory, and practice of diplomacy. (Espionage being the dark art naturally conjoined to statecraft, he studied that, too.) He was well versed in the ideas of the Renaissance theorist Niccolò Machiavelli, the best-known, if not most admired, authority on the subject. By the early 1620s, his own theories on the importance of negotiation during wartime were so advanced that he felt comfortable offering them to Frederik de Marselaer, a Brussels-based diplomat who was revising a book on the duties of an ambassador.

Rubens did most of his writing behind closed doors, but his artistic invention was done primarily out in the open, in a large room on the first floor of his studio. This was a long gallery with four north-facing windows and high ceilings. Apprentices worked alongside him and also above on the second floor, in a domed room lit by an oculus window. There was plenty of space, but even still, Rubens couldn't satisfy the demand for places in his studio. For Anthony Van Dyck, who would become his most famous pupil, he made room, but other talented students—even the children of

friends and relatives—could wait a year or more before finding a position, if they got one at all.

Rubens thrived on the commotion of the studio, and set about his work with a ferocious energy. Rapid brushstrokes augmented the sense of dynamism that was a hallmark of his style, and the sensuous tactility of the paint he applied enhanced the physical presence of his figures on canvas. "Abandon and audacity alone can produce such impressions," the great Romantic painter Eugène Delacroix would later note. The more quickly Rubens worked, he discovered, the more profitable was his studio. Output increased, of course, but clients also enjoyed—and would pay a premium for—works in which his forceful stroke was readily discernible. Rubens actively promoted this fascination with his genius. It was good business, and it pleased his considerable ego. Painting, he felt, was both a discipline and a performance. Guests were encouraged to watch him at the easel. Otto Sperling, a Danish physician who saw Rubens in action, recalled that his talent was such that he could at once paint, dictate a letter, and listen to an assistant reading a classical text in Latin. "When we kept silent so as not to disturb him with our talk," wrote Sperling, "he himself began to talk to us while still continuing to work, to listen to the reading and to dictate his letter, answering our questions and thus displaying his astonishing powers."

A Rubens painting often began with a few quick pen sketches known as *crabbelingen*, or "doodles." He regularly drew from a live model and built up a "costume book" as a reference to ensure his figures were properly fashioned in period attire. Depending on the circumstance, initial studies were followed with larger conceptual drawings, usually on cream paper in a brown bistre ink made from oven soot or chalk, and then preliminary sketches in oil on wood board. As he matured, he would often skip drawing altogether and

begin with an oil sketch. These were then handed off to his apprentices, who scaled his ideas to canvas and brought them to a predetermined level of execution. Some works Rubens completed entirely himself; others he simply finished with a few touches of the brush. Designs for the large tapestries that were a highly profitable Flemish specialty were sent off to local factories for execution. Contracts typically determined just how much of Rubens's personal contribution was required in a particular work, but there was not always a contract, as he often worked on spec. The resulting confusion of authorship was a problem for some of his clients—it remains a problem for collectors and curators—but Rubens considered all of the work his own. Certainly it was lucrative. His prices were high, and he was not prone to negotiate. Indeed, he had so many buyers that he dealt with only the most distinguished connoisseurs. "He sends less competent judges to less competent painters," wrote one client. Those who wanted his pictures had to accept his demands.

The stereotype of the artist as a destitute genius supported only by charity is largely a product of the nineteenth century. The artists of Rubens's era were craftsmen, and those who were masters ran efficient and profitable workshops. But even judged by the standards of his contemporaries, Rubens's success as a capitalist was extraordinary. In its prime, the Rubens studio earned something on the order of 100 guilders per day, a figure that left the painter with an annual salary more than fifty times that of the average mason, and far in excess of the income requirement not just for a baron but also for a prince. Men of those ranks, however, were precluded from engaging in something so base as a trade—let alone one that required manual labor—for their incomes.

Rubens, for his part, saw nothing ignoble in what he called his "*dolcissima professione*," and was unashamed to show off the wealth he acquired through its practice. He could regularly be seen driving

about Antwerp in a luxurious carriage, dressed impeccably and attended to by a flock of servants and assistants. He had few enemies, but even those who found his flights of theatricality self-indulgent or pretentious never dared to accuse him of laziness. He rose before dawn and began work with the first light. He ate a small vegetarian lunch around noon—he avoided meat, lest it upset his digestion and keep him from the easel. Following the meal, he worked through the afternoon until five, after which time he would exercise one of the several fine Spanish horses from his stable along the ramparts encircling the city—the routine of a gentleman, not a tradesman. Supper was taken with family and friends, but again Rubens was fairly abstemious. He didn't drink to excess, and he never gambled.

Evening hours were spent with his growing family and a close-knit circle of friends. Regulars at the Rubens house included his old schoolboy chum Balthasar Moretus, the scholars Jan van den Wouvere and Jan Caspar Gevaerts (known respectively in their Romanist circles as Woverius and Gevartius), and the still-life painter Jan "Velvet" Brueghel, son of the great Pieter Brueghel. (The nickname paid homage to his soft touch with a brush.) Rubens and Brueghel were so close that Rubens, more gifted with words, often handled his friend's correspondence. Brueghel affectionately referred to him as "my secretary." The two masters were also occasional collaborators, a highly unusual practice for artists of their stature. In these innovative works, Rubens painted the human figures, and Brueghel the surrounding floral arrangements (flowers being his specialty). Frans Snyders, another friend and an expert animal painter, was also a frequent collaborator. The benefit of these joint works, beyond their aesthetic pleasures, was that they could be sold at especially high rates, as they combined the skills of multiple masters, thereby providing "added value."

In Rubens's era, genre specialists like Brueghel and Snyders were esteemed somewhat less than painters of grand subjects from history, but Rubens was never snobbish about such distinctions—though he was sure to place himself in the latter, more exalted group. Indeed, his friends routinely praised his generosity and humility, traits cultivated by his mother and his Jesuit education. Early in his career, the artist neatly summed up his personal philosophy with a simple diagram that he sketched into an Antwerp guest book. Above a small circle with a dot at its center, he wrote the Latin phrase *"Medio Deus omnia campo."* "God is all things in the middle of the field." Art history's most celebrated exemplar of carnality was, at least intellectually, a man of quiet moderation. His passions were released in his work.

Of course, the Baroque is not remembered as a time of self-effacement, and neither is its archetypal painter, who compensated for all that self-abnegation with an unprecedented excess of splendor in his work. If Rubens was aware of the ironic disconnect between his personal appetites and the essential nature of his art, he never felt cause to justify it. An enormous, controlling intelligence filtered his hedonistic impulses and provided the discipline that allowed him to create canvases that were larger, with more figures, more color, more drama, and more beauty than anything that had come before. And of course there were more of these pictures, thanks to his expertly staffed workshop and his own personal industry. Rubens made no secret that he reviled nothing so much as the sin of sloth. In a plague-ridden era, the ever-present specter of disease bred an expectation that precious time should be capitalized upon with full energy. When Rubens received a letter from Rome informing him of the death of Adam Elsheimer, a specialist in miniature landscapes painted on copper, he lamented his friend's creative struggles, which resulted in "despair" and "deprived the

world of the most beautiful things." Rubens would never be the victim of his own diffidence, but he was generous enough to act as a dealer for Elsheimer's widow. Using his contacts, he helped her sell off the artist's remaining works at good prices, and without commission.

Rubens was forced to confront an even more painful death in 1611, with the passing of his beloved older brother Philip, then just thirty-seven years old. It was a crushing loss. Philip had always been his closest confidant, and his death left Peter Paul as the lone survivor of the seven children born of Jan and Maria. In his brother's honor, he created one of his most heartfelt works: a group portrait with Philip seated next to his late mentor, Justus Lipsius, and beneath a bust of Seneca, their intellectual hero. Rubens placed himself in that painting, looking out solemnly over his brother's shoulder. His is not a comforting expression, but it does at least signal an adherence to the brand of neo-stoicism championed by Lipsius. "Constancy" was the word with which the philosopher was most commonly identified, and the title of his two-volume meditation on Senecan values, a kind of self-help guide to moral living in a turbulent world. A sense of stoicism was essential to Lipsius; the philosopher defined it as "a voluntarie sufferance without grudging of all things whatever can happen to, or in a man." In difficult times, constancy was the "fair oak" upon which a man might lean his troubled body, and it was the intellectual crutch Rubens looked to when he found himself mourning the brother who years earlier had himself proclaimed a heart "torn apart by anxiety" for his seafaring younger sibling.

Lipsius, a severe man with a sunken face, small eyes, and an aquiline nose, cast an enormous intellectual shadow over the Low Countries during the early seventeenth century, surpassing even that of his forebear Erasmus. His erudition was legendary. (He

famously offered to read passages by Tacitus, one of his favorites, from memory with a dagger held at his gut, waiting for a slip that would never arrive.) The impact of his thinking on Rubens was especially acute. The philosopher's story must have been particularly resonant for the Rubens siblings, as it mirrored the experience of their own family. Lipsius, like Jan and Maria Rubens, had fled the Spanish Netherlands before returning, in mind and body, to the Catholic fold. His theological philosophy was a pragmatic fusion of classical erudition and contemporary Christian orthodoxy that skirted the rifts between the most virulent Catholics and Protestants. That suited Rubens's scholarly nature and his essential sense of temperance. The artist was never ostentatious about his faith, though he dutifully attended an early Catholic mass before beginning his workday. His parents' Calvinist experimentation had bred in him a fairly tolerant worldview, and the religious warring of the Low Countries had impressed him as needlessly destructive. Certainly, his own family had suffered the consequences of sectarian division.

Lipsian political philosophy was similarly modeled on classical precedent, in particular the systems of imperial Rome, on which he was an expert. Lipsius echoed Seneca's injunction that individuals of capacity were obliged to serve the needs of the state. This was something of a truism of the period, shared by humanists across Europe. Michel de Montaigne, the great essayist of the previous century, acted as a mayor, a parliamentarian, and a secret mediator during the French Wars of Religion. In his own essay on the nature of constancy, Montaigne wrote, "The Peripatetic sage does not exempt himself from perturbations, but he moderates them." It is no coincidence that Rubens, who always understood painting to be his primary vocation, would also develop a career as a pragmatic statesman.

~ৡ৴ৼ~

THE DISTINGUISHED SET of citizen-scholars who were Rubens's confreres and clients gathered regularly in the private art galleries, or *Kunstkammer*s, they built in their homes. These rooms were packed from their polished floors to their coffered ceilings with paintings, sculptures, and other wonders, rooms that reflected the worldliness and intellectual ambition of their owners. Nicolaas Rockox, the Antwerp burgomeester, commissioned a *Samson and Delilah* from Rubens and installed it over his fireplace, not far from a bust of Marcus Aurelius and a heartwood chest filled with shells and coins. Rubens himself collected shells, globes, books by the score, a sarcophagus, an Egyptian mummy, even plans for a "perpetual motion" machine. A Byzantine agate vase was a particular favorite.

In 1619, Rubens initiated a weekly correspondence with the Parisian politician and fellow antiquarian Nicolas-Claude Fabri de Peiresc. Rubens wrote that first letter to enlist Peiresc's support in his mission to secure French copyright privileges for a series of printed engravings. In the years following, their epistolary friendship would grow to one of unusual devotion, and it would continue throughout their lives. For Rubens, Peiresc became an invaluable source of intelligence on political affairs in Paris. In addition to his own highly informed commentary on that subject, Peiresc routinely sent along newspapers, pamphlets, and books that were noteworthy or controversial. He also sent fawning compliments. "You surpass all the painters of this century," wrote the Frenchman. "I am convinced that you are the equal of the most excellent masters." Beyond flattery, the subject they engaged in most happily was antiquarian scholarship, and their letters sometimes veered toward academic absurdity. "The reason for comparing the vulva to a snail I

cannot imagine," Rubens wrote in a letter analyzing a pornographic cameo. This, however, did not keep him from comparing the snail's antennae to an engorged labia, though he switched languages from Italian to the more scholarly Latin to maintain propriety.

Such displays of erudition were occasionally disparaged, even then, as the ostentatious vanities of dilettantes, an accusation not without some merit. But they were also markers of an obsessive quest for intellectual enrichment, a project antiquarians considered essential for self-improvement and for understanding the world around them. The realm of scholarship, Seneca argued, was an appropriate place of retreat for men of learning in a troubled age. But men like Peiresc and Rubens also shared a Lipsian worldview in which the historical past was understood to be contiguous with the political present. Theirs was very much a practical brand of humanism, and they believed a strong academic background critical for those in positions of national authority.

Judged by its contents, the most impressive gallery in Antwerp belonged to Rubens. Its walls were adorned with his own paintings, with copies he made from old-master works, and with originals by the likes of Titian, Raphael, Tintoretto, and Veronese. He also collected from among his own circle, including his pupil Van Dyck, and local painters of good but lesser reputation. Rubens, artist of the grand gesture, had a special fondness for the small genre and landscape scenes that he rarely painted himself (and that snobbish Italophiles like Iberti disparaged as the only idioms in which Flemings might be trusted). These works were complemented by the large collection of antiquities he brought back from Rome. He also built an extensive library, with volumes on subjects ranging from architecture and botany to theology and zoology. Classical history was, of course, a special point of emphasis. His taste in literature was generally more scholarly than bombastic. He once complained

of the French writer Père Goulu, "His conceit and vanity are insufferable, and his hyperbole passes all measure."

For Rubens, this was a working collection. Intellectually, it was his conduit to an accurate reconstruction of the historical past, one of the great aims of the antiquarian project. As an artist devoted to the ideals of the Renaissance, he believed a thorough knowledge of the classical tradition was a professional necessity. "In order to achieve the highest perfection one needs a full understanding of the statues, nay a complete absorption in them," Rubens wrote in a treatise on sculpture, though he warned that the painter should at all costs "avoid the effect of stone." To aid in focusing his attention, Rubens designed a special gallery for his statues, a miniature museum modeled on the Roman Pantheon, which he tacked onto the back of the refurbished Flemish house. Willem van Haecht, who had painted the image of the Van der Geest home with Rubens addressing the archdukes Albert and Isabella, depicted a version of the gallery in his *Studio of Apelles*, painted around 1628. (The title offered a thinly veiled reference to Rubens.) The small gallery was semicircular, with a half-dome ceiling punctured by an oculus window and more than fifty niches on two levels for display. This configuration had been endorsed by a long line of influential Italian architectural theorists, including Vitruvius, Sebastiano Serlio, and most recently Vincenzo Scamozzi, who illustrated a similar space in his 1615 pattern book, *L'idea della architettura universale*, of which Rubens owned a copy.

❧

IN 1618, Rubens dramatically expanded his collection of antiquities in a deal with Dudley Carleton, the English ambassador to the Dutch government at The Hague. Carleton was in his mid-forties at the time—he was just four years older than Rubens—but he had

already developed a drawn and weary aspect about him, the product of a peripatetic career in which he had often found himself held responsible for the ill-considered behavior of his superiors. As a younger man, he had been appointed as a court secretary to one of the aristocratic co-conspirators in the so-called Gunpowder Plot, the famously ill-conceived scheme to blow up the Houses of Parliament while King James I was calling it to order. Carleton was briefly detained before he was cleared of any wrongdoing.

Carleton's association with Rubens began before the two men had even met. In 1616, just after Carleton had arrived in the Netherlands, Rubens sold him a hunting scene in exchange for a diamond necklace valued at 50 pounds (about 600 guilders). Hunting scenes were quite fashionable with the English nobility at the time, and Carleton had in fact wanted an even larger version of the same painting. Rubens, however, demanded nearly twice as much for the bigger picture, and the ambassador was in no position to increase his offer.

Carleton, in fact, was in some economic jeopardy, and it was this uncomfortable situation that Rubens would leverage to transform himself into one of Europe's foremost collectors of antiquities. Carleton's straitened circumstances were the product of yet another disastrous experience working on behalf of a highly placed English nobleman, Robert Carr, the Earl of Somerset. Like many British aristocrats of the period, Carr had been bitten by the art bug, and he had arranged for Carleton, then England's ambassador in Venice, to acquire a collection for him in that center of artistic patronage. This was something Carleton had been doing for a while, and with political motivation. Though James I was a bawdy Scotsman with little interest in the arts beyond the occasional trip to the theater, his son Henry, the Prince of Wales, was something of an aesthete, and considered London an isolated intellectual backwater in comparison to

Madrid, Paris, and Rome. If the English Stuarts were to have any credibility in those capitals, Henry thought, they would have to be taken seriously as patrons of the arts. Henry died before he could succeed his father to the throne, but his interest in the arts inspired his countrymen, in particular Carr, who happened to be the king's closest confidant.

With the exception of James himself, there was no more powerful figure in England than Carr. The king doted on him, besotted with his powerful build, his charm, and their shared Scottish roots. James even gifted Carr the seized home of the explorer Walter Raleigh, then resident in the Tower of London as an enemy of the state. Carleton, in Venice, was charged with filling this palatial manor with art. He spent 800 pounds—a small fortune—on a collection of antique marbles and paintings by Venetian masters and then shipped the entire haul off to London. But before Carleton could be reimbursed, Carr was swept up in a scandal that would bring a swift conclusion to his career.

While Carleton was busy rounding up Venetian art for Carr, the earl had availed himself of an object of beauty in London: Frances Howard, wife of Robert Devereux, the Earl of Essex. The extramarital affair generated considerable public outrage. Even Carr's own deputy, Sir Thomas Overbury, was appalled. Carr was not one to tolerate such impudence, and neither was King James, who tried to ship Overbury abroad. When he refused that appointment, the irate king saw to it that he was jailed in the Tower of London. That might have been the end of the matter, but Carr continued with his revenge, having his former secretary murdered with a combination of toxic candies and a poisoned enema. When Carr's culpability in that crime was discovered, *he* was carted off to the tower, notwithstanding his relationship with King James. Alas, this was no good for Carleton; the trove of paintings and antiquities he had acquired

on the earl's behalf had just arrived from Venice. Carleton found the collection in Carr's bowling alley and just managed to liberate it before it was impounded. But he could hardly afford to keep it. "I am by mischance made a master of such curiosities," he complained. The paintings he arranged to sell off (at a considerable loss), but the marbles were harder to bargain away. There was more bad news for him when he arrived at his new post as ambassador to The Hague. The shipment of antiquities was short seven statues. Carleton could do nothing but ruefully summon his customary British forbearance. "I finde some of my owne heads wanting," he wrote.

Even with those losses, the collection of marbles was estimable, and when Rubens heard that Carleton had it on the Continent, he dispatched a letter inquiring if the ambassador would be inclined to accept a reasonable offer for it. The answer, of course, was yes. Carleton had purchased the marbles for the equivalent of 6,000 florins (never mind those missing heads), and he sought only equal value in return. Rubens, for his part, was happy to oblige sight unseen, but wanted to pay in paintings, not cash. "I find that at present I have in house the very flower of my pictorial stock, particularly some pictures which I have kept for my own enjoyment; some I have even repurchased for more than I had sold them to others," he wrote, adding, "I like brief negotiations, where each party gives and receives his share at once." To that end, he attached a list of images from which Carleton could choose, indicating the dimensions and prices of each.

Payment in kind was somewhat less than ideal for Carleton, but he knew that paintings would be far easier for him to move, both literally and figuratively, than his statues. Nevertheless, he was offering Rubens something exceptional, and wasn't about to be hustled. "You, sir, may calculate on having in this collection of marbles, the

most costly and most precious [of its kind], which no prince or private person, whoever he may be, on this side the mountains can have." He had reviewed Rubens's offer sheet and found it, like his heads, wanting. Too many of the paintings were studio productions, and Carleton was interested only in "originals."

Rubens blanched at this suggestion. The question of originality was hardly straightforward given the practices of his workshop. "They are so well retouched by my hand that they are hardly to be distinguished from originals," he wrote. "The reason I would deal more willingly in pictures is clear . . . they cost me, so to speak, nothing. For everyone is more liberal with the fruits of his own garden than with those he must buy in the market. Besides, I have spent this year already some thousands of florins on my estate, and I should not like, for a whim, to exceed the limits of good economy. I am not a prince, *sed qui manducat laborem manuum saurum* [but one who lives by the work of his hands]." The funds in question were almost certainly those used in the construction of the gallery that would eventually house Carleton's statues. In any case, he thought Carleton foolish for not taking a larger number of the retouched paintings, to which he assigned dramatically lower prices and which he considered largely indistinguishable from those he painted entirely himself.

The negotiation wasn't the brief affair Rubens envisioned, but eventually the two parties reached an agreement in which Carleton received eight Rubens originals along with 2,000 guilders' worth of tapestries purchased in Brussels. There was but one caveat: Carleton wasn't buying the artist's false modesty. "I cannot subscribe to your denial of being a Prince," he wrote, "because I esteem you the Prince of Painters and of Gentlemen, and to that end I kiss your hands."

RUBENS MAY HAVE had the financial resources of a prince, and Carleton may have esteemed him as one, but Rubens was not of noble blood, and he kept a safe distance from the royal court in Brussels, even as he profited from its patronage. The archdukes' Coudenberg Palace was a cold, sober place, its severity relieved only by its opulence. Both Albert and Isabella had been reared in Spanish courts noted for their punctilious formality and zealous Catholicism, attributes they brought with them to the Netherlands. Those qualities proved to be particularly useful during the truce years, as they worked to instill a sense of national unity on a polity whose communal bonds had been fractured by years of conflict.

The archdukes began this process of nation building by consolidating their power within the aristocracy. It was their privilege to award membership in the Order of the Golden Fleece, among other honors and titles, and to appoint provincial governors from among the nobility. Once they established a loyal political base, they had at their disposal the mighty financial engine of the Spanish Netherlands, powered by its advanced agrarian system and extensive trade network. Though Madrid constrained their policy-making abilities, the archdukes retained for their own administration moneys collected from the provinces—moneys that had previously been forwarded on to Spain. So endowed, Albert and Isabella spent lavishly on their own court. Coudenberg, along with their other palaces at Tervuren, Binche, and Mariemont, was outfitted with the finest Flemish tapestries and the fruits of their unsurpassed garden of court artists, Rubens chief among them. Albert and Isabella may have been servants of Madrid, but their aggressive program of building and patronage signaled, both to their own population and

to observers abroad, that they were to be taken seriously as sovereigns in the grand Habsburg tradition.

The archdukes spent extravagantly from the public coffers, but they still managed to cultivate a strong bond with their subjects. Albert made it a tradition to wash the feet of worshippers on Maundy Thursday, the feast day just before Easter. In 1615, Isabella won an archery contest at the festival of the Crossbow Guild. Rubens admired her immensely. "She is a princess endowed with all the virtues of her sex," he would write. "Long experience has taught her how to govern these people and remain uninfluenced by false theories which all newcomers bring from Spain."

That piety was something that she and Albert extended across their dominion. Beyond the cult of their own personality, the ultimate unifying force of their monarchy was a resurgent Catholicism. During their rule, Catholics of all denominations—Augustinians, Capuchins, Carmelites, Dominicans, Franciscans, Jesuits—brought a great flood of fervor to the Spanish Netherlands. Antwerp, formerly a haven of religious tolerance and secularism, was to be a shining beacon of the Counter-Reformation. The Church became an omnipresent force in the daily life of the city. Sunday blue laws prohibiting consumption of alcohol and precluding other entertainments were strictly enforced. Witches were hunted and superstition suppressed. Books, plays, and music were censored by the clergy. A proper religious education was forced on the public, the lower classes in particular.

The new religiosity generated an artistic efflorescence the likes of which had never been seen in northern Europe, or perhaps anywhere else. The iconoclasms of the early conflict years had denuded Flemish churches of their artistic patrimony. After years of warring and economic privation, the remnants of so many barren and inad-

equate buildings stood in an appalling state of decrepitude. That would have to change. Enormous sums were dedicated to ecclesiastical reconstruction and beautification. Rubens, having returned from Rome, could see just how beneficial this would be to his career, and was savvy enough to take advantage. Before the expiry of the Twelve Years' Truce in 1621, he executed more than sixty altarpieces, a third for churches in Antwerp. The Jesuits alone spent 500,000 guilders on their Antwerp basilica, St. Charles Borromeo. Rubens designed the facade and a cycle of thirty-two paintings for its ceilings. Working from his templates, Van Dyck and other assistants were responsible for most of the labor on this enormous project, tragically destroyed when the church burned in 1715.

Rubens's two most celebrated ecclesiastical works from the truce years survive, and since 1815 have been united at the Onze Lieve Vrouwekathedraal, where they stand flanking the pulpit. The cathedral was not the intended destination for *The Raising of the Cross*; it was originally commissioned as an altarpiece for the Church of St. Walburga, to which Rubens's dear friend Cornelis van der Geest was principal benefactor. It does, however, make a fitting pendant to *The Descent from the Cross*, an altarpiece created specifically for the cathedral, and at the request of the Harquebusiers' Guild, then under direction of another Rubens intimate, the burgomeester Nicolaas Rockox. The artist earned a combined 5,000 guilders from the two jobs. Both were triptychs in a traditional Flemish format, and in both central panels the focus was on a dramatically lit Christ figure that evoked a deep sense of pathos. The compositional strategies of the Venetian school and the muscularity of Michelangelo were plainly evident in the two altars. Caravaggio's theatrical lighting and emotional force were also unmistakably present. But Rubens's Christ was no commoner; he was a chiseled antique hero, a fusion of

the classical and the Catholic realized with a sense of tragic urgency. From so many disparate inspirations, Rubens had synthesized something majestically his own.

Those two great altarpieces remain in Antwerp, but that was not to be the fate of the monumental *Adoration of the Magi* that Rubens painted to celebrate the signature of the Twelve Years' Truce. Great hopes were pinned on that agreement, but for all its temporary benefits it proved, by any reasonable estimation, to be a disappointment. The truce didn't so much end fighting as initiate a new phase of conflict, a cold war with combat displaced to the territorial margins of empire, and the Scheldt still under blockade. During the truce years, Dutch and Spanish forces engaged in a heated battle for colonial territory, facing off against each other in the Americas, along the West African coast, on the Indian subcontinent, and in the Far East. Matters were equally combustible in the disputed boundary regions that abutted the Low Countries along their German borders. The gradual escalation of hostilities was an impossible drain on the already fragile stability of Lerma's government. With neither financial nor military resources to fight on interminably on so many fronts, Spain was in dire need of a lasting resolution to the war with the Dutch.

In this goal Lerma had a partner in Johan van Oldenbarnevelt, the de facto political leader of the Dutch provinces. Oldenbarnevelt had been instrumental in concluding the Twelve Years' Truce, believing that the costs of war, in blood and treasure, outweighed the potential economic benefits of the colonial trade. Almost as soon as the ink was dry on the truce agreement, he and Lerma initiated back-channel negotiations in an effort to consolidate its temporary, twelve-year term into a permanent peace. The Spanish price for this would be Dutch renunciation of the Indies. In exchange, the Dutch would have their freedom of religion. Spain

was even prepared to give up its demand that the Dutch lift their blockade on the Scheldt—a concession that all but sacrificed Antwerp's economic future and its status as a financial capital.

Lerma chose to place these delicate talks in the hands of his ruthless consigliere, Rodrigo Calderón, the Count of Oliva. The count had been born in Antwerp, and it was hoped his presence in the city, on the pretext of other state business, would not arouse the suspicion of the enemies of peace. Unfortunately, the swaggering Calderón did not prove to be the nimble operative the situation required. When the true intention of his visit became public, there was outrage on all sides. Revanchists in Madrid opposed compromise from the outset. For the archdukes, Calderón's very mission, undertaken on their soil without so much as the courtesy of a warning, was an affront, and to the extent that Spanish objectives diverged from their own— especially in regard to the Scheldt—a direct blow to their interests. In the Dutch provinces, reaction was equally strong, especially among the powerful commercial interests in Holland and Zeeland that stood to benefit most from colonial expansion and, conversely, had most to lose from the potential resurgence of Antwerp as an international center of trade. Calderón was forced to depart in failure, and when he left, he took Rubens's commemoration of the truce along with him—an unintentionally ironic commentary on the situation. The painting, pulled from the walls of Antwerp's town hall, was a gift from the regents of the city, who hoped to curry Calderón's favor and thought it the most beautiful present they could bestow on a man they knew to be a great connoisseur of art.

There seemed to be no brooking a tide of sectarian violence that was sweeping across Europe. Lerma himself had contributed to this deplorable situation, ordering the mass deportation of more than 300,000 Moriscos (Islamic converts to Catholicism) from Spain between 1609 and 1614, over fears about their loyalty. Religious

intolerance was also at issue in May 1618, when a pair of Catholic governors in Bohemia were summarily thrown from a castle window; the so-called Defenestration of Prague was ineffective as a killing—the men survived their fall—but marked the beginning of a war in central Europe between Catholics and Protestants that would drag on for thirty years, metastasizing outward as it ensnared every major power on the Continent.

Neither Lerma nor his Dutch counterpart, Oldenbarnevelt, was anxious to be further drawn into the wars of religion. If anything, the two wanted to remove themselves from these sectarian conflicts, which drained finances and threatened internal stability. Both men, however, would be the victims of their essentially pragmatic agendas, and their downfalls would come in quick and ugly succession. In August 1618, Oldenbarnevelt was arrested after a confrontation with Maurice, the Prince of Orange, who was opposed to his policy of détente. Ten months later, he was beheaded for treason. Lerma was also forced from his office in 1618, and the greater indignity was that he was the victim of a plot masterminded by his own son, the Duke of Uceda. At least he could retire in comfort to his Ventosilla retreat. Calderón was not so lucky. He was thrown from court, tortured into the confession of a murder, and executed. Rubens's *Adoration*, which he brought home from Antwerp, found its way to the Spanish royal collection.

The peregrinations of that painting were indicative of an ever-growing preference for Rubens's work among European royalty during these years, in particular among those hoping to burnish their reputations on the world stage. His singular brand of exultant grandiosity was especially appealing to those who ruled by divine right. To the extent that he compromised his bourgeois ideals in the service of these clients, he was able to prosper by them—enormously. Rubens was hardly naive as to the nature of his position,

and refused to turn a blind eye to the worst excesses, political and otherwise, of those for whom he worked. He nevertheless remained a good burgher, loyal to the Spanish monarchy despite its long history of disdain and neglect for the Flemish population; his own family had been forced into exile by the terror of the Duke of Alva. Of course, the Rubens family's experience in the orbit of William of Orange, champion of the Dutch rebellion, had proven equally devastating—the ruination of his father. Given that personal history, it is no wonder that Rubens would always harbor a certain wariness of authority and profess a distaste for court life. Nor should it be any surprise that conciliation was a value he placed above all others.

Conciliation, however, did not always come so easily, an unhappy fact that often found its way into Rubens's canvases, even those putatively devoted to the theme of love. In his *Rape of the Daughters of Leucippus*, painted around 1617, two warrior brothers abduct a pair of pulchritudinous nude blondes, who seem caught in a state somewhere between terror and ecstasy. This was not a standard scene from the classical repertoire; Rubens plucked it from Ovid, who wrote of the sisters, "The thing they enjoy, they often like to think they give unwillingly." Around the same time, Rubens also painted the hero Perseus rescuing a naked Andromeda shackled to a rocky escarpment. Rubens, during this period, had begun to fully realize his vision of the female body as a medium for conveying visual pleasure and symbolic meaning. Indeed, both pictures might be read as allegories for the plight of Flanders, with the helpless maidens in each case representing his careworn homeland, and their armor-clad heroes the forces of Spain.

Nowhere was Rubens's genius better appreciated—or desired—than England, where eager collectors were anxious to assert their status as connoisseurs on a level equal to their Continental counterparts. One of the most aggressive English aesthetes was Thomas

Howard, the Earl of Arundel, also a Rubens acolyte. They had first met in Brussels in 1612, when Howard commissioned a portrait from the painter, now lost. Two years later, Howard toured Italy on a buying spree with his wife, Aletheia Talbot, and the architect Inigo Jones, who came along for his own inspiration and as a consultant. In Venice, the group was given special treatment by the English ambassador, Dudley Carleton. The world of English aesthetes was indeed small. When Aletheia visited the Rubens workshop in 1620, she sat for a large group portrait that included her jester, her midget, her dog, and Carleton, who appears somewhat less than thrilled with the company in the picture.

Aletheia came at a busy time for Rubens, and if not for political circumstances, she might well have been turned away at the studio door. That her husband was a Catholic in the English court made him an especially useful contact for Rubens, then coming into his own as a diplomatic operator in the service of the archdukes Albert and Isabella. Having a friendly ear in London would always be to Rubens's advantage. As it was, Carleton, who was still stationed in The Hague, had proven to be a friend on whom the artist could depend. A few months earlier, the ambassador had been particularly helpful in Rubens's efforts to secure the copyright for engraved prints of his works in Holland. In this project, Rubens had already enlisted the support of Pieter van Veen, a distinguished lawyer in The Hague and the brother of the artist's former master, Otto van Veen. Even with Van Veen's assistance, however, antagonism between the Dutch and the Spanish was such that Rubens, given his ties to the Spanish-controlled Flemish government, found it difficult to secure the proper license, a fact he considered especially disconcerting. He nevertheless hoped that Carleton might be able to grease the wheels, if not the palms, of the Dutch bureaucracy.

Rubens wanted his copyright privileges, but he wanted Carleton

to press his case with delicacy. If the ambassador felt the request would become a public nuisance, Rubens instructed him to "break off negotiations at once, without making any further advances." Rubens was ordinarily aggressive about making his claims, but in this case he did not want to be seen as "importunate." He refused to specify precisely why he wanted Carleton to restrain himself, citing only "other important reasons." The ambassador may well have surmised what these were: Rubens, long a political agent of the archdukes Albert and Isabella, had now become actively involved in political negotiations with the Dutch on behalf of his sovereigns, and he did not want his personal affairs jeopardizing more important public matters. In any case, this turned out to be a nonissue. Through Carleton's careful intervention, Rubens got the privileges he wanted without controversy.

In the meantime, Carleton once again found himself uncomfortably dealing in art. He and Rubens had become enmeshed in another negotiation in 1619, this time with Carleton serving as middleman for Henry, Lord Danvers. Like his countryman Thomas Howard, Danvers was a great connoisseur of art, and not coincidentally the purchaser (at cut rates) of several of the paintings Carleton had imported in his ill-fated arrangement with Robert Carr, the Earl of Somerset. Now Danvers was unhappy with one of those pictures, a Bassano in markedly poor condition, and had an idea to replace it with a Rubens. Specifically, he wanted to replace it with something akin to the *Daniel in the Lions' Den* that Carleton had received as part of the exchange with Rubens for his antique marbles. "Thoes bewtiful lions in the den would well satisfye my desire," Danvers told Carleton. He suggested a straight-up trade with the painter—the cracked and flaking Bassano for a new picture by Rubens—and arranged for the Bassano to be sent to Antwerp for inspection.

Rubens, predictably, was less than enthusiastic about the pro-

posed bargain. "Ruined" was his assessment of the Bassano, useful only as a model for student drawing and worth no more than 60 guilders. The *Daniel* he sent Carleton in the deal for the marbles had been valued at ten times that much. If Danvers wanted another painting on that scale, he'd have to pay accordingly. As an alternative, Rubens proposed to send Danvers a *Lion Hunt* produced by his studio, but "touched and retouched everywhere alike by my own hand." Given Carleton's historical aversion to studio work, Rubens might have anticipated trouble, and indeed there were premonitions that this arrangement might not be successful when Carleton's agent reported from Antwerp that the picture "scarce doth look like a thing that is finished." Rubens, however, sent it along anyway.

When it arrived in London, there was no hiding Danvers's dissatisfaction. What's more, it was revealed that Danvers was acquiring the painting not for himself but on behalf of Charles, the Prince of Wales, who admired Rubens to no end and who already owned a small *Judith and Holofernes* the artist had painted during his years in Italy. Danvers delivered a brutal assessment to Carleton: "In every painters [*sic*] opinion he hath sent hither a peece scarse touched by his own hand, as the Prince will not admit the picture into his galerye. I could wish thearfore that the famus man would [do something] to register or redeem his reputation in this howse." In conclusion, he wrote that the lions should be sent back to Rubens "for tamer beastes better made."

The rejection was an affront, but the unexpected news that the painting was intended for the future king of England was most welcome (if shocking), and motivation enough for Rubens to swallow his pride. He humbly offered to paint a new picture, one "less terrible," and even agreed to a rebate on the price. "I shall be very glad to have this picture located in a place as eminent as the gallery of

His Royal Highness the Prince of Wales," he wrote to William Trumbull, an English diplomatic agent in Brussels.

The timing was propitious, and for several reasons. Charles, like his late older brother, Henry, saw artistic patronage as a path to international credibility, and he was in position to award a commission of considerable importance—something far greater than the hunt scene under discussion. Work had recently commenced on a new banqueting house for the royal palace at Whitehall, in London. In the future, it would serve as the king's formal reception hall, but its more immediate function was to host the celebration following Charles's pending marriage to Maria Anna, the Spanish infanta. That proposed union would finally heal one of Europe's great rifts. For such a momentous occasion a building of splendor was required, and design was left to the architect Inigo Jones. Inside, a decorative program in paint would complete this project, and only an artist capable of producing a corresponding sense of majesty would do. Rubens, of course, was happy to volunteer his services, never mind the present dissatisfaction with his work. "Regarding the hall in the New Palace," he wrote in that same letter to Trumbull, "I confess that I am, by natural instinct, better fitted to execute very large works than small curiosities. Everyone according to his gifts; my talent is such that no undertaking, however vast in size or diversified in subject, has ever surpassed my courage."

CHAPTER IV

A GOOD PATRIOT

ᗢᔑ᎕ᔐ

Surely it would be better if these young men who
govern the world today were willing to maintain friendly
relations with one another instead of throwing all
Christendom into unrest by their caprices.

—PETER PAUL RUBENS

Whitehall would have to wait, but Rubens found his ambition for
works vast in size and diversified in subject amply satisfied when he
arrived at the doors of the Luxembourg Palace early in the winter
of 1622. He was there at the invitation of Marie de' Medici, the
Queen Mother of France, who had reached out to him at some time
during the previous fall. Marie was in the market for a cycle of
paintings to decorate her new palace on the Left Bank of the Seine,
and she was hoping Rubens might accept the commission. Of all
the monarchs in Europe, none had greater want of his services, for
there was no other royal whose reputation was in so desperate a
need of rehabilitation.

Back in 1600, as a member of Vincenzo Gonzaga's court,
Rubens had been a witness to Marie's proxy marriage to the French
king, Henry IV, at the Duomo of Florence. There were endless

encomiums to her during the celebrations of that event, a litany of tributes to her bright future. But her career ever since had been a prolonged study in unchecked ambition, scandal, and humiliation. Her marriage, launched so auspiciously, was an unhappy one: Henry was a notorious philanderer and a divorcé who had cast off his first wife after she failed to provide him with a male heir. Established on shaky ground, the relationship between Marie and Henry degenerated over time. Marie wasn't one to be spurned, and her considerable lust for power was stoked by a retinue of imported Italian advisers. She did provide for the succession of Henry's Bourbon line—the dauphin, Louis, was born in 1601—but when the king was assassinated in 1610, Marie usurped authority as the head of state. (It was widely, if inaccurately, believed that she had a hand in her husband's murder.) Years later, when young Louis XIII, no longer a minor, reclaimed the authority that was rightfully his, mother and son engaged in an unseemly struggle that resulted first in her banishment from Paris into the French hinterlands and then in a battle between armies under their respective flags. The sad affair was brought to a conclusion only through the intervention of the bishop of Luçon— the future Cardinal Richelieu—Marie's former chief minister, who returned from his own exile to broker an uneasy peace. That agreement, the Treaty of Angers, brought Marie back to Paris and restored some of her influence. To celebrate that homecoming, Marie felt something magnificent was in order, a project grand enough to reaffirm her status as a starring player on the world stage. It was just the kind of politically loaded project for which Rubens seemed destined.

Rubens considered himself eminently suited to the commission, but as a Flemish national who pledged allegiance to Spain, he was a controversial choice for a French queen of Italian descent. French artists were particularly displeased by the snub, even if there was no local candidate with a comparable reputation. Rubens, however,

could count on a series of glowing references. He no doubt received a solid recommendation from Marie's sister, Eleonora Gonzaga, the Duchess of Mantua, whom he had ably served for so many years. In Paris, the Flemish ambassador Henri de Vicq supported his candidacy, as did his superior in Brussels, the archduchess Isabella, who was on good terms with the Queen Mother. Indeed, Isabella was likely the intermediary when Marie first approached the painter. As a token of the women's mutual admiration, Rubens was instructed to pick up a few gifts for Marie at Isabella's Coudenberg Palace on the trip south from Antwerp, including a small female dog wearing a necklace of twenty-four enamel plaques. He also received an informal directive of his own: he was to pay careful attention to the activities of the royal court in Paris, and report back all that he learned. Isabella and Marie were friendly, but Spain and France were traditional foes in a volatile world, and the opportunity for the archduchess to place an agent so close to the French throne was too valuable to pass up.

Rubens's sharp mind and special knack for endearing himself to figures of authority had prepared him well for this clandestine service. Indeed, he had gradually developed into one of Isabella's trusted advisers, a man whose judgment she could rely on without fear of compromise. As a painter doing business across Europe, he was in communication with influential figures in nearly every capital. His network of antiquarian contacts, meanwhile, kept him apprised of political developments major and minor. For Rubens, this was only good business. He needed information on potential clients: Whose fortunes were bright? What kind of subject matter might be appealing or taboo? Who might welsh on one of his very large bills? What he learned he dutifully passed along to his sovereign.

Leaving Brussels for Paris, Rubens might well have thought back to his first diplomatic mission years earlier, when he had departed Mantua for Spain without having so much as consulted

an atlas. That neophyte must have seemed like an entirely different person. He was now a capable diplomatic operator at ease in the most rarefied precincts of European power. His artistic skill had given him entrée into this exalted world, but his success in navigating its darkened corridors was a product of his own shrewd intelligence and personal charm. He was, indeed, the perfect spy.

MARIE'S EXPANSIVE NEW RESIDENCE, the Luxembourg Palace, made a strong impression on Rubens when he first set eyes on it. The location, a short ride from the Seine in suburban St.-Germain, was excellent: comfortably removed from the squalid and overcrowded confines of central Paris, but still connected to the Right Bank and the Louvre by the recently completed Pont Neuf. Marie had purchased the grounds from the duc de Piney-Luxembourg in the spring of 1612, and at once had it cleared for something new. Being a Medici, her natural inspiration was the Pitti Palace in Florence, seat of the family dynasty, and she went so far as to dispatch a draftsman to make measured drawings of it for her French architect, Salomon de Brosse. The first stone of his design was laid in 1615, and though it made allusions to its Florentine predecessor in its rusticated walls and enclosed court, what Rubens found on his arrival was something decidedly French in character and plan, a château more naturally suited to the fields of the Loire than to the hills of Tuscany.

Rubens liked what he saw, and was particularly satisfied with the ceremonial gallery on the first floor of the palace's west wing that would be the site for his work. It was a grand setting, with gilded ceilings and velvet-covered walls. Tall windows ran down either side of the room toward a massive stone fireplace flanked by doors leading into Marie's private apartments. Rubens's charge was to fill the

spaces between those windows, and above the fireplace and doors, with a cycle of paintings celebrating the life and achievements of the Queen Mother. With that job completed, he was to begin on a corresponding series devoted to the life of Marie's deceased husband, Henry IV, to be placed in corresponding position in the opposite gallery on the eastern side of the palace. It was an immense task that would require an efficient and well-honed studio operation. Indeed, Rubens's reputation for organization and alacrity was a significant factor in his selection for the job. With the enormous ceiling program for the Jesuit Church of St. Charles Borromeo, the workshop had proven itself capable of tackling projects of great size. "Italian painters could not do in ten years what Rubens promised to do in four," noted Marie's adviser Claude Magis, the abbé of St. Ambrose.

The scale of work was the least of Rubens's problems. The real challenge, one that would demand every bit of his artistic and political savvy, lay in arriving at a program for the paintings that would celebrate the less-than-salutary life story of his client without causing ridicule, offense, or some combination of the two. There was hardly even an artistic tradition on which he could readily call as precedent. Women were not typically the subjects of painting cycles of a heroic nature.

Rubens stayed in Paris for two months hashing out the subject matter of the cycle, with St. Ambrose negotiating on behalf of Marie. The painter relied on the advice of Nicolas-Claude Fabri de Peiresc, the French antiquarian with whom he had been engaged in a weekly correspondence for several years. Their friendship, formed with the pen, only grew once they met in person. "There is no more lovable soul in the world than that of M. Rubens," Peiresc would write. Admittedly, they made for an unlikely couple when they stood side by side. Rubens, tall and handsome, was the charismatic center of any room he entered. Peiresc was short with a beaky nose and the

slightly disheveled air of a man who spent an inordinate amount of time with his head buried in ancient manuscripts. For all their physical disparity, though, they had much that drew them together, beginning with their shared interest in the classical world. Both had received an intensive Jesuit education as boys (Rubens was older by just three years); and both had traveled to Italy to expand the breadth of their knowledge as young men. Most pertinently, both had been drawn into political affairs when their primary interests lay elsewhere. Peiresc, a parliamentary representative of his native Provence, proved especially useful to Rubens as a guide to the subtleties of Marie's political position—critical for the artist as he developed a plan for decorating her palace.

With Peiresc's assistance, Rubens did his best to monitor the intrigues of the French court, though with mixed results. In particular, he was appalled by the tendency to resolve disputes via the duel, which he described as an "incorrigible mania." The Parisian taste for dramatics offended his sense of moderation and reason, and made for an unfavorable contrast with Isabella's admittedly sterile court in Brussels. "We fight a foreign foe," he wrote, "and the bravest is he who conducts himself most valiantly in the service of his King. Otherwise we live in peace, and if anyone oversteps the bounds of moderation, he is ·banished from the Court and shunned by everyone . . . All these exaggerated passions are caused by mere ambition and a false love of glory." The philosopher in Rubens disdained the most decadent indulgences of Parisian society, but as a painter he would celebrate the sophistication of the French court, conferring a sense of dignity on the insouciant modishness that disgusted his more scholarly friends. It helped that he was just a visitor on the scene. As Peiresc told him, the French court is "a comedy much more agreeable to watch from afar than when one finds oneself caught up in it." This fact, however, did not prevent Peiresc from

attempting to keep Rubens in Paris. He even suggested that Marie take measures to liberate the painter from his Antwerp home and keep him in the French capital on a permanent basis.

Peiresc underestimated Rubens's dedication to his homeland. Indeed, the painter was dutifully gathering intelligence for the archduchess Isabella throughout his time in France. If he had anything to report back to her, it was Richelieu's increasing consolidation of power within the French monarchy, and a sense of the cardinal's rather icy and calculating manner. This Rubens had the chance to experience firsthand at a meeting with Richelieu, who was impressed enough with the painter to commission several works. When Rubens finally left for home at the end of February, he had those commissions and, more important, a contract that would pay him a queen's ransom—20,000 crowns, the equivalent of 60,000 guilders—for his work on the Luxembourg Palace pictures. Still, the conceptual program for that cycle remained unsettled.

Consultations continued through the summer, when the parties finally agreed on a twenty-four-panel series culminating with *The Triumph of Truth*—an ironic final flourish considering the pains that would be taken to whitewash Marie's history and sweep aside unflattering and inconvenient facts. The language of the series was to be allegorical, a system of representation that allowed the painter to associate Marie with heroic figures from ancient and Christian history, and to depict her as an object of ethereal beauty. (That was absolutely a fabrication; Marie was notoriously homely.) Uncontroversial moments from her life, like her wedding to Henry, could be pitched as straight narrative, with little obfuscation. But the scope of the program required several more creative productions. The rift with her son Louis XIII was presented largely in the context of their reconciliation. On this front, satisfying Marie was no more critical than appeasing Louis, the combustible head of state.

In late August, for a brief moment, it seemed as if the whole project might be dead—though not as a result of any disagreement about the subject matter. The cause was even more dire: Rubens was rumored to have been murdered, killed by a deranged member of his own studio. The false news spread like a contagion across France, right to the ear of Marie herself. Peiresc had heard tell of it a few weeks earlier, and he claimed the news had left him completely beside himself. There was a core of truth in the tale. Rubens had been assaulted by one of his printmakers, a young man of extraordinary skill, grand ambition, and fragile temperament. The master, however, had survived the attack, and was alive and well, though aggravated beyond measure.

The printmaker in question, Lucas Vorsterman, had first walked through the big wooden doors of the Rubens studio back in 1619, and he came bearing credentials that advertised an unimpeachable pedigree. Before moving to Antwerp, Vorsterman had honed his craft under the tutelage of the revered Dutch printmaker Hendrik Goltzius, whose work was universally admired for its exquisite detail. In Rubens, he found a master of even greater stature, an artist whose genius Vorsterman understood to be commensurate with his own. Not shy about his own talent, Vorsterman fashioned himself after Rubens, the model gentleman artist. When Vorsterman's first child was born, in January 1620, he enlisted Rubens as the godfather. He emulated everything from the cut of the great artist's whiskers to the rake of his broad-brimmed hat. By profession and inclination, Vorsterman was a copyist, and his work was indisputably excellent.

Even under normal circumstances, the engraver's job is a difficult one, a painstaking translation of color and shadow onto a metal surface using only scratched lines. Retaining the sense of an original work from a different medium is a challenge even with a simple

composition; the dynamic rushes of a Rubens were practically impossible to reproduce on an unforgiving plate. Vorsterman, however, was a magician with the sharp end of a burin, the engraver's pointed tool, and his native ability was magnified by a fanatical perfectionism. Vorsterman worried over and scrutinized his every etched mark, an obsessive attention to detail that eventually so compromised his vision that he would be forced to give up his profession and live off the charity of his daughter. But for the moment, his mania and his ego put him on a collision course with Rubens. Vorsterman felt strongly enough about his own genius that he considered his prints for Rubens to be original works, and he went about acquiring his own copyrights for them. Rubens, of course, expressly considered the works to be his. The prints were copies of works he created himself, for profit, under his own imprimatur, and he had made great efforts to have them copyrighted. Indeed, his entire studio operation was run on the premise that what issued from his mind was his own intellectual property. Vorsterman, meanwhile, with his lateness and his desire for recognition, had derailed the entire engine. "I can no longer deal with him or come to an understanding with him," wrote a frustrated Rubens. In fact, Rubens was more than willing to trade quality for speed of production, and it was for this very reason that he had hired the relatively unknown Vorsterman in the first place, an irony that was not lost on the painter. Somehow, he had found himself burdened with a toxic combination of youth and hubris.

When Rubens had received a commission, in 1621, for a memorial engraving of Charles de Longueval, a Habsburg military commander killed in Germany, he understood that a quick production was imperative. In essence, this was a work of propaganda, and its relevance stood in direct relation to its timeliness. But the disgruntled engraver either would not or could not respond to Rubens's

demand for a quickly executed print. "We have made almost noth-
ing for a couple of years due to the caprices of my engraver,"
Rubens complained to his Dutch lawyer, Pieter van Veen. He com-
plained as well to Vorsterman, who was emotionally unprepared for
an upbraiding from the man he revered above all others, but some-
how considered an equal.

There is no record of exactly what transpired between the two
men. Blows were exchanged. Weapons may have been involved. It
was serious enough for Rubens's advocates to petition Isabella for a
writ of protection. The infanta provided that order, affirming that her
agent was indeed "endangered by the attacks of an evil-intentioned
one of his men, said to have sworn his death." Rubens, for his part,
never mentioned the embarrassing episode, and his continued corre-
spondence allayed the fears of his Parisian clients and admirers.
Sadly, if predictably, it was the end of Vorsterman's work for Rubens.
The painter would henceforth use many a printmaker, but none
quite so skillful as the troubled man who was also one of his greatest
admirers.

Isabella, meanwhile, had good reason to be concerned for
Rubens's welfare. Apart from her interest in his artistic career and his
utility as a source of foreign intelligence, a certain concentration
of her retinue had become a necessity in the preceding year. In
April 1621, the Twelve Years' Truce had fizzled to an uncertain con-
clusion, leaving the Low Countries in a nebulous state of war that
neither side seemed especially interested in pursuing. Three months
later, Isabella lost something more personal: her husband and co-
sovereign, the archduke Albert. Theirs had been an arranged mar-
riage born of political convenience, but it had produced a devoted
and like-minded couple of great mutual affection. The widowed
Isabella, heretofore extravagant in her choice of attire, renounced her
silks and laces, brocades and jewels, and replaced them with the dour

vestments of a Franciscan matron. The public was naturally sympathetic with her, but what she gained in moral authority she lost in political standing. Because she had produced no heir, sovereignty over the Spanish Netherlands reverted to Madrid, and her status was reduced to that of governor. Her independence, already constrained, was now more firmly in the hands of the Brussels-based military junta that answered directly to the Spanish king.

In his final years, Albert had been an aggressive proponent of peace in the Low Countries. In 1620, with the truce nearing an end and with the sectarian hostilities in neighboring Germany leading to mobilization on both sides of the border, he aggressively pressed Isabella's brother, Philip III, to pursue a course of reconciliation with the Dutch. For this minor hubris, he was upbraided by the king and specifically enjoined from making direct overtures on his own initiative. For the moment, Madrid was satisfied to let war resume. Prospects for victory were marginal, but at least it was a drain on Dutch coffers and a distraction from Dutch colonial ambitions in the Americas and East Asia.

Albert ignored Philip's order to refrain from engaging the Dutch in negotiations. In diplomatic circles, rumors circulated that Maurice, the Prince of Orange and leader of the Dutch cause, might be interested in some kind of accommodation. With the lapse of the truce imminent, Albert arranged for a meeting in early 1621 between his closest adviser and one of Maurice's confidants, the widow Bartholde van T'Serclaes. She had informed Albert that the prince would in fact be amenable to a peace offer, and on terms favorable to Spain—provided there be a sweetener in it for Maurice personally. (Specifically, he expected sovereignty over Holland and Zeeland.) If there was reciprocal interest, Albert was to send a representative to The Hague with a formal proposal.

With this intelligence in hand, and having informed Philip that

the Dutch might be amenable to a deal (never mind his bit of insubordination), Albert dispatched an emissary to make the overture. The mission, however, was an abject failure. The Flemish ambassador's arrival in Holland was accompanied by virulent demonstrations, and he left without the peace he had come to transact. Worse, there was a strong suspicion that the whole sorry episode—the "T'Serclaes affair"—had been engineered by Maurice, who could point to Spain's putatively insulting terms (most egregiously, a renunciation of the claim of independence) as a means to unify the Dutch provinces and consolidate his own power.

By the time Rubens left for Paris to negotiate the Medici commission, in January 1622, the truce was a thing of the past, and hostilities between Spain and Holland had resumed, though at a halfhearted pace. In Madrid there was a new king, Philip IV, who had assumed the Spanish throne after his father's death a year earlier. Rather than continue the fruitless ground war in the Low Countries, at the suggestion of Don Diego Messia, one of his military counselors, he opted for an economic offensive against the Dutch. Following that course, Spain used its considerable diplomatic leverage, and also its armada, to curtail Dutch trade in the Mediterranean. In one raid off the coast of France, the Spanish navy seized a Dutch freighter carrying linen, herring, and two thousand cheeses. The Dutch retaliated in kind. The river Scheldt had remained closed during the twelve years of peace, but the Spanish Netherlands had prospered by shifting trading through other ports on the North Sea, which remained open. Now the Dutch reinstated their blockade of the entire Flemish coast. Taxes on goods traveling between Flanders and Holland were increased to punitive levels. (Even war could not halt the flow of beer across the border, though the price went up.) In the far reaches of empire, in the Americas and East Asia, the fighting never stopped.

Predictably, economic war escalated into armed conflict. In the fall of 1621, Spanish forces under the direction of Ambrogio Spinola began to make some headway in the eastern districts of the Low Countries, along the contested German frontier. Buoyed by his modest successes, Spinola set siege to the heavily fortified Dutch city of Bergen op Zoom, which sat on a Scheldt tributary along the border between Flanders and Holland. As a student of history, Spinola knew well that the previous attempt on that city, in 1587 by Alessandro Farnese, had been an abject failure. Farnese had tried to starve out the city, but couldn't complete the job. Spinola instead planned to force it into submission by assault. Recent developments in military architecture, however, made such attacks exceedingly difficult to execute. Systems of wedged bastions and redoubts, like those at the Antwerp citadel, kept defenders safe while allowing them to cover all avenues of approach. Bergen op Zoom proved especially well protected. After six months of futile action, Spinola finally called off the attack. By then, casualties and desertions had cut his force of nearly twenty thousand in half. The whole fiasco was emblematic of the general state of relations in the region: a resource-draining stalemate that accrued to the benefit of neither side but made life impossibly difficult for those sorry Flemings and Hollanders who lived in the border zones where armies collided.

WITH HIS HOMELAND AT WAR, Rubens was forced to balance the substantial professional burden of the Medici commission with Isabella's demand for his services as a political operative. The deadline for Marie's paintings drew ever near, but the artist found himself spending more and more time at the Brussels court, acting as an adviser and agent to his own sovereign. When he returned to Antwerp, he was forced to dodge the manic attacks of Lucas

Vorsterman, his disgruntled engraver. In late April 1622, the same month the infanta issued her restraining order against Vorsterman, evidence suggests Rubens had been assigned a new mission by Isabella, one that would take him into enemy territory. It was in that month that he used his Dutch lawyer, Pieter van Veen, to acquire a passport to travel in Holland, ostensibly to clear the copyright privileges for his engravings. But this was almost certainly a cover for a diplomatic mission. Rubens had received his copyright privileges two years earlier.

Back in 1619, when Rubens had first instructed Carleton to advance his copyright claims in The Hague with great delicacy, he had hinted at "important reasons" for not wanting to ruffle the feathers of the Dutch political hierarchy. He knew even then that the time would come when he would have to rely on the good graces of those same Dutch politicians. Now, three years later, that day had arrived. The T'Serclaes affair, damaging as it was, had not permanently closed backdoor negotiations with the Dutch. The debacle of Bergen op Zoom only reinforced the idea, on both sides of the border, that some kind of settlement was necessary. Future discussions, however, would have to take place with utmost secrecy, lest political opponents have a chance to sabotage them. Having long since placed himself within Isabella's circle of trusted advisers, Rubens could now present himself as a credible diplomatic alternative to T'Serclaes. In fact, Maurice, the Prince of Orange, was his half brother once removed (through Christina von Dietz, the bastard daughter of Jan Rubens and Maurice's mother, Anna of Saxony). For the sake of propriety, he probably didn't mention that relationship. Maurice, anyway, was not Rubens's only relation within the Dutch court. Jan Brant, a first cousin by marriage, also happened to be a familiar and well-situated presence in Maurice's orbit.

Despite his efforts to obtain the paperwork to travel, Rubens

never made it to Holland in 1622. Perhaps his notoriety precluded an undisclosed meeting, even with a relative, or maybe the timing just wasn't right. The Medici project alone was enough to keep him occupied through the winter. But he and the studio worked quickly, and by May 1623 the first installment of that commission was complete. Rubens delivered it in person, carrying a single valise and nine carefully rolled canvases for Marie's inspection. To his great frustration, he was forced to cool his heels for three weeks before the Queen Mother found time to review his work. At least she was pleased with what she saw, and had the wisdom to lavish her painter with the compliments he so much liked to hear. By August he was happily back in Antwerp, and Paris was all but empty of polite society. A fit of plague had sent the nobility bustling off to their rural estates. "As far as contagion is concerned," Rubens advised Peiresc from the safety of home, "the best antidote for that is flight."

Rubens's return allowed him to shift his attentions to political affairs. Just a week after recommending Peiresc quit Paris, he wrote again to his friend, informing him that Spinola was "negotiating secretly for a truce." It was a testament to their relationship that Rubens trusted Peiresc's discretion with that information, and perhaps foolish of him to reveal it so plainly, lest their letters be monitored. France remained adamantly opposed to any peace between Spain and the Dutch, a fact Rubens clearly understood. "With the French it is a state maxim to keep the war in Flanders ever alive, and to cause the King of Spain constant expense and trouble," he wrote, noting the long-standing French financial and military support for the Dutch cause. Nevertheless, it appears Rubens considered the correspondence of two antiquarians above suspicion. His letter to Peiresc was composed in undisguised Italian, his language of choice.

Rubens's knowledge of the secret negotiations undertaken by

Spinola was a mark of his status within Isabella's circle of advisers. Heretofore, that standing had been unofficial. But at the end of September 1623 it was formalized. On the last day of the month, Isabella placed him on the Spanish military payroll. Her order read: "Taken in consideration of the merits of Peter Paul Rubens and the services he has rendered His Majesty, and so that he can continue with convenience, we find it good to assign him a salary of ten ecus per month from the Citadel of Antwerp." That the funds were drawn from the Spanish military budget, and not from her private accounts, indicates that his work was indeed more than "advisory" in nature. He was now officially a spy.

Nine months later, in June 1624, he became something more: a member of the nobility, a prerequisite for his continued diplomatic service. Peiresc's persistent attempts to lure Rubens to Paris, begun on that first trip to Paris in 1622, may also have come to the attention of the infanta. The patent application sent to Philip IV on his behalf noted that "many sovereigns have tried to induce him to leave Antwerp by promises of great honors and large sums of money." It continued, with somewhat less accuracy: "He comes of honorable parents, faithful subjects of His Majesty, and unites to his rare talent as a painter, literary gifts and a knowledge of history and languages; he has always lived in a great style and has the means of supporting his rank." Whatever his family history, the statement attesting to his income was incontrovertibly true.

Rubens was a prideful man, and enjoyed the prestige of his new title. Even without it, he had made it a practice to wear a sword, a nobleman's concession, and otherwise outfit his home and his person in the accoutrements of highest privilege. But even as he enjoyed making a public spectacle of himself—albeit in the most refined manner—he was living a secret life. On same day that Isabella ordered that Rubens be placed on salary by the Antwerp military

command, the artist himself dashed off a letter to Brussels, notifying his superiors that he had just met with "the Catholic," as he was now calling his Dutch cousin Jan Brant. The on-again, off-again peace negotiations with the Dutch were on once again, and Rubens was acting as an agent for Isabella. Brant was his conduit to the Dutch leadership.

Brant was not an easy contact for Rubens to manage. At their most recent meeting, in Antwerp, Rubens found him suffering from a fever, a condition that only aggravated a constitution that was anxious by nature. Brant seemed paranoid—"suspicious of his own shadow," according to Rubens—but he had legitimate reason to worry. Brant's superior in The Hague was a corrupt official with whom Rubens had some previous experience, back when he was looking to secure copyright privileges for his prints. A man who was known to solicit bribes was not the ideal handler for an agent engaged in secret negotiations on enemy soil.

Brant had come to Rubens with a proposal for the painter to pass on to Isabella in Brussels, and from her on to Madrid: that proposal was peace in exchange for a return to the terms of the Twelve Years' Truce. But this wasn't so much an offer as an ultimatum—take it or leave it—and Brant had been instructed to return to The Hague with an unambiguous response, yes or no. Rubens scoffed when his nervous cousin informed him of this. The infanta was expecting something more in the bargain, at a minimum the reopening of the Scheldt, and in any case Rubens was not a man accustomed to caving in to demands, no matter who was making them. "I laughed and replied that these were threats to frighten children, but that [Brant] himself was surely not so naïve to believe them," he wrote back to Brussels. Brant also accused members of Isabella's court of leaking secret messages to the French as a means of intentionally sabotaging the negotiations. Rubens denied the

allegation—he chalked those rumors up to the "tricks and frauds" of Spain's enemies—and somehow convinced Brant to return to Holland without the unequivocal response he had been instructed to obtain.

Rubens was pleased with this outcome, but frustrated by Brant's nervous disposition, which became a serious issue when Brant took his next communiqué straight to Isabella's court in Brussels, bypassing Rubens and potentially exposing their entire negotiation. Relative or not, that was enough to convince Rubens that Brant should be punished with a stiff rebuke from Brussels for his impudence, the better to ensure his future compliance. In the meantime, as a precaution, Rubens suggested to his superiors that Brant be kept in Antwerp, where he could be more easily controlled, and away from Isabella's court, lest his appearance there arouse suspicions among the forces opposed to peace.

The spitefulness with which Rubens treated his cousin was uncharacteristic for the normally even-keeled painter, but he had good reason to be in a foul temper. Just as Brant was causing him problems, in September 1623, Rubens's eldest child, Clara Serena, had fallen gravely sick. She was a precocious adolescent of twelve, with her mother's knowing eyes and her father's sense of self-possession. That maturity—and Rubens's growing prominence—allowed the artist to place her as a young lady-in-waiting to the infanta, a considerable honor. Rubens's personal correspondence all but ceased during the weeks of her illness. She died at the end of October. Rubens turned to his stoicism in the face of the tragedy. If he pushed it from his mind, perhaps it would hurt less. He informed his friend Peiresc about the sad news in a postscript to a letter, after a prolonged lapse in their regular communications. At least he had his work, both as a refuge and as a memorial. Isabella, a somber mother in a black dress, sat for a painting by her husband in

the aftermath, with a pained but somehow comforting smile on her face. The drawings and portraits Rubens had made of Clara Serena, pictures of a young girl staring out at a future of possibility, became cherished family heirlooms.

Rubens welcomed the distraction of his political work as fall turned to winter. The continued negotiations with Brant had a sense of urgency about them that kept him from dolorous thoughts and otherwise removed him from a house that must have seemed haunted by his daughter's absence. The artist managed to keep his cousin in line while their deliberations progressed through the first half of 1624. But by the end of the summer, the French ambassador to Brussels, Nicolas de Baugy, caught wind that something was brewing, and in a series of letters he reported back to Paris what he learned snooping around the back rooms of Brussels. In his first missive, sent on August 30, he informed his superiors that Rubens was conferring daily with the infanta on a proposed truce deal, and that Rubens had even claimed the Dutch had assured him that they were willing to sign. Two weeks later, he reported that Rubens had come to Brussels to paint a portrait of the Polish prince Sigismund, "a matter in which I fancy he will fare better than in the negotiations for a truce, to which he can only give superficial color and shade, without foundation." Finally, after discovering Brant's identity as Rubens's Dutch contact, de Baugy wrote—unfairly—that Rubens was acting purely out of self-interest, and that he was primarily concerned with placing himself in the good graces of the Brant family, from whom he stood to inherit a small fortune. That was certainly not true, as Rubens's contentious relationship with Brant plainly illustrated.

De Baugy misrepresented Rubens's motives, but he was correct in suggesting the painter had little chance of securing a truce deal. (Conversely, the English diplomat William Trumbull assumed that

thanks to Rubens, peace was a fait accompli, and that the Dutch were now "contente to suspend their armes.") While Rubens and Brant were engaged in their game of semisecret shuttle diplomacy during the spring of 1624, there was a steady escalation of hostilities on the ground. In May, Dutch forces captured one of the jewels of the Spanish Empire, the port of São Salvador in the Brazilian colony of Bahia. Spinola had exercised considerable restraint over the past year, when it appeared Rubens and others were making progress in their negotiations, but he was now obliged to undertake a major offensive. The security of Spain's colonial possessions was essential to the stability of the empire and could not be jeopardized. The ground war in Flanders was specifically intended to divert Dutch resources from such attacks overseas. Spinola, forced to take action, again set siege to a fortified Dutch city, this time Breda.

Spinola had learned his lesson at Bergen op Zoom in 1621. When his troops descended on Breda, they came for the long haul, prepared to starve out the city. It was to be an ugly, lingering standoff, made all the more unpleasant by punishing rains that washed out roads and made it difficult for Spinola to provision his army. Supplies had to be ferried north through enemy territory, exposing caravans to sniping and assault. Escorts of as many as fifteen hundred horsemen and four thousand foot soldiers, supplemented by heavy artillery, were required to protect the convoys. The measures were effective; Spinola staved off attacks as well as the defections that doomed his efforts at Bergen op Zoom. By year's end, it had become clear that Breda would be forced to surrender. "There is no power which can save the town, so well is it besieged," wrote Rubens.

Breda finally opened its gates to Spinola's army in May 1625, after nine months of privation. Maurice, the Dutch prince, never saw the capitulation; he died in April, passing on his title to his half brother, Frederick Henry. In Spain, the surrender of Breda was cel-

ebrated as a major victory for the Habsburg cause, a happy comple-
ment to the efforts of the Holy Roman Emperor in Germany.
Diego Velázquez, the preeminent artist of Madrid, would later mark
the event with a suitably grand painting in which Spinola, holding
the baton of command, accepts the keys to a still-smoldering city.
In Flanders, however, no one was fooled into believing this was a
truly decisive victory for Spain, one that would fundamentally alter
the course of war. Astute observers understood that it had come at
immense cost and promised no great future of easy conquest into
enemy territory. Instead, barring a political accommodation, there
would be more of the status quo: continued hostility and painful
deprivation.

IT WAS A BLEAK MOMENT in history, a time when even Rubens
found himself overwhelmed by his political and artistic responsibili-
ties. This was an unusual state for a man who took immense pride in
his ability to juggle several tasks without apparent effort. "I am the
busiest and most harassed man in the world," he complained in Jan-
uary 1625. At that time, he had less than one month before he was
due in Paris with the balance of paintings for the Medici gallery.
Even after his arrival, considerable retouching would be required
during their installation, and there was a strong possibility, given the
delicacy of the subject matter, that certain pictures would demand
major revision. Looming ahead was a fixed and unbreakable dead-
line: the wedding of Princess Henrietta Maria, Marie's daughter.
She was to marry Charles I, the newly crowned king of England, on
May 11 at Notre Dame; afterward Richelieu would host a celebra-
tory feast at Marie's Luxembourg Palace. Naturally, that event
would take place in the palace's west gallery, beneath the new cycle
of paintings advertising the achievements of the bride's mother.

Rubens managed to install the paintings in time for that event, but not without the substitution of one of the major historical canvases. From the very outset of the negotiations over the cycle's program, Rubens had been worried about *The Departure of the Queen from Paris*, the panel depicting the moment when Marie was thrown into exile by her son. That subject was now deemed too provocative to stand. Rubens replaced it, on the spot, with *The Felicity of the Regency*, a masterpiece of allegorical flummery in which a bare-breasted Marie, surrounded by a catalog of gods and symbolic personifications, balances the scales of justice. For the most part, Rubens's compositions were so intentionally dense and obscure in their symbology as to make the practice of interpretation an exceedingly difficult intellectual game. Even experts were confounded. After reading over a laudatory booklet on the paintings written by Claude-Barthélemy Morisot, Rubens drily noted that "while the subjects of the pictures are in general well explained, in certain places he has not grasped the true meaning." (Also, Morisot had somehow neglected to mention his name. That definitely did not sit well.) A few years later, commenting again on Morisot's text, he openly admitted that the meanings of the paintings were all but impossible to determine "without some explanation by the artist himself." And even the artist was less than reliable. He no longer had his written program for the series, on which even he was dependent. "Perhaps my memory will not serve me as accurately as I should like," he wrote. What hope was there for anyone else?

The iconographic opacity of the paintings came in particularly handy when it was time to show them off to Marie's son Louis XIII, a task left to the abbé of St. Ambrose, Marie's adviser. "He served as the interpreter of the subjects," wrote Rubens, "changing or concealing the true meaning with great skill." The artist, unfortunately, only heard about the abbé's suave presentation secondhand, as he

was not there to witness it in person; a clumsy boot maker had injured his foot during a fitting, leaving him bedridden for ten days. No doubt the situation reminded him of his trip to Spain, years earlier, when Iberti had relegated him to the periphery during the presentation of his touched-up Mantuan pictures to Philip III. In any case, the result was the same. Louis "showed complete satisfaction" with the project, and Marie was similarly pleased with her gallery.

Rubens barely escaped another injury during the nuptial ceremony, which he attended with Peiresc's brother, Palamède Fabri, the sieur de Valavez. The two arranged an excellent position for themselves on a grandstand with members of the English diplomatic contingent, just opposite the platform where the service was to be conducted. There they stood making casual conversation when the oversubscribed grandstand suddenly gave way. Rubens managed to skip away from danger, but Valavez wasn't so lucky. He tumbled to the ground, taking a wound to the head. He recovered, though the bloodletting and injections administered as therapy probably didn't help.

It was surely no accident that Rubens appeared on a grandstand with members of the English delegation. In the preceding years he had spent considerable energy cultivating patrons among the English nobility, and he esteemed Charles I to be "the greatest amateur of paintings among the princes of the world." The term "amateur," as Rubens used it in its original French, was not derogatory, but suggested the new king's love and deep knowledge of art. The respect was mutual. Charles had recently acquired a Rubens self-portrait, having done so after imploring the artist so insistently that he had no choice but to accept the honor. Rubens was uncomfortable with the idea of sending his own likeness to a king. It seemed an inappropriate breach of protocol, given his social station and Spanish allegiance; visitors who saw it in Charles's cabinet might well deem the

artist presumptuous. Also, and perhaps more seriously, he simply didn't like to paint self-portraits. In the course of a career of extraordinary production, he made only a handful of them, and even those were generally painted on demand or for a special occasion. The enterprise seemed narcissistic to him, immodest. He was not a man prone to the exploration of his mind's demons—if he had any at all—and he was certainly not one to advertise his innermost thoughts. That said, his pride was such that he was never one to reject an honor. If the king truly wanted his portrait, of course he would oblige.

Charles was actually not present for his own nuptials; it was to be yet another wedding by proxy. A marriage between two royal houses, and this one in particular, was more a political and commercial transaction than a love match, and it was imprudent for the groom to travel to meet his fiancée before the formalization of the marriage contract. To do so would place that entire arrangement in jeopardy: the groom might become ill, injured, or worse while en route; international travel at the time was inherently risky. Moreover, upon arrival he would be, in essence, a hostage in a foreign court.

Charles had learned this lesson the hard way. Two years earlier, he had foolishly departed for Spain while negotiations were still pending for his marriage to the infanta Maria Anna, daughter of Philip III (and niece of the infanta Isabella). Charles, a romantic and impulsive soul, had fallen in love with a portrait of the comely Spanish princess, whom he had never met in person. Despite his better judgment, James I agreed to let his passionate son follow his heart, though he insisted that George Villiers, the Duke of Buckingham, travel along with Charles as chaperone and chief political aide. Buckingham had by that time established himself as the king's latest protégé—indeed, they were said to be lovers—a man James felt comfortable trusting with so delicate a mission. That trust, however, was

entirely misplaced. Indeed, the king might have suspected just how much trouble was in store when his ardent son and equally fervent intimate surreptitiously departed London wearing fake beards and using the pseudonyms Jack and Tom Smith, the better to surprise the Spanish princess and win her heart. In Madrid, two months later, the folly of their adventure gradually became apparent.

The Spanish public appreciated the prince's gallant gesture. To travel incognito across half of Europe in the name of love—that was chivalry. As word of Charles's presence spread through Madrid's streets, throngs gathered to voice their approval at the House of Seven Chimneys, the residence of the English ambassador, where he and the duke made camp. There were parades, a tour of the Escorial, and a gift of paintings from the magnificent royal collection, a present that included a portrait by Titian of the prince's namesake, the Holy Roman Emperor Charles V. (He also received Giambologna's *Samson and a Philistine*, previously a gift of political tribute from the Tuscan grand duke Ferdinand de' Medici to the duke of Lerma.) These ostentatious displays belied the less generous intentions of Spain's calculating chief minister, Gaspar de Guzmán, the Count-Duke of Olivares. The unannounced arrival of the English prince, a gross breach of diplomatic protocol, gave the count-duke ample pretext to stall the marriage negotiations with Buckingham, during which time he became progressively more insistent on Spanish demands. The count-duke was adamant that Maria Anna, after the wedding, be allowed to freely practice her Catholic faith, despite the general prohibitions against Catholicism in England and the fact that her prospective husband was a Protestant.

Had Charles not rushed off so impetuously, these obstacles might well have been surmounted by his conciliatory father. James was especially desperate for the funds that would come as Maria Anna's dowry. He also wanted his wayward nephew, Frederick V,

restored as the elector palatine in Germany. That title carried with it sovereignty over a large swath of southeastern Germany, a breadbasket that encompassed key military and economic corridors. Frederick was now in exile in Holland—he was actually living in the home of the English ambassador, Rubens's friend Dudley Carleton—having been forced from his throne in 1620. In his absence, the Palatinate had been divided among the Holy Roman Emperor, the Duke of Bavaria, and the King of Spain. James thought, and not without reason, that Frederick's restoration might somehow be finagled as part of a carefully brokered marriage contract.

As it was, Charles and Buckingham, stranded in Madrid, had absolutely no leverage to bargain for Frederick's return to his German throne. Indeed, the two English aristocrats were now prey to the machinations of the Count-Duke of Olivares, who shrewdly exploited the prince's infatuation with Maria Anna, teasing him with a glimpse of her here and a peek at her there, until Charles was eyeing her, in the words of the count-duke, "as a cat doth a mouse." Of course, it was Olivares who had Charles trapped and cornered. The prince was in love, but he was in no position to renounce his own church. Charles's requests to leave Madrid without a marriage deal in place were denied by Olivares, and as summer approached, James was forced to warn his son, in Shakespearean tones, of "the danger of your life by the coming of the heats." Finally, Charles had no choice but to agree to Spanish terms, and even then he was not allowed to return to England with his bride. There would be an eight-month wait before her departure, to ensure that the terms of the wedding were properly established in England. Inevitably, after his return home, the prince was forced to renounce the agreement. It was a colossal embarrassment, and a deathblow to Anglo-Spanish relations. Maria Anna, at least, did well for herself. In 1631 she married her cousin Ferdinand III, the future Holy Roman Emperor.

⁓✄⫸⁓

IT WAS WITH THAT HISTORY in mind that Charles, having learned his lesson, now chose to wait for his French bride at Dover, on the English coast. Buckingham was dispatched to escort the new queen across the Channel, a job that left him with three weeks in Paris waiting on Henrietta Maria. He spent that time actively, for the duke hoped to take more than just a new queen back with him to England. Buckingham had a taste for precious objects and spent a good amount of his time in France trying to procure them. For his garden, he acquired a selection of rare tropical plants. His attempt to liberate the *Mona Lisa* from the royal palace at Fontainebleau, however, was politely refused. Da Vinci's masterpiece was not for sale, but as some consolation he could have his portrait made by Rubens, a specialist in just the kind of visual aggrandizement that appealed to the duke's immense ego.

Buckingham dressed carefully for his first sitting with Rubens. He was a man who cared about appearances, and knew that his sartorial choices would shape his image for posterity. He wore an elegant black doublet with scalloped white vents and a high collar that flared out to squared ends edged with lace. His hair fell in gentle brown curls that made for a contrast with his short beard, which was precisely clipped into a plunging spade. He was, in fact, so pleased with the work of his French hairdresser that he paid the man's employer 100 pounds for the right to acquire his services on a permanent basis. Even without all this careful preparation, the duke was undeniably handsome, with strong, sharp features that attracted men and women alike. King James had called him "Steenie," a reference to the angelic face of Saint Stephen.

Buckingham was accompanied during that sitting by his aide-de-camp, Balthasar Gerbier, who recorded their conversation and

catered to the duke's whims, as necessary. Like Rubens, Gerbier was an artist-diplomat—though not quite as skilled in either capacity—and a native of the Low Countries who had fled that land with his parents to escape religious persecution. Formally, he was the duke's "master of the horse," a title that dated back to Roman days but now conferred the status of chief court officer. Beady eyes and a sluice of a nose gave Gerbier a squirrelly appearance that mirrored his pushy, ingratiating personality. He was nevertheless an undeniably nimble political operative, and his penchant for sycophancy extended directly to Rubens, whose career he had been tracking for some time. In 1620 he had even authored a sixty-three-line panegyric to the painter, dubbing him "a shining Phoebus."

It was nice to be esteemed, but Rubens nevertheless approached his meeting with Buckingham with a certain degree of trepidation. It was no great secret that the duke still harbored a resentment over the failed "Spanish match." The depth of that resentment was of particular concern insofar as Buckingham, chief minister to Charles and lord high admiral of the English navy, was in a position to launch a military offensive against Spain and its dependencies, including Rubens's Flemish homeland. At the very least, he could increase the English subsidy to the Dutch, to assist them in their war against Spain. Measuring the duke's level of antipathy, then, was something that fell directly within the purview of the painter, given his role as an agent in the service of Isabella.

As was his practice, Rubens chatted amicably with his subject as he sketched his portrait. Using quick strokes of black and red chalk, which he accentuated with translucent rushes of white, Rubens gradually brought the duke to life. When the drawing was nearly complete, the artist inked in Buckingham's pupils with brown pen, giving his eyes a sense of forceful animation. A slight pursing of the lips imbued the sitter with a feeling of calculated seriousness, hinting

at arrogance. Rubens had correctly surmised that this was precisely how the duke imagined himself: handsome, commanding, pitiless. Indeed, Buckingham was happy with the result, delighted enough to make it the basis for two formal portraits—one half-length and the other equestrian—to be completed by the painter and his assistants back at his Antwerp studio. For the equestrian portrait alone he agreed to pay 500 pounds. The duke also commissioned from Rubens a ceiling painting for the ceremonial hall of his new home in London, York House. Finally, the duke had learned of the unsurpassed collection of antiquities Rubens had amassed back at his Antwerp home. Might the painter be convinced to part with it, he wondered?

Rubens was shrewd enough, both as a businessman and as a diplomatic operative, to see that Buckingham's interest might be leveraged into both financial and political capital. Yes, he told the duke, he would be interested in selling, given an appropriate offer. If the duke would like to inspect the marbles, he was of course welcome to do so, or he could have a local representative make an inventory. With that established, Rubens gently nudged the discussion to the delicate matter of politics. The artist admitted his concern that "great difficulties might arise between the Crowns of Spain and Great Britain" and then suggested that "every honest man should do all in his power" to ensure peace. "Since war was a scourge from Heaven, we should do our best to avoid it," he told the duke. Rubens made a special point to note that Flanders and its regent, the infanta Isabella, were truly innocent bystanders to any conflict between Spain and England. The painter therefore hoped Buckingham would use his influence to "pacify" Charles, the new English king, and otherwise curb his desire for retribution—though he did not say so explicitly.

Buckingham was magnanimous in reply, assuring Rubens that

the joy Charles felt over his union with the French princess meant that all memory of the "unfruitful pretensions" of the past—that is, the failed Spanish Match—would be "buried in oblivion." He did, however, indicate that the situation of the exiled Frederick V, who had been removed from his Palatinate throne by Habsburg forces, was still a "wrong" that "needed a cure." Rubens countered that Isabella, as a neutral party to this situation, might serve as an honest broker in future discussions on the matter. With that, the sitting came to an amicable conclusion. Negotiations between Bucking-ham and Rubens regarding the painter's collection of antiquities would henceforth be conducted through the duke's capable deputy, Gerbier.

The infanta was pleased with Rubens's overtures to Bucking-ham. Upon his return to Flanders she specifically commanded the painter to "maintain this friendship with the duke." But reaching out to Buckingham was not Rubens's only covert accomplishment during his time in Paris. Through the diplomatic rumor mill, he had learned that one of his most devoted clients, Wolfgang Wilhelm, the Duke of Neuburg, was on his way to that city from Madrid, and that his arrival posed a significant threat to the ongoing negotia-tions between Spain and the Dutch, the very negotiations that Rubens had been a party to through his cousin Jan Brant.

Neuburg, a knight of the Golden Fleece and a Spanish client, was in fact the unknowing pawn in an intricate and seemingly implausible conspiracy plot, an affair contrived by a notorious French aristocrat who hoped to promote his own status at the Parisian court at Spanish expense. To accomplish this coup, he had informed a known Spanish agent that France was anxious to serve as a mediator between Spain and the Dutch, and would do all in its power to end the war between them. This, of course, was patently false. France had no interest in mediating peace between Spain and

the Dutch. As Rubens would inform the infanta, the French abhorred the idea of that peace "more than anything on earth." For Cardinal Richelieu, the French chief minister, keeping Spain terminally engaged in conflict was an essential principle of foreign policy, a fact amply demonstrated with the signing of the Treaty of Compiègne, in June 1624, by which France pledged financial support to the Dutch cause.

Neuburg, then, was walking into a trap, having been dispatched as an emissary from Madrid on the basis of false information. Upon his arrival in Paris, the revelation of France's true intentions would provoke a political firestorm and undermine what progress had already been made with the Dutch through the secret negotiations in which Rubens had long been engaged. Indeed, the Prince of Orange had specifically warned Rubens—through Jan Brant— that even letting word of their negotiations reach French ears would bring an end to all talks.

Rubens reported all of this back to Isabella in a dispatch sent by urgent courier on March 15, 1625. "I hope Your Highness will not take offense if I express my opinion according to my capacity, and with accustomed freedom," he wrote. He proceeded to adumbrate, with absolute precision, just how pointless it would be to draw France into the matter:

> *The proposition of the duke of Neuburg, then, will only serve to disclose our secrets and to warn our French enemies in time to oppose our plans with greater certainty and violence, to frustrate them with all their power; it will completely disgust the Prince of Orange and result in breaking all other negotiations which are already so advanced, as Your Highness knows. I do not see how the French can in any way remove the obstacle which alone prevents the success of our enterprise, since they are supporting the*

opposing party with as much persistence as if the failure con-
cerned their own interests . . . It is foolish to believe either the
French desire this, or that they can find suitable means for the
cessation of hostilities any more easily than we can do ourselves,
if we wish. Finally, we need neither their favor, as Your Highness
knows, nor the mediation of the duke; nor is it necessary to buy
from the French what we can have for nothing.

Rubens proposed that Isabella order Neuburg to bypass Paris on his travels, if at all possible, and in any case allow him to make no proposals without her explicit consent. If it was too late to divert Neuburg, Rubens wanted permission to keep the duke "from putting a finger in the pie." Should Madrid still deem it necessary to make an overture to the French, he suggested it come from a neutral intermediary, ideally a representative of the Vatican, rather than from Neuburg, who was in the pocket of Spain and therefore inherently suspect. Moreover, the duke was known to be a vainglorious gossip and could not be trusted to keep the matter quiet. Rubens closed with a request that his letter be "thrown into the fire." The duke made for a lousy diplomat but a good patron, and he did not wish to "arouse his animosity." Still, he concluded, "the public welfare and the service of Your Highness move me more strongly than any other passion."

Isabella took Rubens's message to heart. Through his timely intervention, Neuburg was sidelined, and Rubens was able to resume negotiations with Brant where they had left off. Facts on the ground, however, had shifted. With Spinola's putative victory at Breda, in May 1625, the Spanish had strengthened their negotiating hand. But finding a party to negotiate with, now that Maurice was dead, presented a problem. Frederick Henry, the new Prince of Orange, did not command the Dutch political apparatus with the

authority of his late brother. Instead, matters would have to be set-
tled with the full States General—the fractious assembly of delegates
from the seven members of the United Provinces—an onerous task.

Rubens left it to Brant to deal with that hydra, while offering
him the consoling reassurance that the Spanish were not going to
ramp up their demands. "It is up to you, on your side, to supply
what is wanting," he wrote to Brant a month after his return from
Paris. "Our position, by God's grace, is safe and secure, and it
seems to me that the moderation shown on our side is by no means
slight. For after so great a change, and with so considerable an
advantage, we are keeping the same terms, without revising them in
a single point . . . It now remains for you to make every effort to
bring the desired answer as soon as possible, endorsed by the
advice and orders of those who can maintain and carry it out; then
it will be accepted at once by our side and put into effect."

The letter was written in Italian, but Rubens and Brant had
taken the measure of creating a secret numerical code to protect
the identity of the persons and places named: Isabella was 3; Mau-
rice, 11; Neuburg, 24; Spinola, 26. Such ciphers were typical of
diplomatic correspondence of the period, but the essential trans-
parency of the "Rubens code" suggests its intended purpose was as
much to placate Brant's neurotic mind as to disguise state secrets.
As it was, Rubens made a special point to inform Brant that
Balthasar Gerbier (14), Buckingham's political agent, had recently
visited the artist at his Antwerp home with a proposal to establish
England as an intermediary between Spain and the Dutch, and that
through Rubens's deception Gerbier remained ignorant of their
direct negotiation. Gerbier was ostensibly in Antwerp to look over
Rubens's collection of antiquities on behalf of the duke.

For Rubens, the offer to negotiate through England wasn't much
more appealing than Neuburg's doomed plan to go through France,

and he was anxious to set aside Brant's fears of being either exposed or sidelined in the future. "I believe he will probably be somewhat angry with me," Rubens said of Gerbier, "but the way he pointed out is too long and does not correspond with our plans." He advised his cousin that "as a good patriot," it was now the time "to offer every service to the general welfare, for which we have worked so hard that I hope, with God's help, our efforts will not be in vain."

Unfortunately, not even God could help Brant secure a willing partner in the States General, or at least one deemed acceptable to Isabella. "I have once more spoken urgently with 3 [Isabella] and 26 [Spinola] in favor of your proposition," Rubens wrote to Brant in August, using their code. "According to what 26 writes me, it was not received favorably by 3." Meanwhile, the situation on the ground—or more accurately, at sea—made peace seem an illusory goal. In the late summer, Isabella shifted her court to the port of Dunkirk, where she and Spinola could manage the construction of a fleet to combat the Dutch navy.

Rumors had by then surfaced that England was intent on a major attack on Spain, and that the Dutch would collaborate. Despite his assurances to Rubens in Paris (and Gerbier's more recent overtures in Antwerp), Buckingham had not put the debacle that was the Spanish Match behind him, and was out for revenge even now, two years after the fact. Indeed, he had spent much of his time in Paris, as he was waiting to escort Henrietta Maria back across the Channel, unsuccessfully trying to recruit Cardinal Richelieu to commit France to join England in a two-pronged offensive against Spain. Richelieu, however, resisted these entreaties, preferring instead a more passive form of aggression: financial support for Dutch military efforts.

Rubens, a shrewd judge of the political climate, could see just what was coming. "Should the English armada make a single move

against the king of Spain," he wrote in September, "believe me the world will see a bad game." That prediction was accurate; Buckingham was no more adept a military commander than he was a wedding planner. Roughly a month after Rubens issued his warning, a combined English-Dutch fleet of one hundred ships, under English direction, sailed for the Iberian Peninsula, though without any concrete instructions on where to land. After a good deal of frittering about, they decided on Cádiz, a fortified city on Spain's southern Atlantic coast. The expeditionary force was neither tactically nor logistically prepared for such a campaign. It managed to land, but on a barren island in the port, and without the matériel necessary to mount an assault on a well-armed Spanish garrison. Without potable water, the soldiers requisitioned local wine, which left them in something less than ideal fighting form. "The only prudence the English showed in this enterprise," Rubens wrote, "was in retiring as speedily as possible, even though with great losses, and in disgrace."

If there was any hope of a peace between Spain and England, the attack on Cádiz in October 1625 ended it. Ambassadors were recalled, and Buckingham traveled to The Hague in December to formalize a fifteen-year offensive and defensive alliance with the Dutch. "I have no doubt war will follow," Rubens wrote. It was the day after Christmas, but he was not inclined to be generous. "When I consider the caprice and arrogance of Buckingham, I pity the young king who, through false counsel, is needlessly throwing himself and his kingdom into such an extremity. For anyone can start a war, when he wishes, but he cannot so easily end it."

Rubens wrote that letter from a hotel in Laeken, a Brussels suburb. The artist moved there with his wife, Isabella, and their two sons when an outbreak of plague struck Antwerp at the end of the year. As Rubens had earlier advised Peiresc, the best precaution from contagious disease was flight. (In general, Rubens was suspicious of

the bloodlettings, purgatives, injections, and other treatments that were the hallmarks of contemporary medical practice, remedies often "more grave than the illness itself.")

The Rubenses returned to Antwerp at the end of February 1626, after they thought the worst of the epidemic had passed. In the summer, however, a new outbreak struck the city. Four months later, on June 20, Isabella Rubens died at her Antwerp home. It had been less than three years since Rubens had buried his only daughter. Visited by tragedy again, the grieving husband spent a small fortune on the traditional Flemish ceremony that followed his wife's funeral.

"I find it very hard to separate the grief for this loss from the memory of a person whom I must love and cherish as long as I live," he wrote of his wife. "Truly I have lost an excellent companion." Isabella's death put Rubens into an uncharacteristic depression, one that he could not overcome through immersion in his work or the Lipsian constancy that he had always used as a philosophical bulwark against adversity. "I have no pretensions about ever attaining a stoic equanimity," he wrote. The only palliatives, he felt, were time and travel. "I should think a journey would be advisable, to take me away from the many things which necessarily renew my sorrow . . . The novelties which present themselves to the eye in a change of country occupy the imagination and leave no room for a relapse into grief." Conveniently, diplomatic matters would demand just such a journey—one that would leave him with little time for mourning.

THUNDER WITHOUT LIGHTNING

༶༷༵

I should like the whole world to be in peace, that we might
live in a golden age instead of an age of iron.

—PETER PAUL RUBENS

A grieving Rubens was busy planning to remove himself from
Antwerp in the summer of 1626, but a more pressing concern in
that city was the arrival of unwanted guests from the north. Hostili-
ties between Spanish and Dutch forces had only intensified in the
wake of the Cádiz fiasco, and rumors of an impending Dutch offen-
sive gathered momentum through the summer. The enemy finally
materialized on a stifling morning at the end of August. The sentries
at the Antwerp citadel got first look at the flotilla—four bristling
warships and a convoy of support vessels sitting far off in the
Scheldt estuary, looming and full of menace. Soon enough, the ships
were visible from the docks down by the river and the rooftops of
the city's carefully tended houses. This was the Low Countries, after
all; the land was flat as a stretched canvas. For the military com-
manders up in the citadel, that level topography was a mixed bless-
ing. If there was no high ground to which they might safely retreat,
at least they could see their enemy approaching and have time to

prepare for the onslaught. That was the soldier's perspective, anyway. It offered little consolation to the citizens of Antwerp, to say nothing of the city's most illustrious resident. For Rubens and his neighbors, there was little defense but to stick within the city walls and hope for the best.

The assault commenced at dawn the following morning, when the Dutch flotilla began its ominous creep up the Scheldt toward the city. Antwerp, however, was not its immediate objective. Just northwest of the city, the Dutch shifted course, turning down one of the Scheldt's several tributaries toward the small fort of Kieldrecht, a stronghold that was a critical command point for the all-important local dike system. It was a particularly vulnerable target. Defended by a small garrison and set on a narrow peninsula that jutted out into the water, it could be cut off from the mainland (and reinforcement) by a canal that transformed it into an island. This artificial wadi, which filled and emptied with the summer tides, would be the focus of the Dutch attack. If captured, the fort behind it would be subject to relentless artillery fire and siege. It couldn't hold for more than a few days.

The Hollanders expected an easy surprise victory, but they had severely miscalculated. Spinola, whom Rubens considered a supremely gifted military tactician, had anticipated their strategy and prepared his forces accordingly. The previous day, as the enemy flotilla hove into view, he had a boat bridge formed across the Scheldt so his soldiers might quickly reach the Flemish plain. He then dispatched four regiments to reinforce the area. At Kieldrecht, six cannon were set up on a bluff overlooking the canal, with an infantry battalion lined up on one bank and the armed local peasantry positioned on the other.

At ten in the morning, with the tide running high and the sun already blazing, the Dutch ships pushed into the canal—and the

teeth of Spinola's trap. Taking heavy fire from both flanks, and baking under the sun, they spent two hours in a bloody, futile struggle to establish a foothold on the fort side of the canal. By noon, the extent of the rout was apparent. As winds began to pull the tide out of the canal, and with it the Dutch flotilla, the Hollanders began a hasty retreat. The order to fall back came too late for a pair of the Dutch ships, which lay grounded in the shallows along with their crews, munitions, and twenty-eight battle-ready horses. Rescue launches were repulsed by the Spanish guns.

For one day, the Dutch had been stopped. Still, there was little celebration in Antwerp. The Dutch fleet, while in retreat, was still visible out on the Scheldt. It was assumed that they would return, better prepared, in the not-too-distant future. Rubens was a stoic, but not a fatalist. "I assure you that in public affairs I am the most dispassionate man in the world, except where my property and my person are concerned," he once wrote. Now something had to be done.

꩜

THE CHOICE OF KIELDRECHT as a target illustrated the strategic importance of hydrological systems in the Low Countries. While the Dutch were planning that ill-fated attack, the Flemish military hierarchy was itself readying a massive engineering project designed to reorder the region's waterways. This wildly ambitious scheme, the brainchild of Rubens's antiquarian friend Jan van den Wouvere, would in theory return Antwerp to the glory it had known in the previous century while concurrently dealing a massive economic and military blow to Holland. Woverius's grand scheme was to divert the course of the Rhine River before it entered Dutch territory, where it served as a commercial artery and a natural defensive barrier against Spanish incursion. To accomplish this, Woverius planned to link the Rhine with the Maas River, in Spanish-controlled territory,

via a great canal of more than thirty miles running just below the Dutch border. The Maas would also be linked to the Demer River, which was to be fed by another canal into the Scheldt, thereby providing an unbroken navigable waterway from the economic heartland of western Germany straight through to Antwerp.

Plans for the Fossa Mariana (Canal of the Virgin) progressed rapidly over the summer of 1626. In June, the terrain was scouted by Woverius and the Italian engineer Giovanni de' Medici, who was brought in to supervise construction. Rubens admired Medici, as did the cardinal Alonso de la Cueva, chief Spanish minister on the Brussels junta. There was no greater proponent of aggressive action against the Dutch than the cardinal, who happily endorsed the canal plan. In September, as work was set to begin, he wrote to Philip in Madrid, assuring the king that it was "an easy project" and that it could be "speedily done without any great cost." Initial estimates put those figures at eight months and a half-million guilders.

Spinola, as commander of Spanish forces, was especially enthusiastic about the project. The drying up of the Dutch Rhine and its many tributaries would open up his enemy's southern flank, providing unhindered access into the Dutch provinces as far as Utrecht. That kind of easy territorial expansion seemed a good deal more appealing than the slow and arduous siege warfare that had won him Breda at such a terrible cost. But beyond its strategic utility, Spinola understood the value of what was, in effect, a massive make-work project. In one of his weekly letters to Paris, Rubens neatly summed up Spinola's motivations: "He fears to embark upon the siege of some strong place at the wrong time, without being certain of success, and yet, on the other hand, does not want to leave his soldiers inactive thus appearing to spend the king's money uselessly. He has therefore undertaken this project to avoid doing nothing."

The canal project was not without its detractors. The towns

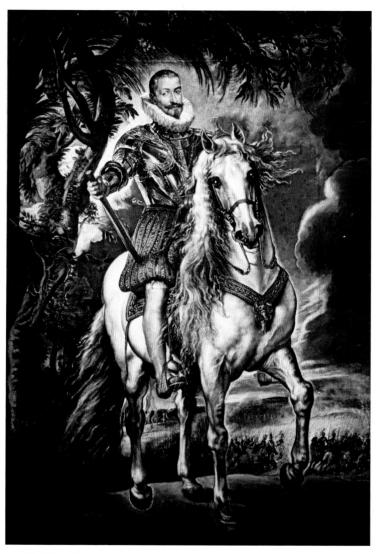

The Duke of Lerma was the most powerful man in Spain, a fact Rubens conveys in this equestrian portrait, his first true masterpiece.

༄

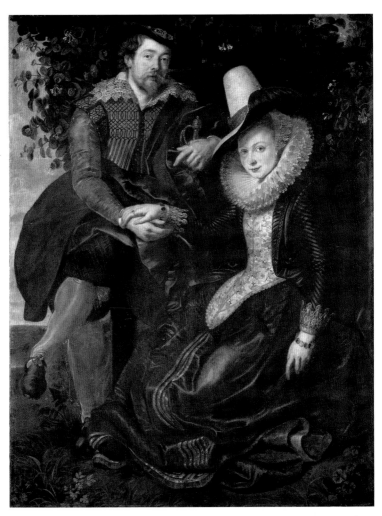

This unusually informal portrait under a bower of honeysuckle captures Rubens and his first wife, Isabella Brant, just after their marriage.

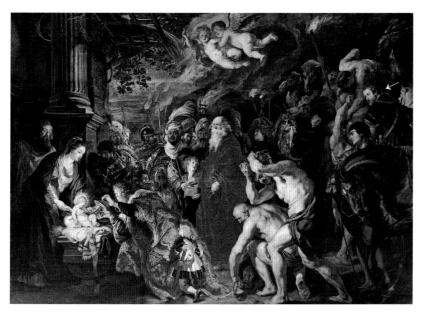

Rubens painted the *Adoration of the Magi* to commemorate the signing of the Twelve Years' Truce, in 1609. Two decades later he found it in Madrid and inserted a portrait of himself, on horseback looking over his shoulder, on the far right side.

The private formal garden behind the Rubens home (top) was a place where visiting agents and dignitaries could escape prying eyes and ears. A trompe l'oeil composition of a canvas drying in front of a loggia is visible just below the third story, on the far right. His sculpture gallery is at bottom left.

TOP (DETAIL) AND RIGHT: In this painting by William van Haecht (1615), Rubens can be seen in the bottom left corner conversing with a group including the archdukes Albert and Isabella at the home of his friend and patron Cornelis van der Geest.

⚜

RIGHT: In this memorial portrait, known as *The Four Philosophers*, Rubens painted himself standing behind his deceased brother, Philip. Justus Lipsius, their late intellectual mentor, sits at a table next to Philip with the statesman and family friend Jan van den Wouvere. Rubens owned the bust of Seneca, another stoic hero.

As a young painter in the service of the Duke of Mantua, Rubens witnessed the proxy marriage of Marie de'Medici at the Duomo in Florence. Two decades later he painted the scene for the cycle Marie commissioned from him for her new Parisian residence, the Luxembourg Palace.

TOP LEFT: Rubens thought George Villiers, the Duke of Buckingham, would pay a steep price for his arrogance. He did, but not before Rubens captured that quality in this sketch, made in Paris in 1625.

TOP RIGHT: Diego Messia cut a menacing presence that Rubens effectively captured in this drawing. Messia became a regular patron of the painter, and a political ally.

RIGHT: Rubens considered Ambrogio Spinola, one of the great military minds of the age, a close personal friend, though he claimed Spinola knew less about art than a stable boy.

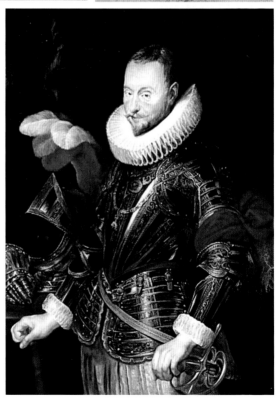

Philip IV already had an equestrian portrait by Velázquez, but he removed it in favor of one by Rubens, which was given pride of place in the royal palace. The Rubens was destroyed by fire in 1734 and is known today by this copy.

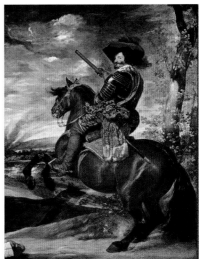

The Count-Duke of Olivares appears almost cartoonishly villainous in this classic portrait by Diego Velázquez. Rubens befriended both Olivares and Velázquez during his mission to Spain in 1629.

The Saint George in this painting, traditionally interpreted as an allegory of the vanquishing of war (represented by the slayed dragon), looks suspiciously similar to Charles I, for whom the painting was intended. The London skyline appears in the background.

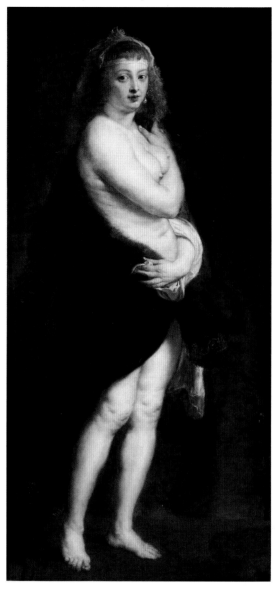

Rubens married his second wife, Helena Fourment, when she was sixteen and he was fifty-three. He was besotted by her beauty and regularly used her as a model, as in this famous portrait of her in a fur wrap.

adjacent to the proposed route, fearing both enemy attacks and the predations of poorly paid Spanish troops, were unhappy at the prospect of becoming garrisons along what promised to be a new front line. Those fears were realized almost as soon as construction began, with Dutch forces under Frederick Henry, the Prince of Orange, persistently raiding the works in an effort to halt progress. The Dutch offensives, combined with the onset of foul weather and the overall scale and complexity of the project, inevitably set the timetable back and boosted the estimated price. Rumors of delays and cost overruns spread across Europe, but in Antwerp were met with denial. "Work progresses valiantly on the canal," Rubens wrote to his Paris correspondent toward the end of October. A month later, he rejected the suggestion that things were not, in fact, progressing with alacrity. "Here we know nothing of the difficulty of which you write concerning the new canal; on the contrary it is affirmed that the work is proceeding with incredible activity."

The massive expenditure on the Fossa Mariana was, in fact, a drain on finances already stretched to their limit. Throughout the fall and winter of 1626, Antwerp's bankers were preoccupied with rumors of a possible Spanish currency devaluation, which would have had drastic consequences on the financial market and the local economy in general. Recession and exorbitant spending had left Madrid dependent on the exploitation of its colonial empire, which was as unreliable as it was prodigious. War on the seas combined with the inherent difficulties of navigation and the vagaries of weather made it hard for officials to count on the timely arrival of treasure. In November, fear of English piracy delayed a fleet carrying desperately needed gold from Peru. The idea that plunder might fall into enemy hands was a matter of grave concern. In the event of capture, the Spanish captains were ordered to scuttle their ships; they were even issued necklaces that carried a papal dispensation permitting suicide.

Surrender would not necessarily have done them much good any-way, for there was little mercy to be found on the seas. That February, a Dutch warship captured seventy Flemish merchant marines, shackled them back-to-back in pairs, and summarily cast them over-board. Such treatment was common. When an appalled Rubens learned of the incident, he recommended reprisals in kind, "up to the same number of men." The suggestion was intended more as a prag-matic deterrent than as a spiteful act of revenge, but its cold-blooded calculation illustrates the extent to which Rubens's essentially moder-ate worldview was controlled by a sober realism about the nature and conduct of war.

Rubens paid careful attention to naval matters. Spain's colonial possessions were critical enough to the crown that he was specifi-cally instructed by Spinola to track developments on the seas. That order had paid off back in June, when Rubens dispatched an urgent, top secret message to Spinola about a pending threat on the Brazil-ian coast. One of Rubens's informants in Zeeland had alerted him that a Dutch fleet had been sent to carry out a surprise attack on the Portuguese settlement at Bahia, a frequent target of the Dutch. "A warning of this obvious danger deserves to be sent to His Majesty by express messenger," Rubens wrote to Spinola. "Perhaps there would be time to warn the Governor of Bahia by a special caravel, so that he might be on guard." The alert was, in fact, passed on to Madrid, but it didn't do much good. Nine months later, in March 1627, Dutch warships under the command of Piet Heyn—"that famous pirate," as Rubens described him—raided the Spanish merchant fleet in Bahia harbor, carrying off more than twenty-five hundred chests of sugar. All around the globe, Dutch power was on the rise. Just a few months before Rubens had sent his warning about Bahia off to Spinola, the Dutchman Peter Minuit "purchased" the island of Manhattan from its native inhabitants for the equivalent of

60 guilders. That may have been history's greatest real estate swindle, but in truth it was the immense expenditures on the East and West India companies that were making the Dutch, in Rubens's estimation, the "masters of the other hemisphere."

The upstart Dutch were off settling new continents on the other side of the world, but the Spanish couldn't even dig a ditch in Europe. By April 1627, all construction on the Fossa Mariana had stopped. Rubens blamed an especially harsh winter that made work difficult, but admitted that even in the case of good weather, there would have been no money for the project. In May, edicts arrived from Madrid imposing the long-feared currency devaluation, or *quarto*. That, combined with the cumulative effect of so much war, left Antwerp in a pitiful state. "This city . . . languishes like a consumptive body, declining little by little," Rubens wrote. "Every day sees a decrease in the number of inhabitants, for these unhappy people have no means of supporting themselves either by industrial skill or by trade. One must hope for some remedy from these ills caused by our own imprudence."

Rubens made certain that his family would forever be safe from that kind of financial ruin. Toward the end of the previous November, after five months of mourning his wife's death, he departed Antwerp on an unexplained journey, warning his Parisian friends to expect a hiatus of about a month in their correspondence. Leaving his sons behind with family, he traveled to the port of Calais, taking with him the better part of his collection of antiquities, crated up carefully to protect against the hazards of the road. That same month, in a letter to a patron in Rome, Jan Brueghel wrote that his friend Rubens was selling the contents of his cabinet to the king of England, and that he would receive the sum of 130,000 crowns in return.

Brueghel's information was not quite correct. Rubens had yet to

reach a final agreement on the sale of his collection, and the buyer was not Charles I but his impetuous favorite, the Duke of Buckingham. In Calais, Rubens was to meet with Balthasar Gerbier, and the two men would conclude the deal for Rubens's antiquities that had been in the works since the painter first met the duke in Paris following the proxy marriage of Charles I and Henrietta Maria. Rubens anticipated a strong return for his statues, given their intrinsic value and Buckingham's profligacy, and thought his discussions with Gerbier might also be productive on the diplomatic front. Unfortunately, there was no sign of the duke's master of the horse. Rubens waited for Gerbier in Calais for three weeks before word finally came that he was to meet him in the French capital.

The delay was frustrating, but Rubens always enjoyed Paris. He arrived in that city on Christmas Day and set himself up at the residence of Henri de Vicq, the infanta's Parisian ambassador. (The antiquities remained in storage at Calais.) On short notice, de Vicq's *hôtel* made for a nice pied-à-terre, and its use was one of the perks of his status and his friendship with the ambassador. It was, in any case, to be a brief stay. Within forty-eight hours, Rubens and Gerbier had finished their business. Rubens, always a good negotiator, had exceeded even his own high standards, and was justifiably elated with the arrangement: in exchange for the bulk of his antiquities, thirteen paintings by his own hand, and a few other works, he was to receive 100,000 florins from the duke. This was a truly staggering sum, and all the more impressive considering Rubens had acquired most of the antiquities from Dudley Carleton for the cash equivalent of just 6,000 florins—and Rubens had paid two-thirds of that not with cash but with his own paintings, which cost him only labor and materials. When it came to one-sided deals, Peter Minuit had nothing on him.

Writing back to a mutual friend, the Parisian antiquarian Pierre

Dupuy, and perhaps unaware of the enormous sum the artist received, Peiresc noted that Rubens surely made the sale with "some regret," especially as the buyer was the rather buffoonish Buckingham and not a more serious-minded individual. Collecting in the pursuit of scholarship was acceptable among the group of humanist academicians with whom Peiresc associated; collecting for the sake of status was a vanity to be discouraged. Rubens, for his part, considered his collection a form of currency, both intellectual and financial. Before the sale he had his studio assistants build plaster molds from which copies of all the most important works could be made for future reference and display. That greatly mitigated what sadness he felt at the loss of the originals. As his workshop practice indicated, the concept of authenticity was something Rubens approached with a great deal of latitude. With ill-intentioned Dutch invasion forces making regular appearances on the Scheldt, it was only prudent to convert his fragile collection into more secure assets. The cash received from Buckingham was rapidly shifted into real estate holdings in and around Antwerp, a more stable form of investment.

After coming to an agreement in principle with Gerbier (the transaction would not be finalized for several months), Rubens spent an additional few weeks in Paris, not all of it happy. On New Year's Day he once more found himself immobilized in that city with a foot problem, this time an attack of gout, an ailment that would nag him for the rest of his life. He was still gimpy when he finally made it back to Brussels in late January 1627, whereupon he was treated to a greater indignity. His unanticipated two-month absence from the scene, combined with the inaccurate rumor that he had been dealing with Charles I, left his spymasters suspicious that he had secretly traveled to England without having informed them of his intention to do so, at the very least a major breach of protocol and potentially an act of treason.

Rubens managed to clear his name by mid-February—the essential charge was, indeed, false—but his protestations of complete innocence were somewhat disingenuous. While it was true that he had not traveled to England, it was also true that his conversations with Gerbier had not been restricted solely to matters of commerce. Rubens, of course, had initiated diplomatic conversations with Buckingham and Gerbier in Paris back in 1625, but those talks had been more probative than substantive, and undertaken with the tacit approval of Isabella. On this most recent trip to Paris, however, Rubens had taken up political matters with Buckingham's agent on no authority but his own. The painter, in all sincerity, believed he was acting in the best interests of his sovereign, that he would be remiss to let such a rare opportunity slip by, and that his actions would meet with approval at home—at the worst, they could simply be rejected by his superiors. After all, Isabella had previously instructed him to develop his relationship with Buckingham, so he was really just following orders. Indeed, the maintenance of such contacts was one of the essential principles of contemporary diplomatic practice, and there was no greater champion of the approach than Cardinal Richelieu, who devoted an entire chapter of his *Testament politique* to the utility of continuous negotiations. "I may venture to say boldly," he wrote, "that to negotiate without ceasing, openly or secretly, in all places, and that although no present benefit shall accrue from it, nor any prospect of future advantage present itself, is what is absolutely necessary for the good and welfare of States."

At his first meeting with Gerbier, Rubens had suggested that whatever animosities existed between Spain and England, his native Flanders remained a neutral party, and would always have an interest in forging a peace between those two crowns, especially if England could be counted upon to bring its Dutch ally to heel. Now,

with Buckingham's hopes of an English invasion of Spain foiled at Cádiz, and with his relations with France having degenerated as well, it seemed an appropriate time to once more begin peace talks in earnest. The infanta seemed a natural honest broker between Charles I and her nephew Philip IV. The two artist-diplomats Rubens and Gerbier could serve as the conduits of this negotiation. Rubens knew this idea would appeal to the ambitious Gerbier, whose eyes lit up at the very thought of finding himself in the middle of a grand international drama.

Isabella and Spinola also latched onto Rubens's audacious proposal. With the situation on the ground becoming progressively more desperate, something had to be done, and there weren't many good alternatives. Whatever doubts there may have been about Rubens's conduct were brushed aside. In an official letter to Gerbier, Spinola formally authorized Rubens as an intermediary. In the meantime, Gerbier was granted a passport into the Spanish Netherlands, where he delivered a letter from Buckingham offering a "Suspension of Arms for two, three, four, five, six, or seven years, restoring commerce to its original footing as in times of peace, during which time an accommodation [that is, a permanent accord] may be treated for." The proposed truce would apply not just to England and Spain, however, but also to the Dutch and to Denmark, another Protestant ally engaged with Catholic forces under the Habsburg flag of the Holy Roman Emperor, Ferdinand II.

England's attempt to bring both its Dutch and its Danish allies into the negotiation may have appeared generous, but from a Flemish perspective their addition needlessly introduced all of the problems plaguing central Europe into what was already a complicated negotiation. England's specific aim in broadening the field was the restoration of Charles's brother-in-law Frederick V to the Palatinate. But Rubens knew that this offer would not pass in Spain, if for no

other reason than that the situation in Germany was to a large extent beyond Philip's control, never mind his shared Habsburg lineage with Ferdinand II. Rubens stated this in no uncertain terms in his reply to Gerbier: "England should be disabused of the ideas that the king of Spain can absolutely control the affairs of Germany." It was the infanta's adamant position that only Spain and England be included in the proposed armistice. Even the Dutch were to be removed from this negotiation, a demand that seemed almost counterintuitive, given that a truce with the Dutch was, in the end, the infanta's top priority. Her fear, and Rubens's, was that in any multilateral armistice agreement, the Dutch would demand language in which they would be described as "free states" among equals, terminology that would be categorically unacceptable in Madrid. With an agreement between Spain and England in place, however, the Dutch could be compelled to make a separate deal with Spain in which the Dutch would have their freedom, just not in name. Rubens concluded his message to Gerbier with an appeal for a kind of quid pro quo arrangement: "It would be thoroughly appreciated in Spain and by her Serene Highness [Isabella], if the king of Great Britain would interpose his authority and good-will to this accommodation, and by this means would greatly oblige the king of Spain to make reciprocal efforts to adjust the affairs of Germany." In other words, following a treaty between England and Spain, England would press the Dutch to accept a peace with Madrid, and Spain would cajole its allies to restore Frederick V to the Palatine throne. But the treaty between England and Spain had to come first.

Those terms were eventually passed on to Charles I, though not immediately, as Buckingham had seen fit to have Gerbier begin the negotiations while the king was hunting at Newcastle, lest he be opposed to the project. Upon Charles's return to London, however, he gave his general approval to the direction of talks. It would be

acceptable to restrict the scope of discussions—"a great undertaking never advances straight forward upon two roads," Gerbier wrote—with the proviso that all negotiations proceed in absolute secrecy. Toward that end, Gerbier provided Rubens with a cipher to be used in all future correspondence.

Gerbier's missive was dated March 9, 1627. Rubens received two other letters with that same postmark, both directly from Buckingham, both suggesting that negotiations might not be quite so simple as Gerbier suggested. In the first, the duke affirmed Charles's interest in a settlement, promising his support so long as it would not preclude Frederick V's return to the Palatinate. In the second letter, presumably sent after some further deliberation, he ramped up the English demands. Now he indicated that any agreement would have to entail some accommodation of Dutch interests, and that the Spanish king would be obliged to use all his power to reestablish Frederick to his throne.

Rubens passed the letters from Buckingham on to Isabella and Spinola, but continued negotiation was beyond even their authority. Further talks would require consultation with Philip IV and the Count-Duke of Olivares. A courier was dispatched to Madrid, but a month later there was still no word from the Real Alcázar, the royal palace. Rubens, as a matter of protocol, wrote apologetic letters to his English contacts. "As soon as the answer comes from His Catholic Majesty, I shall inform Your Excellency," he told Buckingham in April, "for I wish as much as I ought to see the completion of this *beau chef d'oeuvre*."

It was not until June that Philip made his reply. The English overture pleased the Spanish king, but he was not at all happy about the central role Rubens had assumed in the negotiations. Yes, the artist had been ennobled, but there was no escaping his arriviste position and his tradesman's status. He was a nobleman not by

blood but *de concession*, and on the social ladder that placed him several rungs and a good distance below those of hereditary title. "I am displeased at your mixing up a painter in affairs of such importance," Philip lectured his aunt. "You can easily understand how gravely it compromises the dignity of my kingdom, for our prestige must necessarily be lessened if we make so insignificant a person the representative with whom foreign envoys are to discuss affairs of such great importance." With that caveat, he authorized Isabella to proceed with talks for an alliance with the English crown.

~❧~

RUBENS WAS SPARED the Spanish king's condescending remarks. For his part, he wasn't especially impressed with Philip's role in affairs of state. While the painter had secured his own economic future with the sale of his collection to Buckingham, his native Antwerp had been left to suffer the dismal consequences of Spanish neglect and the twenty-two-year-old king's childishly obstinate refusal to compromise with the Dutch. "We are exhausted and have endured so much hardship that this war seems without purpose to us," he wrote. The storefronts and vendors along the Meir and in the Grote Markt—celebrated by artists during the city's golden age for their overflowing abundance—were practically barren. Down at the waterfront, the docks stood idle. The painter Sebastian Vrancx, a Rubens confrere, made something of a specialty of scenes of Antwerp's bustling harbor, but his nostalgic pictures captured that great port during its heyday in the sixteenth century, when the city was still a financial powerhouse. Now even the relative prosperity of the truce years—meager in comparison to the days of yore—was a distant memory. Antwerp was on the verge of wholesale destitution, and Rubens placed the blame squarely on the policies of Madrid. "If Spanish pride could be made to listen to reason, a way might be

found to restore Europe," he wrote. "We are exhausted not so much by the trials of war as by the perpetual difficulty of obtaining necessary supplies from Spain, by the dire need in which we constantly find ourselves, and by the insults we must often endure through the spitefulness or ignorance of those ministers, and finally by the impossibility of acting otherwise."

In May 1627, with Spain still weighing its options, a frustrated Rubens chose to take matters into his own hands. Opportunity had presented itself at the beginning of that month with the arrival in Flanders of the abbé Scaglia, ambassador of Savoy. The son of an Italian count, Cesare Alessandro Scaglia di Verrua was both a patron of the arts and a notorious political meddler—"a man of the keenest intellect," according to Rubens. Scaglia, in turn, esteemed the painter as much for his sharp political mind as for his sure touch on a canvas. The two men had much in common. Like Rubens, who was fifteen years his senior, Scaglia had first traveled to the Spanish court in the year 1603, when he was just a boy, and later had a prolonged residence in Rome. Scaglia, too, had met with Buckingham in Paris at the proxy marriage of Henrietta Maria and Charles I, at which time he had appealed for the duke's support on behalf of Savoy.

Situated along the crucial military corridor that linked southern and northern Europe, Savoy existed in a state of perpetual anxiety, forced to constantly juggle its relations with the great powers. Scaglia's trip to Paris had been prompted by the recent collapse of Savoy's relationship with France, a situation that left Scaglia scurrying through Europe's capitals shopping for allies. With France alienated, Scaglia was especially anxious to win the support of the Spanish king. (Philip and the Duke of Savoy were estranged brothers-in-law.) Scaglia's latest mission had taken him to Flanders from London, where Buckingham had fully briefed him on the stunted negotiations Rubens had initiated between England and

Spain. An accord between those two powers would be welcomed at Savoy's court in Turin as it would provide a check to French power, and the meddlesome Scaglia was only too happy to throw his hat into the ring as yet another mediator.

At best, Scaglia was an unnecessary interloper, but an astute Rubens seized on his presence as a means to reignite negotiations. On May 19, using the agreed cipher, he wrote to Gerbier proposing a secret summit in Holland. The attendees would be Carleton (English ambassador to The Hague), Scaglia, Gerbier, and himself, all of whom could be gathered on the pretext of their mutual interest in the arts. As a group, they could hash out the language of an accord. The key sticking point was going to be the Dutch demand for recognition of its independence. Always a pragmatist, Rubens believed that if the Dutch were granted that freedom in practice, they would be willing to renounce their formal claims. "I have friends there of high standing," he wrote to Gerbier, "who will not fail in their duty." Presumably he meant his cousin Jan Brant, though the suggestion of influence indicates there may have been other assets, pehaps even Frederick Henry, the Prince of Orange.

Rubens would need Gerbier's assistance in making his summit meeting happen, and in particular he would need Gerbier's help if he was to be permitted to attend the proceedings—something he considered essential. He specifically asked that Gerbier have Buckingham write back, and in doing so state that "His Excellency desires that I be sent, with the permission of my superiors, to the place where I can meet you under the favorable circumstance of the presence of Carleton and Scaglia." If Rubens had overstepped his authority in Paris, his conduct here was far out of line, and he knew it. The painter was, on his own and without any authority, orchestrating a meeting with an enemy power on a matter critical to the foreign policy of the Spanish crown, and he was surreptitiously

requesting a foreign statesman demand his participation in the affair. "Keep this request of mine secret, so that no one may ever know that this was done at my instruction," he wrote to Gerbier. In a postscript he added, "I beg you burn this letter as soon as you have made use of it, for it could ruin me with my masters, even though it contains no harm. But at least it would spoil my credit with them, and render me useless for the future." At the very least.

⁕

RUBENS'S DANGEROUS GAMBIT paid off. At the end of May, Gerbier and Carleton were dispatched to The Hague. Scaglia soon followed. On June 13, Carleton wrote to Edward Conway, the English secretary of state, assuring him that "Rubens pasport is graunted him, so we are likely to see him here quickly." He later confirmed that the passport had been issued on the pretext that Rubens was traveling to deal in matters relating to his art.

In fact, it would be more than a month before Rubens would make it onto Dutch soil. The delay was due, in part, to the anticipated arrival in Brussels of Don Diego Messia, one of Philip's chief ministers. He was carrying with him news "of the greatest consequence," according to the painter, ostensibly concerning the funding of the Spanish war effort against the Dutch. Messia, who was engaged to Spinola's daughter, would also be coming with wide latitude and authority from Philip to orchestrate negotiations on behalf of Spain, though he would presumably defer to his future father-in-law, the hero of Breda.

From an English perspective, word of Messia's pending arrival did not bode well. Carleton, an old diplomatic hand, was inherently wary of Messia's intervention, and his own contacts in the Dutch diplomatic community confirmed those suspicions. At the beginning of July, he wrote to Conway in London to express his

concern: "I must lett your Lord understand that such advises as are come of late dayes from Bruxells to the Prince of Orange from such secret intelligencers as they here relye upon, all concurre that howsoever there is good affection in those parts to pacification, out of Spayne comes no signe of any such intention."

By mid-July, with Messia delayed in transit—he had, supposedly, injured himself while stepping from a coach outside of Bordeaux—and the English growing impatient, Rubens was ordered to travel north to Spanish-controlled Breda. From his room at the Swan, he dashed off a letter to Gerbier in The Hague offering to meet just over the border in Zevenbergen; he was permitted to travel no farther into enemy territory. That didn't sit well with Gerbier; Zevenbergen was too close to Flanders for his tastes. "My going thither would cause reports and suspicions," he replied. Secrecy, as Charles had commanded, was essential, as there were any number of parties—in particular the French—who would be anxious to sabotage whatever progress they might achieve. "Choose whether you will come to Delft, Rotterdam, Amsterdam, or Utrecht, if The Hague does not suit you." Later in the day, having had a chance to "ruminate" on the matter, Gerbier dispatched a second, badgering missive to Rubens, warning that the whole negotiation was in jeopardy. "I must tell you, as my friend, that I apprehend this business will end in smoke . . . If the Infanta and the Marquis are so zealous about this good business, why then render it subject to suspicions? . . . Do not let this business which took its rise upon the subject of pictures, end in smoke; our ancient friendship gives me liberty to speak freely." The tone was grating, and Gerbier capped the message with a pestering comment about a few works Rubens still owed Buckingham. This was typical for Gerbier, who existed in a state of almost perpetual (and occasionally justified) aggrievement that was constitutionally anathema to the more self-secure Rubens.

Manipulating correspondence was one thing; disobeying a direct order was another. Traveling beyond Zevenbergen without permission was out of the question. Instead, Rubens returned to Brussels and formulated a plan that would satisfy all parties: As soon as arrangements could be made, he would embark on a multi-week tour of Holland on which he would visit with the most prestigious painters in that land, apprising himself of developments in the field and acquiring works for his own collection, now depleted. Gerbier, fellow artist and connoisseur, would meet him along the route, ostensibly to conclude the transaction with Buckingham. (That deal had always been the cover for their negotiations, and a few details remained outstanding, as Gerbier's previous missive suggested.) This strategy was not without its perils. When Carleton heard of it, he wrote to the artist directly, warning that if he spent too long in Holland, he would be in serious jeopardy, subject either to the embarrassment of deportation or, worse, to arrest for treason.

It was risky, but Rubens was willing. His celebrity, he thought, would insulate him from the worst dangers. "I regard the whole world as my country, and I believe that I should be very welcome everywhere," he once wrote. The infanta consented as well. Writing to her nephew Philip in Madrid, she defended her decision to allow Rubens to participate in the secret negotiation he had done so much to initiate. His status as an artist was not an issue. "Gerbier is a painter just as Rubens is," she told Philip. "It matters little who takes the first steps; if they are followed up, direction will naturally be entrusted to persons of the highest rank."

~~❧~~

RUBENS VENTURED into enemy territory on July 20, stopping first in Rotterdam before meeting Gerbier at Delft the next day, the first of eight they would spend together. That quiet city of canals was just a

short ride from The Hague. Rubens made it a special point to avoid
the Dutch capital, where his presence would have engendered wild
speculation among the political classes. Carleton, to avoid suspicion,
chose to leave the proceedings entirely in the hands of Gerbier, even
as he was the senior diplomat. "In this ombragious tyme and place
there can not bee too much circumspection used to prevent incon-
veniences," he wrote back to London. To avoid any misunderstand-
ings, he secretly dispatched his nephew to inform Frederick Henry,
the Prince of Orange, of the negotiations. The prince was thought to
be amenable to some kind of accommodation with the Spanish,
even as he was massing an army against them at Arnhem.

Delft was just the first stop on the itinerary of the two artist-
diplomats, and given its proximity to the chattering hordes at The
Hague and the relative paucity of artists worth visiting, it was not a
good place for them to remain. Scaglia joined them there, but only
briefly. To keep up appearances, the group probably visited the
workshop of Michiel van Mierevelt, a distinguished portraitist and
friend of Pieter van Veen, Rubens's Dutch lawyer. When they had a
chance to remove themselves from their hosts, they broached the
subject that had brought them together, delicately at first. Rubens
was effusive about the good intentions of his superiors and their
receptivity to England's overtures. But whenever Gerbier tried to
draw from him some concession, the great Flemish painter parried.
Rubens was a man accustomed to delivering the most tangible of
miracles, but now he was placing the creative onus squarely on his
English counterpart.

Carleton kept tabs on the two men, reporting back to London
that the artists were "walking from towne to towne," discussing pol-
itics and pictures. At Utrecht, the two men lodged at the Kasteel
van Antwerpen. The name of that elegant boardinghouse along the
Oudegracht must have been a comfort to Rubens. It was also the

finest place for a visitor to lay his head in Utrecht, and it was just a short stroll west from its door to the center of town, where the painter Gerrit van Honthorst had recently purchased a decommissioned cloister on the Dom Square. It was an impressive home, one appropriate for the dean of the painters' guild in a city that was then the capital of Dutch art.

Utrecht's reputation as a haven for art made it a logical destination for a painter traveling from Flanders. That it was also known as a Catholic holdout in the increasingly pluralistic, or at least tolerant, United Provinces also made it appealing for a visitor who practiced that religion. Indeed, Utrecht could boast a long tradition as a center of Catholic learning. Adrian VI, a Utrecht native, had been elected pope in 1522. A century later, better than half of the city's population of thirty thousand practiced the Roman faith, though not too publicly. Services were held in *schuilkerken*, underground prayer rooms, some resplendently ornamented. Rubens, who liked a morning mass, probably visited one during his stay.

Among its intellectuals, Utrecht's Catholic history bred an interest in the classical tradition of Rome, heart of the Counter-Reformation. Honthorst himself spent at least four years honing his craft there. His dusky, candlelit genre scenes earned him an impressive following among Rome's leading patrons (including the cardinal Scipione Borghese, also a Rubens client) and the nickname Gherardo della Notte—Gerrit of the Night. When he returned, he became the most visible of several Utrecht painters, the *Caravaggisti*, who made a business of fusing the Italian painter's frank theatricality with a more domesticated Dutch sensibility.

Honthorst's painting was indebted to Caravaggio, but his professional practice was quite consciously modeled on that of Rubens. Indeed, when Rubens walked into the Honthorst studio for the first time, it must have seemed quite familiar: a large open

space, one hundred meters square, packed with student apprentices who paid a 100-guilder annual tuition to learn from the master. One student in particular caught Rubens's eye: Joachim von Sandrart, an ambitious twenty-one-year-old from Frankfurt who was at work on a painting of the Greek philosopher Diogenes. According to Sandrart, Rubens was "well pleased" with the picture, and made a few encouraging suggestions.

As Honthorst was occupied with other affairs—in fairness, Rubens and Gerbier had arrived on short notice—Sandrart was deputized to escort the two men around Utrecht. Together, the group visited the studios of Abraham Bloemaert, éminence grise of Utrecht's artists, and his son Hendrick, also a painter; Cornelis van Poelenburg, an old Rubens acquaintance from Rome, who commemorated the meeting with a portrait of himself and his old friend; and the *Caravaggisti* Jan van Bijlert and Hendrick ter Brugghen. Rubens especially admired Ter Brugghen. He also took a shine to the sycophantic Sandrart. When Rubens and Gerbier left Utrecht, the young German went along with them. Whether he had any idea of what exactly the two men were discussing when he was out of earshot is unclear. In his account of the experience, written years later, it seems he had accepted at face value Rubens's explanation that the whole excursion had been intended "to forget his sorrows" following the death of his wife.

The enlarged group's first destination, after Utrecht, was Amsterdam, the city that had become all that Antwerp was in its golden age. Sheltered by the Zuider Zee and defended by the fierce Dutch navy, Amsterdam was now the financial capital of northern Europe, and its commercial tentacles extended clear around the globe. Its population, when Rubens and company arrived, was already beyond 100,000 and growing at an astounding rate. Rubens must have seen in it the Antwerp his parents knew, a proud boomtown

inventing itself daily. After a visit to the young metropolis just a few years earlier, Dudley Carleton had mused that forsaken Antwerp was a "towne withowt people" whereas in teeming Amsterdam there was a "people without a towne." Pleasure, then, was not what attracted Rubens and Gerbier to the city. It was commerce that made Amsterdam great, and it was commerce that brought the two artist-diplomats there. During their brief stay, Rubens and Gerbier met with the art dealer Michel Le Blon, who was commissioned to ship the remaining works owed Buckingham back to England. Given the Dutch blockade of the Flemish coast, it was necessary to send the pictures through Holland.

Upon his return to Utrecht, with Gerbier back in The Hague and Sandrart still in tow, Rubens was treated to a ceremonial banquet at the Honthorst home. Catholics (like the Honthorsts and Bloemaerts) drank with Calvinists (like Bijlert and Ter Brugghen) in a convivial atmosphere of mutual respect, united by the arts. Matters of religion were discussed, if at all, with an air of intellectual decorum. For Rubens, it must have seemed almost a fantasy come alive, a tangible reproduction of the secularized Antwerp that his parents knew in their youth and that the city might even become again if the destructive war between the Spanish and the Dutch could be resolved. If that scene made a strong impression on Rubens, the artist similarly impressed his hosts, at least according to Sandrart. "As far as he is excellent in his art," he wrote, "I also found him perfect in all other virtues, and I observed that he was highly esteemed by persons of the most exalted as well as the most humble rank."

That hagiographic sentiment masked the reality that during their eight days together, Gerbier and Rubens had progressed no further in their negotiation than they had on their first afternoon together in Delft. Shortly after they separated, Gerbier wrote in

frustration, "Rubens had brought nothing in black and white, and all that he said was only in words." Rubens, of course, had been specifically enjoined by the infanta and Spinola not to put anything down in writing—even their hands were tied until Messia's long-delayed arrival. This, however, did not preclude Rubens from requesting that Gerbier supply *him* with the draft of a formal agreement, a proposal flatly rejected by Buckingham's agent. With Messia still en route and Spanish intentions unknown, England was not prepared to offer up terms, for fear of revealing its hand and then being undercut. When the two envoys parted, they had achieved nothing of substance, though Rubens had convinced Gerbier to remain in The Hague for another month while Messia, now reported to be healing his injury in Paris, made his way north to Brussels. When Carleton heard about that, his native skepticism only increased. Writing back to England, he noted drily that Messia's "long abode there under pretense of sickness must needs cover somewhat else . . . Why could not Messia, though sick, come as well forward from Paris to Bruxells as he did in the same estate from Burdeaux to Paris?" That was a reasonable question, and the answer would prove displeasing to all parties.

꧁꧂

BACK IN ANTWERP, Rubens found himself in an unpleasant limbo—in his words, "suspended between hope and fear." A new Dutch offensive near the German border only amplified that sense of unease. Frederick Henry, the Prince of Orange, had placed his army in three siege camps around the fortified city of Groenlo, and rumors swirled through Brussels and Antwerp as to its fate. By the beginning of September 1627, the defenders had run out of ammunition and had taken to firing from their cannon whatever matériel could be requisitioned. The son of Maurice, the late Prince of

Orange, was killed by a pewter spoon. Eventually, even Groenlo's kitchen cupboards ran bare, and the town was forced to surrender. It was a victory for the Dutch, though not a major breakthrough in the war.

Another military campaign, however, was proving to be an even greater impediment to the prospects of an Anglo-Spanish treaty. Back in early July, just as Rubens and Gerbier were haggling over the location of their meeting in Holland, the Duke of Buckingham landed with an assault force of more than six thousand English soldiers at Île de Ré, a well-defended island guarding the French port of La Rochelle. Buckingham's attack on Spain at Cádiz, two years earlier, had been an utter fiasco. Now, with Spain still a declared enemy, he was trying his hand as a military commander once again, this time in support of La Rochelle's Huguenot population, then under siege by French forces. Even with the duke's history of political and military bungling, reports of this mission came as a surprise within Europe's diplomatic community. Rubens himself commented that he "never believed the English would have the boldness to make war on Spain and France at the same time," and astutely speculated that the move would bring about an alliance of convenience between Spain and France, traditional foes.

Buckingham and his forces were still bogged down on the French coast when Rubens wrote to Gerbier, on August 27, to apologize for stranding him for so long in The Hague. While admitting Gerbier had cause to be upset, Rubens suggested that Messia was now, finally, on his way to Brussels and that this augured well for their plans. That report, however, was inaccurate. In fact, Messia would not arrive for another two weeks, and when he did he carried with him news that would dash the hopes of all those who had been working to broker an Anglo-Spanish alliance. As Carleton had suspected, Messia's prolonged stay in Paris did indeed "cover

somewhat else." That, specifically, was news of just the alliance of convenience between Spain and France, the two great Catholic powers of western Europe, that Rubens had predicted. If that information wasn't exactly shocking, what came next was: Spain and France had secretly agreed to their alliance a year and a half earlier, in March 1626. This was to be not merely a defensive pact, either, but an offensive treaty predicated on a joint invasion of England.

And so it was revealed that for the last several months Spain had been playing a double game, treating for peace with England through Rubens at the same time that it was planning to attack it with France. When Philip had granted his aunt Isabella permission to negotiate with England—albeit without Rubens—he simply backdated the authorization by fifteen months, to predate the already-agreed Franco-Spanish alliance. (So much for the "dignity" of his kingdom.) Messia's mission, from the start, had been to travel to Paris to plan the joint Franco-Spanish invasion of England. Buckingham's attack on the French coast, however, superseded the invasion plan. Instead of that grand operation, Messia agreed that the Spanish fleet would provide assistance to French naval and ground forces fighting Buckingham's men at Île de Ré.

For Spinola and the infanta, this news came as a blow. Rubens reported that the two were "much grieved at the resolution" taken by Spain. For a week, the group worked to "disabuse" Messia of the error of Spanish policy, and to petition Madrid to continue the peace process with England. Their interest, of course, was primarily to end the war with the Dutch, which had such devastating consequences in Flanders. They strenuously objected to any close alliance with the French, who had been allies and financial supporters of the Dutch cause ever since the 1624 Treaty of Compiègne. In such straitened circumstances, with coffers so empty that work on the Fossa Mariana was already halted, it made more sense to forge

peace rather than instigate a war. Rubens was particularly upset. "It appears strange that Spain, which provides so little for the needs of this country that it can hardly maintain its defense, has an abundance of means to wage an offensive war elsewhere," he wrote. He chalked up the Franco-Spanish alliance to "an excess of ardor for the Catholic faith, and hatred for the opposing party."

The objections of the Flemish leaders did not go unheeded; Messia had particular reason to take the counsel of Spinola, his future father-in-law. But for the moment there wasn't much choice but to officially notify the English of the new alliance, if not its ultimate objective. Negotiations would have to be put on hold, at least temporarily. In an official letter written on the morning of September 18, Rubens reluctantly informed Gerbier of the new state of affairs. "It is thought for the present the business cannot be proceeded with," he wrote, "because the arrival of the Lord Don Diego Messia has enlightened us on the union of the kings of Spain and France for the defense of their kingdoms."

That was the official response. But after so many months working with him, Rubens clearly felt he owed Gerbier more of an explanation. His reputation not just as a diplomat but as a gentleman was dependent on his integrity, here thrown into question by forces beyond his control. The alliance with France, he tried to assure Gerbier, would "be like thunder without lightning, which will make a noise in the air without producing an effect, for it is a compound of diverse tempers brought together in a single body against their nature and constitution, more by passion than reason." For his own part, he regretted their failure and pledged that his intentions had always been sincere and that he had devoted all of his energies to their negotiations.

Even that apologia, however, was not exculpatory enough to assuage the guilty conscience of a man not normally given to bouts

of insecurity. Writing yet again on the same day, Rubens placed blame for the failed negotiations squarely on the shoulders of the Count-Duke of Olivares, Philip's scheming and heedless *valido*:

> *The business is at an end, and the orders received from Spain cannot be altered. I will not deceive you under pretext of friendship, but speak the truth openly; the Infanta and the Marquis are resolved to continue our Treaty, being of the opinion that the "Concerts" between France and Spain will have no effect, and will not last, so that every wise man, be he a politician or a priest, laughs at it . . . no change can be promised, and some time must elapse before we can hope that Olivares will open his eyes and agree to it . . . In the meantime, if you are willing to maintain matters with us in their present state, and to keep Buckingham in good humor, this can do no harm. We do not pretend thereby to prevent or to retard any warlike enterprise, nor are we trying to conceal any plot. We do not wish to keep you any longer, by vain hopes, away from my Lord your master and from your dear wife.*

Gerbier appreciated Rubens's efforts, but there was no escaping the reality of the situation. "The game is at an end," he wrote in a disillusioned letter to Edward Conway, the English secretary of state. At the beginning of October, he was recalled from The Hague.

❧

ENCLOSED WITH THE FINAL LETTER of apology to Gerbier was a formal note of contrition from Rubens addressed directly to Buckingham, then still embroiled on the coast of France. "No change of fortune or violence of public destiny," he wrote, "will be able to separate my affections from your very humble service, to which I have

dedicated myself, and vowed once for ever to be." With brush or pen, Rubens was a master of the grandiose gesture of flattery. In this case, however, the pledge of eternal allegiance was disingenuous. Barely a week later, he wrote to his Parisian friend Pierre Dupuy, telling him frankly that Buckingham's "temerity" in attacking France was altogether inexcusable. "He seems to me, by his own audacity, to be reduced to the necessity of conquering or of dying gloriously. If he should survive defeat, he would be nothing but the sport of fortune and the laughingstock of his enemies."

Rubens's prognostication, in the coming months, would prove deadly accurate. On November 8, after a summer of futility, Buckingham sailed in disgrace from Île de Ré, having lost nearly two-thirds of his 6,884-man expeditionary force. By that time, he had also lost the respect and control of his men. The final English retreat was a chaotic, disorganized massacre, with the duke's soldiers cut to pieces as they crossed an open, unprotected bridge. Upon his return to England, the duke was bitterly lampooned in barroom lyrics that expressed the national frustration:

> *And art return'd again with all thy faults,*
> *Thou great commander of the al-goe-naughts;*
> *And left the Isle behind thee; what's the matter?*
> *Did winter make thy teeth begin to chatter?*

Charles nonetheless treated the duke to a hero's welcome, commending his bravery while blaming the loss on foul weather, which prevented the king from sending in reinforcements. Few believed that story, either at home or abroad. "Most impudent lies" was Rubens's response. In fact, Charles had left his favorite high and dry. It was not wind and rain that had held up Buckingham's reinforcements—it was paintings, and paintings Rubens knew well.

Just as the duke was bogged down on the coast of France, his sovereign was completing a two-year negotiation that would net him the finest fruits of the unrivaled Mantuan art collection, which had been put up for sale by the reduced Italian duchy. Charles, a connoisseur among princes, could hardly resist such an opportunity. But he'd been forced to make a choice: the paintings or the reinforcements for Buckingham. He could not afford both. The king was already in debt to the tune of 125,000 pounds, and his Italian banker, Filippo Burlamacchi, was ready to cut him off. "If it were for £2,000 or £3,000 it could be borne, but for £15,000"— the cost of the paintings—"besides the other engagements for his Majesty's service, it will utterly put me out of any possibility to do anything in those provisions which are so necessary for My Lord Duke's relief," wrote the financier. "I pray let me know his Majesty's pleasure." His Majesty chose the Raphaels and Titians of Mantua, his friend be damned. When Rubens later found out about the purchase, he was appalled. "This sale displeases me so much that I feel like exclaiming," he wrote. But it was the fate of those beloved Mantuan masterworks that concerned him, not the life of the duke. He hated to see the old city lose its artistic legacy.

The rout of Buckingham was actually a disguised blessing for those interested in an Anglo-Spanish alliance. A month after the duke's return to England, an express messenger showed up at the door of the Rubens house in Antwerp carrying with him an urgent letter from Gerbier. Though he had declared, barely three months earlier, "The game is at an end," he was now desperate to retake the field. "It is a fact well known to everyone that help from England was detained by unfavorable winds, and that was the sole reason for the unfortunate outcome," Gerbier informed an incredulous Rubens. "It is the usual stratagem of great leaders to retire in order to take up the same enterprise soon after with greater force and advantage."

There was no mistaking the intention of Gerbier's missive. From his private office, Rubens immediately drafted a note to Spinola: "The English are so embittered by their poor success against the French that they will do anything to enable them to take up that war again without the hindrance of the Spanish," he wrote. England was prepared to bargain and was practically throwing itself at Spain's mercy. As it was, Spinola was already planning a trip to Madrid, both to give his daughter away in marriage to Messia and to argue the case against the French alliance before Philip and the Count-Duke of Olivares. The king had granted him a three-month leave of absence from his duties in Flanders to make the trip, on which he would be accompanied by his prospective son-in-law. A renewed overture from England, an overture that carried with it the possibility of a resolution to Spain's economically catastrophic war with the Dutch, would only support their cause.

The game, indeed, was very much alive.

CHAPTER VI

MORE USEFUL THAN

INJURIOUS

⌘

> The interests of the whole world are intimately connected
> at this moment, but the kingdoms are governed by
> men without experience, indisposed to follow any advice
> but their own, incapable of carrying out their own
> schemes and unwilling to accept other people's.
>
> —PETER PAUL RUBENS

Spinola and Messia left for Madrid on January 3, 1628, with a hard rain lashing down that transformed the road south into a rutted, porridge-like quagmire. They had only just begun their journey when their baggage cart tipped over in the wind. It was not the start they had hoped for, but they were still happy to be traveling together. There was urgent state business to attend to in Madrid, of course, and the two men could plot their strategy at court on the long ride to the Spanish capital. Better yet, they could get to know each other as father and son. Messia, the young lion of Spain, would be marrying Polyxenia Spinola, daughter of the hero of Breda, the very week of their scheduled arrival in Madrid.

Before their damp and windswept departure from Flanders,

both men visited Rubens at his Antwerp home, and not just to confer on political matters. The artist hadn't had much time to practice his true calling during the previous year—his constant travel on both personal and state business had severely curtailed the studio's output—but the breakdown in negotiations following his trip to Holland had at least allowed him the freedom to get back to the work he enjoyed best. Among the projects that engaged him were portraits of the two soldier-diplomats heading south.

Messia's sitting began with a portrait drawing. On a thick sheet of cream paper, Rubens set up a faint grid of regulating lines, and began the quick work of drafting the marquis in black and white chalk. Beneath a head of unruly hair, he sketched Messia casting a forbidding, almost cruel glance at some unseen subordinate off to his right. When the artist was satisfied, he went over it with more chalk, adding a bit of red for color and black ink for emphasis. In the finished painting that followed, Messia stands ramrod straight in a gleaming suit of armor. The marquis had a reputation to uphold as a man of formidable martial ability, and Rubens treated him accordingly. The portrait was probably commissioned to celebrate Messia's recent elevation to the title of marquis, and he was justifiably proud to own it. In the future, he would acquire additional works from Rubens, purchased both from the artist himself and on the open market. Indeed, he considered himself a "grande aficionado" of Rubens's work. Rubens, in turn, judged Messia among the "greatest admirers" of the art of painting in the world.

Ambrogio Spinola, on the other hand, was no one's idea of a great connoisseur. According to Rubens, he had "no taste for painting" and understood "no more about it than a janitor." This, however, had not kept Rubens from developing a genuine and abiding affection for him. In a time of grandiloquent verbosity, Spinola played his cards close to the vest, a trait Rubens particularly admired.

"He is the most prudent and the most sagacious man I have ever met," wrote the artist. That fondness is evident in Rubens's portrait. As with his future son-in-law, Rubens pictured Spinola wearing a gleaming suit of armor, a plumed helmet resting by his side. But Spinola's ruddy-cheeked countenance is gentle and knowing rather than foreboding and severe. There is almost—but not quite—a smile issuing from the beatific face above his well-starched ruff collar.

Rubens was still working on that portrait of Spinola in late January when he received another visitor at his residence on the Wapper: Josias de Vosberghen, Denmark's ambassador to The Hague. Unlike the two marquises, Vosberghen had no interest in commissioning art from the painter; he had come south from Holland for one reason only: to conduct clandestine state business with Rubens. An eccentric prone to flights of exaggeration, Vosberghen introduced himself as an intimate of Frederick Henry, the Prince of Orange, and a confidant of Dudley Carleton, his English counterpart in the Dutch court. Through Carleton, he had learned of the failed negotiations between Spain and England, and he was now presenting himself as yet another mediator capable of resurrecting them. Most crucially for Rubens, he offered a path to reconciliation with Holland and an end to the war of attrition that had such terrible consequences on the artist's beloved Antwerp.

As a representative of Protestant Denmark, Vosberghen was not a disinterested party to the state of affairs in the Low Countries. In 1625, sensing an opportunity to exploit what was already a chaotic situation in neighboring Germany, Denmark's king had sent an invasion force south into Saxony. Two years later, that army had been thoroughly vanquished by Habsburg troops loyal to the Holy Roman Emperor, and those Catholic forces had subsequently occupied the entire Jutland peninsula, that thumb of land separating the North and the Baltic seas that makes up much of Denmark's

territory. Denmark, then, had much to gain from a peace with Habsburg Spain, and Vosberghen was there to suggest a bit of diplomatic quid pro quo.

Walking along the carefully tended paths of Rubens's handsome garden, Vosberghen got straight to his point. "If the king of Spain deals directly with the Dutch, he will never attain his purpose," he explained. On the other hand, if Spain could compel its Habsburg allies to return Jutland to Denmark and the Palatinate to Frederick V, the Danes and their English allies would push the Dutch to relinquish their claim of independence. As Rubens took that in, the ambassador added, "Is it not unjust that, for the sake of a mere name, all Europe should live in perpetual war?"

Rubens may have agreed with that last assertion, but he knew Vosberghen's demands were beyond the control of his sovereign. "The claims of England and Denmark concern Spain only because of its blood-relationship with the house of Austria," he replied. Indeed, this was precisely the argument he had made a year earlier when the Spanish negotiating team had insisted that, in Gerbier's words, "a great undertaking never advances straight forward upon two roads."

Vosberghen countered that Spain was so influential that its mere insistence would overcome any opposition among its Habsburg allies. That was probably wishful thinking, but the Dane was undeterred. He informed Rubens that he would be making similar overtures in London, his next port of call, and wanted permission to use the painter as a conduit to the infanta after his arrival there. Before departing, he even left Rubens a secret code to cover their future correspondence.

The artist duly reported his conversation with the Danish diplomat to Isabella and, via dispatch, to Spinola, then still en

route to Madrid. The two were not especially pleased to have yet another interloper meddling in their affairs. They had similarly looked askance at the efforts of Savoy's Abbé Scaglia to introduce himself into negotiations a year earlier. (He had since been side-lined, despite his best efforts.) And as of February 1628, it didn't seem as if they needed any help, for they were already conducting secret peace talks with the Dutch on their own: negotiations had been under way for several months at Roosendaal, some thirty-five miles north of Antwerp in Dutch territory. Indeed, the infanta's representative at those talks, Johan Kesselaer, had made substantial progress, with the Dutch conceding that their title as "free states" need not be a precondition to further negotiations with the Span-ish crown. It is quite probable that Rubens himself was a party to these talks, at least in their early stages. The previous October, Rubens had made an unexplained and undocumented trip into Holland, presumably on diplomatic business.

With the Roosendaal talks in mind, Vosberghen was kept cool-ing his heels in Antwerp until directions arrived from Madrid, in late March 1628. "His Royal Majesty of Spain is very well disposed to make peace with those with whom he is at war" was Spinola's predictably tepid response. Vosberghen would have to be officially authorized by the allied parties he claimed to represent (that is, the English and the Dutch) before Spain would deign to treat with him. It was just the kind of noncommittal committal that had so aggra-vated Gerbier in the past, and it was no doubt meant to dispose of the Danish agent without formally rejecting his offer. It was left to Rubens to inform Vosberghen of this development. "There cannot be any basis for negotiation until you obtain your powers in good form," he wrote to the Dane. At least, Rubens added sympatheti-cally, Spinola's presence in Madrid suggested that progress was

imminent. "His diligence will overcome all delays on the part of Spain," he wrote. That, he might have guessed, was promising too much.

<center>⚜</center>

VOSBERGHEN DID MAKE IT to London, but he was no more success-ful there than he was in Flanders. Gerbier thought him a "strange microcosm" and was not inclined to trust him one way or another. "To speak the truth," he told Carleton, "I am of opinion that his alchemy will bring forth nothing but smoke, seeing the inconstancy of his mind and of his imagination." In the meantime, Gerbier had retaken correspondence in earnest with a party he always believed to be, at the very least, sound of mind: Rubens.

In fact, the two men had never been out of touch, even when relations between their respective crowns were at a nadir. The pre-vious December, just before Christmas, Rubens had written to Gerbier, informing him of Spinola's impending departure for Madrid—a hopeful development. But he enclosed with his own let-ter one from the marquis that he knew Gerbier would not receive with pleasure. In that note, Spinola demanded Gerbier explicitly spell out English conditions for a prospective peace deal with Spain. "When any one thinks of agreeing with another, it is well to propose a thing that is much to the purpose, that thus they may agree," he wrote.

That phrasing must have struck hard at Gerbier, who had recently spent a good four months marooned in Holland explicitly waiting for just that kind of firm commitment from Rubens but receiving nothing even remotely concrete. His aggravation pent up, he dispatched a series of replies to Rubens expressing both the English position and his upset personal feelings. It was a measure of Gerbier's flustered disposition that they were written in several lan-

guages and that some were coded and others not, a state that compounded the already difficult challenge of deciphering his rather creative grammar and handwriting. These papers arrived in packets at Rubens's rooms at the Golden Swan, his usual residence in Brussels, over the course of a single day at the end of March. (The long wait for Gerbier's response was due to the death of a courier en route, one of the hazards of seventeenth-century correspondence.) Rubens, who had presumably come to the capital to facilitate negotiations, immediately took Gerbier's letters to Coudenberg Palace, where he was given a private audience with the infanta. Only Rubens could translate Gerbier's awkward, coded messages. From the mess, he went over the salient points with Isabella:

- Gerbier remained upset about his treatment during the previous round of negotiations. He believed that the talks in Holland had been a ruse to allow Spain time to form an offensive treaty with France, behind England's back.
- Given that history, it was incumbent on Spain to offer a concrete proposal, and to officially authorize the infanta to negotiate with England.
- Charles was using all his powers to bring the Dutch to heel. Their insistence on being described as "free states" in any formal documents—a nonstarter for Spain—could be circumvented by referring to the Dutch merely as "allies" of Great Britain.
- Scaglia was to be kept as an intermediary. His political skill made him a useful ally to the negotiators and a potentially disruptive enemy, especially with the French working to undermine their efforts. Also, Scaglia's Savoyard couriers could travel directly between Flanders and England, a useful convenience. (The English couriers they had been using were forced

to travel through Holland, a detour that sent their correspondence through enemy territory.)

- Vosberghen, on the other hand, could be jettisoned. His plan to broaden the scope of the negotiation was pointless. "He who wishes to embrace the whole will succeed in nothing," wrote Gerbier.

- All negotiations would have to remain secret. This was of pivotal importance to the English king, who was already at loggerheads with a volatile Puritan opposition in Parliament that was absolutely against any treaty with Catholic Spain.

At the infanta's instruction, Rubens sent a précis of the Gerbier correspondence along to Spinola in Madrid, as well as a few of the original letters. Most of the documents Rubens retained, figuring the marquis would have trouble deciphering the codes and translating Gerbier's arcane Flemish grammar. He did not, however, shy from reproducing the hectoring, frustrated tone Gerbier had adopted in his correspondence. Frankly, he was entirely sympathetic to his English counterpart's aggravation. He, too, was tired of the needless hurdles Madrid imposed while Flanders—and the rest of Europe—suffered. For his beloved but blockaded Antwerp, the situation was especially dire. "Our city is going step by step to ruin," he wrote, "and lives only upon its savings; there remains not the slightest bit of trade to support it."

Rubens was right, at least, in thinking that Spinola had more to worry about than the illegible correspondence of a British agent. When Spinola and Messia arrived in Madrid, in the last week of February, their coach was received outside the city by a large contingent of court functionaries anxious to meet the hero of Breda. The mood was jubilant. In just four days, Spinola would celebrate the marriage of his daughter to his traveling companion. That

affair, the social event of the season, would take place in the court of the Real Alcázar, with Philip IV and all the grandees of Spain in attendance.

For the moment, however, it did not go unnoticed that Spinola departed his glorious welcome in the private carriage of the king's *valido*, the dour-faced Count-Duke of Olivares. It was the first time the two had met, and from the start it was an uncomfortable relationship. Their personalities, certainly, could not have been more different. Olivares was severe and punctilious, an intellectual, and, as Rubens would later note, a plotter of "great enterprises." He reputedly kept a coffin in his chambers as a standing reminder of his mortality. Frightened visitors often wondered if theirs was at stake. An equestrian portrait by Velázquez shows the count-duke sneering over his shoulder on a rearing steed, the upturned ends of his mustache giving him an aggressively menacing, even villainous appearance. This was a far cry from the regal mounted portrait Rubens had made of Olivares's predecessor, the Duke of Lerma— to say nothing of the painter's stately depiction of Spinola in his gleaming armor. Those contrasting images of Olivares and Spinola, the former belligerent and the latter self-possessed, explained a good deal about the two men, and their antipathy. The count-duke was an emotional man, prone to fits of melancholy, and insistent on the maintenance of his image as a broker of Spanish power. Spinola, however, had little to prove; his military accomplishments conferred a natural authority. He was a soldier's soldier, a man gripped by logistics and details, not especially eloquent but persuasively frank when the situation required, as it did now.

Bumping along the road into Madrid, Spinola had the unenviable task of informing the second-most-powerful man in Spain (the most powerful man, according to many) of precisely that which he did not wish to hear. As the commander of the Spanish army in

Flanders, Spinola had been the blunt instrument of the count-duke's foreign policy—a policy he could no longer support. The war in the Low Countries was not going well. Spanish offensives had stalled. Their great canal project was but a ditch in the ground. The Dutch had taken Groenlo. There were no funds to pay the army. The prospect of widespread mutiny—for which there was ugly historical precedent—was dangerously close to becoming reality. The entire country was on the brink of catastrophic financial collapse. As Spinola saw it, there were but two options: substantially increase war funding from Spain or forge a peace with the Dutch. As the former seemed out of the question, there was no alternative—it was time to make peace. With the Habsburg forces of the Holy Roman Empire threatening in nearby Germany, the Dutch would be motivated to bargain.

From the comfort and safety of his apartments at Madrid's royal palace, the count-duke had developed an entirely different vision of Spanish affairs. As far as he was concerned, this was no time for compromise. With the English humbled, France bogged down fighting the Huguenot rebellion at La Rochelle, and imperial troops ready for action in Germany, the time was right for Spain to press its advantages across Europe and to secure its colonial empire abroad. That the Dutch were making concessions at Roosendaal only hardened his resolve. "Never in history," he said, "has there been such a favorable season for the Catholic cause."

Spinola and Olivares's heated, joyless ride into the city culminated in a private audience before His Royal Majesty Philip IV. Tall, gawky, and still a month shy of his twenty-third birthday, the conflict-averse "Planet King" stood pensively in his bedchamber, where he received his most important visitors. (The moniker alluded not to the breadth of his empire but to his celestial presence as the head of state.) Normally, he simply deferred to the advice of

the count-duke; the *valido* had been his mentor ever since Philip had ascended the throne at the tender age of sixteen. In that time, Olivares had orchestrated state policy while the young king received the rigorous physical and intellectual education appropriate for a Habsburg ruler. Now, however, his reflexive dependence on Olivares was tempered by the commanding presence of Spinola, the most distinguished military officer in his service. The hero of Breda was not a man who could be easily dismissed, especially when he was speaking with such insight and conviction. Inevitably, given Philip's temperament, there was no resolution, and the debate moved on to the Council of State.

For better than a month, Olivares and Spinola vied for support within the council, making impassioned arguments behind closed doors over troop strength requirements, the costs needed to effectively prosecute a war, and the extent of Spain's diplomatic and military leverage across Europe. It was, by any standard, a nasty fight between two political heavyweights. To Olivares, Spinola was an overly cautious obstructionist without the political vision to capitalize on Spain's great hegemonic moment. Spinola, conversely, presented Olivares as an ideologue divorced from the ugly realities on the ground in the Low Countries—ugly realities generated by the count-duke's failed policies.

Removed from the action and largely in the dark, Isabella's Brussels court was consumed by anxiety as Spinola fought the battle of his political life. Indeed, the embroiled marquis had little time for correspondence describing the shifting allegiances within the council. In mid-April, Rubens wrote to his Parisian friends that Spinola was "gaining authority" with Philip and his ministers, but the truth was that this assertion was based more on hope than on fact. Two weeks later, with frustration setting in, the artist complained of Spanish intransigence, not to mention the "lazy and

indolent character" of its citizens, a slur that was well beneath his dignity. By summer, he was almost entirely disillusioned. "The Spaniards think they can treat this sagacious man as they are in the habit of treating all those who go to that court for any business," he wrote. "All are dismissed with empty promises, and kept in suspense by vain hopes which are finally frustrated without having settled anything."

As Rubens both feared and suspected, Spinola was putting up a valiant effort but fighting a losing battle. The end product was a Solomonic decision to authorize Isabella to negotiate with the Dutch, as Spinola wished, but to make demands so uncompromising and draconian that they would almost certainly be rejected. These were outlined in a twenty-three-article memorandum authored by Olivares, the key stipulations being: Dutch withdrawal from the Americas; the opening of the Scheldt; open Catholic religious practice in the provinces; and a full recognition of Spanish sovereignty in perpetuity. In exchange, the Dutch would be granted what they already had in practice—de facto political freedom. Moreover, Spinola was ordered to return at once to Brussels to begin a new military offensive aimed at increasing Spanish leverage. The Dutch would be forced to capitulate either in the field or at the bargaining table—whichever came first.

Isabella was informed of this new policy direction in a letter from her nephew Philip written on May 1, 1628. In addition, the infanta was ordered to supply the king with *all* of Rubens's correspondence with Gerbier and Buckingham regarding a peace agreement with England, not just the letters Rubens had seen fit to forward along to Spinola. If the crown was to do business with England, the crown was to be fully informed of the conduct of its agents. How was Philip to be sure that Rubens—a mere artist—

had not misconstrued some important point or failed to capture some delicate nuance in Gerbier's correspondence?

It was another in a string of condescending requests emanating from Madrid, but Rubens was by now inured to such affronts to the extent that he was aware of them, and being inherently positive in outlook, saw quickly how it might be turned to his own advantage. He was already planning the long journey he had hoped to take in the wake of his wife's death. The brief trips he had made since then, first to France and then to Holland, had been all business, and not without stress. He was ready for something a bit grander. Rome had beckoned. After so depleting his cabinet of antiquities in the sale to Buckingham, a trip to the city he loved so much would allow him to restock his trove of classical statuary and medals. The potential patronage of the Vatican must also have been a draw. On the way south, he could stop to look again at his Medici cycle in Paris and then visit his old friend Peiresc at his home in Provence. Indeed, he had informed several of his friends, including the antiquarian Jan Caspar Gevaerts, of his intention to travel to Italy before the end of the year.

Now, however, he saw it would be expedient to change his itinerary. In place of Rome, why not go directly to Madrid, where he could personally translate Gerbier's letters? There, he would have entrée to the collections of the Escorial, and if not the patronage of the pope, then of the king of Spain. Better still, his expenses would be paid, and he would have the opportunity to see to it that all of his diplomatic work would not be simply abandoned by Philip and his do-nothing Spanish court. An oft-quoted proverb came to mind: "He who wants something goes himself; he who does not sends another." Rubens, perhaps in response to Philip's foot-dragging, had even taken up the promise of opportunity as a subject for his art. While waiting for Madrid to take action, he repeatedly depicted

the allegorical figure Occasio, a typically refulgent maiden whose golden locks (representing the chance for peace) were grabbed not by a willing prince but by a sullen warrior. Given the situation, he could be forgiven for his pessimism. At the same time, with Antwerp suffering, he sketched out several more realistic images of human suffering: a bereaved woman sitting, head in hand, crumpled on the ground as battle is waged behind her; a pair of naked warriors placed back-to-back, their wrists lashed with an angry sea in the distance. So, yes, Rubens told Isabella, he would be happy to forward his correspondence along to His Majesty, but with the coding and the language barrier and Gerbier's weird syntax, wouldn't it be better if he delivered the letters in person?

Even this proposal was too much for the unsure king to resolve without consultation. On July 4, the Council of State decided—or rather did not decide—that negotiations with England "may be pushed forward or held back according as it be judged opportune. If they are to be continued, the advent of Rubens will be more useful than injurious." Two days later, Philip sent off his answer to Isabella. "On the subject of Peter Paul Rubens," he wrote, "since he has given us to understand that he will come to Madrid if bidden to do so, and will bring with him the letters in his possession on the subject of the negotiations with England, it will be well for your Highness to request him to do so, but after agreeing with him that he shall be careful to bring all the documents of the kind which he has in his hands . . . Nevertheless, we must abstain from insisting on it with him, but leave him to decide it according to his own convenience."

That was good enough. Rubens, unlike Philip, never lacked for decisiveness. This was, after all, the man who liked "brief negotiations, where each party gives and receives his share at once." On August 13, the infanta informed both the king and the count-duke

that Rubens would soon be on his way. Preparations began at once. A letter of recommendation for Deodate del Monte, the artist's assistant of so many years, was notarized. During his absence, custody of the painter's two boys would be jointly entrusted to their maternal grandfather and uncle. The education of his elder son, Albert, whom he called "my other self," was left to Gevaerts, "the best of my friends and high priest of the Muses." In the event some calamity might befall him, Rubens prepared a legal statement recording all of the worldly goods they would inherit. Looking at it all on one sheet, even Rubens himself must have been astonished by the scale of his accumulated wealth. Much of it was in real estate. There was his own home and workshop on the Wapper, of course, along with the adjacent houses, another a few blocks away on Jodenstraat, and seven more recently purchased with the profits from the Buckingham sale, which he leased out. Beyond the city walls, he had a thirty-two-acre farm, at Zwijndrecht, and a smaller tract at Ekeren, for which he annually received 400 guilders in rent. There were financial instruments as well, large annuities to be paid by the city of Antwerp and the state of Brabant. And finally there were the family jewels, not just his late wife's gems—those were valued at 2,700 florins—but also Rubens's paintings, those by his own hand and the many other works, large and small, old master and contemporary, he had purchased for his cabinet. Whatever the fate of their father, Albert and Nicolas Rubens would never want for material advantage.

RUBENS WAS HAPPY to be back in the saddle, and the ride south from Antwerp to Spain was a scenic one. In a rush, he barely stopped to admire the French countryside, and didn't even pay a call on his Parisian friends. His only significant break was a detour

to the Atlantic coast for a review of the impressive French siege works at La Rochelle. (Buckingham's English force had been dispatched at nearby Île de Ré, but a stalwart Huguenot contingent stood firm within the city walls.) He was given a private tour by the superintendent of the works, which he deemed "a spectacle worthy of admiration." Then it was on to Madrid, posthaste. The infanta had specifically ordered him not to dawdle, and the king himself was expecting his arrival.

It was good, then, that Rubens kept himself fit, and practiced his riding technique daily along the Antwerp ramparts. For a lesser man, the long trip might have been an enervating trial. For Rubens, a skilled equestrian, it was a matter of personal satisfaction that he could make it in good time. On September 15, a mere two weeks after departing Antwerp, he proudly trotted his horse across the broad expanse of the Plaza de Palacio and through the main gate of Madrid's Real Alcázar. It had been decades since his last visit to the royal palace, and though he recognized its broad expanse, there was no denying that it had changed considerably—and for the better—in the intervening years. The Alcázar that he had seen on his first trip to Madrid, a brief stopover during his embassy for the Duke of Mantua, was a dank and grim affair, with small windows and thick walls designed to protect its inhabitants from enemy fire and the harsh summer rays of the Castilian sun. The name itself, derived from the Arabic term for "castle," *al-qasr,* testified to its origins as a ninth-century Moorish fortress. More recently, when Philip III returned his court to Madrid after its abbreviated residence in Valladolid, he initiated a major campaign to beautify the building and its grounds, under the direction of the royal architect, Juan Gómez de Mora. The entirely new front facade, with classically framed windows and a central portico, was only completed in 1621.

Rubens came alone, but not unencumbered. Packed carefully

against the elements—he had learned his lesson on that first Spanish trip—were eight canvases to be placed in the Salón Nuevo, a large reception hall on the main floor of the palace with balconies looking out onto the plaza below. Gómez de Mora had remodeled it into a magnificent gallery with richly carpeted floors and gilded cornices, the better to accentuate the most cherished fruits of His Majesty's art collection. Among the paintings installed when Rubens arrived were eight Titians, including the famous equestrian portrait *Charles V at Mühlberg*. As a pendant to it, there was a portrait of the reigning monarch, Philip IV, also on horseback. That was the work of the gifted young painter recently honored with the title "usher to the king's chamber": Diego Velázquez.

Rubens had pushed himself hard to complete the paintings he carried with him in the frantic month before he left Antwerp. These pictures, with their biblical and classical subjects, were conceived as four paired sets, each somehow reflective of the virtues of Habsburg rule in general and Philip's reign in particular. In designing the allegorical program, however, Rubens couldn't help but reference the mission that had commanded his attention for the past two years, and now brought him to Madrid: the negotiation with England. The inescapable subtext of his *Samson Breaking the Jaws of the Lion* was the figurative defanging of Buckingham and the British crown (historically identified with the lion). The *Reconciliation of Jacob and Esau*, depicting biblical brothers, made subtle allusion to Philip and Charles, the two art-loving young kings who had, in fact, nearly become brothers (in-law) in 1623. All together, the group of paintings made an inspired pictorial argument for the cause Rubens came to support, though one abstract enough to avoid any suggestion of impropriety.

These were not the only Rubenses to reach Madrid along with the painter. In the weeks before he departed Antwerp, another ship-

ment left Flanders for the Spanish capital, this one carrying a series of twenty enormous tapestries celebrating the Eucharist. It was his biggest tapestry series to date, though not his first. The hangings were a gift from the infanta to the Convent of the Descalzas Reales, where she had prayed in her youth, and she had paid dearly for them: 30,000 guilders for Rubens's designs and another 100,000 for the tapestries themselves. In its scale, or at least its price, the project rivaled the series of paintings Rubens had created for Marie de' Medici, though the infanta's intentions were considerably less narcissistic than those of the vainglorious French queen. As a mark of tribute, Rubens inserted the humble infanta's image into one of the tapestries.

The painter's arrival did not go unnoticed in the halls of the great palace. The Alcázar was the residence of the royal family, but also the seat of Spanish government, and its paired courtyards, one each for the king and the queen, were typically alive with the hustle and bustle of grandees, functionaries, merchants, and assorted looky-loos. The papal nuncio, Giovanni Battista Pamphili, reported Rubens's presence back to Rome, noting that "he often confers in secret with the count-duke, and in a manner very different from which his profession permits." The story emanating from the king's chambers was that Rubens was in town to favor His Royal Highness with a portrait, but Pamphili wasn't buying that explanation. "It is believed that this great friend of Buckingham has come to propose a treaty of peace between the two kingdoms," he wrote, "or else that he has been charged, as one enjoying the confidence of all his countrymen, to say what they think of a truce to be concluded in Flanders." The Venetian envoy, Alvise Mocenigo, similarly informed his doge that Rubens "has had several secret interviews with the count of Olivares."

They were right, of course. From practically the moment he had

dismounted his horse, Rubens had been consulting with Olivares on matters of state. Unlike Spinola, the artist seemed to get along well with the count-duke, who held him in high esteem. Whereas the marquis was an old soldier, quiet and efficient, Rubens was an urbane man of letters and no threat to the *valido*'s authority. They had, in fact, already established a respectful and charitable relationship. A few years earlier, at the count-duke's request, the artist had drawn a portrait of Olivares for use in a commemorative print. (Never having seen him in person, Rubens worked from original images provided by Velázquez.) Olivares responded with a gracious note, thanking Rubens for "the love that you have shown me." Upon the death of Rubens's wife, Isabella, the count-duke sent a letter of condolence.

This budding friendship did not prevent Rubens from offering a typically gimlet-eyed appraisal of Olivares and his retinue. In his correspondence from Madrid, he bemoaned the rather "severe" and "supercilious" nature of Spanish intellectual life, a tone set by the count-duke. Despite these personal reservations, Rubens was well prepared to navigate in that kind of atmosphere, and achieved in short order that which had failed Spinola for months: the conversion of Olivares to his cause. Rubens's gift for persuasion and his amicable relationship with Olivares surely contributed to this success. Though the count-duke remained unwilling to compromise with the Dutch, a peace with England was something he was beginning to see as useful. As Rubens argued, such a treaty would mean one less enemy for Spain and, through the good offices of the English king, increase pressure on the Hollanders to cave in to his demands.

At the end of September, the count-duke took Rubens and his advice to the Council of State. Olivares opened the session with a lengthy preamble, carefully framing the proposed peace negotia-

tion from a position of Spanish strength. England, having learned the futility of any attack on Spain after its pitiful and unprovoked expedition at Cádiz, was now on its knees before the Habsburg crown. Olivares proceeded to review his own correspondence with English ministers for the council, and then called upon Rubens to make a presentation to the assembly. Flanked by his new ally, Rubens exhibited the papers he had brought from Antwerp and asserted that in his estimation England was sincere in its desire to make a formal peace with Spain, and on acceptable terms.

Together, Olivares and Rubens made for a convincing team, and they could bolster their case by noting that an English envoy, newly arrived in Madrid, had informed them that Buckingham himself was willing to come to Spain to negotiate the proposed agreement. Moreover, Buckingham would be joined by Sir Francis Cottington, a two-time English ambassador to Spain and the most powerful Hispanophile in the English government. Informed of these positive developments, the typically wavering council accepted Olivares's request to formally open negotiations, and the diffident king followed with his approval. For a moment, it looked as if the whole plan just might come together.

Buckingham, however, was in no position to make a trip to Madrid—or anywhere else—in September 1628. He was dead, and had been for more than a month. At the end of August, a wounded and disgruntled veteran of the disastrous campaign at Île de Ré had taken a knife to the duke at Portsmouth, on England's southern coast. News of Buckingham's assassination did not reach Madrid until October, after the meeting of the Council of State. Rubens had in recent months predicted just such an ignominious end for his patron, suggesting the French failure would make him "the sport of fortune." But the moment of his death was, to say the least, inopportune. Buckingham, though widely detested, was the pri-

mary English champion of a Spanish alliance, and while it seemed there was still enthusiasm for the idea at Whitehall, there would be a temporary hiatus in discussions while the political situation in London sorted itself out.

RUBENS TOOK FULL ADVANTAGE of his extended time in the Spanish capital. He was assigned a suite of rooms in the Alcázar, where he shared a studio space with Velázquez adjacent to the Gallery of the North Wind, which was itself conveniently placed between a game room and the count-duke's private apartments. From their window, the two artists could look out to a mountain landscape. Off to their right they could see the *picadero*, used as a bullring and for equestrian sports. It is appealing to imagine the two men painting together in the crisp morning light and, in the afternoon, talking about their craft on leisurely strolls through the gridded parterre of the Jardín de la Reina, adjacent to the eastern wing of the palace. They had probably been in contact even before Rubens's trip to Spain, in regard to Rubens's portrait drawing of the count-duke.

According to Francisco Pacheco, Velázquez's father-in-law, the two painters became friends during Rubens's stay in Madrid, and even traveled together to visit the Escorial, an hour's ride north of the city. At the very end of his life, in one of his last letters, Rubens wrote fondly of that trip, though he didn't mention his traveling companion. The climb up through the Guadarramas was hard work for the artists, but they had made their journey on a warm day with gentle breezes. From the summit of La Nava, beneath an immense wooden cross, the two men could look over a great valley toward the broad facade of the monastery, the village adjacent to it, and the royal hunting lodge—the Fresneda—with its two crystalline ponds. To their right, clouds wisped over the Sierra Tocada. A her-

mit walking with a donkey and a deer peeking in from the sur-
rounding forest made for a scene so idyllic Rubens felt compelled
to paint it "on the spot."

Pacheco, the author of a history of painting, claimed Rubens
admired the works of his son-in-law for their humility—not an
attribute normally associated with Rubens's art, but one he appreci-
ated in others, especially the Flemish genre painters who were his
friends and occasional collaborators. Rubens recognized a great tal-
ent (like Caravaggio) when so confronted, and was self-possessed
enough to assimilate new ideas without becoming a slave to them
(like Caravaggio's Utrecht disciples). Velázquez, however, appears to
have had no measurable effect on Rubens, who was then past his
fiftieth birthday and twenty-two years the Spaniard's senior. Rubens,
similarly, had little discernible impact on Velázquez, even if he could
reasonably claim to be the single most influential artist alive, and cer-
tainly the best paid. In truth, their work was inherently irreconcilable.
Whereas Rubens's canvases were, for the most part, emotionally
charged and full of dynamic, colorful energy, Velázquez's pictures
were marked by a controlling, almost clinical detachment. This, how-
ever, did not necessarily preclude them from becoming friends.

If there was any friction between the two painters, or more
likely a sense of rivalry, it was probably driven by Rubens's budding
relationship with Philip. For five years, Velázquez alone had been
allowed to paint the king from life, a privilege extended to him by
Olivares as a means of controlling the imagery of state. (Titian had
been given this honor during the reign of Charles V.) The very pre-
text of Rubens's stay in Madrid impinged upon that status, and
Philip had every intention of taking advantage of his presence.

Widely traveled, well-read, adored by kings and queens, and an
undisputed master of his art, Rubens must have appeared a roman-
tic figure to the youthful Planet King, who had a keen interest in the

world beyond Spanish borders, a world he had never experienced firsthand. At the encouragement of his mentor, the count-duke, Philip had developed a genuine interest in the arts. He was a regular at Madrid's two raucous public theaters, the Corral de la Cruz and the Corral del Príncipe, and was a patron of the great dramatists Lope de Vega and Pedro Calderón de la Barca as well as the rival poets Francisco de Quevedo and Luis de Góngora. He was conversant in nearly as many languages as Rubens, and had even translated the work of the Italian traveler Lodovico Guicciardini, who in the preceding century dubbed Antwerp the marketplace "of all the universe." His relationship with Velázquez testified to his interest (and good taste) in painting. If he thought the professional practice of that art was beneath the dignity of a member of his diplomatic staff, he didn't think it base to take up the tools of that trade himself, as a hobby. Juan Bautista Maino, an artist and Dominican friar, gave Philip regular instruction in drawing. "The king takes great delight in painting and in my opinion is a very gifted prince," wrote Rubens after a few months at court. He followed up that appraisal with a more nuanced assessment: "He is endowed with all the good qualities of mind and body, as I can affirm from my personal knowledge of him. If he were less distrustful of himself, and relied less on others, he would be equal to the most exalted rank, and capable of governing empires. But as it is, he is paying the price of his own credulity and the incapacity of others, and is the object of a hatred he has done nothing to deserve."

The proximity of the artist's studio to the king's quarters, just a few rooms away on the main floor of the Alcázar, made it convenient for Philip to sit for the master. The two men talked amicably as Rubens worked, sketching the king's spade-shaped visage, with its high forehead and jutting "Habsburg jaw"—a genetic deformity magnified over generations of inbreeding. Rubens made a series of

portraits of Philip, in various poses, some for the king himself, some destined for the infanta in Brussels. In early October, Rubens borrowed equipment from the royal armory and stables for an equestrian portrait commissioned by the king for his own use. Philip was aware of the magnificent equestrian portraits Rubens had made for Lerma and Buckingham, and he wanted that same grandiose treatment for himself. Rubens obliged, sitting His Majesty on a charging bay horse, with allegorical figures representing justice and faith hovering overhead and an American Indian, symbol of his extensive empire, off to the side holding a gleaming helmet. This Philip was every bit the symbol of divine authority, hardly the same man that Rubens described as "distrustful of himself." Not surprisingly, the king was thrilled with it. Indeed, Philip was so pleased that he decided to install it opposite Titian's *Charles V at Mühlberg* in the Salón Nuevo—displacing the equestrian portrait only recently completed for that very space by his favored court artist, Diego Velázquez. In a celebratory verse, the poet Lope de Vega called Rubens "*el nuevo Ticiano*."

That compliment was perhaps more appropriate than Vega realized. While Rubens was figuratively emulating Titian, he was also quite literally imitating the Venetian master. During his stay in Madrid, Rubens made copies for his own use of virtually every Titian in the city, both in the royal collections and in private hands, a total of more than twenty paintings. These were done in addition to the roughly two dozen entirely new compositions Rubens finished, meaning he operated at a pace of about one finished painting per week during his stay in Spain, not counting drawings and preparatory works. It was an astonishing rate of production, and all the more impressive given that he was without his usual workshop assistants (though he undoubtedly had some help) and his primary business in Spain was diplomacy, not painting. That he came down

with another debilitating case of gout during the stay didn't help either, and if even that wasn't distraction enough, one of his English patrons, James Hay, the Earl of Carlisle, had asked him to keep an eye out for shipments of perfume from the Indies. Rubens did that, too, tipping Hay off to a consignment of fragrant oils from Goa, arriving by way of Angola.

Through it all, Rubens somehow found time to make substantial alterations to the *Adoration of the Magi*, the large canvas he had painted in 1609 to celebrate the signing of the Twelve Years' Truce. That painting, plucked from the walls of the Antwerp town hall and given to Rodrigo Calderón, had found its way into the royal collection after Calderón's disgrace and execution in 1621. Rubens discovered the large picture languishing in a basement wing of the Alcázar reserved for the king's use during the summer. When the treaty it celebrated concluded, the painting had become politically obsolete. It was not, however, beyond redemption, thanks to Rubens's endlessly malleable allegorical language. With the artist campaigning for a new international accord, a painting in which kings come together to bestow gifts on a symbol of peace must have seemed relevant once again. Rubens, naturally, decided to resuscitate it, in the process extending the canvas both horizontally and vertically to give him extra space in which to work. Among his alterations was the insertion of a donkey looking away from the central action, perhaps a veiled commentary on those who turn their backs on the peace process. But the most curious addition was a figure sitting on a white steed at the right edge of the canvas. He wears a maroon doublet with a chain of gold draped over his shoulders and a sword peeking up from his hip—the accoutrements of a gentleman. It is, incontrovertibly, the artist himself, Peter Paul Rubens. If there was to be a treaty with England, surely he had earned his place in the picture.

RUBENS WAS READY and willing to gallop off on his white steed, olive branch in hand, but a stream of bad news filtering in from abroad put all of Spain's plans in jeopardy. The assassination of Buckingham alone had been enough to table negotiations with England. More troubling was the deteriorating situation in northern Italy. The death of Vincenzo II of Mantua (the son of Rubens's erstwhile patron) without an heir had provoked an awkward free-for-all in the region, with Spain and Savoy opposing the strongest claimant, the French-backed Duke of Nevers. At stake was access to the critical military corridor, the so-called Spanish Road, that linked Spain's Italian possessions with its holdings in the north. This combustible situation was tenable for Spain only as long as the main body of the French army was pinned down on the Atlantic coast, still engaged in its protracted battle with the Huguenot rebellion at La Rochelle. But by late September 1628 rumors had begun to spread that a truce there was imminent, and by the end of October peace had arrived. Those French troops were now free to move on to Italy.

Olivares had no good response to this development. His best soldiers were already in Flanders, and he couldn't even afford their salaries—for those war funds, he was dependent on the Mexican silver fleet, due some time before year's end. It was thus with some horror that he reviewed the note handed him by a page on a cool December evening, with the French envoy, Guillaume Bautru, already in his office. The count-duke grimaced, and Bautru surmised that the news must have been serious if it was to interrupt their meeting. He was right. The dispatches in Olivares's rigid hands told him that the entire silver fleet—every last ship—had been taken by the Dutch sea captain Piet Heyn at the Bay of

Matanzas, on the northern coast of Cuba. Heyn escaped with every ounce of booty on more than twenty ships, in all more than 11 million florins' worth of treasure and matériel, most of it belonging to the king. Perhaps the greatest insult was that the Spanish sailors had surrendered without firing a single shot. The implications of that debacle would be felt across Europe.

No great leaps of imagination were required to see just what was in store. Frederick Henry, the Prince of Orange, had been massing his army around 's Hertogenbosch, in Spanish-controlled territory, for months, planning some kind of offensive. Now he had the means to prosecute war on a grand scale, using his enemy's own funds against its depleted and underpaid army. A concerned Olivares turned to Spinola, his top general, who was still in Madrid, and still hoping against hope that the count-duke might see reason and make peace with the Dutch. Olivares ordered him to return to Flanders to retake command of Spanish forces. Spinola refused. The marquis remained adamant that a diplomatic solution was the only responsible way forward in the Low Countries, and would not leave Madrid without a plan that would keep Flanders from the horrors of both Dutch invaders and Spanish mutineers. Rubens was stunned by his friend's insubordination, even if he agreed with him in principle. When, in April 1629, the Prince of Orange finally put 's Hertogenbosch to siege, Spinola was still in Madrid.

The marquis would never return to the Low Countries. In his efforts to bring a peace to that region, he spent all of his political and physical capital. He was recalcitrant, but Olivares was no less stubborn. If Spinola would not go to Flanders, he could not stay in Spain. Instead, the count-duke shunted him off to Milan, to supervise recovery from another Spanish humiliation. Richelieu's French troops, released from La Rochelle, had reached Italy, and their presence had forced the Spanish surrender of Mantua. The action

effectively dissolved the Franco-Spanish alliance that had been formed secretly in March 1626. That agreement had never been much more than a dead letter. In July, Spinola left for Milan, where he would take over as governor-general of Lombardy. Velázquez, anxious to visit Italy for the first time—perhaps on the prompting of Rubens—joined his retinue.

The trip represented an exciting new adventure for the thirty-one-year-old painter, but it was a sad finale for the marquis. Spinola died at the Castello Nuovo on September 25, 1630, a depleted man past his sixtieth birthday. When Rubens found out, a month later, he was heartbroken. "The only thing I can tell you is that it was caused by labors and anxieties too heavy for his strength and his age," he wrote. "He seemed tired of life . . . In him I have lost one of my greatest friends and patrons."

Spinola's marginalization and ensuing death did not bring Rubens's mission to a conclusion. If anything, the negotiations Rubens had done so much to champion now appeared a political necessity for a financially straitened Spain, if it was to fight wars in both Flanders and Italy. Following Buckingham's assassination, Olivares made it a priority to secure assurances that England remained committed to a peace deal. Cottington, whose position at court had only grown stronger with the death of Buckingham, confirmed his sovereign's positive intentions. In Brussels, the infanta received similar promises from Sir Richard Weston, the powerful lord treasurer, and passed them along to Madrid.

What was required was a trusted emissary who could be sent to England on Spain's behalf. Rubens, of course, was the ideal candidate. While Spinola had experienced a rapid erosion of his political standing, Rubens had only seen his position rise. Olivares in particular found in him an astute and trustworthy political mind. Philip, the king who had once decried the participation of "a mere

painter" in diplomatic affairs, was similarly won over by the visiting artist.

Having thus settled on the painter as his representative, in late April 1629 Philip composed a long dispatch to his aunt Isabella in Brussels, notifying her that he was sending Rubens to London. Upon his arrival in the English capital he would be empowered to establish a temporary armistice, and to pave the way for the formal exchange of ambassadors between the two countries, who would subsequently conclude the negotiation of a permanent peace. Rubens himself was supplied with two sets of formal diplomatic instructions written by Olivares—a standard protocol for traveling emissaries. The first, "ostensive," set was to be shown to his English negotiating partners. "Whenever the king of England shall send to Spain a person authorized to negotiate the peace, our king, in turn, will send someone to England," it said. "As for the interests of the relatives and friends of the king of England [that is, Frederick V, the Elector Palatine], His Catholic Majesty [Philip IV], with the [Holy Roman] Emperor and the Duke of Bavaria, will do what he can."

The second set of instructions was for Rubens's eyes only, and outlined not just the above points but also several other responsibilities with which he was secretly charged. Principal among these was "to prevent as far as possible" an accord between England and France, rumored to be in the final stages of negotiation. Indeed, Cardinal Richelieu had taken definitive steps to outmaneuver his terminally equivocal Spanish counterparts. Successful campaigns at La Rochelle and in northern Italy had improved French standing on the international stage, and the cunning chief minister shrewdly reminded his English counterparts of the bonds of marriage between Charles I and his French bride, Henrietta Maria. He also made certain to note their shared interest in returning the Palatinate to English control—France had no desire to see unfriendly Habs-

burg troops along its border. For Rubens, Richelieu's aggressive overtures to England presented an enormous challenge. In order to secure Spain's demand for peace, he would have to win over Charles I without having his efforts undermined by France's notoriously devious and far more experienced foreign minister. Indeed, Richelieu was well on his way to cementing his reputation as one of the more adept schemers in the history of European statecraft.

The Frenchman was a formidable obstacle, but on a personal level Rubens was more concerned with the opposition of the Dutch, who also maintained an influential presence at the English court. The painter had always understood the primary benefit of an Anglo-Spanish treaty to be not so much the peace between the two principals as the pressure such an agreement would place on the Dutch to reach their own settlement with Madrid, and finally put an end to the hostilities that had so devastated his Flemish homeland, and Antwerp in particular. The Dutch, conversely, were naturally opposed to an Anglo-Spanish treaty, as it would undermine their position at the bargaining table with Spain.

There was, then, a great deal for Rubens to overcome in London. To reinforce the painter's standing as a diplomatic officer, Philip bestowed on him the title secretary to the Privy Council of the Low Countries. Among the many privileges of this office was an annual salary of nearly 1,000 florins, as well as the right to pass the position on to an heir. As a token of the king's personal admiration, Rubens also received a gift from His Royal Highness, a ring of gold set with diamonds. It was just the kind of reward that pleased the painter—a physical affirmation of his aristocratic bearing—and he accepted it with pride. Two days later, he was on his way to London.

THE CONNECTING KNOT

✧

> We ought to consider that all the States of Europe have
> necessary ties and commerces one with another, which
> makes them to be looked upon as members of one and the
> same commonwealth. And that there can hardly happen
> any considerable change in some of its members, but what
> is capable of disturbing the quiet of all the others.
>
> —FRANÇOIS DE CALLIÈRES

Leaving Madrid, Rubens retraced the route he had taken south eight months earlier, traveling north by land through Spain and then into France. Once again, the demands of his mission forced him to skip over Provence, and the chance to visit with his close friend Peiresc. He arrived in Paris on May 10, a Thursday, and lodged for the evening with the Flemish ambassador, Henri de Vicq. He managed to visit his own works at the Luxembourg Palace—he immodestly told his friend Pierre Dupuy he had seen nothing "so magnificent" in Madrid—but had time for little else. By the thirteenth he was in Brussels.

At Coudenberg, news that de Vicq had almost certainly delivered in Paris was confirmed by Isabella: on April 20, more than a

week before Rubens had departed Madrid, England and France had agreed to the basic terms of a mutual nonaggression pact. That must have come as a blow. Rubens's orders from Olivares had specifically instructed him "to prevent as far as possible" the making of that agreement. Now he would have to keep that accord from flowering into a full-scale offensive alliance against Spain and its dependencies. And while dealing this setback to Richelieu, Rubens would have to establish Spain's own treaty with England.

Before discharging him, Isabella was kind enough to relieve Rubens of at least one duty. Based on the rather dubious political philosophy that the enemy of one's enemy is one's friend, Olivares had been supporting the Huguenot rebellion in France with an enormous annual subsidy, even as Catholic Spain, home of the Inquisition, had been waging war on the "heretic" Dutch provinces for decades in the name of religion. Before Rubens left Madrid, Olivares supplied him with letters of credit totaling some 30,000 ducats, which he was to deliver to the seigneur de Soubise, the Huguenot representative in London. The funds were to be used to recruit a mercenary army in England, and to resuscitate the beleaguered Huguenot cause in the wake of the capitulation of La Rochelle. (The Huguenots retained a few enclaves of support in France.) Given that England's new armistice with France made it exceedingly unlikely that any recruiting would be permitted on British soil, Isabella chose to appropriate Soubise's subsidy for her own needs. After all, she was the one fighting an underfunded war on Spain's behalf, and against a Protestant enemy at that.

The Dutch blockade of the Flemish coast meant Rubens could not risk a Channel crossing on a vessel running a Spanish flag—he was well aware of the fate of prisoners who fell into the hands of the hostile navy patrolling the waters separating the Continent from the British Isles. His mission, anyway, entitled him to travel on an En-

glish warship, which is exactly what he demanded of the English envoy, Hugh Ross, when he arrived at the port of Dunkirk. Ross sent that request up the chain of command. "His orders are not to hazard his mission or his messages except on an English ship, for he is mightily afraid of the Hollanders," he wrote. Two days later, John Mince, captain of the HMS *Adventure*, received an urgent message from the royal palace at Whitehall, in London. Mince took the note, lifted its wax seal, and read. The text, composed in a sharp, authoritative hand, was concise: proceed across the Channel to Dunkirk; a gentleman would be waiting there, and he was to be "conducted into this kingdom with such servants & baggage as shall belong unto him." No name was given: the mission was top secret. The note was signed, simply, "Charles K." *K* as in "King."

The thirty-five guns Captain Mince commanded on the *Adventure* proved more than adequate protection for the painter-diplomat and his small entourage. (Rubens was accompanied by his brother-in-law Hendrik Brant, an Antwerp lawyer probably brought along as a sounding board, and several servants.) With the Rubens party aboard, the ship sailed from Dunkirk early on the morning of June 3, and that same evening safely deposited them on English soil under the chalk white cliffs of Dover. After a night on the coast, Rubens left for London.

AS HIS EXCHANGE with the English envoy at Dunkirk suggested, Rubens was well versed in the finer points of diplomatic protocol. The first book on diplomatic practice, *Ambaxiatorum brevilogus*, was published in 1436. Most early texts on the subject focused on international law, as established through treaties and other covenants. Diplomatic conduct eventually became a subject of study in its own right. Rubens made a special point of keeping abreast of this litera-

ture. When the letters of the revered French cardinal and diplomat Arnaud d'Ossat were published, in 1624, the painter immediately arranged for a copy to be shipped from Paris by courier, and devoured it upon arrival. He also continued his correspondence with the Brussels-based diplomat Frederik de Marselaer, begun years earlier, when de Marselaer was editing his book on diplomatic practice. Indeed, in the very year Rubens traveled to England, a new edition of that book, *Legatus*, was published by the Plantin Press, then under the direction of Rubens's friend Balthasar Moretus.

Resident ambassadors did not become a standard feature of European diplomacy until the latter half of the fifteenth century. (The title "ambassador" is considerably older than that; its linguistic cousin "envoy" is derived from the Spanish verb *enviar*, "to send.") In Renaissance days, the ambassador was understood to be the virtual embodiment of his monarch; he traveled in splendor and was treated with munificence. Since the ambassador was a "guest," his sovereign host was expected to cover his lavish expenses. Predictably, these enormous costs became a point of contention. Spain went so far as to institute a scheme of annual stipends for foreign governments. Elaborate systems of protocol were developed to cover the rights and privileges of the entire diplomatic community, from the ambassador down. Petty grievances between representatives could escalate into major international incidents. Spain and France famously existed in a state of perpetual conflict over the "precedence" of their respective ministers at foreign courts—on one level, a technical argument about who was to be introduced first at ceremonial functions, but by extension a dispute as to the respective standing of the two nations in the world. While Rubens was in London, England's ambassador in Paris caused a minor flare-up in relations by referring to Charles as the "Most Serene King" (rather than the "King of Great Britain"), which the French

interpreted as a slight on the serenity of their own monarch. If an air of effortless grace characterized the successful diplomat, there was always beneath the surface a punctiliousness and exacting attention to detail—all traits Rubens possessed.

Rubens's rank as a privy councillor of Flanders entitled him and his entourage to a residence provided by the English crown during his stay in London. Accommodations were made at York House, primary home of the Duke of Buckingham before his assassination. This was actually not a single building but a compound of structures Buckingham had appropriated from another disgraced aristocrat, Sir Francis Bacon, who had been charged with public corruption in 1621. After taking possession, Buckingham spent much of his time and fortune renovating the place so he could entertain in suitably high style. The painter Orazio Gentileschi, one of Charles's court artists, was granted residency on the property. And of course Rubens himself was the most famous beneficiary of the duke's artistic program.

When Rubens arrived in 1629, Buckingham's widow still lived in the main building, but the place was overseen by his old friend Balthasar Gerbier, who occupied a large house on the property facing the Strand, the elegant Westminster avenue that was the city's premier address. Part of that street's appeal was access to the Thames. The river was London's primary artery of transportation, and York House had its formal entrance on its water side. That gate, three arches of deeply rusticated Portland stone capped by a pediment ornamented with statuary, must have seemed strangely familiar to Rubens when Gerbier greeted his launch for the first time. The similarity to the portico he had built for his own home back in Antwerp was unmistakable; indeed, it may have been the inspiration for the designer of the York gate.

Inside the compound, Rubens found a good deal more that was

familiar. On the ceiling of the main hall was the allegorical painting Buckingham had commissioned from him at their providential first meeting four years earlier in Paris. The irony of that composition, in which Mercury and Minerva, the gods of diplomacy and wisdom, lead the duke to the "Temple of Virtue," was surely not lost on the painter. Perhaps, he must have thought, his present mission might redeem some of that message. More happily, he was reunited with the collection of antiquities he had sold to Buckingham, all those marbles and medallions that so captured his imagination. In the garden was Giambologna's *Samson and a Philistine*, which he had seen in the collection of the duke of Lerma on his first trip to Spain for Vincenzo Gonzaga. It had subsequently found its way into Buckingham's possession after he and Charles made their brideless escape from Madrid in 1623.

Rubens might have wished to fully explore the York collections during his first week in London, but he simply didn't have the time. The morning after his arrival, he was summoned to an audience with Charles I at his palace in Greenwich, perched above the Thames a few miles to the east of London. Set on a restorative stretch of parkland, the picturesque redbrick castle known affectionately as the Palace of Pleasaunce was built in the early fifteenth century and first used as a royal getaway from the hubbub of the city center. Over the years, however, and through a series of expansions, it had lost a bit of its luster. By the time Rubens arrived, it was looking somewhat out-of-date and down-at-the-heels. Architectural fashion had passed it by, and the future could be seen across the expanse of its front lawn, where a shimmering Italianate box of a building was rising to its second story. That vision of elegance in bright white marble was the Queen's House, designed by the architect Inigo Jones for Charles's late mother, Anne of Denmark. After more than a decade's work and the death of Queen Anne herself, it was still under construction.

When Charles learned that Philip, his Spanish counterpart, had selected Rubens as his emissary, he was especially pleased. Francis Cottington, who had recently been promoted to the position of Chancellor of the Exchequer and remained one of Charles's chief councillors, noted, "The king is very content, not only in respect to [Rubens's] mission, but because he wants to know a person of such merit." Indeed, Charles was known to delight in the company of artists, and he had a particular fascination with Rubens. The self-portrait he had commissioned from the painter—inappropriately, as far as Rubens was concerned—was installed just outside the bed-chamber of Charles's Whitehall Palace, where he could inspect it daily. Charles's immense expenditure on the Mantuan art collection spoke to his interest in the arts. The king, a true aesthete, took considerable pride in his powers of connoisseurship and his discriminating taste. When a shipment of new paintings came in, he would have their labels removed and then test his ability to identify the artists who had created them. This made for an amusing intellectual challenge, but he was serious about his hobby. If Rubens had any question about that fact, he needed only to think back a few years earlier, when Henry, Lord Danvers had deemed a Rubens lion hunt intended for Charles's collection unsatisfactory, and had demanded that the painter do something to "redeem his reputation."

Rubens's status, at least as an artist, was no longer at issue when he was ushered into his first meeting with Charles. Indeed, his profession was once again the cover for his appearance at court. In the wake of his arrival in London, the Venetian envoy, Alvise Contarini, wrote back to the doge, "I do not know whether the king will see him, but he may under the pretense of pictures, in which he delights greatly." This was not an altogether inaccurate report. Charles and Rubens did have an art project to discuss: the elaborate painting series to be installed in the ceiling of the new Banqueting House at

Whitehall, designed by Inigo Jones. Rubens had first broached this commission back in 1621, when he had advertised that he was "by natural instinct, better fitted to execute very large works than small curiosities" and that his talent was such that no undertaking, "however vast in size or diversified in subject," had ever surpassed his courage. If those claims seemed presumptuous at the time, he had by now proven them no exaggerations. The success of his cycle of paintings for Marie de' Medici at the Luxembourg Palace, along with his many other royal commissions, made a forceful argument that no living artist was more skilled at delivering the kind of bombastic grandiosity demanded by those who claimed their authority was a divine right. The preliminary program that had been established for the Banqueting House ceiling was especially well suited to Rubens. It was to be a celebration of the peaceful reign of Charles's late father, James I, who in 1604 had signed a treaty with Spain. That accord was a model for the one Rubens had now come to negotiate. If he was successful in that mission, the new agreement would be signed in the very building in which the ceiling paintings would be installed. The Banqueting House was built to serve as a formal reception hall for just such important state occasions as the signing of international accords.

Charles wanted Rubens for the commission, but discussion of that job was not on the agenda of their first meeting. For the moment, there was state business to attend to, and it took precedence over the artistic matters that, given the choice, the two men would surely have preferred to address. As it was, the king and the painter exchanged pleasantries, and Rubens offered Charles a copy of his instructions from Madrid, which he read with some dissatisfaction.

"As God is my witness," Charles said after an uncomfortable pause, "I desire peace with all my heart, but it will be necessary for your King to offer something from your side to facilitate the matter."

Philip's rather vague offer to "do what he can" to restore Frederick V to the Palatine throne was hardly the concession Charles had hoped to receive. "Neither faith, conscience, nor honor permit me from entering into any accord with your Catholic Majesty without the restitution of the Palatinate," he told the painter. In addition, he had been expecting a more substantial peace agreement than the temporary armistice that Rubens had been authorized to offer, pending a formal exchange of ambassadors. A truce, as far as he was concerned, was just another Spanish attempt to stall the peace process, a means of undermining English relations with the other European powers while Spain sacrificed nothing. He wouldn't have it.

Taken aback, Rubens noted politely that Spain was simply not in a position to guarantee the return of the Palatinate, which had been partitioned among the Holy Roman Empire, Bavaria, and Spain. Of course, Philip could *request* that his allies return their portions of the disputed territory to Frederick V, but without some carrot as an incentive they had little reason to do so. In any case, Rubens simply did not have the authority to treat with Charles on this matter. He would, however, be happy to forward Charles's demand back to Madrid. In the meantime, he asked only one concession from the English king. Until there was an answer from Spain, he begged Charles not to extend the armistice he had signed with France into a more permanent, full-fledged alliance—to do so would surely doom any hope for a peace between their respective countries, England and Spain. Charles agreed. France could wait.

Rubens's quick thinking had saved the day—securing that final concession from Charles was critical to moving the talks forward, and no small accomplishment—but Rubens still left Greenwich disheartened by his visit with the king. He should have expected Charles to be a demanding and difficult negotiating partner. What the king wanted, he expected to receive, and he was notoriously

petulant when it was not immediately forthcoming. The impetuous trip to Spain in search of a bride was a product of his rash temperament. Charles had repeatedly dissolved the obstreperous English Parliament over questions of his authority, most recently in March, when he had embarked on an autocratic period of "Personal Rule" that would last eleven years. He did so at considerable cost, however, both politically and financially. Without Parliament's cooperation, raising capital for both his art collecting and his military adventures posed a considerable challenge. This, in turn, made it incumbent upon him to forge peace with his primary adversaries, France and Spain. He simply could not afford the alternative.

The days following that initial royal audience were a whirlwind for Rubens, though he was not entirely pleased with his treatment. Dudley Carleton, his old trading partner, threw him a fine dinner party—that was nice. More important, he had several meetings with Richard Weston, the lord treasurer, and Cottington, the two most powerful men at court and the chief proponents of the Spanish peace. For the most part, however, he was forced to keep a rather low profile in order to minimize speculation as to the true reasons for his presence in London. Both the general public and a large faction within the English court were adamantly opposed to any kind of peace with Catholic Spain, and there was no reason to antagonize them before the essential parameters of a deal could be established.

In fact, a certain sense of frustration characterized both the English and the Spanish camps during Rubens's first week in London. Isaac Wake, a well-connected diplomat and figure at court, wrote that the king found the offer of truce meager to the point of being disrespectful, and now suspected Spanish motives. Conversely, Wake observed that Rubens was upset by the relatively cold welcome he had received at court. Spain's enemies, meanwhile, had

figured out what Rubens was up to, and were making bold efforts to discredit him. The Dutch envoy, Albert Joachimi, informed his English counterparts that any negotiations conducted through the artist would be "contrary to their common interests" and damaging to Charles's reputation. Contarini was especially harsh. "Rubens is a covetous man, so he probably aims at being talked about and some good present," he wrote. That was surely one of the least generous appraisals of the artist committed to print during his lifetime.

While Rubens was struggling through the opening round of negotiations, his movements were closely tracked by another Spanish agent in London. Isabella had a mole in Charles's inner circle, George Lamb, a secretary to one of the king's longtime confidants, Sir John Coke. A week after Rubens had arrived, Lamb sat down at his desk and composed a report on the painter's less than heroic arrival in London. This was painstaking work. After completing five double-sided pages in black ink, he switched to red and carefully translated each word into code in the space between the lines. The chosen cipher was something altogether more complicated than the simple numerical device Rubens had used in his correspondence with his Dutch cousin Jan Brant. (A good code, typically based on a phrase known only by the agent and his handler, was thought to be all but unbreakable.) When Lamb was finished going over the entire document, he copied the coded text onto fresh paper and addressed it to his Flemish contact "Jacques Han" of Antwerp. Eventually, it made its way to Brussels, and from there it was passed on to Olivares in Madrid.

Lamb's report was not encouraging. He described the truce offer as falling "farre short" of English expectations, and noted that although Rubens had been entertained reasonably, Spain had few friends at court and "one of three named is not to be relyed upon." Rubens was particularly worried about the volatility of his English

counterparts. "Rarely, in fact, do these people persist in a resolution, but change from hour to hour, and always from bad to worse," he wrote of the English in a letter to Olivares, a man whose own constancy Rubens had often questioned in private. As far as the artist was concerned, the entire structure of Charles's government was ill conceived. "Whereas in other courts negotiations begin with the ministers and finish with the royal word and signature," he wrote, "here they begin with the king and end with the ministers."

The difficulty of this method became readily apparent during Rubens's second meeting with Charles, again at his Greenwich palace. The king received the painter warmly, but quickly shifted matters forward. "Let's get down to particulars," said the king. He had reconsidered his demand regarding the Palatinate and had a new offer for Rubens: Spain should surrender its garrisons in the Palatinate and in the meantime call an international conference in Madrid, at which the fate of the Bavarian and imperial strongholds would be resolved. That proposal took Rubens aback. He knew, based on his private conversations with both Weston and Cottington, that the two influential lords were specifically opposed to such an arrangement; they considered any partition plan unacceptable, as they believed that to accept only the Spanish garrisons would essentially guarantee they would lose the rest of the contested territory held by Spain's Habsburg allies. With a peace signed, England would have no leverage at the bargaining table, as Spain would have fulfilled its duty. The other parties could simply bow out of the conference, having conceded nothing.

Following his audience with Charles, Rubens immediately informed Cottington and Weston of the king's latest proposal. They were so incredulous that the artist actually requested a follow-up meeting with Charles, at which he asked the king to reconfirm his offer, which he did, in the presence of the two lords. Cottington and

Weston recapitulated their objection to the king's proposal, and offered an alternative that would eliminate the leverage issue: they suggested a time limit be set for the complete restitution of the Palatinate. This, of course, was not going to pass muster in Madrid, as Rubens again pointed out. Spain could not be held responsible for any delays imposed by third parties, even if they were its allies.

Once more, it seemed Rubens had successfully held his ground, but that was where discussion ended for the day, and once again he found himself discouraged by a state of affairs that appeared to be caught at an interminable standstill. Indeed, he openly considered a return to Flanders, where he might consult with Isabella and await further instruction from Madrid in the comfort of his Antwerp home. Cottington, however, convinced him to stay. If Rubens were to leave now, Cottington advised him, all hope would be lost. Rubens was inclined to believe Cottington; in their short time together, the two men had developed a comfortable working relationship based on mutual respect, candor, and shared goals. Within the English court, no one was more committed to a peace with Spain. Cottington's sincerity, Rubens informed Olivares, "could be no greater if he were a Councilor of State of our own king." The artist, conversely, had won a reputation among the English for his integrity—a reputation that he had fostered through his dealings on the art market and sealed by his conduct in London. Writing to Cottington, the artist's friend Dudley Carleton described him as "too honest a man to speak untruths contrary to his own knowledge."

That was not entirely true. Rubens understood that the foreign representative was occasionally required by duty to stretch the boundaries of truth. Indeed, it was an English diplomat, Henry Wotton, who in 1604 had famously quipped, "An ambassador is an honest man sent to lie abroad for the good of his country." Wotton paid dearly for that remark; King James was not amused by the

implication that he was conducting a foreign policy based on lies and misinformation, and removed him from diplomatic service. Outright duplicity was condemned as a matter of crude tactlessness, but it was nevertheless well understood that ambassadors could not always be entirely honest, and for this reason they were given a blanket immunity when abroad—even, in Rubens's words, when they were "assigned dolorous tasks." For the most part, however, it was in the best interests of the diplomat to be trustworthy. "Confidence alone is the foundation of all human commerce," Rubens wrote.

Rubens's reputation for sincerity was one of his great strengths as a diplomat. Indeed, Cottington was especially concerned that Rubens remain in England and continue to work toward compromise, lest his departure leave the field open for a diplomat of less sterling character, namely, Charles de l'Aubespine, marquis de Châteauneuf. The French ambassador was scheduled to arrive in London within the week to formalize the nonaggression pact the French and the English had agreed to back in March. It was no secret that Châteauneuf had been charged with extending the terms of that treaty into a full-scale offensive and defensive alliance against Spain. In their last meeting, Rubens had raised this issue with Charles, who replied that he could hardly abide the French and that he was loath to make an agreement with them. A true Englishman, he considered the French an inherently untrustworthy people, never mind that he had married a Frenchwoman. If Spain hadn't wasted so much of the last two years dithering, the king told Rubens, he would not have been forced to deal with France to begin with. As it was, he pledged again that he would conclude no further pact with France while the discussions with Spain were still pending. Unstated was an implied threat that he would make just such a league if Spain did not accede to his demands. In a letter to

Olivares, Rubens ruefully noted this, and claimed that if he had been given appropriate authority in the first place, he "could have broken off the French treaty in twenty-four hours."

Charles did little to hide his essential antipathy to his Gallic suitors. He sent a fleet of royal carriages to meet Châteauneuf at the coast, as he was obliged to do by diplomatic tradition, but he did not make the trip himself. Rubens was happy to hear about the snub, and the ambassador's icy reception at court. Châteauneuf, however, was fully prepared for this unpleasant eventuality, and the always cunning Richelieu had supplied him with just the means to remedy it: cash. "All the leading nobles live on a sumptuous scale and spend money lavishly, so that the majority of them are hopelessly in debt," Rubens wrote to Olivares. "I know from reliable sources that Cardinal Richelieu is very liberal and most experienced in gaining partisans in this manner."

Châteauneuf was the public face of French diplomacy in London, but behind closed doors overtures were being made by another emissary, a shadowy figure named Furston who brought an offer directly from Richelieu. In a clandestine meeting, he informed Weston that France was secretly plotting to "attack the king of Spain from all sides." The plan called for a simultaneous assault on Spain's forces in Germany, Italy, and the Low Countries. France wanted England to join in this fight with a coordinated naval attack on the Iberian coast, to be undertaken in cooperation with the Dutch navy. In return for its support, England would receive "*carte blanche*" from France. The Palatinate would surely be recovered, in its entirety. Weston was offered an enormous personal bribe to rally his support.

It was an ambitious plan, but it didn't find traction with either Weston or his sovereign. Cottington informed Rubens of Charles's reaction: "The king simply laughed at it and said he was well

acquainted with the wiles and tricks of the Cardinal Richelieu, and that he would prefer to make an alliance with Spain against France than the other way around." If there had been any hope for such an adventure, Châteauneuf bungled it by grievously overstepping the bounds of diplomatic protocol, in the process terminally alienating the king to the French cause. In his zeal to conclude an alliance with England (and to prevent Spain from doing the same), he had become insistent that Charles call Parliament to session so it could weigh in on the matter. This was a desperate wedge move, one intended, in Rubens's words, to "gain the good will of the people," and in so doing force the king's hand. The Puritan-led Parliament was categorically opposed to any deal with Catholic Spain, and that body assuredly would have supported a French alliance over that offered by Rubens.

The Frenchman's gambit, however, was doomed from the outset. Châteauneuf might have known from recent history that appeals to Parliament would not sit well with the king, who had disbanded the body just a few months earlier. Charles was intransigent when it came to questions of his own authority. Moreover, it was considered entirely inappropriate for a visiting diplomat to interfere in the internal affairs of his host country. In a letter back to Madrid, Rubens happily notified Olivares that Châteauneuf had undermined his own cause with his "insolence."

While the French contingent was stumbling, Rubens was making significant headway. At the beginning of July, he convinced Charles to name the ambassador he would send to Madrid to finalize negotiations, and also to set a date for this ambassador's departure. The selection naturally fell to Cottington, and the chosen day was August 1. The only stipulation from the English was that Spain reciprocate with its own ambassador, and that Charles be assured that the two countries could reach acceptable terms. To be absolutely clear on this front,

Rubens asked that Charles put down his terms in writing, so that he might forward them on to Madrid.

In the long course of the Anglo-Spanish negotiation, both sides had been resistant to that request, always afraid it might be used against them. Gerbier, after the failed summit in Holland, had all but broken off discussions with the complaint that Rubens "had brought nothing in black and white, and all that he said was only in words." But now, thanks to Rubens's persistence, Charles acceded. On the principal subject under discussion, the restitution of the Palatinate, he was willing to settle only for the return of the Spanish garrisons, with the pledge that Philip merely intercede in good faith with his Habsburg allies regarding their respective claims. Cottington was stunned. "A miracle has been wrought in obtaining this document from the king of England," he told Rubens.

Charles understood just what a coup this was for the painter, and how potentially dangerous it would be for him if word of the agreement were to become public. Opposition to Catholic Spain within England was rabid. Precautionary measures were therefore required before the terms outlined in what the parties were now calling "The Document" could be disclosed. With that in mind, the king absolutely forbade Rubens to show the letter to anyone but his handlers overseas. (He also told Rubens that he would never have given such a letter to Richelieu.) The language of "The Document" was also somewhat less than straightforward. In an accompanying cover letter to Olivares, Rubens had to explain that Charles was "unwilling to express himself as clearly in writing as he had done orally." Nevertheless, it was all there—the count-duke would just have to read between the lines. For the sake of security, Rubens only sent a ciphered copy. He retained the original on his person in London.

A month later, he followed up with another letter to Olivares. "I consider this peace to be of such consequence that it seems to me

the connecting knot in the chain of confederations of Europe," he wrote. Rubens had the vision to see, as the French diplomat François de Callières would later write, that the "necessary ties and commerces" between European states bound them together into a single, intertwined unit. "I admit that for our King the peace with the Hollanders would be most important," Rubens wrote, "but I doubt that this will ever come to pass without the intervention of the King of England."

Rubens may justifiably have considered himself a diplomatic miracle worker, but his handlers in Spain, and the count-duke in particular, were not initially pleased with his performance. The painter had discharged his responsibilities with an alacrity foreign to the terminally diffident Spanish crown. Even before learning that Rubens had secured the secret document from the English king, Olivares had dispatched a brusque letter admonishing Rubens for exceeding the authority he had been granted in Madrid. Rubens responded with a spirited defense of his actions in which he claimed that he had served merely as an honest intermediary, and that he had—against considerable opposition—convinced Charles to choose peace with Spain over peace with France. In addition, he had seen to it that Charles name a sympathetic ambassador, that a date be set for that ambassador's departure, and that he be provided with instructions that would be considered acceptable in Madrid. "I do not feel that I have employed my time badly since I have been here," he told Olivares, "or that I have overstepped in any way the terms of my commission." Enclosed with his apologia were letters of support from both Weston and Cottington that praised his performance. In all, Rubens made a convincing argument. In August, his response was read before the Council of State at the Real Alcázar. It was enough to satisfy their concerns. In the minutes to that meeting it was noted that the council gave Rubens "approbation and thanks for what he has done and written, and for

the tact with which he has acted." So informed, Rubens told Olivares that those kind words were "to be attributed not so much to any ability of mine, as to the goodness and the generous disposition of Your Excellency in appreciating even the slightest talent in others." In paint or print, the artist knew how to lay the praise on thick.

RUBENS CONSIDERED HIS WORK done and wished to return home, but he was once again compelled to stay by his English counterparts. He had, perhaps, been premature in advertising the success of his mission. Cottington's departure remained contingent on Spain's reciprocating with an ambassador of its own, and on Madrid's willingness to accept the terms outlined in "The Document." But by the time that text made it all the way to the count-duke's desk in Madrid, Cottington's scheduled departure date of August 1 had come and gone, and Charles was becoming impatient for a reply. Cottington was rescheduled to leave a month later, but even that plan was scuttled as Rubens awaited word from Madrid. Finally, at the end of August, he learned that Don Carlos Coloma had been appointed Spanish ambassador to England. That was enough to temporarily alleviate the fears of his negotiating partners, but there was a caveat: Coloma was presently in command of the Spanish army in Flanders, a position he had inherited when Spinola left for Madrid the previous year. Now, with the Prince of Orange on the offensive and 's Hertogenbosch still under siege, he was in no position to leave his post.

Rubens used the delay to his advantage. When Joachimi, the Dutch envoy, sought an audience with Charles to request a subsidy for the Dutch military campaign against Spain, the artist-diplomat made sure Charles refused the appeal. Rubens was well armed to make a case before Charles against support for the Dutch. "All the

kings and princes of Europe, in the interests of self-preservation, ought to conspire to bring them down," he noted. In the span of a few decades, the nascent Dutch republic had become a maritime superpower, its tentacles reaching clear around the globe. Dutch naval power and colonial expansion posed a serious international threat, and not just to Spain. Charles was especially vulnerable, given the close alliance between the Dutch and members of the Puritan opposition in his own country. Rubens played on the English king's fears of insurrection, warning him that the Dutch were well placed to make a run at his crown, and soon. Now was the time to press them, before it was too late. Charles, he argued, should "employ his authority to induce the Hollanders to some reasonable accord with Spain, and if they refuse, threaten to abandon them entirely, or even aid our king against them."

Rubens was prescient in this regard. In 1688, a Dutch invasion force linked up with English partisans to force Charles's son, James II, from his throne. The "Glorious Revolution" left William III, great-grandson of William the Silent, as the new English king. For the moment, however, Rubens did not realize that just as he was making his case against an Anglo-Dutch treaty, Spain was achingly close to signing its own treaty with the Dutch, and without recourse to any outside intervention. This development had been precipitated by a shift on the ground in the Low Countries. A Spanish offensive into the Dutch heartland had pushed the Dutch back to the bargaining table at Roosendaal, and the negotiating parties had agreed on the principal terms of a truce. Those conditions, and whether they should be accepted, became the subject of intense debate—known as the *groote werck*, or "great affair"—that would occupy the Dutch political leadership into the New Year and in the months that followed.

Rubens, meanwhile, had managed another coup. Already, he

had blocked Richelieu's scheme to have France join forces with England to wage a multipronged war against Spain. Working in tandem with Cottington, he had actually turned that very idea back on its creator. Rubens happily informed Olivares that Cottington, as Charles's ambassador, would now travel to Madrid with full authority to make an offensive alliance with Spain *against* France. This was accomplished despite the fact that Charles had recently formalized the nonaggression pact with France that had necessitated Châteauneuf's trip to London. Neither the French nor the English were particularly enthusiastic about that accord, which they had formally agreed to back in April. At the banquet celebrating it, at Windsor Castle, Charles didn't even break out the best royal dishes. The next day, word arrived that French naval units in the Caribbean had taken by force seven English vessels and an island owned by the Earl of Carlisle. So much for the armistice.

WITH HIS PRIMARY RESPONSIBILITIES filled and nothing left for him but to await the arrival of Coloma, Rubens finally had an opportunity to take some pleasure in his time in England. As a moneyed widower with a reputation for genius and the king's ear, he must have made an alluring target for the unattached women at court. Rubens wasn't known for indulging in pleasures of the flesh, except on canvas, but as Callières would write in his primer on diplomatic conduct, if the "opportunity of conversing with the ladies" should present itself, the ambassador "ought not neglect to get them on his side by entering into their pleasures, and endeavoring to render himself worthy of their esteem." Of course, Callières was French.

Rubens, at least in public, led a respectable life. In late September he traveled to Cambridge, where he received a tour of the col-

leges and an honorary master's degree from the university chancel-lor. A budding Anglophile, he described England as "a spectacle worthy of the interest of every gentleman, not only for the beauty of the countryside and the charm of the nation; not only for the splen-dor of the outward culture, which seems to be extreme, as of a peo-ple rich and happy in the lap of peace, but also for the incredible quantity of excellent pictures, statues, and ancient inscriptions which are to be found in this court." It should come as no surprise that he liked all of that artwork: he had either owned or created a good deal of it, especially the works he found at York House. Rubens was particularly impressed by the collection of antique marbles assembled by Thomas Howard, the Earl of Arundel. The artist claimed he had "never seen anything in the world more rare." He visited the earl's house on the Strand, also known for its luxuri-ous garden, several times. It didn't hurt that Howard was also a Rubens client. The portrait Rubens had made of the earl's wife, Aletheia Talbot (with her dog, her midget, her jester, and Dudley Carleton), was one of the prizes of the Howard collection. Before Rubens left London, he completed a bust-length portrait of the bearded earl dressed in a suit of armor to serve as a complement.

That was just one of the many paintings Rubens began in the studio he set up for himself at York House. With so much free time, he was able to rededicate himself to his art. Though Balthasar Ger-bier had been essentially removed from the negotiating process, he had been a fine host, and as a token of respect Rubens painted a portrait of Gerbier's wife, Deborah, and their four children. The women of the Gerbier family also served as models for the first of two canvases destined for the collection of Charles I. Both were allegorical works that made allusion to the peace process that had drawn Rubens to England. In the monumental *Allegory of Peace and War*, the goddess Minerva wards off an armor-clad Mars, who furi-

ously charges at a lovely nude maiden and a huddled family. This was not one of Rubens's more opaque constructions; the meaning was undisguised. Minerva, representing wisdom, restrains a war god bent on the destruction of innocence and prosperity. It was a sobering theme, but a magnificent picture: nearly ten feet wide and brimming over with color and figures and objects that allowed Rubens to fully demonstrate his technical virtuosity. The theme had been gestating for some time, dating at least to his compositions of 1628 focused on the figure Occasio, the golden-haired female who represented the opportunity for peace. That the familial grouping in the foreground was modeled on the Gerbiers added a sense of personalization. As a gift, it was a rather extraordinary physical and symbolic representation of the rewards of the very peace Rubens had come to negotiate.

The second of those allegorical works, a *Saint George and the Dragon*, was considerably smaller than the first, but its subject matter was closer to Charles's heart. The king had a special fondness for Saint George, the patron saint of the Order of the Garter, the most prestigious chivalric order of his realm. In 1627, he traded a book of drawings by Hans Holbein for a Raphael painting of Saint George, which immediately became one of his prized possessions. Rubens exploited the king's special interest in this subject; his Saint George was clearly set in an English landscape (the London skyline is visible in the background), and the hero himself appears to have been given the facial attributes of the king. It was not too much of a leap to read in it a celebration of Charles's role as a peacemaker, slaying the metaphorical dragon of war. Rubens liked the painting so much that he chose not to give it to the royal patron it so evidently represented. Instead, he sent it back to Antwerp, ostensibly as a pleasant reminder of his time in England. When he got home, months later, he expanded the canvas and darkened its mood.

Desiccated corpses were added to the foreground and frightened onlookers to the background. The alterations suggest the fate of conflict's innocent victims. Rubens, back home in beleaguered Antwerp, may well have been thinking of his Flemish countrymen when he put in those unhappy figures. They were not enough, however, to dissuade an art dealer working for Charles from purchasing the painting for the King and returning it to London just a few years later.

The crowning artistic glory of Rubens's stay in London was the ceiling of the Banqueting House at Whitehall, the commission for which he had begun campaigning in 1621. Few documents remain describing the circumstances of the ceiling's invention, but it seems certain that the program was developed in close collaboration with Inigo Jones, the architect of the building and Charles's chief adviser on artistic matters. (His official title was surveyor of works.) It is unfortunate so little is known of the interaction between the men, two of the brightest minds of their time. They were of roughly the same age (Jones was just four years Rubens's senior), and both had come into their artistic maturity after formative study of antique and Renaissance works in Italy. Indeed, Jones was a member of that small circle of minds capable of a sustained intellectual engagement with Rubens in the fields in which he was chiefly interested, art and classical history, at his own level. They undoubtedly discussed Jones's study of Stonehenge; the architect believed, wrongly, that the monoliths were Roman ruins, and had led excavations there to investigate this hypothesis.

For the ceiling of the Banqueting House, the two men arrived at a design of immense complexity, a rectangular grid of nine paintings that celebrated the career of James I, Charles's father. The inspiration was Veronese's ceiling for the Church of San Sebastiano, in Venice, with its gilded coffers and similarly elaborate program. Rubens's

Whitehall ceiling was to be even more magnificent. Its enormous central panel, an oval, depicted James's apotheosis, with the king rising overhead as if he'd been drawn straight up into the heavens. That panel was flanked, in the central column, by a pair of rectangular canvases, *The Union of the Crowns* (Scotland and England) and *The Peaceful Reign of James I*, the latter installed directly above Charles's throne at the south end of the hall. Here, as in *The Allegory of Peace and War*, Minerva wards off a charging Mars. The implication was that Charles had inherited his father's mantle as a divinely graced peacemaker. That allusion would have been fairly clear to the typical connoisseur of the period, but, as with Rubens's paintings for Marie de' Medici, the ceiling's iconography was largely abstruse, a condition compounded by the installation of the paintings a distant fifty feet above the heads of those who would interpret their meaning. Their readability would be further compromised by soot (the room was lit by candle) and water damage. Before long, they were all but obscure except in their broad strokes—it was enough for distinguished visitors to know they were by Rubens. In any case, they were soon obsolete. Rubens's ceiling celebrated British unity, but Charles's disdain for Parliament brought on the English Civil War. In January 1649, he was beheaded on a scaffold erected directly in front of the Banqueting House.

Rubens never saw the Banqueting House canvases in place. Though he produced several studies for the ceiling during his stay in London, the scale of the job required that it be completed back in his Antwerp studio, which he was beginning to miss sorely by the late fall of 1629. "I should be happier over our peace or truce than over anything else in this world," he wrote to his friend Gevaerts at the end of November. "Best of all, I should like to go home and remain there all my life." By that time, Cottington had left for Madrid. Coloma, however, was still stuck in Flanders. A tired

Rubens, now the target of English frustration, took out a bit of his own in a letter to the infanta Isabella. "I curse the hour I set foot in this country," he told her.

Coloma did finally make it to London. At a ceremony on January 13, 1630, beneath the ceiling that would soon hang with his own paintings, Rubens watched as the ambassador was introduced to the king. Over the next two months, Rubens remained in London as an adviser to Coloma. It would be another eight months before the Anglo-Spanish peace would finally be signed, in mid-November 1630. Two months after that, in Madrid, Cottington and Olivares put their signatures to another document, a secret treaty that called for a joint Anglo-Spanish offensive against the Dutch. This was a critical development, and a direct result of the measures Cottington and Rubens had taken together in London to turn Richelieu's anti-Spanish scheme back on France. What precise role Rubens had in forging this new, anti-Dutch alliance is unclear, but it is hard to imagine he did not have some significant hand in it during its incipient stages. By the terms of the deal, Charles would receive a monthly stipend from Spain during the hostilities, and the rights to occupy Zeeland after a successful invasion.

Had England and Spain succeeded in that joint campaign, they might have radically altered European borders. But the plan, whatever its advantages, grew to such complexity that it collapsed under its own weight before it could be implemented. Beyond logistical issues, Olivares was saddled with the uncomfortable reality that both his treasury and his military were overextended. Charles, for his part, was happy merely to have his peace with Spain, and he appreciated Rubens's efforts in bringing it to fruition.

Before the artist's return to Antwerp, in March 1630, the king knighted the painter at a Banqueting House ceremony, presenting him with a jewel-set sword and a diamond-studded hatband pur-

chased from Gerbier for 500 pounds. Not to be outdone by his Spanish counterpart, Charles pulled a ring from his finger and slipped it onto the artist's hand. The royal patent certifying his peerage didn't arrive at the artist's Antwerp home until the following December, but when Rubens finally received it, he must have been pleased. It read, "We grant him this title of nobility because of his attachment to our person and the services he has rendered to us and to our subjects, his rare devotion to his own sovereign, and the skill with which he has worked to restore a good understanding between the crowns of England and Spain." Mission accomplished.

Or was it?

THE HORRORS OF WAR

❧

> I am a man of peace, and I flee quarrels and lawsuits like the
> plague; I hold that an honest man's desire ought to be above
> all to enjoy perfect tranquility of mind in public as in private life,
> performing all the services he can, without injuring anyone.
>
> —PETER PAUL RUBENS

On his penultimate day in London, Rubens paid a call at the
Chelsea residence of Albert Joachimi, the Dutch envoy who had
spent so much of the preceding nine months working to block his
every move. It was an unlikely meeting between political adver-
saries, and one Rubens had undertaken on his own initiative, with-
out authorization from his superiors in Brussels or Madrid. The
pretext for the visit was a bit of minor diplomatic business: thirty
Flemish sailors had recently been captured off the English coast by
the Dutch navy, and Rubens was hoping to win their release. That
would have made for a satisfying feather in the already well-plumed
and jewel-encrusted cap he would be wearing upon his return
home.

But Rubens also had something greater in mind: the peace with
Holland that had been his goal from the very moment he had under-

taken diplomatic work on behalf of Spain. The primary benefit of the accord with the English, as he had recently advised Olivares, was that it would force the Dutch to the negotiating table. Rubens, however, was no longer prepared to sit and wait for Olivares to take up this cause. Impatient with the constant delays from Madrid, he was ready to test the efficacy of the plan he had devised with Cottington—but without permission from any higher authority.

Sitting with Joachimi, he now proposed a truce that would "bring quiet and rest after long war to all the seventeen provinces." Rubens was not content, however, to make this offer merely on behalf of Spain. He suggested as well that an armistice between Spain and the Dutch was the express will of Charles I. Implicit was the threat that if the Dutch failed to comply, they would find themselves at odds with England. Rubens had no authority, either from Charles or from his own monarch, to make such a loaded offer—or any offer at all—even if his reasoning was sound and his intentions pure. Dutch militancy, he knew, was an increasing concern for Charles; that Cottington had been authorized to make an offensive treaty with Spain upon his arrival in Madrid only reinforced this belief. Joachimi, however, wasn't fooled by Rubens's ploy. "I cannot believe the king has made any such motion," he told the painter. What's more, after months of debate over the peace terms already proffered at Roosendaal—the so-called *groote werck*—Joachimi knew that hard-liners within the Dutch political establishment would be opposed to any settlement, regardless of the English king's pressure. The Roosendaal talks were dead. If there was to be peace in the Low Countries, he told Rubens, there was "but one way feasible: chasing the Spaniards out." Adding insult to injury, Rubens got no traction on the release of the captured sailors.

Rubens did not leave England on a high note, but he was nevertheless happy to return to his family and neglected studio in

Antwerp. Minus his four-day stopover en route from Madrid to London, he had been absent from home for a year and a half. Little had changed in that time. His house was in order, his cabinet of wonders intact, his exotic garden well tended, and—most important—his two sons in good health. There were celebrations to mark his return and festive meals with his antiquarian friends followed by spirited discussions on matters historical, scientific, and political. Soon, the elegant home on the Wapper had a new resident. On December 6, 1630, just nine months after his return from London, Rubens put an end to his bachelor days. The bride was Helena Fourment, the sixteen-year-old daughter of a respected tapestry dealer with whom he had done business. She was even a relation, though not by blood. (She was a first cousin, by marriage, of Isabella Brant, Rubens's deceased wife.) Rubens had known her for years, through his connection to the Brant family, and had even used her as a child model. Her older sister, Susanna, had also posed for him. (The intimacy of those portraits, and their number, suggest she might have been something more than a model.) That Helena came from a solid burgher family, and one that he knew well, was especially important to Rubens. In Brussels, it had been proposed that he make a court marriage. He rejected that advice in favor of a bride who "would not blush to see me take my brushes in hand." Helena was quite happy to watch him practice his art, especially when she was its subject.

Theirs was a September-May romance, or perhaps a November-February one. The disparity of their ages raised a few eyebrows, but it was not outside the bounds of propriety in an age of short life spans and early maturity, especially for women. Rubens was fifty-three at the time of the wedding and especially ardent; he used his considerable influence to win a special dispensation to marry during Advent, when such rites were normally precluded. Writing to his friend

Peiresc, he explained that he was no longer "inclined to lead the abstinent life of a celibate." To see Helena was to understand his carnal impulse. In a poem delivered during the nuptial festivities, Rubens's old friend Jan Caspar Gevaerts extolled her virtues, equating her to the heroines of the classical past Rubens so frequently celebrated on canvas:

> *Now he owns the living image of Helen of Flanders, who is far more beautiful than her of Troy. Whiter than snow, she is no daughter of the swan that betrayed Leda. She has no mark between her brows, like that which, they say, disfigured the forehead of the daughter of Tyndarus. In her pure soul she unites all the gifts that adorned the maidens of Hellas and Latium. 'Twas thus that Venus, with her golden locks, rose from the sea. 'Twas thus that Thetis became the bride of Peleus, in the days when Thessaly was the home of the great gods. The beauty of her shape is surpassed by the charm of her nature, her spotless simplicity, her innocence, and her modesty.*

Gevaerts may have exaggerated Helena's virtues, but so did Rubens. In his later years, she became an inexhaustible wellspring of his art. Hers was the face that launched a thousand paintings, and her body countless more. The nude was Rubens's great métier, and she had the kind of ample figure he had always liked to paint: fleshy and pink in its overwhelming erotic abundance. She was the walking model of his vision of Baroque splendor, and he ravished her on canvas, luxuriating in her body's every crease, dimple, swell, and curve. Not all of his paintings of her were explicitly erotic. Rubens also depicted his young wife in the finest silks, draped in fur, and strolling about the garden of their Antwerp home with the

four children she gave him in their time together. When he died, in 1640, she was pregnant with a fifth.

Rubens's plentiful satisfactions at home were tempered by a mounting frustration with political affairs. Responding to a letter of congratulation on his marriage from his friend Jan van den Wouvere, he wrote, "Though I find myself most contented in the conjugal state, as well as in the general happiness over the peace with England, I have occasion to lament my misfortune in ever having become involved in this affair." Rubens had spent a considerable sum out of his own pocket during his trips to Spain and England, and he was now being jerked around by a series of bureaucrats as he awaited reimbursement. "This seems to me such an insufferable affront and insult that I could almost abjure the form of this government," he wrote. "I am so disgusted with the court that I do not intend to go for some time to Brussels."

For a while, he was able to keep himself from the diplomatic grind. At the beginning of the New Year, Philip himself requested that Isabella dispatch Rubens back to London as an envoy. "One needs proven ministers with whom one is satisfied," the king wrote. The newly married artist rejected this call from his sovereign, however, and Isabella was forced to find a substitute and then notify her nephew of Rubens's decision. Philip, in fact, had wanted Rubens to serve as the Spanish ambassador, but the Council of State, still stuck on his professional status, refused to endorse a candidate who "lived by the product of his work."

At least the crown paid the money it owed him, and as a gesture of her own appreciation—and perhaps to help make up for the delinquency—the infanta herself presented him with a silver pitcher and basin decorated with antique figures. A few months later, in July 1631, she petitioned Philip to make him a knight of the realm. "He has served Your Majesty in the affairs that Your Majesty

and his ministers know, and with all fidelity and satisfaction," she wrote. "Your Majesty knows him and his good qualities, and knows how rare he is in his profession." In August, Rubens was officially granted the title *caballero*.

The elevation in status was more than just a ceremonial honor. Once again he had been conscripted into diplomatic affairs, and, as Isabella's petition indicated, the new title would allow him to continue his service "with added luster and authority." The political necessity that now required his attention was the predicament of his old client Marie de' Medici. Ever ambitious, the Queen Mother had foolishly become engaged in a power struggle with Richelieu—a losing battle. Knowing that her son Louis XIII had already exiled her once, she might have guessed that she could not count on his filial loyalty. In February 1631, on Richelieu's orders, she was banished under guard to Compiègne, in northern France. That guard was not careful enough to prevent her escape. Toward the end of July, the fugitive queen crossed over into Flemish territory at Avesnes, seeking asylum and Spanish military support against her son.

That is where Rubens found her, ego undiminished, even as her circumstances were a good deal less magnificent than those to which she was generally accustomed. Isabella had sent him as a councillor to the marquis d'Aytona, the Spanish ambassador to Brussels, who led the diplomatic delegation. Rubens, Isabella reasoned, would be an ideal intermediary, given his long-standing relationship with Marie. The artist was nothing if not sympathetic to her plight. Indeed, he'd been monitoring her situation with deep concern ever since she had been evicted from her Paris residence. His interest was mercenary as much as it was benevolent. In the months following his return from London, his studio had been engaged in work on the cycle of paintings illustrating the life of Henry IV that Marie had commissioned for the eastern wing of the

Luxembourg Palace. The considerable effort he and the studio had devoted to those pictures was now, he thought, "labor entirely wasted." Payment was almost certainly out of the question. The destitute queen, so recently his greatest patron, now found herself in the uncomfortable position of begging a loan from Rubens. He was happy to provide the funds, though he took a pair of diamonds as collateral. The "mere painter" was now the creditor of a queen of France, and a Medici no less. That must have been some considerable satisfaction.

Rubens was much more than a pecuniary ally to Marie. After his own experience fending off Richelieu's attacks in London, Rubens had no love for the cardinal, and found in Marie's situation an opportunity to engineer his downfall. While the queen had been exiled at Compiègne, her son Gaston, the Duke of Orléans, had escaped to Spanish-controlled Franche-Comté, and from there to the independent Duchy of Lorraine. Gaston shared his mother's aversion to Richelieu, and had spent the months of her captivity raising an army to wage a fratricidal war against his brother, Louis XIII. Even before Marie's escape, Gaston had petitioned Spain for financial support and the right to quarter his soldiers in Spanish-controlled territory. Those entreaties had been received with a certain coolness in both Brussels and Madrid. Richelieu was no friend of Spain, but war with the Dutch was already a severe drain on funds.

Rubens understood the Spanish reluctance to be drawn into conflict with France, but he considered it worth the price. If Richelieu could be removed from power, Spain would be relieved of a most troublesome foe. In a long and digressive letter to Olivares, he made a passionate argument in favor of intervention against the perfidious minister who "keeps the world in turmoil." "I have never worked for war, as Your Excellency can confirm, but have always

tried, insofar as I have been able, to procure peace everywhere," he wrote. Richelieu, however, was such an international danger as to warrant action, and not by halves, either. "Surely we have in our time a clear example of how much evil can be done by a favorite who is motivated more by personal ambition than regard for the public welfare or the service of his king," he wrote. That phrase might easily have applied to Buckingham or even Olivares himself, but Rubens was careful to place Richelieu in direct contrast to the count-duke, whom he praised as "a minister endowed with courage and prudence, who aspires to nothing but the true glory and grandeur of the king, his master." Rubens thought it was just the right time to plumb the count-duke's wells of courage: "It would be so unreasonable to let slip an opportunity the like of which has not presented itself for one hundred years, that one ought to make a virtue out of necessity." Removing so dangerous a foe would be worth the cost, even if the bill ran into the millions.

Rubens sent his treatise to Olivares on the first day of August. Two weeks later Olivares presented his argument before the Council of State, in Madrid. Their conclusion was unanimous: the painter, though well-meaning, was operating at a level above his capacity. There would be no Spanish intervention against Richelieu. Even with Spanish support, the count-duke questioned Gaston's ability to remove the cardinal. The potential costs of failure—financially, militarily, politically—were simply too high. If Gaston could independently demonstrate an ability to win in the field, Spain might reconsider, but until then it would be Olivares's policy to press for another reconciliation between Marie and her other son, Louis XIII.

Rubens's stalwart support, though ineffective in rallying the count-duke, still garnered him the appreciation of the Queen Mother. Jean Puget de la Serre, a member of her entourage, wrote a

glowing tribute to the painter after Marie visited his Antwerp home. "His judgment in affairs of state and his intellect and self-control exalt him so high above the rank of his profession, that the works of his wisdom are as remarkable and admirable as those of his brush. Her Majesty enjoyed extreme contentment in contemplating the animated marvels of his pictures." The cash advance also didn't hurt.

<center>✌</center>

MARIE HAD ESCAPED FRANCE, but the political situation in Flanders was not especially stable either. In the year following Rubens's return from England, the infanta's grip on power had become alarmingly precarious. The Anglo-Spanish alliance Rubens negotiated in London, however impressive in its own right, had little restraining effect on the Dutch, as had been hoped. A string of Dutch victories in the field, combined with continued economic hardship at home, bred a growing resentment of Spanish stewardship within the Flemish population. Madrid placed blame for the sad state of affairs in the Low Countries on Isabella and her poorly functioning, underfinanced administration. Locals looked askance at Madrid, which effectively controlled Flemish domestic and foreign policy. Even Rubens was angry. "It appears that Spain is willing to give this country as booty to the first occupant, leaving it without money and without any order," he wrote. The Flemish aristocracy, which had been jealous of its lost prerogatives ever since the Duke of Alva's reign of terror, was particularly impatient with the infanta, who was accused by her enemies of being a mere puppet of Spain.

With the threat of an internal insurrection dangerously close to reality late in 1631, Isabella summoned Rubens to Coudenberg Palace. The painter, who had so recently lobbied for war with

France, was now conscripted to secretly broker a peace deal with its Dutch ally, this time through direct negotiation with Frederick Henry, the Prince of Orange. That, in theory, would solve everyone's problems, at least temporarily. Peace would breed some modicum of prosperity in Flanders, and thereby placate the restive population. Spain could hardly afford the continued fighting. Isabella's personal situation was so volatile that Madrid would just have to accept what terms could be drawn. For months she had been bickering with Olivares, who had grown disconsolate over the state of affairs in his crumbling empire. "I know that I get nothing right, and never will," he wrote to her in June. Across the Dutch border, Frederick Henry had shown himself to be a willing and reasonable negotiating partner. By December 1631, he had supplied Rubens with a passport allowing him free passage into enemy territory. When Isabella dispatched her agent, he left carrying "full power to give the fatal stroke unto Mars."

Rubens made the trip to The Hague in three days, arriving on a Tuesday evening after a stopover at Bergen op Zoom. He kept a low profile during the trip, not wanting to arouse suspicion along the way. After he had returned, he told Balthasar Gerbier, now acting as an English agent in Brussels, that he had not been identified on the journey. In the Dutch capital, he took a suite of rooms at an inn close to the Oude Hof, the prince's residence, and sent a messenger there with a request for an audience. A short while later, Frederick's secretary arrived at his door.

Rubens could not have been happy to see who had come to greet him. It was the man he called "Junius," the same corrupt official he had accused of taking "bribes with both hands" years earlier, when he had enlisted the support of the lawyer Pieter van Veen to secure copyright privileges for his prints in Holland. Rubens and Junius had also crossed paths during the secret negotiations

Rubens managed through his cousin Jan Brant, "the Catholic." As ever, his presence was a poor omen of things to come. The Prince of Orange, he informed Rubens, was greatly astonished that the painter had come to Holland. Indeed, he told the painter, he would make "a good capture" for the prince. If Rubens hoped to avoid becoming a prisoner of war, he should turn around and retrace his steps at once.

This wasn't quite the reception Rubens had been expecting, but he correctly surmised that he was being tested. After noting that he had come on a passport issued by Frederick himself, he composed a pleading note to the prince, begging the opportunity to speak with him and going heavy on the obsequiousness, as was his wont. Junius delivered it, and soon after there was another knock on his door. This time it was a page, and he was there to escort Rubens to the Oude Hof.

Late in the evening, with important business at stake, neither Rubens nor the prince would have broached the rather unsavory shared family history that made them distant familial relations, even if both men were surely aware of it. (Christina von Dietz, daughter of Jan Rubens and Anna of Saxony, was a stepsister of both men.) Instead, Rubens moved directly to the subject at hand: a truce that would bring peace to the Low Countries. He had been granted authority to strike a bargain with the prince, in which Spain would relinquish a series of Flemish cities, including hard-won Breda, in exchange for Pernambuco, the sugar-rich Portuguese colony on the coast of Brazil, captured by the Dutch in 1630. For Isabella, this was a considerable territorial sacrifice, but one that Olivares could live with back in Madrid, as it protected what was most vital to the Spanish crown—the colonial empire that filled its treasury. It was, perhaps, a generous offer, but Frederick Henry was in no position to accept it, at least on his own. Any treaty would have to win the

approval of the full Dutch States General, and after the long disputations of the *groote werck* he was not especially sanguine about the prospect of achieving it, even if he supported the Spanish proposal himself. With that, and a promise to keep channels open, Rubens was dismissed.

That meeting was somewhat less than hopeful, but Rubens didn't give up on his efforts to rally the prince. A month later, at the beginning of February, he wrote to Frederick Henry, pressing him on the terms they had discussed, and he followed that up with another letter two weeks hence. The prince never replied. At the end of March, the frustrated painter wrote once more to The Hague, this time to Constantijn Huygens, an adviser to Frederick (he was also a great connoisseur, and Rembrandt's first champion), inquiring in a rather passive-aggressive tone as to whether the prince had even received his letters. Frederick had read them, Huygens replied, but they were still subject to "deliberations." Rubens got the message, and passed it on to Isabella. "I do not see that it is possible to make any further efforts on our side for now," he wrote.

Frederick wasn't interested in negotiating because, in the months after Rubens's visit to The Hague, the run of the war had tipped heavily in his favor. In February 1632, just as Rubens was sending his pleading letters to Frederick, Isabella learned that her most distinguished and influential general, Henri de Bergh, had defected to the Dutch side, taking with him all of the troops under his command. Shortly thereafter, she uncovered a ring of aristocratic conspirators plotting her overthrow. Spain's enemies, and even its allies, were quick to exploit this situation for their own benefit. Richelieu did all he could to encourage the plotters. They also received intelligence from Balthasar Gerbier, a man always happy to place himself at the center of an intrigue, never mind his

long-standing friendship with Rubens and his many years working to bring peace to Spain and England. Gerbier's various enemies had always thought him shameless and unreliable, and his actions proved those judgments entirely valid. He even took to spying on Rubens, his erstwhile negotiating partner and houseguest, though without much success. "I got nothing out of him," he wrote. Gerbier did, however, take the rather extreme measure of having the painter tailed. Rubens never found out.

Isabella managed to break up the plot to remove her from power, but at a significant cost to her political standing. Her aristocratic opposition, now led by Philippe Charles d'Arenberg, the Duke of Aarschot, insisted that she call a States General of the Flemish provinces, and that this body be allowed to negotiate a truce on its own terms with its Dutch counterpart. In her desperation to avoid this outcome, which would have been entirely unacceptable in Madrid, she turned to Rubens, her most trusted negotiator. In late August, she dispatched him to meet with Frederick Henry at Maastricht, recently captured by the Dutch prince after a three-month siege. Once more, Rubens was given "full power to give the fatal stroke unto Mars." Once more, he was rebuffed, though the proceedings of their meeting remained veiled in secrecy.

That mission would prove to be the most controversial of Rubens's political career. His failure to conclude a deal made it impossible for the infanta to resist Aarschot's demand that the Flemish States General be allowed to independently negotiate with the Dutch. She was not, however, about to make it easy for them. In December 1632, when a team of Aarschot's deputies traveled to The Hague, they found their ability to bargain undermined by their ignorance as to the precise terms Rubens had discussed with Fred-

erick Henry at Maastricht. Isabella could have sent a brief, but instead arranged a passport for Rubens so that he might join in the deliberations, on her behalf.

That move enraged Aarschot, a pompous, stubborn man of considerable arrogance. The last thing he wanted was Isabella's oversight, and in the person of a painter, at that. The duke was heir to one of Europe's most storied noble dynasties, and had little patience for those of lesser social station. He advised Isabella that Rubens would not be recognized by the Flemish delegation at The Hague, so there was no point in his making the journey north. Aarschot wanted Rubens's papers, not Rubens. And so in early January, with talks stalled in The Hague, Aarschot excused himself from the deliberations and made a special trip to Antwerp to pry those papers directly from the artist's hands, a task he considered well beneath his dignity. On the morning of his arrival, he sent a note to Rubens demanding that the artist deliver the documents to him, in person.

In the more obsequious days of his youth, Rubens might have complied without hesitation, but the artist was no longer a political neophyte, a man with no standing. He had a sure sense of his own importance, and patents of nobility from two kings that certified it. He didn't take well to being summarily ordered around, especially by a man he considered just short of traitorous. Isabella was his patron, after all, and he had done nothing but follow her orders. With no alternative, however, he was forced to pack up his papers for the duke. But he wasn't going to show up in person to hand them over. In an accompanying note, he defended his behavior with thinly disguised antipathy. "I stand upon firm ground and entreat you to believe that I shall always be able to give a good account of my actions," he wrote. "I protest therefore before God that I have

never had any orders but to serve your Excellency, in all ways, in the conduct of this affair."

Aarschot wasn't interested in those excuses. "I might well have omitted to do you the honor of answering you, considering how grossly you have failed in your duty of coming to see me," he wrote in a reply brimming with condescension. "It matters little to me upon what ground you stand on and what account you can render of your actions. All I can tell you is that I shall be greatly obliged if you will learn from now on how persons of your station should write to men of mine."

That was enough. As far as Rubens was concerned, he had fulfilled his obligations to his sovereign. In his *Epistulae morales*, Seneca advised that the prudent citizen is wise to retreat to his own endeavors when the state becomes too corrupt for remedy. Petrarch later expanded on that point, emphasizing that a withdrawal from worldly affairs was all but necessary if one was to achieve "something great and veritably divine." Rubens, trained in the Lipsian tradition of neo-stoicism, was well aware of these prescriptions. "I carried out negotiations of the gravest importance, to the complete satisfaction of those who sent me and also of the other parties," he wrote to Peiresc. It was now time to "cut the golden knot of ambition" and return, full time, to his *dolcissima professione*. Having come to this decision, he made a final journey to Isabella's palace in Brussels, to beg her permission to be relieved of his duties. Isabella was not anxious to give up her secret diplomatic weapon, but he was adamant, and after some convincing she relented. It was his last successful negotiation. In his letter to Peiresc, he wrote that his retirement had proven harder to win than any favor she had yet granted him.

Aarschot's pride eventually got the better of him. Word of his

sharp exchange with Rubens soon was the talk of polite society in the Low Countries—and beyond. It was one thing to insult the Spanish king's favorite painter, but Aarschot's insistence on the prerogatives of the Flemish States General was an affront to Philip himself, and that would not pass. A new Spanish administrator was dispatched from Madrid with orders to rein in the duke and put a stop to all negotiations conducted by the States General. Under firm new leadership, and with Spanish military and economic power at its command, the Brussels junta reasserted the king's authority, bolstering Isabella's shaky regime. In November 1633, a frustrated Aarschot left for Spain to plead the case of the Flemish aristocracy before Philip. Isabella, still nervous about the precarious state of affairs in Flanders, advised her nephew to receive him "with as much courtesy as possible."

Isabella was especially concerned, because she had recently been advised by Gerbier, the freelancing diplomatic gadabout, that Aarschot had been among the ringleaders of the unsuccessful coup to remove her from power. Gerbier himself had been implicated in that conspiracy, and its failure left his reputation in jeopardy. As an expedient, he turned informant against the very plot he had previously worked to foment. Ever duplicitous, he even called on Rubens to testify on his behalf before Isabella. Rubens responded with a lukewarm endorsement of the man who had been surreptitiously reporting on his comings and goings. If he wasn't quite sure of Gerbier's treachery, his antennae were perceptive enough to sense something wasn't quite proper. Isabella remained unconvinced of Gerbier's sincerity, but paid him a bribe of 20,000 crowns for the full details of the plot against her. Shortly thereafter, the pious infanta so esteemed by Rubens as both a patron and a sovereign died of natural causes at the age of sixty-seven. The marquis d'Aytona, the Spanish ambassador Rubens knew well through the

recent negotiations with Marie de' Medici, was installed as interim governor.

In fact, Gerbier's charge against Aarschot was bogus, and Philip might well have been inclined to follow his deceased aunt's advice to let Aarschot off without any punishment were it not for the duke's own insolence. Aarschot was offered a full pardon in exchange for testimony about the conspiracy and an oath of fidelity. His responses, however, were so lacking in candor that Philip had him jailed. The duke died in prison after seven years of captivity. He was never tried for the crime he did not commit.

Rubens, meanwhile, had become increasingly weary of Gerbier. Indeed, he had been forced to intervene on behalf of his old "friend" in the previous year, when Gerbier had initiated negotiations with Isabella to bring Rubens's former pupil Anthony Van Dyck to London as a court painter to Charles I. The problem was that Gerbier had begun these discussions without even the courtesy of informing Van Dyck, who was quite understandably incensed. Rubens, ever the diplomat, managed to smooth over the hurt feelings, and Van Dyck eventually took the appointment. Gerbier later returned to England and, in 1638, was knighted for his service to the crown. His allegiance to Charles presented him with some difficulties during and after the English Civil War, but he managed to survive. That, always, was his primary skill. He died in 1663, at the age of seventy-one.

Only once more was Rubens compelled to return to diplomatic service, but the mission collapsed almost before it began. In the summer of 1635, with talk of conciliation in the air, he was recruited to travel through Holland to test the waters for yet another possible peace agreement with the Prince of Orange. The pretext for this trip would be a visit to Amsterdam to look at a few paintings requiring authentication—he had been invited by local dignitaries—while

en route to England to install his canvases at the Whitehall Banqueting House. The ruse was soon discovered in Holland, and the States General refused to grant him a passport, which was just as well. "I have preserved my domestic leisure," he wrote to Peiresc, "and by the grace of God, find myself still at home, very contented." The Whitehall paintings were sent to London by courier.

<center>~≫≪~</center>

IN THAT SAME LETTER TO PEIRESC, Rubens professed a "horror of courts." In the final years of his life, he managed to avoid them almost entirely, even as his professional practice meant he was never far removed from political affairs and those who orchestrated them. His values, for all of his wealth and titles of nobility, would always be those of the burgher elite. He nevertheless remained a favorite of Philip IV, who commissioned him to provide a decorative program of more than sixty paintings, mostly mythological scenes drawn from Ovid, for the Torre de la Parada, the king's hunting lodge outside of Madrid. (Rubens made oil sketches for the paintings, which were executed on canvas by his studio assistants.) Charles was so pleased with the Banqueting House ceiling, when it finally arrived, that he sent Rubens a gold chain as a reward. Even Frederick Henry, his implacable negotiating foe, begged the great painter for a work from his brush.

Through all of his travels, Rubens remained a devoted servant of his beloved Antwerp. When the beleaguered city needed him most, at the close of 1634, he was ready and willing to lend it his aid. The occasion was the ceremonial entry into the city of Cardinal-Infante Ferdinand, the strong-willed younger brother of Philip IV. Rubens had painted Ferdinand on his most recent trip to Madrid, a half-length portrait in his clerical habit. The prince had been made a cardinal as a matter of political expedience, but he was by nature

a man of action disinclined to the ascetic life of a church elder. "Rid me of these cardinal's robes, that I may be able to go to the war," he demanded. He got his chance. It had long been planned that he should succeed his aunt Isabella as governor of the Spanish Netherlands. When he received the sad news of her passing, in 1633, he was brushing up his administrative and martial abilities in Milan. From there, he marched north with an army, taking a detour along the way to rout the Protestant forces of Sweden at the Battle of Nördlingen, in Germany. By November 1634 he was ensconced in Brussels, having relieved d'Aytona of command.

The arrival of a new prince was traditionally grounds for a civic celebration of welcome. Antwerp, its economy weak and its citizens still doleful about their prospects, chose to roll out the red carpet for the cardinal-infante, and to do so in the grandest style. All of the struggling city's financial and intellectual muscle would be leveraged in the rather desperate hope that Ferdinand would be moved to come to its rescue. Who better to oversee this grand project than the city's favorite son, Peter Paul Rubens? There was no one, anywhere, more skilled at orchestrating a massive decorative program designed to impress a royal patron.

Rubens dutifully accepted the commission, and set to work planning a reception that might embarrass a Roman emperor. In December 1634, he presented his ideas to the city magistrates. Three triumphal arches would be thrown up on the route Ferdinand would follow through the city. A series of stages, each with an allegorical scenic program, would be constructed at key civic sites. An elaborate portico, more than two hundred feet long, would be built along the Meir. There would be flags and bunting and statues and three hundred lampposts capped with tar-barrel torches to keep the city ablaze at night, when a spectacular pyrotechnics show would enliven the sky above.

It was an extraordinary vision, and the initial schedule required it to be ready in a single month—and during winter no less, when construction would be most difficult. The Rubens workshop, accustomed to large projects and tight deadlines, now became the headquarters for an operation of unprecedented scale. Architects, artists, craftsmen, suppliers, and bureaucrats came in and out in waves, all hoping for a moment with the master, who sat in the center of it all, making sketches, interviewing subordinates, delegating jobs, and granting approvals. The press of work challenged even his famed ability to manage a great many tasks at once. "I am so overwhelmed with work," he wrote in the midst of the preparations, "that I have not time to write, or even to live." (Being Rubens, he found the time.) All of Antwerp's resources were marshaled and placed at his disposal. The cost was enormous. The city raided its meager treasury and even then had to impose a special tax on beer to pay for it all—no small sacrifice for the average *sinjoor*, who drank three pints per day and considered it his birthright.

When the day of reckoning arrived, the city ramparts were packed with spectators, and trumpeters played from its ceremonial gate, which had been gilded for the occasion. At four o'clock, Ferdinand marched down from Alva's old citadel, a troop of his best horsemen before him, to be greeted by the burgomeester and a salvo from the civic guard. A young girl draped with flowers presented him with a laurel crown and a golden salver. So equipped, Ferdinand began his procession through the city toward the first of Rubens's stages, where a large painting depicted a maiden of Flanders kneeling before the new prince. If there was any question as to its meaning, a Latin inscription, written by Gevaerts, made it clear: "To thee we look for our salvation; the days which the plagues of war have made evil will through thee become better days; the road lies open before thee, and Victory flies on snowy wing to greet

thee." For the rest of the afternoon and into the evening, Ferdinand was guided along Rubens's scripted path, the message of civic desperation drummed home with an insistent determination. On Nieuwstraat, Ferdinand saw his victory at Nördlingen, and with it a request that he return peace to the troubled land of Flanders. At the Stage of Mercury, on the plaza before the Church of St. John, there was a prayer for the reopening of the Scheldt. Above it, Rubens illustrated the city's plight with a personification of the river collapsed over a barren urn. Abandoned ships, a destitute sailor, and a starving child were added for emphasis.

Rubens was not there to greet Ferdinand at the city gate, nor did he accompany the cardinal-infante on his procession through the many installations he had designed and seen to completion. The superhuman effort required to produce the great spectacle precipitated an acute case of gout that left Rubens bedridden in his Antwerp home. Ferdinand, who stayed eight days in the city, made a special point to call on the recuperating painter to express his compliments and gratitude. When Rubens recovered, he painted a new portrait of the infante, with his cardinal's robes exchanged for a shining suit of armor and the red sash of a military commander. Ferdinand, in turn, granted Rubens the sinecure of court painter, as Albert and Isabella had done before him.

The armor suited Ferdinand, who soon found himself embroiled in a two-front war with France and Holland that left him in no position to offer financial assistance to Rubens's beloved city. Spain's two enemies had agreed on a pact of mutual aggression, their aim being to squeeze Flanders from above and below and then to divide it between them, with the Dutch-speaking north handed over to Holland and the Francophone south delivered to France. (Back in Madrid, Olivares may well have cursed himself for not taking Rubens's prescient advice, given just a few years ear-

lier, to remove Richelieu from power at any cost.) Ferdinand, however, proved an able defender of his adopted homeland. In 1635, he made forays deep into enemy territory, to both the north and the south. His most impressive performance came in defense of Antwerp, in June 1638, when he routed a Dutch offensive at Kallo, just a few miles from the city walls. He captured more than twenty-five hundred prisoners and eighty river transports in what he claimed to be the greatest victory in the long history of the conflict with the Dutch. The Franco-Dutch alliance was left to flounder.

The good *sinjoren* were grateful for the rescue, and demonstrated that sentiment at their annual fair. A decorated chariot in the shape of a boat, designed by Rubens and drawn by a pair of white horses, carried an enormous trophy in honor of the warrior hero. Ferdinand appreciated the gesture, if not the ardor, of the local celebrants. "The great festival they call the *kermis* took place here yesterday," he wrote. "It is a long procession with many triumphal carts . . . and after it has all passed by, they will eat and drink and get thoroughly drunk, because without that it's not a festival in this country. There's no question that they live like beasts here."

Rubens was familiar with the boisterous, coarser aspects of the Flemish character, but he looked upon them with a native's sympathy that Ferdinand, a foreigner of noble blood, could never quite understand. In his later years, the *kermis* was a subject Rubens would happily take up, just as Pieter Brueghel had before him. Rubens's paintings, classically inspired compositions in bucolic settings bathed in warm light, suggest a certain romanticized pride in Flemish custom, notwithstanding its occasional boorishness and vulgarity.

As Rubens grew older, he gave in more and more to his pastoral impulse, both on canvas and in his daily life. In May 1635, he traded in his modest country house in nearby Ekeren for a massive

estate outside of Mechlin. The Castle Steen was built of stone and enclosed by a moat. Orchards and rolling meadows stretched as far as the eye could see, and one could see a good long ways from the crenellated guard tower adjacent to the big manor house. Rubens paid nearly 100,000 florins for it, and the right to call himself the Lord of Steen.

On his peaceful new estate, Rubens took up landscape painting in earnest for the first time in his career. Freed from diplomatic service, he also celebrated the pleasures of family, love, and society in pictures of extraordinary grace and beauty, images that often depicted his beautiful wife, Helena Fourment. She was there in *The Feast of Venus*, a Roman debauch in which he placed her in the arms of a muscled Satyr, and she was there, in several guises, in *The Garden of Love*, a more respectable outdoor fete. If her face was not immediately recognizable, she was at least spiritually present in a series of love-themed mythological paintings—*The Three Graces, The Judgment of Paris, Venus and Adonis, Diana and Callisto*—that remain, to this day, among his most beloved pictures.

Those canvases were balanced by a series of less sanguine meditations on the costs of war, raw acknowledgments that, for all of his own good fortune and the ostentatious luxury enjoyed by his royal clients, the world was still a cruel place, and that man was often responsible for his own tribulations. Rubens, raised by a single mother who kept her family together through war and the degeneracy of her husband, persistently depicted the female figure as a paragon of virtue and peace felled by male bloodlust. In a sketch made in chalks and gouache some time after his return from London, he drew Mars, dagger in hand, dragging a woman off by the hair as Minerva and Hercules look on helplessly. In a monumental *Massacre of the Innocents*, a gruesome slaughter painted in 1636,

children are speared and trampled by Roman soldiers. A swooning mother in the foreground wears a contemporary dress, a striking suggestion of the relevance of the mythological scene.

Rubens deplored violence in practice, but no painter, before or since, depicted it with such relish or sheer beauty. Whether it was a lion hunt, a crucifixion, or a battle scene, his expressive brush-strokes and dynamic compositional structures suited themselves to an aesthetic celebration of mortal brutality. Rubens's violence could be gratuitous—skewered children and severed heads on pikes—but for the most part it was not of an easy, pandering variety. Rubens had spent a lifetime working to establish peace in Europe, and his paintings of war were meditations on its awful costs, rather than bellicose arguments for aggression. Even his warrior heroes were tragic figures. A cycle of paintings, made during the truce years, related the story of the valiant Roman consul Decius Mus, who sacrificed himself to save his own army.

Rubens's great masterpiece on the theme of violence was his *Horrors of War*, painted in the winter of 1638 as a commission for the Grand Duke of Tuscany. The composition, for which he was paid 142 florins, was derived from the earlier sketch of Mars dragging off a female figure, but with significant alterations. At the center of the large canvas, Rubens painted the war god rushing forward with a bloody sword as a nude Venus, one of his most beautiful, drapes herself across his body in an effort to restrain him. An architect, protractor in hand, is thrown on the ground, symbolizing the urban destruction that is war's inevitable consequence. Mars treads on a book and paper—the sad fate of the arts and sciences. Cowering at the side is a woman with a child in her arms. As Rubens wrote in an explanatory note about the painting, that maternal figure "indicates that fertility, procreation, and parental love are disrupted by war, which ruins and destroys everything."

Opposite her is another disconsolate female figure, reeling in terror. "That grieving woman," the artist wrote, "clad in black with a torn veil, robbed of all her jewels and ornaments, is the unfortunate Europe, which has endured plunder, humiliation, and misery for so many years now, so deeply felt by everyone, that I need say no more on the subject."

In fact, he had a bit more to say on the subject. It was in that same year, 1638, that his old friend Balthasar Moretus commissioned from him a title-page design for yet another edition of Frederik de Marselaer's primer on diplomatic conduct. Rubens responded with a typically sophisticated composition: Minerva (representing wisdom) and Mercury (patron of ambassadors) reach out to each other below a bust of Politica, an allegorical personification of good government, itself crowned by the towers of a vigorous city. Angels fill the sky above. Dancing children appear in relief below. In a letter, Rubens described the design in some detail, explaining the significance of its many elements in a monologue that shifted from the exploits of the Athenian politician Themistocles to his own philosophy on the conduct of foreign affairs. "The advice gleaned from Minerva's wisdom must be put into action through eloquence, through the words best suited to the issue, so that the ambassador fulfills his duty with composure," he wrote. "Through the accomplishments of ambassadors (indicated by the olive branch which they bear), who judiciously conduct public affairs, the citizens are preserved."

Two years after he wrote those words, Rubens succumbed to the gout that had plagued him for so much of his adult life. His final decline was rapid. By the spring of 1640, the artist's dexterous hands were crippled to the extent that he could no longer hold a pen. A series of doctors treated him in his last days; Ferdinand even dispatched his personal medical team from Brussels, but to no

avail. All the bloodlettings and false cures may well have done more harm than good, a possibility of which Rubens was acutely aware—he had always been suspicious of such treatments. Diet may also have contributed to his problems. Herring, a staple of the Flemish table, contains a hormone that exacerbates the effects of gout.

Rubens died on May 30, 1640, at the elegant home he designed for himself in Antwerp, with his wife by his side. Three days later he was buried at the Church of St. James. In the years following, an altar was raised in his honor, with paired columns, a statue of the Madonna by one of his prized students, and an epitaph in Latin composed by his old friend Gevaerts. Indeed, no Flemish writer of merit failed to pen an encomium to the great painter-diplomat, but few achieved the majesty that was Rubens's signature. Antwerp's Alexander van Fornenbergh may have come closest. "The rhyming geniuses who have celebrated Rubens in bold verses and composed learned poems in his honor all imagine they have carried off the palm, but they have taken charcoal to paint the sun," he wrote. Only Rubens could have gotten away with that.

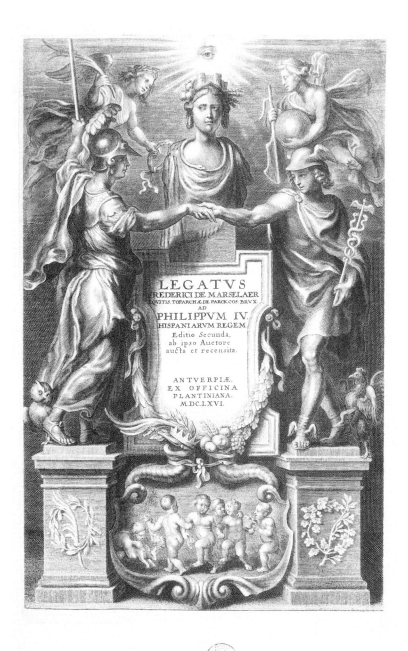

LEGATVS

FREDERICI DE MARSELAER
EQVITIS, TOPARCHÆ DE PARCK, COS. BRVX.
AD
PHILIPPVM IV.
HISPANIARVM REGEM.
Editio Secunda,
ab ipso Auctore
aucta et recensita.

ANTVERPIÆ,
EX OFFICINA
PLANTINIANA.
M.DC.LXVI.

EPILOGUE

꒰꒰꒱꒱

We are not likely to see a painter-diplomat like Rubens again. Ours is an age of specialization, and the practice of diplomacy has become a fully professionalized calling. Modern modes of travel and telecommunication mitigate against the need for the kind of proxy diplomacy conducted by Rubens. Though back-channel negotiations are still a useful tool in a statesman's repertoire, it is hard to imagine a scenario in which a delicate matter of policy would be entrusted to an artist, especially a painter. The contemporary art world is an insular place, and its stars are practically groomed to challenge conventional authority and command public attention—hardly desirable character traits for a reliable political operative. A chef or an architect would seem a more plausible, if still unlikely, candidate for a covert diplomatic role. Those professions remain grounded in craftwork, but confer on their foremost practitioners a measure of deference among figures of international power.

Rubens, however, was born at a time when the greatest painters

worked at the pleasure of kings and queens and heads of state. He honored them with his brush, and served them as a diplomat. In return, he was celebrated by his royal patrons, and sometimes more for his ability as an ambassador than for his skill as a painter, which was almost universally considered without equal. Sadly, that same political career is almost entirely forgotten by scholars of political history. For art historians, it is of ancillary interest, worthy of attention to the extent that it informs Rubens's work as an artist, but not in its own right and only marginally for any broader access it might give to his personality or the context in which he practiced.

The vicissitudes of history are at least in part to blame for this state of neglect. Rubens's greatest achievement as a statesman, the treaty he negotiated between Spain and England, is now a footnote in the grand sweep of seventeenth-century international relations, no matter how critical it may have appeared at the moment of its signature or how much skill was required to bring it to fruition. Rubens never achieved his ultimate diplomatic objective, a reconciliation of Spain and the Dutch provinces, and with it peace in the Low Countries. That did not come until eight years after his death, with the signing of the Treaty of Münster, in 1648; with it, the Dutch formally won their independence from Madrid. That treaty was the first of a pair of accords signed in Germany in 1648 (the second was the Treaty of Osnabrück) that together constituted the Peace of Westphalia, which brought to a simultaneous close the Eighty and Thirty Years' wars.

Münster gave the Dutch the freedom in name that they already had in practice, but it did not open Antwerp to the world. By the terms of the treaty, the Scheldt remained closed to international traffic. Antwerp's golden age had come in the sixteenth century; the seventeenth would belong to Amsterdam. Belgium would not receive its own independence for nearly two centuries, during which time it

passed through Spanish, Austrian, French, and Dutch control. Even now it is a land without a common language, a federation of relatively autonomous and culturally heterogeneous regions. Antwerp's resurgence as an international trading center did not come until the latter half of the nineteenth century, fueled by the spoils of Belgium's colonial empire. Large-scale industrialized growth, funded by the Marshall Plan, followed World War II. Today, Antwerp is again one of the busiest ports in the world and an international design capital.

It is also very much a city Rubens would recognize, a fashionable center of winding lanes and discreet charm. Alva's old citadel is gone; Antwerp's Koninklijk fine arts museum sits in the *terrain vague* that once separated the old fort from the city proper. Its Rubens galleries are among its prized attractions. Indeed, nearly four centuries after his death, the painter's presence in the city is ubiquitous, emanating from the bronze statue of him that commands the Groenplaats, Antwerp's central plaza. Adjacent to this is the Onze Lieve Vrouwe-kathedraal, where Rubens's two great altarpieces—*The Raising of the Cross* and its pendant illustrating the descent therefrom—flank the pulpit. The limpid light of the cathedral hasn't changed much since the days of the painter, and many other landmarks of that time are similarly intact: the offices of the Plantin Press, for instance, and the home of his friend Nicolaas Rockox, filled with a connoisseur's collection of art and bric-a-brac. The Grote Markt still has its medieval character, and the Meir is still Antwerp's main thoroughfare. Just off it, on the Wapper, is a facsimile of the home and studio Rubens built for himself after his return from Rome. Only the portico and garden pavillion remain from the days of the artist; subsequent owners dramatically reshaped the elegant complex Rubens had built for himself. One even turned it into an equestrian academy. The painstaking reconstruction one finds today was undertaken only in the early

twentieth century, and completed during the Nazi occupation of Belgium. Rubens's palpable eroticism was not considered "degenerate" by the National Socialists. They claimed him instead as an exemplar of muscular Aryan genius. One of the most important academic monographs on the painter was published in Munich in 1942—an uncomfortable reality for contemporary scholars.

This, of course, was always an issue with the opacity of Rubens's works; meanings could be assigned to them, regardless of the painter's intention, and never mind what he might have thought. Sometimes this was a benefit, sometimes not. As the scholar Jacob Burckhardt wrote in his landmark study of the painter, *Recollections of Rubens*, "The position of art is especially perilous when it has to serve a prevailing opinion, patriotic, political or religious, in great historical pictures."

But a larger problem for Rubens has been not so much the imposition of distasteful readings on his pictures as a more profound loss of meaning altogether. Even in the seventeenth century, a lively debate could be had among critics and connoisseurs as to the utility of allegorical painting, and whether it was appropriate to combine contemporary and historical figures and events. In the years following, the British master Joshua Reynolds called that kind of mishmash a "fault," though he gave the great Rubens a pass. By the end of the nineteenth century, Burckhardt could describe Rubens's allegorical mode of representation as "a vogue which is now absolutely obsolete." The mythological, historical, and biblical stories that were the subjects of his paintings are no longer familiar to modern viewers. Even scholars have trouble deciphering the intricate statecraft of seventeenth-century Europe that was the subtext (and occasionally the primary theme) of his art.

With his works shorn of so much intellectual freight, the

popular perception of Rubens has sunk to a lowest-common-denominator view of the artist as an indefatigable promoter of Baroque power with a special predilection for plump ladies. The term "Rubenesque" entered the lexicon as a euphemism for a voluptuous female figure in 1913, in the women's magazine *Maclean's*—the editors found his taste "eccentric." Indeed, modern audiences, for the most part, admire rather than adore him. His works can be impenetrable, and they do not leave obvious traces of a troubled personality; Rubens was not the maladjusted, self-destructive genius so many of us have come to expect of great painters. Those characteristics more aptly describe his brooding contemporaries Caravaggio and Rembrandt, both more popular today. Rubens, however, was famously well-balanced. If nothing else, that much is clear from even a brief glimpse at one of his very few self-portraits. There is no great sense of introspection in these pictures, no hinting at unfathomable psychological depths, no access given to the inner workings of a complex mind. The traditional polarity of the portrait is inverted: you are not invited to gaze in at the soul of Peter Paul Rubens; instead, he looks out appraisingly at you, betraying little more than a commanding self-possession.

The formalist reduction of Rubens began in the decades following his death, and one of the chief culprits was his own biographer, Roger de Piles. Like Rubens, de Piles conducted diplomatic work under the cover of a career in the arts (as a collector and critic), and actually penned his influential *Abrégé de la vie des peintres* (Short History of the Lives of the Painters) while imprisoned in The Hague for spying on behalf of France. His notorious *Balance des peintres*, published in 1708, graded fifty-six contemporary and historical artists on a scale of 0 to 18 (the higher the better) in the categories of composition, drawing, color, and expression. Rubens's combined

score of 65 was equaled only by Raphael. Leonardo and Michelangelo received 4s in color; Rembrandt was done in by a 6 in drawing; Caravaggio got a 0 for expression.

On de Piles's ledger, Rubens received his highest marks for composition and color, and it was on these terms that he was most celebrated in Paris. His "design," however, was a point of contention. Nationalist critics advocated the more severe classicism of Nicolas Poussin, and connoisseurs divided between camps of *Rubenistes* and *Poussinistes*. Compared with the Frenchman, Rubens appeared almost wanton in his handling of the body, an artist to be appreciated primarily for his bravura application and modulation of color. The aestheticization of the Rubens legacy was only accelerated by his association with the painters of the rococo, Antoine Watteau and François Boucher most prominently, who freely adapted his style in pictures of sweet, frivolous pleasure. As the esteemed historian Kenneth Clark wrote, "Rubens did for the female nude what Michelangelo did for the male. He realized so fully its expressive possibilities that for the next century all those who were not the slaves of academicism inherited his vision of the body as pearly and plump."

Rubens would always be an "artist's artist," a painter admired for his technical virtuosity and creative invention. "He dominates," wrote Eugène Delacroix, "he overwhelms you with so much liberty and audacity." Some have considered him too overpowering. The English critic John Ruskin, in 1849, called him "vulgar," a sentiment echoed two decades later by the American painter Thomas Eakins. "Rubens is the nastiest most vulgar noisy painter that ever lived," Eakins wrote. "His men are twisted to pieces. His modeling always crooked and dropsical and no marking is ever in its right place or anything like what one sees in nature . . . His pictures always put me in mind of chamber pots."

That attitude has been, for the most part, an aberration.

Rubens's work has been a vital source for painters of various periods, schools, and nationalities. His influence is evident in the work of Auguste Renoir, Willem de Kooning, and Lucian Freud. The opacity of his paintings, along with his attention to the painted surface, anticipated the implacability and object fetishism of so much contemporary work, in particular the minimalist and conceptual movements. His workshop production remains a standard, in terms of both its scale and its profitability, by which others are measured even as art making has become an industrialized process. His works still command top dollar. In 2002, a "lost" Rubens *Massacre of the Innocents* (it had been incorrectly attributed) was sold at auction for the equivalent of $86 million, then the fourth-highest figure on record for a painting.

One of the more poignant references to Rubens can be attributed to Pablo Picasso, one of the few painters in history who could match his natural genius, and ironically one who was said to abhor him. Rubens was nevertheless an unavoidable touchstone for the Spaniard, and Rubens's monumental meditation on the unholy cost of violence, *The Horrors of War*, was inevitably a source of inspiration when Picasso began work on his response to the Nazi bombing of the Basque village of Guernica, in late April 1937. That immense black-and-white canvas, more than twenty-five feet across and eleven feet tall, quoted Rubens's earlier work, but with a savage, unrelieved brutality. It first was exhibited at the Spanish Pavilion of the 1937 Paris World's Fair and then traveled around the world, drawing attention to and raising funds for the republican cause in the Spanish Civil War. Three centuries earlier, Rubens had been similarly moved by the plight of innocent civilians in his own homeland.

The dangers posed by a dogmatic foreign policy, an insular government, and a renunciation of the world system of diplomatic

exchange have never been more apparent. Indeed, it can be astonishing how little distance separates our century from the time of Rubens, despite the passing of so many years and our extraordinary leaps forward into modernity. Fully four centuries ago, long before the idea became a commonplace, Rubens understood that the interests of the entire international community are bound together inseparably, that Europe is united by a "chain of confederations." Today, that metaphor has become a physical reality. The European Union, headquartered in the artist's native Belgium, seems even in its imperfections a fulfillment of his vision of a continent at peace, administered by policy makers accountable for their actions.

Rubens was hardly naive about the commercial, religious, and political forces pulling against the fragile stability of international community. He was deeply suspicious of alliances of convenience and saw how easy it was for regional conflict to metastasize into global calamity. But he also knew that international bonds represented an opportunity for a pragmatic diplomat; relationships could be leveraged and resources deployed to spread peace across an entire continent united by mutual interest. It was that vision that drew him into political affairs, and kept him engaged even when forces aligned against him. "I should like the whole world to be in peace, that we might live in a golden age instead of an age of iron," he wrote. In his art and in his diplomatic work, he gave color to that dream, even if he never saw it fully realized.

It is sadly ironic that Rubens's homeland is once again a place divided against itself. Chauvinist voices in Dutch-speaking Flanders and Francophone Wallonia threaten to dissolve a fragile federal union held together by an increasingly pressed centrist coalition. For Belgians fighting to save their union, Rubens should be a useful symbol, a universally esteemed treasure beloved by all. His artistic

project was defined by an essential internationalism, by an ability to merge disparate traditions into a unified, coherent whole. Politically, he was a relentless advocate for regional peace and stability, goals for which he worked tirelessly, at great personal sacrifice. Though he could justifiably claim to be a citizen of the world, and would have been a welcome emigrant in any one of Europe's great capitals, he made his home in Antwerp, a small city that prized its cosmopolitan history and tradition of openness. A dozen languages could be heard on its streets, Dutch and French among them. Rubens was comfortable in either of those tongues, but given the choice, he spoke Italian. That was an intellectual's choice, and one that indicated a certain progressive humanism, a way of thinking informed by but not captive to history. It was that vision, simultaneously looking forward and back, to which he gave such dramatic color, on canvas and in life.

ACKNOWLEDGMENTS

꒰꒳꒱

This project took flight in the office of Sarah Burnes, an adviser and advocate of Rubensian wisdom for whom no praise is too great. Thanks also to Chris Parris-Lamb for his encouragement, and to all of David Gernert's expert staff for their support.

It is an honor to be published by Nan A. Talese. I'm grateful for her faith and her gimlet editorial eye. Ronit Feldman has improved every aspect of this book, and has kept me sane with her optimism and clear thinking. Thanks also to Lorna Owen and Luke Epplin for their contributions. My gratitude goes to all my fellow travelers in the publishing industry in this uncertain time for the book.

My interest in the political career of Peter Paul Rubens was sparked years ago in a seminar room under the direction of Elizabeth Alice Honig. I am immensely grateful for that early inspiration, and for her generous support throughout this project.

Renilde Loeckx made it possible for me to conduct research on Rubens in Belgium. Thanks also to Liliane Opsomer in New York,

and to Frank Deijnckens, Carl Depauw, and Ben van Beneden in Antwerp.

This book was written in the Frederick Lewis Allen Room at the New York Public Library. To work daily at that institution is an extraordinary gift. I thank all the many librarians, there and elsewhere, who assisted me, especially David Smith and Paula Baxter. Thanks also to my Allen Room colleagues Beth Fertig, Susan Jacoby, Mark Lee, and Alex Rose.

I thank all of my friends and family for their support, especially Mark and Valeria Kuchment. My parents, Hal and Jane Lamster, warrant sainthood.

Even when life is most difficult, my daughter, Eliza, finds a way to glow my stars. Finally and above all I thank my wife, Anna Kuchment, who gives color to my world. Rubens himself could not do her justice.

CAST OF CHARACTERS

THE RUBENS FAMILY

Peter Paul Rubens: artist, diplomat, scholar

Jan Rubens: father of Rubens

Maria Pypelinckx Rubens: mother of Rubens

Philip Rubens: brother of Rubens

Isabella Brant Rubens: first wife of Rubens

Jan Brant: father-in-law of Rubens

Jan "the Catholic" Brant: Dutch cousin of Rubens

Helena Fourment: second wife of Rubens

THE SPANISH

Philip II: king of Spain; son of Holy Roman Emperor Charles V

Philip III: king of Spain; son of Philip II

Philip IV: king of Spain; son of Philip III

Duke of Lerma: chief minister of Philip III

Count-Duke of Olivares: chief minister of Philip IV

Duke of Alva: governor of the Spanish Netherlands

Margaret of Parma: governor of the Spanish Netherlands

Alessandro Farnese, Duke of Parma: son of Margaret, governor of the
 Spanish Netherlands

Archduke Albert of Austria: sovereign of the Spanish Netherlands

Infanta Isabella Clara Eugenia: daughter of Philip II; wife of Archduke
 Albert and co-sovereign of the Spanish Netherlands

Ambrogio Spinola: military commander of the Spanish Netherlands

Diego Messia: Spanish statesman; son-in-law of Spinola

Cardinal-Infante Ferdinand: governor of the Spanish Netherlands

THE FLEMINGS

Justus Lipsius: scholar and mentor of Philip Rubens

Jean Richardot: statesman and friend of the Rubens family

Otto van Veen (Vaenius): painter and teacher of Rubens

Nicolaas Rockox: Antwerp burgomeester and friend of Rubens

Jan van den Wouvere (Woverius): statesman and friend of Rubens

Jan Caspar Gevaerts (Gevartius): humanist and friend of Rubens

Duke of Aarschot: nationalist aristocrat and statesman

THE DUTCH

William the Silent of Nassau, Prince of Orange (William of Orange):
 stadtholder, leader of Dutch revolt

Anna of Saxony: wife of William of Orange, paramour of Jan Rubens

Maurice of Nassau, Prince of Orange: stadtholder; son of William and
 Anna

Frederick Henry, Prince of Orange: stadtholder; son of William and
 Louise de Coligny

Johan van Oldenbarnevelt: statesman

Pieter van Veen: lawyer; brother of Otto van Veen

THE FRENCH

Marie de' Medici: Queen Mother of France

Cardinal Richelieu: chief minister

Louis XIII: king of France; first son of Marie

Gaston, Duke of Orléans: second son of Marie

Nicolas-Claude Fabri de Peiresc: humanist and friend of Rubens

Palméde Fabri, sieur de Valavez: brother of Peiresc and friend of Rubens

Pierre Dupuy: friend of Rubens; brother of Jacques

Jacques Dupuy: friend of Rubens; brother of Pierre

THE ITALIANS

Vincenzo Gonzaga, Duke of Mantua: patron of Rubens

Annibale Chieppio: Mantuan secretary of state

Annibale Iberti: Mantuan ambassador to Spain

Ferdinand I de' Medici: Grand Duke of Tuscany

THE ENGLISH

James I: king of England

Charles I: king of England; son of James I

Henrietta Maria: queen of England; daughter of Marie de' Medici

George Villiers, Duke of Buckingham: favorite of James I and Charles I

Balthasar Gerbier: agent for Buckingham and England

Dudley Carleton, Lord Dorchester: diplomat and art collector

Francis Cottington: secretary of state and ambassador to Spain

Richard Weston, First Earl of Portland: lord treasurer

CHRONOLOGY

1548 Augsburg Transaction grants autonomy to the Low Countries, but they are still subject to the Holy Roman Emperor.

1556 Abdication of Charles V, Holy Roman Emperor. Habsburg Empire cleaved in two, with Ferdinand II ruler of Austrian branch and Philip II sovereign of Spain and its possessions, including the Low Countries.

1559 Treaty of Cateau-Cambrésis halts warring between Spain, France, and England.

1561 Marriage of Jan Rubens and Maria Pypelinckx.

1566 William of Orange leads "Beggar" movement against Spanish rule.
 Iconoclasm sweeps across the Low Countries.

1567 Duke of Alva arrives to restore order in the Low Countries via reign of terror.

1568 The Rubens family flees Alva's terror for Cologne.

1571 Jan Rubens arrested for extramarital affair with wife of William of Orange.

1572 France, England, and "Beggar" forces unite to oust Spain from
 the Low Countries.

1573 Jan Rubens paroled.
 Alva relieved of command.

1574 Birth of Philip Rubens.

1576 Antwerp sacked during "Spanish Fury." Antwerp falls under
 control of William.

1577 Birth of Peter Paul Rubens at Siegen, Germany, on June 28.

1579 Dutch provinces renounce Spanish authority with Union of
 Utrecht.
 Flemish provinces pledge loyalty to Spain with Treaty of Arras.

1582 Alessandro Farnese leads Spanish reconquest of the Low
 Countries.

1584 William of Orange assassinated. His son Maurice takes Dutch
 command.

1585 Farnese recaptures Antwerp. Protestants forced out.

1587 Death of Jan Rubens.

1588 Defeat of the Spanish Armada.

1589 Rubens family returns to Antwerp.

1596 Archduke Albert becomes governor of the Spanish Netherlands.

1598 Philip II dies. Philip III assumes Spanish throne. Infanta Isabella
 marries Archduke Albert; they become co-sovereigns of the
 Spanish Netherlands.

1600 Rubens, a member of the painters' guild, travels to Italy and joins
 the court of the Duke of Mantua.

1603 Rubens departs on embassy to Spain for the Duke of Mantua.

1604 Rubens returns to Italy.
 Spain and England sign peace treaty.
 Ambrogio Spinola, Spanish military commander, captures
 Ostend.

1608 Rubens returns to Antwerp from Rome.

1609 Signature of the Twelve Years' Truce between Spain and the
 United Provinces.

 Rubens commemorates truce with *Adoration of the Magi* for the
 Antwerp town hall.

 Rubens marries Isabella Brant, becomes court painter to the
 archdukes Albert and Isabella.

1610 Rubens purchases property on the Wapper in Antwerp.

1611 Death of Philip Rubens.

 Rubens works on Antwerp altarpieces.

1618 "Defenestration of Prague" marks beginning of Thirty Years'
 War.

 Duke of Lerma (Spain) and Johan van Oldenbarnevelt
 (Holland) fall from power.

 Rubens acquires antiquities collection from Dudley Carleton.

1619 Initiation of Rubens-Peiresc correspondence.

1621 Twelve Years' Truce ends. Hostilities between Spain and Holland
 resume.

 Death of Philip III. Philip IV assumes Spanish throne.

 Death of Archduke Albert. Isabella reduced in status to
 governor.

 Spinola fails to take Bergen op Zoom.

 Palatinate occupied by Catholic powers. Frederick V, Elector
 Palatine, exiled.

 Rubens offers services for the Banqueting House in London.

1622 Rubens to Paris to meet Marie de' Medici.

 Rubens begins work as a covert operative.

 Rubens attacked by disgruntled employee.

1623 Failure of the Spanish match in Madrid.

 Rubens formally enters diplomatic service; conducts secret talks
 through his cousin Jan Brant.

 Death of Clara Serena Rubens, daughter of Rubens.

1624 Treaty of Compiègne; France allies with the Dutch.
 Rubens ennobled by Spain.

1625 Rubens to Paris for installation of the Medici cycle.
 Rubens meets Buckingham in Paris. Agrees to sell duke his
 antiquities.
 Spinola takes Breda.
 Buckingham launches failed attack at Cádiz.
 Death of Maurice, Prince of Orange. Succeeded by his brother
 Frederick Henry.

1626 Spain and France form secret alliance.
 Work commences on Fossa Mariana canal project.
 Death of Isabella Rubens.
 Rubens completes sale of collection to Buckingham in Paris,
 opens diplomatic talks with Gerbier on his own authority.

1627 Dutch raid port of Bahia, in Spanish-controlled Brazil.
 Buckingham launches failed attack at Île de Ré.
 Death of Vincenzo II, Duke of Mantua; crisis of succession
 follows.
 Rubens travels through Holland to secretly negotiate peace
 terms with England.

1628 Rubens travels to Spain to promote Anglo-Spanish alliance.
 Buckingham assassinated.
 Dutch capture Spanish treasure fleet at Bay of Matanzas.
 French and Huguenots sign truce at La Rochelle.

1629 Spain capitulates to French terms over Mantuan affair with
 Treaty of Susa.
 Dutch commence siege of 's Hertogenbosch.
 Charles I initiates "Personal Rule."
 France and England agree to armistice.
 Rubens named privy councillor by Philip, travels to London to
 negotiate Anglo-Spanish alliance.

1630 Signature of Anglo-Spanish accord.

Rubens ennobled by Charles I, returns to Antwerp.

Rubens marries Helena Fourment.

1631 Rubens made *caballero* by Spain.

Marie de' Medici flees to Flanders.

Rubens travels to The Hague to negotiate peace with the Dutch.

1632 Henri de Bergh defects to Dutch.

Rubens travels to Maastricht to negotiate peace with the Dutch.

Flemish aristocrats open talks with the Dutch.

1633 Rubens turns over papers to Aarschot.

Death of the infanta Isabella.

1634 Cardinal-Infante Ferdinand becomes governor of the southern Netherlands.

1635 Antwerp celebrates arrival of Ferdinand.

France and Dutch begin two-front attack on Flanders.

Rubens's mission to Holland collapses before it begins.

Rubens purchases Castle Steen.

1638 Ferdinand wins Battle of Kallo.

1640 Death of Rubens at his Antwerp home on May 30.

1648 Treaties of Münster and Osnabrück establish the Peace of Westphalia, ending Eighty and Thirty Years' wars.

NOTES

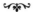

PROLOGUE

1 modeled himself: On Rembrandt's Rubens obsession, see Simon Schama's
 indispensable *Rembrandt's Eyes*, 26–27.
2 but not the reverse: In the twentieth century, many notable writers and
 entertainers engaged in spycraft, including Noël Coward, Roald Dahl, Ian
 Fleming, and Hedy Lamarr. Most became involved with covert activity dur-
 ing World War II.
3 *politique*: On the use of this term, see Schama, *Rembrandt's Eyes*, 43.

CHAPTER I: A NOVICE WITHOUT EXPERIENCE

5 "You are going": Niccolò Machiavelli to Raffaello Girolami, Oct. 28, 1522.
 Reprinted in Machiavelli, *Chief Works*, 116.
5 not one motivated by pure altruism: The duke was also interested in the
 recently vacated admiralty of the Spanish fleet, a title for which he was theo-
 retically eligible as a fellow Habsburg ruler and loyal Spanish client. On
 Vincenzo's motivations, see Jaffé, *Rubens and Italy*, 67–73.
6 centerpiece of the gift: On the full contents of Vincenzo's gift, see ibid., 67.
6 copies of works by Raphael: Most were made from collections in Rome, and
 executed by a minor Italian painter, Pietro Facchetti. Rooses, *Rubens*, 70.
7 inept soldiering: On Vincenzo's military career, see Chambers and
 Martineau, *Splendours of the Gonzaga*, 224.
8 selected for this mission: On Vincenzo's selection of Rubens, and on the

mission to Spain generally, see Jaffé, *Rubens and Italy*, 67–73; Rooses, *Rubens*, 53–106; and Schama, *Rembrandt's Eyes*, 102–14. That the advent of the artist-diplomat may have been prompted by the need to have an artist capable of restoration work was suggested to me by Elizabeth Honig.

8 comfortable in the society of court: According to Roger de Piles, Rubens "was born with all the advantages that make a great painter and a great politician." See "Life of Rubens" (1681), in Baglione, Sandrart, and de Piles, *Lives of Rubens*, 77–78.

9 "it be not absolutely necessary": Wicquefort, *Embassador and His Functions*, 49. Wicquefort and Rubens may well have crossed paths.

10 "he learned with such facility": Philip Rubens, "Latin Life of Peter Paul Rubens," 37. On the Verdonck education, see Schama, *Rembrandt's Eyes*, 76.

11 "There always glimmered": Joachim von Sandrart, excerpt from *Teutsche Academie*, in Baglione, Sandrart, and de Piles, *Lives of Rubens*, 35.

11 On Rubens and Stimmer, see Schama, *Rembrandt's Eyes*, 77–79.

12 "no plague": Rooses, *Rubens*, 53. It is unclear whether del Monte accompanied Rubens on the mission to Spain for Vincenzo.

14 Rubens to Rome: On Rubens and Montalto, see Jaffé, *Rubens and Italy*, 9–11.

15 knew just what he was doing: Vincenzo was not always the most studied aesthete. He said of Rubens, "He is not bad at painting portraits." Chambers and Martineau, *Splendours of the Gonzaga*, 214.

17 "I stood there like a dunce": Rubens to Chieppio, March 29, 1603, in Magurn, *Letters of Peter Paul Rubens* (henceforth *LPPR*), 27. The events of Rubens's trip to Spain are largely reconstructed through his voluminous correspondence.

19 "They almost crossed themselves": Rubens to Chieppio, March 18, 1603, in ibid., 24. Rubens lamented that he had paid heed to the Mantuan court's "busybodies and pseudo-experts."

20 "No one can accuse me of negligence": Rubens to Chieppio, April 2, 1603, in ibid., 29.

20–21 "I hope that for this first mission": Rubens to the Duke of Mantua, May 17, 1603, in ibid., 30–31.

21 "I regret that I am poor": Rubens to Chieppio, May 17, 1603, in ibid., 32.

21 "Malicious fate": Rubens to Chieppio, May 24, 1603, in ibid., 32–34.

22 "God keep me from resembling them": Ibid., 33. The most distinguished Spanish painter of the time was the preternaturally strange El Greco. A prejudice against Spanish painting of this period lasted for centuries. In his *Recollections of Rubens*, written at the end of the nineteenth century, the historian Jacob Burckhardt wrote, regarding Rubens's equestrian portrait of Lerma, "There was no other painter in the whole country who could have produced anything tolerable in that genre." (4)

23 "Flemish painting": Michelangelo, quoted in Snyder, *Northern Renaissance Art*, 88.

24 Democritus and Heraclitus: Their stories were found in Seneca and Juvenal, favorites of Rubens, and more recently in an essay by Montaigne with which he may well have been familiar.

24 "He could still have reserved": Rubens to Chieppio, July 17, 1603, in *LPPR*, 35.

25 "great satisfaction": Rubens to the Duke of Mantua, July 17, 1603, in ibid., 34.

28 "I do not fear": Rubens to Chieppio, Sept. 15, 1603, in ibid., 36.

28 fairly complimentary in his reports: Iberti to the Duke of Mantua, Sept. 15, 1603, in Rooses and Ruelens, *Correspondance de Rubens et documents épistolaires* (henceforth *CDR*), 1:210. Iberti wrote, "I believe that what he will give me is sincere, because he seems to me an honest man."

28 "I should not have to waste more time": Rubens to Chieppio, Nov. 1603, in *LPPR*, 37–38.

28 "*Qui timide rogat*": The epigram is spoken by the character Phaedra in Seneca's drama of that title, itself an adaptation of *Hippolytus*, by Euripedes.

29 "Aegeus was less anxious": Philip Rubens to Peter Paul Rubens, 1604, quoted in Lescourret, *Double Life*, 241–42.

29 "the citie which of all other places": Thomas Coryat, quoted in Chambers and Martineau, *Splendours of the Gonzaga*, xvii.

31 *The Mantuan Circle of Friends*: On the speculation that Galileo appears in the painting, see Reeves, *Painting the Heavens*.

32 that leather-bound book: According to an early biographer, Giovanni Pietro Bellori, who saw the book before its destruction in the eighteenth century, there were "observations on optics, on symmetry, on proportions, on anatomy and on architecture, with an inquiry into the principal passions of the soul, and actions based on descriptions by Poets, with examples of the work of the painters." Quoted in Logan, *Peter Paul Rubens*, 18–19. The book is essential on Rubens's work as a draftsman.

32 Santa Croce: A scandal involving the church's "true cross" fragments also reflected badly on the archduke. On this, and the commission generally, see Schama, *Rembrandt's Eyes*, 99–101.

32 the son of Jean Richardot: Another of Richardot's progeny, Guillaume, was at present traveling as a student with Philip Rubens in Italy. He appears, along with Philip, Peter Paul, Justus Lipsius, and presumably Galileo, in Rubens's *Mantuan Circle of Friends*.

33 "out of pure necessity": Rubens to Chieppio, Dec. 2, 1606, in *LPPR*, 39–40.

34 Rubens admired Caravaggio: On Rubens's affinity for the Italian, and his purchase of the *Death of the Virgin* for Vincenzo, see Schama, *Rembrandt's Eyes*, 131–33.

35 a gentleman scholar: The art historian Julius Held has stated "flatly" that Rubens was "*the* most learned artist who ever lived." *Rubens and His Circle*, 167.

35 "I know not which to praise most": Quoted in Rooses, *Rubens*, 212.

35 "by far the best": Rubens to Chieppio, Feb. 2, 1608, in *LPPR*, 42–43.
36 "As he is my vassal": Archduke Albert to the Duke of Mantua, Aug. 5, 1607, in *CDR*, 1:388.
37 "It will be hard for me": Rubens to Chieppio, Oct. 28, 1608, in *LPPR*, 45–46.

CHAPTER II: EVERY MAN FOR HIMSELF

39 "Who is of so hard and flinty a heart": Lipsius, *Tvvo Bookes of Constancie*, 72.
39 Maria had taken care: On Maria's will, see Schama, *Rembrandt's Eyes*, 134. See also Rooses, *Rubens*, 3.
40 "for the bewtie": Carleton to John Chamberlain, Dec. 15, 1616, in Sainsbury, *Original Unpublished Papers Illustrative of the Life of Sir Peter Paul Rubens* (Henceforth, Sainsbury), 9–12.
40 his family's sad story: On the Rubens family background, see Rooses, *Rubens*, 2–3.
41 a thriving metropolis: On Antwerp's golden years, see especially Isacker and Uytven, *Antwerp*; Murray, *Antwerp in the Age of Plantin and Brueghel*; Van der Stock, *Antwerp*; and Sutton, *Age of Rubens*, especially Sutton's essay "The Spanish Netherlands in the Age of Rubens," 106–30, and David Freedberg's, "Painting and the Counter Reformation in the Age of Rubens," 131–45.
43 "the mother of the arts": Van Mander, *Dutch and Flemish Painters*, 419.
43 "the metropolis of the world": Quoted in Isacker and Uytven, *Antwerp*, 85.
43 "of all the universe": Quoted in Honig, *Painting & the Market*, 4. This is the definitive source on the market scenes of Aertsen and his nephew Joachim Beuckelaer.
44 Charles had united the territories: This narrative is particularly indebted to the work of Geoffrey Parker, Jonathan Israel, and Simon Schama. See in particular Parker, *Dutch Revolt*; and Israel, *Conflicts of Empires*.
46 denuded of traditional Catholic language: See Rooses, *Rubens*, 3.
47 righteous fulminations: On the iconoclasm, see Freedberg, *Iconoclasm and Painting in the Revolt of the Netherlands*; and Crew, *Calvinist Preaching*.
47 "Twenty persons bore the image": Dürer, *Dürer's Record of Journeys to Venice and the Low Countries*, 42.
48 a standing ruin: Richard Clough, an English merchant surveying the damage to the cathedral, wrote, "It looked like a hell . . . They have so spoiled it that they have not left a place to sit on." Quoted in Crew, *Calvinist Preaching*, 12. The catastrophe was redoubled in the 1581 "quiet Iconoclasm," a further devastation following the removal of Catholics from positions of authority.

48 "send a soldier to Flanders": Parker, *Army of Flanders*, 70.

49 "Putting in new men": Quoted in Parker, *Dutch Revolt*, 107.

49 "We care nothing for your privileges": Quoted in Schama, *Rembrandt's Eyes*, 55.

50 "who extirpated sedition": Quoted in ibid., 55. The statue was eventually removed and melted down by the Spanish crown to avoid inciting the local population. See Held, "On the Date and Function of Some Allegorical Sketches by Rubens," errata.

50 "Everyone must be made in constant fear": Duke of Alva, quoted in Schama, *Rembrandt's Eyes*, 57.

50 "He who becomes master": Machiavelli, *The Prince*, chap. 5, in *Chief Works*.

51 "A goodly sum": Quoted in Geyl, *Revolt of the Netherlands*, 102.

51 "Thou takest away": Excerpt from the Ghent Paternoster, in R. G. D. Laffan, *Select Documents of European History* (London: Methuen, 1930), 103.

51 Jan and Maria Rubens: On the saga of the Rubens family, and Jan's affair with Anna of Saxony, see Schama, *Rembrandt's Eyes*, 41–71; and Rooses, *Rubens*, 5–15. Both are reliant on Bakhuizen van den Brink's *Het huwelijk van Willem van Oranje met Anna van Saxen*.

55 "every satisfaction": Maria Rubens to Jan Rubens, quoted in Rooses, *Rubens*, 8.

55 "How could I have the heart": Maria Rubens to Jan Rubens, quoted in ibid., 9–10.

56 "for the sake of my poor children": Maria Rubens to Johan of Nassau, quoted in Schama, *Rembrandt's Eyes*, 67.

57 "the little girl": Ibid., 66.

59 Alva's terror was only just beginning: On Alva and the beginning of the Dutch rebellion, see Parker, *Dutch Revolt*, 99–168; and Geyl, *Revolt of the Netherlands*, 98–118.

59 The Spanish Fury's viciousness: See Parker, *Dutch Revolt*, 169–87.

60 Alessandro Farnese: On Farnese's sweeping military vision and the planned Spanish invasion of the British Isles, see Mattingly, *Armada*, 43.

61 "It is the saddest thing": Quoted in Sutton, "Spanish Netherlands in the Age of Rubens," 108.

65 even with the Scheldt closed: Flemish politicians continued to lobby for the reopening of the Scheldt during this period, to no effect.

66 "I will not dare to follow him": Rubens to Johann Faber, April 10, 1609, in *LPPR*, 52.

67 "I have little desire to become a courtier again": Ibid.

68 his first major commission: Abraham Janssens, who was superseded by Rubens as the preeminent master of Antwerp, also painted an allegorical celebration of the Twelve Years' Truce.

71 "I cannot behold": Domenicus Baudius to Rubens, Oct. 4, 1611, in Rooses, *Rubens*, 213.

71 handsome house: On its history and contents, see especially the works of Muller: *Rubens as Collector*; "Rubens's Collection in History," introduction to Belkin and Healy, *House of Art*, 11–85; "Perseus and Andromeda on Rubens's House"; and "Rubens's Museum of Antique Sculpture." See also Rooses, *Rubens*, 145–55; and Baudouin, "Rubens House at Antwerp."

72 something new to his neighbors: The painter Frans Floris had built a classically inspired home for himself in the sixteenth century, but it was of less sophisticated design.

72 "suited to housing families": Quoted in Lescourret, *Double Life*, 243.

73 "in imagination alone": McGrath, "Painted Decoration of Rubens's House," 245. On the trompe l'oeil frieze on the Rubens house, see this essay and Muller's "Perseus and Andromeda on Rubens's House."

75 Willem van Haecht: The artist depicted the scene several years after the occurrence of the event it represented. See Baudouin, *Pietro Pauolo Rubens*, 286.

75 Nicolas-Claude Fabri de Peiresc: On Peiresc, and on antiquarianism generally, see Miller, *Peiresc's Europe*.

75 large room on the first floor: The most convincing account of the studio's design and operation is Muller, "Rubens's Collection in History."

76 could wait a year or more: In May 1611, Rubens wrote a letter to an important client, Jacob de Bie, apologizing for not being able to find a place for someone he had recommended, with the excuse that he had already rejected over a hundred applications, including those from family members.

76 "Abandon and audacity alone": Quoted in Alpers, *Making of Rubens*, 153.

76 "When we kept silent": Otto Sperling, quoted in Belkin, *Rubens*, 5.

76 *crabbelingen*: On Rubens's technique, see especially Logan, *Peter Paul Rubens*, 3–18.

77 Designs for the large tapestries: Though they are not nearly so revered today, tapestries were both valued aesthetically and generally more expensive than paintings, owing to their size and the immense costs of their manufacture.

77 "He sends less competent judges": Quoted in Rooses, *Rubens*, 214. One dealer compared his intransigence in bargaining to the biblical Medes, whose laws were inalterable.

77 100 guilders per day: The annual income requirements for a baron and for a prince were 6,000 and 14,000 guilders, respectively. On Rubens and his income, see Filipczak, *Picturing Art in Antwerp*, 73–88.

77 "*dolcissima professione*": Quoted in *LPPR*, 1.

77 He could regularly be seen: The English diplomat Thomas Roe, who met the artist in Antwerp, wrote that Rubens had "grown so rich by his profes-

sion that he appeared everywhere, not like a painter but a great cavalier with a very stately train of servants, horses, coaches, liveries, and so forth." Quoted in White, *Peter Paul Rubens*, 73.

78 He didn't drink to excess: According to his biographer Roger de Piles, "He maintained a great aversion against too much wine and good living, as well as gambling." See "Life of Rubens" (1681), in Baglione, Sandrart, and de Piles, *Lives of Rubens*, 80.

78 "my secretary": In Italian, "mio secretario": Brueghel to Ercole Bianchi, Dec. 9, 1616, in *CDR*, 2:92. Rubens frequently collaborated with his friends, usually genre specialists. On the valuation of collaborative works, see Honig, *Painting & the Market*.

79 "*Medio Deus omnia campo*": On this phrase, see Muller, "Rubens's Collection in History," 15.

79 His passions were released in his work: Svetlana Alpers has argued that the artist sublimated his more carnal urges into the figure of Silenus, a fat and happy drunk from Greek mythology. Rubens painted this obscure character with an oddly persistent regularity. See Alpers, *Making of Rubens*, 101–57.

79–80 "deprived the world": Rubens to Faber, Jan. 14, 1611, in *LPPR*, 53–54.

80 a group portrait: Now in the collection of the Pitti Palace, and commonly known as *The Four Philosophers*. Van den Wouvere is the fourth figure in the painting.

80 "a voluntarie sufferance": Lipsius, *Tvvo Bookes of Constancie*, 9.

80 His erudition was legendary: On Lipsius, see especially Grafton, *Bring Out Your Dead*, chap. 12; and Miller, *Peiresc's Europe*. Rubens's last child, a daughter born in February 1641, eight months after the painter's death, was named Constantia.

81 "The Peripatetic sage": Montaigne, *Complete Essays of Montaigne*, 31. Montaigne may have been a model for Rubens, in that he was a moderate Catholic and cultural figure conscripted into political service. Unlike Rubens, however, he was born into the aristocracy.

82 *Kunstkammer*s: On Antwerp's private galleries, in particular that of Rubens, see especially Muller, "Rubens's Collection in History." The Byzantine vase, now known as the "Rubens Vase," is in the collection of the Walters Art Museum in Baltimore.

82 "You surpass all the painters": Peiresc to Rubens, in Rooses, *Rubens*, 344.

82 "The reason for comparing": Rubens to Peiresc, Aug. 3, 1623, in *LPPR*, 91.

83 a practical brand of humanism: On antiquarianism and politics generally, see Miller, *Peiresc's Europe*. On the education of authority figures, see 64–65.

84 "His conceit and vanity": Rubens to Pierre Dupuy, March 16, 1628, in *LPPR*, 245. On the specific contents of Rubens's collection, see Muller, "Rubens's Collection in History."

84 "In order to achieve": Quoted in Logan, *Peter Paul Rubens*, 33n.

84 special gallery for his statues: See Muller, "Rubens's Collection in History"; and "Rubens's Museum of Antique Sculpture."

86 Carr was swept up in a scandal: On Carleton and Carr, see especially Brotton, *Sale of the Late King's Goods*, 59–65. See also Donovan, *Rubens and England*.

87 "I am by mischance made a master": Carleton to John Chamberlain, Feb. 20, 1617, in Sainsbury, 300.

87 "I finde some of my owne heads wanting": Carleton to Chamberlain, March 25, 1617, in ibid., 301.

87 "I find that at present": Rubens to Carleton, April 28, 1618, in *LPPR*, 60–61.

87 easier for him to move: "To persons who are always in motion, as my situation obliges me to be, a thing of so much weight is not convenient," Carleton wrote. Carleton to Rubens, April 27, 1618, in Sainsbury, 32.

87 "You, sir, may calculate": Ibid.

88 "They are so well retouched": Rubens to Carleton, May 12, 1618, in *LPPR*, 61–62.

88 "I cannot subscribe to your denial": Carleton to Rubens, May 22, 1618, in Sainsbury, 37.

89 unsurpassed garden of court artists: Also on the archdukes' payroll were Otto van Veen, Jan Brueghel, Joos de Momper, Frans Francken, and Sebastian Vrancx.

90 grand Habsburg tradition: On the archdukes' court and reign, see especially Israel, "The Court of Albert and Isabella, 1598–1621," in *Conflicts of Empires*, 1–22; and David Freedberg, "Painting and the Counter Reformation in the Age of Rubens," in Sutton, *Age of Rubens*, 131–45.

90 "She is a princess endowed": Rubens to Jacques Dupuy, July 20, 1628, in *LPPR*, 276–77.

90 That piety was something: See Israel, "Court of Albert and Isabella," 1–22; and Freedberg, "Painting and the Counter Reformation," 131–45.

91 more than sixty altarpieces: See Schama, *Rembrandt's Eyes*, 151; and Freedberg, "Painting and the Counter Reformation," 133–34.

92 a new phase of conflict: On hostilities during the truce, see Israel, *Dutch Republic*, 66–95; and Geyl, *Netherlands in the Seventeenth Century*, 18–83.

93 Calderón's very mission: See Israel, *Dutch Republic*, 16–17.

93 most beautiful present: See Rooses, *Rubens*, 125.

94 downfalls would come in quick and ugly succession: See Israel, *Dutch Republic*, 60–65.

95 "The thing they enjoy": Translation adapted from Elizabeth McGrath, *Subjects from History*, pt. 13 of the *Corpus Rubenianum Ludwig Burchardt* (London: Harvey Miller, 1997), 1:129.

95 Nowhere was Rubens's genius better appreciated: The Englishman Henry Peacham, author of a 1634 primer on aristocratic behavior, *The Compleat Gentleman*, lauded Rubens as "the best story teller of his generation." (110)

96 Howard toured Italy: On the Howards as connoisseurs, see Brotton, *Sale of the Late King's Goods*, 41, 54.

97 "break off negotiations at once": Rubens to Carleton, May 28, 1619, in *LPPR*, 71.

97 Rubens got the privileges: The Dutch States General passed a resolution granting Rubens his rights on June 8, 1619, provided that he supply one plate for each work to be copyrighted. The resolution noted the recommendation of "lord Carleton, ambassador of the king of Great Britain." See Rooses, *Rubens*, 327.

97 "Thoes bewtiful lions": Danvers to Carleton, Aug. 7, 1619, in Sainsbury, 49.

98 "Ruined": Rubens to William Trumbull, Jan. 26, 1621, in ibid., 50.

98 "touched and retouched": Ibid.

98 "scarce doth look like a thing": Toby Matthew to Carleton, Nov. 25, 1620, in ibid., 53.

98 no hiding Danvers's dissatisfaction: Danvers's secretary carped that Rubens had not "shewed his greatest skill in it." Thomas Locke to Carleton, March 18, 1621, in ibid., 57.

98 "In every painters [*sic*] opinion": Danvers to Carleton, May 27, 1621, in ibid., 57–58.

98 "less terrible": Rubens to Trumbull, Sept. 13, 1621, in *LPPR*, 77.

CHAPTER IV: A GOOD PATRIOT

101 "Surely it would be better": Rubens to Valavez, Feb. 20, 1626, in *LPPR*, 130.

103 a small female dog: On gifts for Marie, see Rooses, *Rubens*, 349. The necklace and dog may have been delivered on a later trip.

104 Luxembourg Palace: On the building and its architect, see Coope, *Salomon de Brosse*.

104 Rubens liked what he saw: De Brosse's assimilation of Italian and northern European architectural vocabularies was something Rubens could intuitively appreciate; he approvingly referred to the building in his monograph on the palaces of Genoa.

105 "Italian painters could not do": Quoted in Rooses, *Rubens*, 352.

105 The real challenge: On the difficulty of the Medici commission, see Belkin, *Rubens*, 181–90; and Saward, *Golden Age of Marie de' Medici*.

105 "There is no more lovable soul": Quoted in Rooses, *Rubens*, 350.

106 "incorrigible mania": Rubens to Valavez, Dec. 26, 1625, in *LPPR*, 122.

106 "a comedy much more agreeable": Quoted in Miller, *Peiresc's Europe*, 70.

108 Lucas Vorsterman: On the Vorsterman affair, see Held, "Rubens and Vorsterman," in *Rubens and His Circle*, 114–25.

109 "I can no longer deal with him": Rubens to Pieter van Veen, April 30, 1622, in *LPPR*, 87. Earlier, Rubens had informed Van Veen that "it seemed a lesser evil to have the work done in my presence by a well-intentioned young man, than by great artists according to their fancy." Rubens to Van Veen, Jan. 23, 1619, in ibid., 69.

109 Charles de Longueval: On Longueval, see Held, "Rubens and Vorsterman,"

114–25. If the term "propaganda" did not yet exist, the concept surely did.

110 "We have made almost nothing": Rubens to Van Veen, April 30, 1622, in *LPPR*, 87.

110 "endangered by the attacks": Quoted in Held, "Rubens and Vorsterman," 116.

111 specifically enjoined from making direct overtures: "Experience has shown how damaging and prejudicial has been [the truce] now in effect, and that were we to continue with it, it would prove the total ruin of these realms." Philip III to Archduke Albert, quoted in Israel, *Dutch Republic*, 73.

111 Bartholde van T'Serclaes: The widow of Florent van T'Serclaes, one of Maurice's advisers. On the T'Serclaes affair, see especially ibid., 73–85.

112 two thousand cheeses: On the political and military landscape after the truce, see ibid, 96–161.

113 The whole fiasco: See ibid., 100–102; and Parker, *Army of Flanders*, 180–81.

115 "As far as contagion is concerned": Rubens to Peiresc, Aug. 3, 1623, in *LPPR*, 92.

115 "negotiating secretly for a truce": Rubens to Peiresc, Aug. 10, 1623, in ibid., 93.

115 "With the French it is a state maxim": Rubens to Isabella, March 15, 1625, in ibid., 104.

116 "Taken in consideration of the merits": *Ordonnance de l'infante Isabelle*, Sept. 30, 1623, in *CDR*, 3:248–49.

116 "many sovereigns have tried": Inigo Brizuela (l'Eveque de Segovie) to Philip IV, Jan. 29, 1624, in ibid., 3:266. The patent of nobility was granted in Madrid on June 5. Ibid., 3:295.

117 "suspicious of his own shadow": Rubens to Pierre Pecquius, Jan. 22, 1624, in *LPPR*, 96. Pecquius was chancellor of Brabant and a longtime Rubens associate.

117 "I laughed and replied": Rubens to Pecquius, Sept. 30, 1623, in ibid., 94–95.

118 Clara Serena: On Rubens and her death, see *CDR*, 3:288. On speculation about her role in the court of the infanta and on Rubens's portraits of her, see Logan, *Peter Paul Rubens*, 244. On the mourning portrait of Isabella, see White, *Peter Paul Rubens*, 194.

119 "a matter in which I fancy": De Baugy, quoted in Rooses, *Rubens*, 394–95.

120 "contente to suspend their armes": Trumbull, quoted in Sainsbury, 76.

120 The ground war in Flanders: "The chief reason why we decided to renew the war with the Dutch on the expiry of the truce, was that our army should engage them on land so that they should not have the forces to attempt ventures such as this by sea," wrote Philip. Quoted in Israel, *Dutch Republic*, 131.

120 "There is no power": Rubens to Valavez, Dec. 12, 1624, in *LPPR*, 98.

121 more of the status quo: On Breda, see Israel, *Dutch Republic*, 106–9.

121 "I am the busiest and most harassed": Rubens to Valavez, Jan. 10, 1625, in *LPPR*, 101.

122 "while the subjects of the pictures": Rubens to Jacques Dupuy, Oct. 29, 1626, in ibid., 149–51.

122 "without some explanation": Rubens to Pierre Dupuy, Jan. 20, 1628, in ibid., 231.

122 "He served as the interpreter": Rubens to Peiresc, May 13, 1625, in ibid., 107–10.

123 "the greatest amateur": Rubens to Valavez, Jan. 10, 1625, in ibid., 101.

124 a romantic and impulsive soul: Of Maria Anna, Charles wrote, "If you wonder how I can love before I see, the truth is I have both seen her picture and heard the report of her virtues by a number whom I trust, so as her idea is engraven in my heart where I hope to preserve it till I enjoy the principal." Quoted in Brotton, *Sale of the Late King's Goods*, 85. I am especially indebted to Brotton's account of the trip by the "Smiths" to Spain (86–105) and the failed Spanish Match. Arturo Pérez-Reverte used this episode as the basis for his historical novel *Captain Alatriste*.

126 "as a cat doth a mouse": Quoted in Brotton, *Sale of the Late King's Goods*, 96.

126 "the danger of your life": Quoted in ibid., 101.

128 "a shining Phoebus": Quoted in Donovan, *Rubens and England*, 24.

129 "great difficulties might arise": The Rubens-Buckingham dialogue is reconstructed from the notes taken by Gerbier. Sainsbury, 68–69.

130 "maintain this friendship": Roger de Piles, "Life of Rubens" (1681), in Baglione, Sandrart, and de Piles, *Lives of Rubens*, 71.

131 "I hope Your Highness": Rubens to Isabella, March 15, 1625, in *LPPR*, 103–7.

133 "It is up to you": Rubens to Brant, July 20, 1625, in ibid., 113–14.

133 Such ciphers were typical: On secret codes of the time, see Callières, "The Use of Ciphers," in *Art of Diplomacy*, 164–65. The book was first published in 1716 as *The Art of Negotiating with Sovereign Princes*, but reflected long-standing ideas on cryptography.

134 "I believe he will": Rubens to Brant, July 20, 1625, in *LPPR*, 113–14.

134 "I have once more": Rubens to Brant, Aug. 25, 1625, in ibid., 115.

134 "Should the English armada": Rubens to Valavez, Sept. 19, 1625, in ibid., 115–17. For the raid on Cádiz, see Israel, *Dutch Republic*, 115–16.

135 "The only prudence": Rubens to Valavez, Jan. 9, 1626, in *LPPR*, 123–25.

135 "I have no doubt": Rubens to Valavez, Dec. 26, 1625, in ibid., 121–23.

136 "more grave than the illness": Rubens to Jacques Dupuy, Oct. 15, 1626, in ibid., 145–47.

136 "I find it very hard": Rubens to Pierre Dupuy, July 15, 1626, in ibid., 135–36.

CHAPTER V: THUNDER WITHOUT LIGHTNING

137 "I should like the whole world": Rubens to Pierre Dupuy, April 22, 1627, in *LPPR*, 178.

138 The assault commenced at dawn: The Dutch attack on Kieldrecht, and Spinola's defense, are recounted in detail by Rubens in a letter to Pierre Dupuy on Oct. 1, 1626. See ibid., 142–44.

139 "I assure you": Rubens to Valavez, Jan. 10, 1625, in ibid., 102.

140 Fossa Mariana: On this project, see Israel, "A Spanish Project to Defeat the Dutch Without Fighting: The Rhine-Maas Canal, 1624–9," in *Conflicts of Empires*, 45–62. The project was initially named the Fossa Eugeniana, for the infanta, Isabella Clara Eugenia. She chose to rename it for the Virgin.

140 "an easy project": De la Cueva to Philip III, quoted in ibid., 45.

140 "He fears to embark": Rubens to Pierre Dupuy, Oct. 1, 1626, in *LPPR*, 143.

140 not without its detractors: On support of and resistance to the Fossa project, see Israel, "Spanish Project," 49–53.

141 "Work progresses valiantly": Rubens to Jacques Dupuy, Oct. 29, 1626, in *LPPR*, 150.

141 "Here we know nothing": Rubens to Pierre Dupuy, Nov. 19, 1626, in ibid., 156.

142 "up to the same number": Rubens to Valavez, Feb. 15, 1626, in ibid., 128.

142 "A warning of this obvious danger": Rubens to Spinola, June 29, 1626, in ibid., 135.

142 raided the Spanish merchant fleet: See Israel, *Dutch Republic*, 196–97.

143 "masters of the other hemisphere": Rubens to Pierre Dupuy, June 29, 1628, in *LPPR*, 272. On Dutch colonial expansion generally, see especially Shorto, *Island at the Center of the World*; and Brook, *Vermeer's Hat*.

143 "This city . . . languishes": Rubens to Pierre Dupuy, May 28, 1627, in *LPPR*, 185.

144 justifiably elated: Pierre Dupuy, who had a chance to spend some time with the artist, dashed off a letter to their mutual friend Peiresc, noting that Rubens was "in a very good mood." Dupuy to Peiresc, Jan. 11, 1627, in *CDR*, 4:26. The brothers Jacques and Pierre Dupuy, along with Peiresc's brother, the sieur de Valavez, became Rubens's regular Paris correspondents after Peiresc left the capital for his home in Provence.

144 a truly staggering sum: After commissions, and the subtraction of a canvas, Rubens's take was reduced to a still-princely 84,000 florins.

145 "some regret": Quoted in Rooses, *Rubens*, 407.

145 copies of all the most important works: These may have been made at Buckingham's expense, another benefit of the deal for Rubens.

146 "I may venture to say": Quoted in Callières, *Art of Diplomacy*, 70.

147 "Suspension of Arms": Gerbier to Rubens, Feb. 23, 1627, in Sainsbury, 71.

148 "England should be disabused": Rubens as paraphrased by Gerbier in an undated memorandum, in ibid., 72–75.

149 "a great undertaking": Gerbier to Rubens, March 9, 1627, in ibid., 77.

149 "As soon as the answer comes": Rubens to Buckingham, April 21, 1627, in ibid., 79.

149 his tradesman's status: In Spain, paintings were taxed as any ordinary man-ufactured goods, much to the consternation of the painters' guild. See Vergara, *Spanish Patrons*, 91.

150 "I am displeased": Philip to Isabella, quoted in Rooses, *Rubens*, 417.

150 "We are exhausted": Rubens to Pierre Dupuy, Oct. 21, 1627, in *LPPR*, 209.

150 "If Spanish pride": Rubens to Pierre Dupuy, May 6, 1627, in ibid., 179.

151 "a man of the keenest intellect": Rubens to Pierre Dupuy, June 4, 1627, in ibid., 186.

151 For a short biography of Scaglia, see *Oxford Dictionary of National Biography* (New York: Oxford University Press, 2004), vol. 49. Entry by Toby Osborne.

152 "I have friends there": Rubens to Gerbier, May 19, 1627, in Sainsbury, 84.

152 "His Excellency desires": Ibid., 83–84.

153 "Rubens pasport is graunted": Carleton to Conway, June 13, 1627, in ibid., 84.

154 "I must lett your Lord understand": Carleton to Conway, July 2, 1627, in ibid., 85.

154 "My going thither": Gerbier to Rubens, July 13, 1627 (1), in ibid., 88–89.

154 "I must tell you": Gerbier to Rubens, July 13, 1627 (2), in ibid., 89–90.

155 he wrote to the artist directly: The warning was actually sent to Rubens in care of Arnold Lunden, an Antwerp relation who handled the painter's cor-respondence from Holland in order to maintain secrecy.

155 "I regard the whole world": Rubens to Valavez, Jan. 10, 1625, in *LPPR*, 102.

155 "Gerbier is a painter": Isabella to Philip, quoted in Rooses, *Rubens*, 417.

156 "In this ombragious tyme": Carleton to Conway, July 25, 1627, in Sainsbury, 91.

156 "walking from towne to towne": Ibid.

157 Gerrit van Honthorst: On the Dutch painter, see J. Richard Judson, *Gerrit van Honthorst, 1592–1656* (Doornspijk, Netherlands: Davaco, 1999).

157 Utrecht's reputation: On painting and religion in Utrecht, see Joaneath Spicer and Lynn Federle Orr, eds., *Masters of Light* (New Haven, Conn.: Yale University Press, 1997), in particular the essays by Benjamin Kaplan and Marten Jan Bok, and Bok's biographies. Schama's *Rembrandt's Eyes* is especially insightful on the Rubens trip to Holland.

157 *schuilkerken*: On Catholic worship in Utrecht, see Spicer and Orr, *Masters of Light*, 60–72.

158 "to forget his sorrows": Sandrart, reprinted in Baglione, Sandrart, and de Piles, *Lives of Rubens*, 40.

159 "towne withowt people": Carleton to Chamberlain, Oct. 14, 1616, in ibid., 13.

159 a fantasy come alive: See Schama, *Rembrandt's Eyes*, 247. Schama describes

Utrecht as "a tantalizing vision of what a reconciled Netherlands *might* look like were [Rubens's] patient labors for peace to bear fruit."

159 "As far as he is excellent": Sandrart, reprinted in Baglione, Sandrart, and de Piles, *Lives of Rubens*, 40.

160 "Rubens had brought nothing": Gerbier, paraphrased by Sainsbury, 94.

160 "long abode there under pretense": Carleton to Conway, Aug. 16, 1627, in ibid., 94.

160 "suspended between hope and fear": Rubens to Pierre Dupuy, Aug. 12, 1627, in *LPPR*, 196.

161 "never believed the English": Ibid., 196–97. The fight for La Rochelle provides the backdrop to Alexandre Dumas's historical novel *The Three Musketeers*.

162 "much grieved at the resolution": Rubens to Pierre Dupuy, Sept. 23, 1627, in *LPPR*, 205–6.

163 "It is thought for the present": Rubens to Gerbier, Sept. 18, 1627, in Sainsbury, 100.

163 "be like thunder": Ibid., 100–101.

164 "The business is at an end": Ibid., 102–3.

164 "The game is at an end": Gerbier to Conway, Sept. 25, 1627, in ibid., 98.

164 "No change of fortune": Rubens to Buckingham, Sept. 18. 1627, in ibid., 103–4.

165 "He seems to me": Rubens to Dupuy, Oct. 14, 1627, in *LPPR*, 208.

165 Buckingham sailed in disgrace: On the massacre at Île de Ré, see Gardiner, *A History of England Under the Duke of Buckingham and Charles I*, 164.

165 "And art return'd again": Quoted in Donovan, *Rubens and England*, 30.

165 "Most impudent lies": Rubens to Pierre Dupuy, Dec. 30, 1627, in *LPPR*, 217.

166 "If it were for £2,000": Quoted in Brotton, *Sale of the Late King's Goods*, 122.

166 "This sale displeases me": Rubens to Pierre Dupuy, June 15, 1628, in *LPPR*, 269.

166 "It is a fact well known": Rubens related Gerbier's message in a letter to Spinola on Dec. 17, 1627, in ibid., 215–16.

167 "The English are so embittered": Ibid., 216.

CHAPTER VI: MORE USEFUL THAN INJURIOUS

169 "The interests of the whole world": Rubens to Jacques Dupuy, July 20, 1628, in *LPPR*, 277.

170 Messia's sitting: On Rubens's portrait of the marquis, see Logan, *Peter Paul Rubens*, 231–32. An *Immaculate Conception* may also have been ordered with the portrait.

170 "grande aficionado": Quoted in ibid., 231.

170 "greatest admirers": Rubens to Pierre Dupuy, Jan. 27, 1628, in *CDR*, 4:359.

170 "no taste for painting": Ibid. Rubens compared Spinola's knowledge of painting to that of a *portefaix*, "a porter."

172 "If the king": The conversation between Rubens and Vosberghen is a reconstruction based on the comprehensive précis Rubens delivered to Spinola in his letter of Feb. 11, 1628, in *LPPR*, 235–37.

173 "His Royal Majesty of Spain": Rubens to Vosberghen, March 18, 1628, in ibid., 245–46.

174 "strange microcosm": April 5, 1628, in Sainsbury,114–16.

174 "When any one thinks of agreeing": Spinola to Rubens, Dec. 21, 1627, in ibid., 109.

175 the salient points: Gerbier adumbrated these in his letter to Rubens of March 30, 1628, in ibid., 109–13.

176 "Our city is going": Rubens to Pierre Dupuy, Aug. 10, 1628, in *LPPR*, 279.

177 "great enterprises": Rubens to Olivares, Aug. 1, 1631, in ibid., 378.

178 there were but two options: On Spain's political choices, see Israel, *Dutch Republic*, 223–50; and Elliott, *Count-Duke*, 323–58.

178 "Never in history": Quoted in Elliott, *Count-Duke*, 329.

179 "gaining authority": Rubens to Pierre Dupuy, April 13, 1628, in *LPPR*, 256.

179–80 "lazy and indolent": Rubens to Pierre Dupuy, April 27, 1628, in ibid., 259.

180 "The Spaniards think": Rubens to Jacques Dupuy, July 20, 1628, in ibid., 276.

180 a Solomonic decision: See Elliott, *Count-Duke*, 346–58; and Israel, *Dutch Republic*, 223–49.

181 a subject for his art: One Occasio drawing was a study for a painting, *The Victor Seizing the Opportunity for Peace* (c. 1630), no longer extant. The two mordant images, *Victims of War* and *Two Captured Soldiers*, survive. See Held, *Oil Sketches.*

182 "may be pushed forward": Philip IV to Isabella, July 4 and 6, 1628, in Rooses, *Rubens*, 446–50.

183 "my other self": Rubens to Gevaerts, Dec. 29, 1628, in *LPPR*, 295.

183 his accumulated wealth: On the Rubens estate, see Rooses, *Rubens*, 451.

184 "a spectacle worthy of admiration": Rubens to Pierre Dupuy, Dec. 2, 1628, in *LPPR*, 291.

184 Madrid's Real Alcázar: On the palace and its art program, see Orso, *Philip IV and the Decoration of the Alcázar of Madrid.*

184 Rubens came alone: It is possible he was accompanied by a small retinue of servants and assistants.

185 These pictures: On the paintings Rubens made for and in Spain, see Vergara, *Spanish Patrons*, 57–112. See also Volk, "Rubens in Madrid and the Decoration of the Salón Nuevo in the Palace."

186 celebrating the Eucharist: See Vergara, *Spanish Patrons*, 42.

186 "he often confers in secret": Pamphili and Mocenigo quoted in *LPPR*, 283.

187 "the love that you have shown me": Quoted in Vergara, *Spanish Patrons*, 35–38.

187 "severe" and "supercilious": Rubens to Peiresc, Aug. 9, 1629, in *LPPR*, 322.

188 "the sport of fortune": Rubens to Pierre Dupuy, Oct. 14, 1627, in ibid., 208.

189 According to Francisco Pacheco: For the text of Pacheco's discussion of Rubens's friendship with Velázquez, see Vergara, *Spanish Patrons*, 190.

190 "on the spot": Rubens to Gerbier, March 15, 1640, in *LPPR*, 412. Rubens may have made more than one trip to the Escorial. He described the (lost) painting of the Escorial in an undated letter to Gerbier the next month.

190 their work was inherently irreconcilable: On Rubens and Velázquez, see Vergara, *Spanish Patrons*, 106–9. What influence the two men had on each other, if any, is a matter of academic debate.

191 regular instruction in drawing: On Philip IV and the arts, see Elliott, *Count-Duke*, 169–91.

191 "The king takes great delight": Rubens to Peiresc, Dec. 29, 1628, in Rooses, *Rubens*, 479.

192 "*el nuevo Ticiano*": Quoted in Vergara, *Spanish Patrons*, 70.

193 Among his alterations: On Rubens and the *Adoration*, see ibid., 80–93. See also Volk, "Rubens in Madrid and the Decoration of the King's Summer Apartments." It is possible that the self-portrait was inserted at the request of Philip, as a means of acquiring an image of the painter.

194 The count-duke grimaced: On Olivares and the loss of the silver fleet, see Elliott, *Count-Duke*, 362–63.

196 "The only thing I can tell you": Rubens to Pierre Dupuy, Oct. 1630, in Rooses, *Rubens*, 447.

197 two sets of formal diplomatic instructions: The instructions themselves are lost, but Rubens reviewed them in his letter to Olivares on July 22, 1629, in *LPPR*, 317–20.

CHAPTER VII: THE CONNECTING KNOT

199 "We ought to consider": Callières, *Art of Diplomacy*, 68.

199 "so magnificent": Pierre Dupuy to Peiresc, May 18, 1629, in *CDR*, 5:43.

200 enormous annual subsidy: On the redirected aid to the Huguenots, see Rooses, *Rubens*, 486–87.

201 "His orders are not to hazard": Ross to William Boswell, May 28, 1629, in Sainsbury, 127. The original reads, "Monsieur Reubines is heir at Dunquerquen and attendis for ane schipe of sum force to bring him from hence to ingland for his order is not to hazard his commission nor his messiwes except that it be in ane schip of ingland, for hie is mychtelie affrayit of the hollanderis."

201 "conducted into this kingdom": Charles I to John Mince, May 30, 1629, in *CDR*, 5:51. Rubens was accompanied on the mission to England by his brother-in-law Hendrik Brant, a distinguished legal mind in his own right.

Rubens probably brought him along to serve in an advisory capacity, though what service he actually performed, if any, is unknown.

201 Diplomatic conduct: On the history of the ambassador, see among others, H. M. A. Keens-Soper and Karl W. Schweizer, introduction to Callières, *Art of Diplomacy*, 1–52; Mattingly, *Renaissance Diplomacy*; Nicolson, *Diplomacy*; Spencer Walpole, *Foreign Relations* (London: Macmillan, 1882); and Wicquefort, *Embassador and His Functions*.

202 Arnaud d'Ossat: Among his many accomplishments, the cardinal negotiated the marriage of Marie de' Medici to Henry IV.

203 York House: On its history, see London County Council, *Survey of London* (London: London County Council, 1937), 18:51–60. The party responsible for the design of the York Water Gate is something of a mystery. It has been variously attributed to Gerbier, Inigo Jones, and Nicholas Stone. It was built in 1626, meaning that whoever designed it would have had the opportunity to see the Rubens portico in Antwerp.

204 Inigo Jones: On the architect, see Leapman, *Inigo*.

205 "The king is very content": Quoted in Gachard, *Histoire politique et diplomatique*, 120.

205 the company of artists: Richard Perrinchief, in his 1676 biography of the king, *The Royal Martyr*, wrote that Charles "delighted to talk with all kinds of artists." On Charles's art habit generally, see Brotton, *Sale of the Late King's Goods*.

205 "I do not know": Quoted in Brotton, *Sale of the Late King's Goods*, 147–48.

206 "As God is my witness": Rubens reported the details of this conversation in his letters to Olivares on June 30, 1629. It appears the artist condensed his account of this first meeting with his audiences with the king at Greenwich on June 25. Rubens to Olivares, three letters dated June 30, 1629, in *LPPR*, 299–306.

208 Wake observed: Wake to Carleton, July 4, 1629, in Sainsbury, 133–35.

209 "contrary to their common interests": Secretary of John Coke (George Lamb) to "Jacques Han," June 15, 1629, in *CDR*, 5:60–63.

209 "Rubens is a covetous man": Quoted in Brotton, *Sale of the Late King's Goods*, 147–48.

209 Lamb sat down: On this report, see the commentary in *CDR*, 5:66–68.

209 "farre short": Secretary of John Coke (George Lamb) to "Jacques Han," June 15, 1629, in ibid., 5:61.

210 "Rarely, in fact": Rubens to Olivares, June 30, 1629, in *LPPR*, 301.

210 "Let's get down to particulars": Ibid., 302.

211 "could be no greater": Rubens to Olivares, Sept. 21, 1629, in ibid., 343.

211 "too honest a man": Carleton to Cottington, March 21, 1630, in Sainsbury, 148–49.

211 "An ambassador is an honest man": Wotton wrote the epigram in Latin in a visitors' guest book while traveling through Austria. See Smith, *Life and Letters of Sir Henry Wotton*, 1:49. Also useful on the history of diplomacy.

212 "assigned dolorous tasks": Quoted in Warnke, *Peter Paul Rubens*, 183.

212 "Confidence alone is the foundation": Rubens to Olivares, Aug. 1, 1631, in *LPPR*, 375.

213 "could have broken off": Rubens to Olivares, June 30, 1629, in Rooses, *Rubens*, 486.

213 "All the leading nobles": Rubens to Olivares, July 22, 1629, in *LPPR*, 314.

213 "attack the king of Spain": Ibid., 315–16.

213 "The king simply laughed": Ibid., 316.

215 "A miracle has been wrought": Rubens to Olivares, Aug. 24, 1629, in ibid., 326.

215 "unwilling to express himself": Rubens to Olivares, July 22, 1629, in ibid., 314.

215 "I consider this peace": Rubens to Olivares, Aug. 24, 1629, in ibid., 329–30.

216 "I do not feel": Rubens to Olivares, July 22, 1629, in ibid., 317–18.

216 "approbation and thanks": Minutes of the Spanish Council of State, Madrid, Aug. 20, 1629, in ibid., 495.

217 "to be attributed": Rubens to Olivares, Sept. 21, 1629, in ibid., 338–39.

217–218 "All the kings and princes": Ibid., 343–44.

218 the *groote werck*: Alternatively, the *groote saecke*. On the negotiations and the public reaction to them, see Israel, *Dutch Republic*, 228.

219 "opportunity of conversing": Callières, *Art of Diplomacy*, 78.

220 "a spectacle worthy of the interest": Rubens to Pierre Dupuy, Aug. 8, 1629, in *LPPR*, 320–21.

220 the many paintings Rubens began: On Rubens's paintings in London, see especially Donovan, *Rubens and England*.

221 fondness for Saint George: For Charles and his obsession with Saint George, see Pitman, *Dragon's Trail*.

221 darkened its mood: On the expansion of the *Saint George*, see Belkin, *Rubens*, 223.

223 Their readability would be further compromised: The paintings were cleaned and restored several times. After one cleaning, the panels were reinstalled in the wrong positions, where they remained for much of the twentieth century before the distinguished scholar Julius Held noticed the error. There is considerable literature on the commission. See especially Donovan, *Rubens and England*; Julius Held, "Rubens' Glynde Sketch and the Installation of the Whitehall Ceiling," in *Rubens and His Circle*, 126–37; Millar, "Whitehall Ceiling"; Palme, *Triumph of Peace*; and Strong, *Britannia Triumphans*.

223 "I should be happier": Rubens to Gevaerts, Nov. 23, 1629, in *LPPR*, 350.

224 "I curse the hour": Rubens to Isabella, Nov. 24, 1629, in ibid., 352.

225 "We grant him this title": Patent of nobility, reprinted in Rooses, *Rubens*, 491.

227 "I am a man of peace": Rubens to Peiresc, Aug. 16, 1635, in Rooses, *Rubens*, 615.

228 "but one way feasible": Carleton (Dorchester) to Cottington, March 21, 1630, in Sainsbury, 148–49. There was to be one final affront. When Rubens left London, he brought with him a dozen young Catholic theological students headed for Flemish convents and Jesuit colleges. Their travel required royal permission, which they had, for whatever reason, not acquired. At Dover, English port officers kept the party from leaving for two weeks before the matter was resolved. See *CDR*, 5:282–86.

229 "would not blush to see me": Rubens to Peiresc, Dec. 18, 1634, in *LPPR*, 393.

230 "inclined to lead": Ibid.

230 "Now he owns the living image": Gevaerts, quoted in Rooses, *Rubens*, 500.

231 "Though I find myself": Rubens to Van den Wouvere, Jan. 13, 1631, in *LPPR*, 370–71.

231 "One needs proven ministers": Correspondence regarding Rubens's potential service in London is quoted in ibid., 358.

231 "He has served Your Majesty": Quoted in Vergara, *Spanish Patrons*, 110–11.

233 "labor entirely wasted": Rubens to Pierre Dupuy, March 27, 1631, in *LPPR*, 372.

233 "keeps the world in turmoil": Rubens to Olivares, Aug. 1, 1631, in ibid., 374–81.

235 "His judgment in affairs": Jean Puget de la Serre, *Histoire curieuse de tout ce qui c'est passé à l'entrée de la reyne mère du roy très chrétien dans les villes des Pays-Bas* (Antwerp, 1632; 2nd ed. Amsterdam, 1848), available on the Oxford University faculty Web site.

235 "It appears that Spain": Rubens to Van den Wouvere, Jan. 13, 1631, in *LPPR*, 371.

236 "I know that I get nothing": Quoted in Elliott, *Count-Duke*, 404.

236 "full power to give": Gerbier to Charles I, Dec. 19, 1631, in Sainsbury, 165–66.

236 A short while later: Gerbier's letter to Charles I on Dec. 26, 1630 (in ibid., 166–67), describes Rubens's mission to The Hague in detail.

237 Christina von Dietz: Unlike his older brother Maurice, Frederick Henry actually had no blood relationship with von Dietz. He was the son of the fourth wife of William of Orange, Louise de Coligny.

237 a considerable territorial sacrifice: On the *groote werck* negotiations, see Israel, *Dutch Republic*, 223–49. Precisely what terms Rubens offered Frederick Henry is unknown, but this seems the most likely scenario, given the circumstances.

238 "I do not see": Rubens to Isabella, April 12, 1632, in *LPPR*, 383–84.

239 "I got nothing out of him": Gerbier to Charles I, Dec. 26, 1630, in Sainsbury, 166–67.

240 "I stand upon firm ground": Rubens to Aarschot, Jan. 29, 1633, in Rooses, *Rubens*, 518.

241 "I might well have omitted": Aarschot to Rubens, Jan. 29, 1633, in ibid.

241 "something great and veritably divine": On Seneca and Petrarch, see Miller, *Peiresc's Europe*, 51–52.

241 "I carried out": Rubens to Peiresc, Dec. 18, 1634, in *LPPR*, 391–96.

242 "with as much courtesy": Quoted in Rooses, *Rubens*, 521.

243 Gerbier's charge against Aarschot: On the Gerbier-Aarschot episode, see ibid., 521–23.

244 "I have preserved": Rubens to Peiresc, March 16, 1636, in *LPPR*, 402.

245 "Rid me of these cardinal's robes": Quoted in Rooses, *Rubens*, 556.

245 the Battle of Nördlingen: Ferdinand's troops joined those of the future Holy Roman Emperor Ferdinand II.

245 he presented his ideas: The preparations are described in detail in Rooses, *Rubens*, 558–70. See also John Rupert Martin's *Decorations for the Pompa Introitus Ferdinandi*, pt. 16 of the *Corpus Rubenianum Ludwig Burchard* (New York: Phaidon, 1972).

246 "I am so overwhelmed": Rubens to Peiresc, Dec. 18, 1634, in Rooses, *Rubens*, 559.

246 Alva's old citadel: The structure, a symbol of oppression, was actually decommissioned and taken apart in the years after Alva's departure, and subsequently reconstructed as a defensive bastion.

246 "To thee we look": Texts from the Pompa Introitus in Rooses, *Rubens*, 560–62.

248 greatest victory: Quoted in Israel, *Dutch Republic*, 259.

248 "The great festival": Quoted in Alpers, *Making of Rubens*, 47.

249 Castle Steen: On this estate and its purchase, see Rooses, *Rubens*, 571–72; and Baudouin, "Rubens House at Antwerp."

250 "indicates that fertility": Rubens to Justus Sustermans, March 12, 1638, in Warnke, *Peter Paul Rubens*, 184–85.

251 "The advice gleaned": Quoted in ibid., 183–84.

252 "The rhyming geniuses": Quoted in Rooses, *Rubens*, 619.

EPILOGUE

255 Those professions: The closest American analogy to Rubens would probably be Paul Revere: a craftsman (silversmith) and wealthy entrepreneur who was drawn into public service.

257 Only the portico and garden pavillion remain: The reconstruction is largely based on engravings produced in the late seventeenth century. See Belkin and Healy, *House of Art*; and Schama, *Rembrandt's Eyes*.

258 an exemplar of muscular Aryan genius: See Evers, *Peter Paul Rubens*. It was one of several publications on Rubens that Evers completed during World War II.

258 "The position of art": Burckhardt, *Recollections of Rubens*, 115.

258 "a vogue which is now": Ibid., 110.

259 "Rubenesque": The editors of *Maclean's* actually first used the term
 "Rubensesque," but the shorter version soon overtook it.

260 "Rubens did for the female": Kenneth Clark, *The Nude* (New York:
 Pantheon, 1956), 148.

260 "He dominates": Delacroix, quoted in Belkin, *Rubens*, 324. Ruskin and
 Eakins, quoted in Alpers, *Making of Rubens*, 10 and 133–35, respectively.

261 said to abhor him: See John Richardson, *A Life of Picasso: The Triumphant
 Years* (New York: Knopf, 2007), 166.

SELECTED BIBLIOGRAPHY

❦

It is an exhilarating task to evoke the life and personality of Rubens.

These are the first words of Jacob Burckhardt's *Recollections of Rubens*, one of the many touchstones of Rubens scholarship, and they are, incontrovertibly, true. For evidence of their veracity, one need only visit Kolvenierstraat, the narrow Antwerp lane just behind the painter's reconstructed house on the Wapper. There, with a privileged view of the Rubenshuis garden, scholars, students, collectors, and curators can project themselves back into the artist's day as they avail themselves of an entire library devoted to Rubeniana. Perhaps no artist has attracted so many gifted scholars. Rubens's engagement with politics, his portrayal of the female body, his collecting, his business practices, his philosophical, literary, and religious ideas—these aspects of Rubens's life and work have made him an especially fertile subject for historians of every ideological proclivity, and his immense output has left no shortage of material for analysis, discussion, and theorizing. Given the enormity of the literary production devoted to Rubens, it would be impossible for this bibliography to be in any way comprehensive. It is, instead, an overview of the works that treat centrally with his political career, and otherwise have shaped my thinking on the artist and his times. I am in particular debt to the scholars Svetlana Alpers, Frans Baudouin, Kristin Lohse Belkin, Julius Held, Elizabeth Alice Honig, Jonathan Israel, Michael Jaffé, Ruth Saunders Magurn, Jeffrey Muller, Geoffrey Parker, Max Rooses, Charles Ruelens, and Simon Schama.

❦

Alpers, Svetlana. *The Making of Rubens*. New Haven, Conn.: Yale University Press, 1995.

Ashley, Maurice. *Life in Stuart England*. New York: Putnam, 1964.

Baglione, Giovanni, Joachim von Sandrart, and Roger de Piles. *Lives of Rubens*. Introduction by Jeremy Wood. London: Pallas Athene, 2005.

Bakhuizen van den Brink, Reiner Cornelis. *Het huwelijk van Willem van Oranje met Anna van Saxen, historisch-kritisch onderzocht*. Amsterdam, 1853.

Baudouin, Frans. *Pietro Pauolo Rubens*. Translated by Elsie Callander. New York: Abrams, 1977.

———. "The Rubens House at Antwerp and the Château de Steen at Elewijt." *Apollo* 105 (1977): 181–88.

Belkin, Kristin Lohse. *Rubens*. London: Phaidon, 1998.

Belkin, Kristin Lohse, and Fiona Healy. *A House of Art: Rubens as Collector*. Introduction by Jeffrey M. Muller. Antwerp: Rubenshuis and Rubenianum, 2004.

Bellori, Giovanni Pietro. *The Lives of the Modern Painters, Sculptors, and Architects*. Translated by Alice Sedgwick Wohl. 1672; reprint, New York: Cambridge University Press, 2005.

Bergin, Joseph. *Cardinal Richelieu: Power and the Pursuit of Wealth*. New Haven, Conn.: Yale University Press, 1990.

Blunt, Anthony. "Rubens and Architecture." *Burlington* 121 (1977): 609–21.

Braudel, Fernand. *A History of Civilizations*. Translated by Richard Mayne. London: Penguin, 1994.

Brook, Timothy. *Vermeer's Hat: The Seventeenth Century and the Dawn of the Global World*. New York: Bloomsbury, 2007.

Brotton, Jerry. *The Sale of the Late King's Goods: Charles I and His Art Collection*. London: Macmillan, 2006.

Burckhardt, Jacob. *Recollections of Rubens*. London: Phaidon, 1950.

Callières, François de. *The Art of Diplomacy*. Edited by H. M. A. Keens-Soper and Karl W. Schweizer. New York: Holmes & Meier, 1983.

Cammaerts, Emile. *Belgium: From the Roman Invasion to the Present Day*. London: T. Fisher Unwin, 1921.

———. *Rubens: Painter and Diplomat*. London: Faber and Faber, 1932.

Campbell, Caroline, and Alan Chong. *Bellini and the East*. London: National Gallery, 2005.

Carleton, Dudley. *Letters from and to Sir Dudley Carleton*. 3 vols. The Hague: Pierre Gosse Jr. and Elie Luzac fils, 1759.

Chambers, David, and Jane Martineau. *Splendours of the Gonzaga*. London: Victoria & Albert Museum, 1981.

Christiansen, Keith. *Andrea Mantegna: Padua and Mantua*. New York: Braziller, 1994.

Conant, Jennet. *The Irregulars: Roald Dahl and the British Spy Ring in Wartime Washington*. New York: Simon & Schuster, 2008.

Coope, Rosalys. *Salomon de Brosse and the Development of the Classical Style in*

French Architecture from 1565 to 1630. University Park: Pennsylvania State University, 1972.

Cooper, Charles Henry. *Annals of Cambridge*. Vol. 3. Cambridge, U.K.: Warwick, 1845.

Corpus Rubenianum Ludwig Burchard: An Illustrated Catalogue Raisonné of the Work of Peter Paul Rubens Based on the Material Assembled by the Late Dr. Ludwig Burchard in Twenty-six parts. Edited by the Nationaal Centrum voor de Plastische Kunsten van de XVIde en XVIIde Eeuw. Various publishers, 1968–present.

Crew, Phyllis Mack. *Calvinist Preaching and Iconoclasm in the Netherlands, 1544–1569*. New York: Cambridge University Press, 1978.

Croft-Murray, Edward. "The Landscape Background in Rubens's *St. George and the Dragon*." *Burlington* 89 (1947): 90.

Cruzada Villamil, Gregorio. *Rubens, diplomático español*. Madrid: Medina y Navarra, 1874.

Donovan, Fiona. *Rubens and England*. New Haven, Conn.: Yale University Press, 2004.

Duke, Alastair. *Reformation and Revolt in the Low Countries*. London: Hambledon, 1990.

Dürer, Albrecht. *Dürer's Record of Journeys to Venice and the Low Countries*. Edited by Roger Fry. New York: Dover, 1995.

Elliott, J. H. *The Count-Duke of Olivares: The Statesman in an Age of Decline*. New Haven, Conn.: Yale University Press, 1986.

———. *Richelieu and Olivares*. New York: Cambridge University Press, 1991.

Evers, Hans Gerhard. *Peter Paul Rubens*. Munich: Bruckmann, 1942.

———. *Rubens und sein Werk*. Brussels: De Lage Landen, 1943.

Filipczak, Zirka Zaremba. *Picturing Art in Antwerp, 1550–1700*. Princeton, N.J.: Princeton University Press, 1987.

Freedberg, David. *Iconoclasm and Painting in the Revolt of the Netherlands, 1566–1609*. New York: Garland, 1988.

Gachard, Louis Prosper. *Histoire politique et diplomatique de Pierre-Paul Rubens*. Brussels: Office de Publicité, 1877.

Gachet, Emile. *Lettres inédites de Pierre-Paul Rubens*. Brussels: Hayez, 1840.

Galardi, P. Ferdinand de. *Traité politique concernant l'importance du choix exact d'ambassadeurs habiles avec l'utilité des ligues et du rétablissement des ordres militaires en Espagne*. Cologne: Chez Pierre de la Place, 1660.

Gardiner, Samuel Rawson. *A History of England from the Accession of James I to the Outbreak of the Civil War, 1603–1642*. 10 vols. Reprint, New York: AMS, 1965.

———. *A History of England Under the Duke of Buckingham and Charles I, 1624–1628*. 10 vols. London: Longmans, Green, 1875.

Geyl, Pieter. *The Netherlands in the Seventeenth Century: Part One, 1609–1648*. New York: Barnes & Noble, 1961.

————. *The Revolt of the Netherlands*. New York: Barnes & Noble, 1958.

Goetzmann, William N., and K. Geert Rouwenhorst, eds. *The Origins of Value: The Financial Innovations that Created Modern Capital Markets*. New York: Oxford University Press, 2005.

Goldgar, Anne. *Tulipmania: Money, Honor, and Knowledge in the Dutch Golden Age*. Chicago: University of Chicago Press, 2007.

Grafton, Anthony. *Bring Out Your Dead: The Past as Revelation*. Cambridge, Mass.: Harvard University Press, 2002.

————. *What Was History? The Art of History in Early Modern Europe*. Cambridge, U.K.: Cambridge University Press, 2007.

Guicciardini, Ludovico. *Belgique 1567*. Brussels: Office de Publicité, 1943.

Held, Julius S. *The Oil Sketches of Peter Paul Rubens*. 2 vols. Princeton, N.J.: Princeton University Press, 1980.

————. "On the Date and Function of Some Allegorical Sketches by Rubens." *Journal of the Warburg and Courtauld Institutes* 38 (1975): 218–33.

————. *Rubens and His Circle: Studies by Julius S. Held*. Edited by Anne W. Lowenthal, David Rosand, and John Walsh Jr. Princeton, N.J.: Princeton University Press, 1982.

————. "Rubens's Sketch of Buckingham Rediscovered." *Burlington* 118, no. 861 (Aug. 1976): 547–51.

Honig, Elizabeth Alice. *Painting & the Market in Early Modern Antwerp*. New Haven, Conn.: Yale University Press, 1998.

Huet, Leen. *De brieven van Rubens*. Amsterdam: Meulenhoff, 2006.

Hughes, Anthony. "Naming the Unnamable: An Iconographical Problem in Rubens's 'Peace and War.' " *Burlington* 122, no. 924 (March 1980): 157–66.

Huvenne, Paul. *The Rubens House, Antwerp*. Brussels: Ludion, 1990.

Isacker, Karel van, and Raymond van Uytven, eds. *Antwerp: Twelve Centuries of History and Culture*. Antwerp: Fonds Mercator, 1986.

Israel, Jonathan I. *Conflicts of Empires: Spain, the Low Countries, and the Struggle for World Supremacy, 1585–1713*. London: Hambledon, 1997.

————. *The Dutch Republic and the Hispanic World, 1606–1661*. Oxford: Clarendon, 1982.

Jaffé, Michael. *Rubens and Italy*. Ithaca, N.Y.: Cornell University Press, 1977.

————. *Rubens: Catalogo completo*. Milan: Rizzoli, 1989.

Jardine, Lisa. *The Awful End of Prince William the Silent*. London: HarperCollins, 2005.

————. *Going Dutch: How England Plundered Holland's Glory*. New York: Harper, 2008.

————. *Worldly Goods*. London: Macmillan, 1996.

Jong, Jan de, and Bart Ramakers et al., eds. *Rubens and the Netherlands*. Zwolle, the Netherlands: Waanders, 2006.

Kett, Charles W. *Rubens*. London: Sampson Low, Marston, Searle, & Rivington, 1880.

Leapman, Michael. *Inigo: The Life of Inigo Jones, Architect of the English Renaissance*. London: Review, 2003.

Lescourret, Marie-Anne. *Rubens: A Double Life*. Chicago: Ivan R. Dee, 1993.

Lipsius, Justus. *Tvvo Bookes of Constancie*. Translated by John Stradling. Reprint, New Brunswick, N.J.: Rutgers University Press, 1939.

Lockyer, Roger. *Buckingham: The Life and Political Career of George Villiers*. New York: Longman, 1981.

———. *The Early Stuarts: A Political History of England, 1603–1642*. New York: Longman, 1989.

Logan, Anne-Marie. *Peter Paul Rubens: The Drawings*. In collaboration with Michiel C. Plomp. New York: Metropolitan Museum of Art, 2004.

Lombaerde, Piet, ed. *The Reception of P. P. Rubens's "Palazzi di Genova" During the 17th Century in Europe: Questions and Problems*. Turnhout, Belgium: Brepols, 2002.

Machiavelli, Niccolò. *The Chief Works and Others*. Translated by Allan Gilbert. Durham, N.C.: Duke University Press, 1965.

Magurn, Ruth Saunders, ed. and trans. *The Letters of Peter Paul Rubens*. Cambridge, Mass.: Harvard University Press, 1955.

Mattingly, Garrett. *The Armada*. Boston: Houghton Mifflin, 1959.

———. *Renaissance Diplomacy*. London: Cape, 1955.

Mauclère, Jean. *Rubens: Diplomate et grand seigneur*. Paris: Colbert, 1943.

McGrath, Elizabeth. "The Painted Decoration of Rubens's House." *Journal of the Warburg and Courtauld Institutes* 41 (1978): 245–77.

Millar, Oliver. *The Age of Charles I: Painting in England, 1620–1649*. London: Tate Gallery, 1972.

———. "The Whitehall Ceiling." *Burlington* 98 (1970): 258–65.

Miller, Peter. *Peiresc's Europe: Learning and Virtue in the Seventeenth Century*. New Haven, Conn.: Yale University Press, 2000.

Montaigne, Michel de. *The Complete Essays of Montaigne*. Translated by Donald Frame. Stanford, Calif.: Stanford University Press, 1957.

Morford, Mark. *Stoics and Neostoics: Rubens and the Circle of Lipsius*. Princeton, N.J.: Princeton University Press, 1991.

Muller, Jeffrey M. "The Perseus and Andromeda on Rubens's House." *Art Bulletin* 59 (Dec. 1977): 131–46.

———. *Rubens as Collector*. Princeton, N.J.: Princeton University Press, 1989.

———. "Rubens's Museum of Antique Sculpture: An Introduction." *Art Bulletin* 59, no. 4 (1977): 571–82.

Mumford, Lewis. *The City in History: Its Origins, Its Transformations, and Its Prospects*. New York: Harcourt, Brace & World, 1961.

Murray, John J. *Antwerp in the Age of Plantin and Brueghel*. Norman: Oklahoma University Press, 1970.

Nicolson, Harold. *Diplomacy*. New York: Harcourt, Brace, 1939.

Orso, Steven N. *Philip IV and the Decoration of the Alcázar of Madrid*. Princeton, N.J.: Princeton University Press, 1986.

Palme, Per. *Triumph of Peace: A Study of the Whitehall Banqueting House.* London: Thames and Hudson, 1957.

Panofsky, Erwin. *Early Netherlandish Painting: Its Origins and Character.* 2 vols. New York: Icon, 1971.

Parker, Geoffrey. *The Army of Flanders and the Spanish Road, 1567–1659.* New York: Cambridge University Press, 1972.

———. *The Dutch Revolt.* Rev. ed. New York: Penguin, 1985.

———, ed. *The Thirty Years' War.* 2nd ed. New York, Routledge, 1997.

Parker, Geoffrey, and Lesley M. Smith, eds. *The General Crisis of the Seventeenth Century.* 2nd ed. New York: Routledge, 1985.

Peacham, Henry. *The Complete Gentleman, The Truth of Our Times, and The Art of Living in London.* Ithaca, N.Y.: Cornell University Press, 1962.

Piles, Roger de. *Dissertation sur les ouvrages des plus fameux peintres*; *Le cabinet de Monseigneur le duc de Richelieu; La vie de Rubens.* Reprint, Geneva: Minkoff, 1975.

Pitman, Joanna. *The Dragon's Trail: The Biography of Raphael's Masterpiece.* New York: Touchstone, 2006.

Price, J. L. *Culture and Society in the Dutch Republic During the 17th Century.* London: Batsford, 1974.

The Priviledges of an Ambassadour: Written by a Civilian to a Friend Who Desired His Opinion Concerning the Portugall Ambassadour. London: Baldwin, 1654.

Rea, Hope. *Peter Paul Rubens.* London: George Bell and Sons, 1905.

Reeves, Eileen. *Painting the Heavens: Art and Science in the Age of Galileo.* Princeton, N.J.: Princeton University Press, 1997.

Rooses, Max. *L'oeuvre de P. P. Rubens: Histoire et description de ses tableaux et dessins.* 5 vols. Antwerp: J. Maes, 1886–92.

———. *Rubens.* Translated by Harold Child. 2 vols. Philadelphia: J. B. Lippincott, 1904.

Rooses, Max, and Charles Ruelens, eds. *Correspondance de Rubens et documents épistolaires concernant sa vie et ses oeuvres.* 6 vols. Antwerp: Veuve de Backer, 1887–1909.

Rosenthal, Lisa. "Manhood and Statehood: Rubens's Construction of Heroic Virtue." *Oxford Art Journal* 16, no. 1 (1993): 92–105.

———. "The *Parens Patriae*: Familial Imagery in Rubens's *Minerva Protects Pax from Mars*." *Art History* 12, no. 1 (March 1989): 20–38.

Rubens, Philip. "The Latin Life of Peter Paul Rubens by His Nephew Philip." Translated by L. R. Lind. *Art Quarterly* 9, no. 1 (1946): 37–44.

Rubens, Philippe. *Philippi Rvbeni electorvm libri II.* Antwerp: Ex Officina Plantinana, 1608.

Sainsbury, William Noël. *Original Unpublished Papers Illustrative of the Life of Sir Peter Paul Rubens, as an Artist and a Diplomatist.* London: Bradbury & Evans, 1859.

Saward, Susan. *The Golden Age of Marie de' Medici.* Ann Arbor, Mich.: UMI Research Press, 1982.

Schama, Simon. *The Embarrassment of Riches: An Interpretation of Dutch Culture in the Golden Age.* New York: Knopf, 1988.

———. *A History of Britain: The British Wars, 1603–1776.* London: BBC, 2001.

———. *Rembrandt's Eyes.* New York: Knopf, 1999.

Scribner, Charles, III. *Peter Paul Rubens.* New York: Abrams, 1989.

Sharpe, Kevin. *The Personal Rule of Charles I.* New Haven, Conn.: Yale University Press, 1992.

———. *Politics and Ideas in Early Stuart England.* New York: Pinter, 1989.

Sharpe, Kevin, and Peter Lake, eds. *Culture and Politics in Early Stuart England.* Hampshire, U.K.: Macmillan, 1994.

Shorto, Russell. *The Island at the Center of the World.* New York: Doubleday, 2004.

Skaterschikov, Sergey. *Skate's Art Investment Handbook.* New York: Skate Press, 2008.

Smith, Logan Pearsall. *The Life and Letters of Sir Henry Wotton.* Oxford: Clarendon, 1907.

Snyder, James. *Northern Renaissance Art.* New York: Abrams, 1985.

Stechow, Wolfgang. *Rubens and the Classical Tradition.* Cambridge, Mass.: Harvard University Press, 1968.

Strong, Roy. *Britannia Triumphans: Inigo Jones, Rubens, and Whitehall Palace.* London: Thames and Hudson, 1980.

Sutton, Peter C., ed. *The Age of Rubens.* Boston: Museum of Fine Arts, 1993.

Van der Stock, Jan, ed. *Antwerp: Story of a Metropolis.* Antwerp: Hessenhuis, 1993.

van Mander, Carel. *Dutch and Flemish Painters: Translations from the "Schilderboeck."* Translated by Constant Van de Wall. New York: McFarlane, Warde McFarlane, 1936.

Vera y Figueroa, Juan Antonio de. *Le parfait ambassadeur.* Paris, 1642.

Vergara, Alexander. *Rubens and His Spanish Patrons.* New York: Cambridge University Press, 1999.

Vlieghe, Hans. *Flemish Art and Architecture, 1585–1700.* New Haven, Conn.: Yale University Press, 1998.

Volk, Mary Crawford. "Rubens in Madrid and the Decoration of the King's Summer Apartments." *Burlington* 123, no. 942 (Sept. 1981): 513–29.

———. "Rubens in Madrid and the Decoration of the Salón Nuevo in the Palace." *Burlington* 122, no. 924 (March 1980): 168–80.

Warnke, Martin. *Peter Paul Rubens.* Woodbury, N.Y.: Barron's, 1980.

Wedgwood, C. V. *The Political Career of Peter Paul Rubens.* London: Thames and Hudson, 1975.

Wegg, Jervis. *The Decline of Antwerp Under Philip of Spain.* London: Methuen, 1924.

White, Christopher. *Peter Paul Rubens: Man and Artist.* New Haven, Conn.: Yale University Press, 1987.

Wicquefort, Abraham de. *The Embassador and His Functions.* London, 1716.

Woollett, Anne T., ed. *Rubens & Brueghel: A Working Friendship.* Los Angeles: J. Paul Getty Museum, 2006.

ILLUSTRATION CREDITS

✧

PAGE 5:

The Marriage by Proxy of Marie de' Medici and Henry IV in Florence, October 5, 1600, Réunion des Musées Nationaux/Art Resource, NY

PAGE 6 TOP LEFT:

Duke of Buckingham, Albertina, Vienna

PAGE 6 TOP RIGHT:

Marquis de Leganès (Don Diego Messia), photo: akg-images

PAGE 6 BOTTOM:

Studio of Peter Paul Rubens, *Marquis Ambrogio Spinola,* c. 1630, Saint Louis Art Museum, Museum Purchase, 33: 1934

PAGE 7 TOP:

Equestrian Portrait of Philip IV of Spain, Scala/Art Resource, NY

PAGE 7 MIDDLE:

Diego Velázquez, *Portrait of Gaspar de Guzman, Duke of Olivares on Horseback,* 1634, Scala/Art Resource, NY

PAGE 7 BOTTOM:

Landscape with Saint George and the Dragon, RCIN 405356, the Royal Collection ©2009 Her Majesty Queen Elizabeth II

PAGE 8:

Helena Fourment (Het Pelsken/The Furlet), 1638, Erich Lessing/Art Resource, NY

EPILOGUE:

Title Page, *Legatus,* Museum Plantin-Moretus/Prentenkabinet, Antwerpen—UNESCO World Heritage, photo, Peter Maes

INDEX

❧❦❧

Aarschot, Philippe Charles d'Arenberg, Duke of, 239–43, 268

Abrégé de la vie des peintres (de Piles), 259

Adoration of the Magi (Rubens), 68–69, 92–94, 193, 273

Adrian VI, Pope, 157

Adventure, HMS, 201

Aertsen, Pieter, 43

Albert VII, Archduke of Austria, 32, 36–37, 62–63, 64, 67–69, 74–75, 84, 89, 93, 96, 97, 110–12, 247, 268

Alberti, Leon Battista, 30

Aldobrandini Marriage, 31

Alicante, Spain, 19, 22

Allegory of Peace and War, The (Rubens), 220–21, 223

Alva, Fernando Álvarez de Toledo, Duke of, 49–53, 59, 95, 235, 257, 267, 271, 272

ambassadors, history or duties of, 202

Ambaxiatorum brevilogus, 201

Amsterdam, 52–53, 158–59, 243, 256

Angers, Treaty of (1620), 102

Anna of Saxony, 53–56, 57, 62, 114, 237, 268

Anne, Queen of Denmark, 204

Antwerp, 13, 39–53, 191

 Counter-Reformation and, 90–92

Fossa Mariana canal project and, 139–41, 143, 162, 178

history and description of, 41–44, 257

Koninklijk museum in, 257

plague outbreak in, 135–36

resurgence of, 257

Rubens and, 10–12, 30, 57–60, 65–69, 71–78, 82, 83–84, 85, 91–92, 96, 129, 183, 203, 223, 228–29, 244–48, 257–58, 263

Spanish-Dutch conflict and, 3, 27, 45–53, 59, 60, 93, 137–41, 143, 150–51, 159, 162–63, 171, 176, 198, 244–48, 251–52, 256, 272

Apelles, 73, 74

Armada, Spanish, 61, 272

Arras, Treaty of (1579), 60, 272

Augsburg Transaction (1548), 44, 271

Bacon, Francis, 203

Balance des peintres (de Piles), 259–60

Baroque period, 1, 14, 44, 79, 259

Bassano, Jacopo, 13, 97–98

Battle of the Amazons (Rubens), 75

Baudius, Domenicus, 71

Baugy, Nicolas de, 119

Bautru, Guillaume, 194

Bavaria, 207